Inappropriate Bodies

Art, Design, and Maternity

EDITED BY RACHEL EPP BULLER
AND CHARLES REEVE

DEMETER

Inappropriate Bodies
Art, Design, and Maternity
Edited by Rachel Epp Buller and Charles Reeve

Copyright © 2019 Demeter Press

Individual copyright to their work is retained by the authors. All rights reserved. No part of this book may be reproduced or transmitted in any form by any means without permission in writing from the publisher.

Demeter Press
140 Holland Street West
P. O. Box 13022
Bradford, ON L3Z 2Y5
Tel: (905) 775-9089
Email: info@demeterpress.org
Website: www.demeterpress.org

Demeter Press logo based on the sculpture "Demeter" by Maria-Luise Bodirsky www.keramik-atelier.bodirsky.de

Printed and Bound in Canada

Front cover image: RUCHIKA WASON SINGH, *Balagan in Metamorphosis I,* Chinese ink and Chinese painting colour on xuanjhie paper. 69.85 cms x 69.85 cms. 2015.
Front cover artwork: Michelle Pirovich
Typesetting: Michelle Pirovich

Library and Archives Canada Cataloguing in Publication
Title: Inappropriate bodies : art, design, and maternity
Edited by Rachel Epp Buller and Charles Reeve.
Names: Buller, Rachel Epp, 1974- editor. | Reeve, Charles, 1962- editor.
Description: Includes bibliographical references.
Identifiers: Canadiana 20190144807 | ISBN 9781772582093 (softcover)
Subjects: LCSH: Mothers in art. | LCSH: Motherhood in art. |
LCSH: Human figure in art.
Classification: LCC N7630.I53 2019 | DDC 704/.042—dc23

MIX
Paper from
responsible sources
FSC® C004071

We dedicate this book to our children,
Daniel, Daisy, Lucy, Charlie, and Minnie;
to our partners, Tim and Amy;
and to our mothers, Dianne and Phyllis.

Acknowledgments

This book has been a labor of love, carried out over the course of several years. We thank first and foremost our families, whose very presence continued to push our ideas in new directions, for their steadfast support in the midst of writing deadlines. Thanks to Andrea O'Reilly for her enthusiastic championing of our project and her unwavering belief that this manuscript would eventually come together. Many thanks to our contributors for their patience and perseverance through rounds of editing. We thank our anonymous peer reviewers, whose detailed insights shaped the volume in significant ways. And finally, thank you to the many writers, artists, mothers, and thinkers whose voices and creations have shifted our conversations and will continue to do so.

Contents

CONTENTS

Inappropriate Bodies:
An Entry Point

Rachel Epp Buller

Imagine encountering this logic problem on an exam:

> If maternity is perceived to be a cultural ideal, and a cultural
> ideal is perceived as appropriate, is maternity appropriate?
> A. Yes. B. No.

Given the question's sequential framing, you likely would mark the
answer as A, Yes. Or if you perceived a trap, you might choose B, No.
But the real answer to this trick question, perhaps one not even offered
as a potential answer on the exam, is C—Yes and No. Maternity is
both a cultural ideal and a cultural taboo, both appropriate and inap-
propriate. Like Schrödinger's cat, maternity occupies two contradicto-
ry states at once.

In the years since Charles and I each began writing about maternity
and the maternal body in contemporary art contexts, we have encount-
ered explicit and implicit variations on this question-and-answer
scenario. The question—is maternity appropriate?—is not only broad
and dependent on the contexts of place, race and ethnicity, class,
sexuality, ability, and religion, but it also falls prey to ever-shifting
cultural landscapes of what seems acceptable regarding women's
bodies. Given this fluidity and ambiguity, we choose not to argue for
maternity's appropriateness but rather to investigate the possibility that
maternity exists in an in-between space, a place of being both/and—
both lauded and censored, both appropriate and inappropriate—in

many contexts. And we see how contemporary artists confront this simultaneity, as they probe the *how* and *why* of maternity and the maternal body as ideal and taboo, whether by emphasizing maternity's grotesque physicality—strategically pushing back against cultural restrictions imposed upon yet reinscribed by maternal bodies—or by proposing ways of considering maternity that go beyond or outside these dualisms. Consider Jenny Saville's paintings, how the paint's thick impasto emphasizes the rippling flesh of female bodies filling the canvas, or Mary Kelly's film *Antepartum* (1973), which records her full-term unborn child's alien-like movements beneath her tightly stretched abdomen. Renee Cox's larger-than-life *Yo Mama* photographs (1992-96) herald the magnificence of pregnant and breastfeeding bodies while implicitly asking whose bodies get to be seen as the maternal ideal. Jill Miller's *The Milk Truck* (2011) uses humour to address cultural prohibitions of maternity: her breastfeeding emergency vehicle, a converted ice cream truck topped by an enormous breast with a red flashing nipple, came to the rescue of nursing mothers whose bodies were policed in public. This visual spectacle on wheels subversively drew attention away from the mother's body and redirected it onto the truck itself, its absurdity adding levity to a tense encounter.

Our thinking about maternal bodies and expectations in differing cultural contexts has evolved significantly over the past decade, primarily through germinal conversations inspired by and through an exciting variety of publications, conferences, and exhibitions. When I first met Charles at an Association for Research on Mothering conference in New York in 2008, few art history scholars had given sustained attention to maternal bodies. Andrea Liss had published several essays in journals and edited collections, and Sandra Matthews and Laura Wexler's *Pregnant Pictures* (2000) examined diverse cultural representations of pregnancy in the U.S. in visual art, medical textbooks, and popular culture.[1] But the publication of Liss's ground-breaking book *Feminist Art and the Maternal* (2009) opened the floodgates to a wealth of art-based writing and thinking about maternal experiences, often bringing many voices into conversation together. Although several artistic and scholarly voices appear in a number of these contexts, each book, journal issue, symposium, or exhibition offered its own lens and expanded the conversation in new directions. Jennie Klein and Myrel Chernick's *The M Word: Real Mothers in Contemporary Art* (2011) bridged

generational divides, anthologized significant existing feminist texts and reflections by artists and curators on art and motherhood, and placed them in conversation with a diversity of contemporary artistic and scholarly voices. This work built on the *Maternal Metaphors* exhibitions, first organized by Chernick in 2004 and then collaboratively in 2006. The 2010 *Mutter* exhibition in Graz, Austria, explored mothering's intersections with minority cultures in contemporary art, whereas Felicita Reuschling examined mothering from the perspective of immigrant care work in her Berlin exhibition *Beyond Re/Production* (2011). In *Reconciling Art and Mothering* (2012), I brought together artists and art historians to promote dialogue across theory and practice and to expand conversations as much as possible by drawing on voices from six continents. Natalie Loveless's *New Maternalisms* exhibitions and publications considered intersections of art practice, theory, and history through a lens of feminist new materialism to consider the maternal as a political and ethical orientation. Susan Bright's *Home Truths: Photography and Motherhood* (2013) engaged with a specific medium while highlighting investigations into adoption, infertility, child loss, and maternal eroticism.[2] Lena Šimić and Emily Underwood-Lee shifted conversations towards live art and performance in *Live Art and Motherhood* (2016) and in their maternal-themed special issue of *Performance Research* (2017). Elena Marchevska and Valerie Walkerdine's soon-to-be-published collection *Maternal Structures in Creative Work* (2019) builds on some of the work begun by Chernick and Klein and emphasizes the importance of intergenerational dialogue and continuing conversations and maternal activist work across generations so that wheels are not continually reinvented. Some initiatives begin conversations based in a particular medium, such as Ashlee Wells' photographic *4th Trimester Bodies Project*; in geographic specificity, such as Ruchika Wason Singh's *Archive for Mapping Mother Artists in Asia*; in cultural specificity, such as the *ReMatriate Collective*[3] of Indigenous activist women and artists in Canada; or in technological connectivity, such as Sarah Irvin's online database project *Artist-Parent Index*. Maternally minded artists and writers have gathered together in many conferences and symposia over the past decade, which emphasizes the international links among them.[4] Although English has been the primary working language of these gatherings, many participants return home and extend these discussions across linguistic and disciplinary boundaries.

But even as these conversations expand outwards, they have a circular quality. New artist-mothers and maternal scholars join discussions and all is novel to them, whereas others create innovative initiatives and conversations unrelated to past and concurrent efforts.[5] Despite the Internet's global reach, we are not always part of the same conversations or aware of our predecessors. As artists, curators, and art historians, we must document work and circulate ideas to retain institutional memory while building connections and sharing ideas beyond borders, especially those of our own comfort. In *To Become Two: Propositions for Feminist Collective Practice,* Alex Martinis Roe calls for the creation of cross-generational feminist knowledges by "valuing and constructing authorship differently: as a relational process, where protagonists are appreciated for their distinction, but also where the networks, collaborations, and dialogue that have made their work possible are heard and valued in each of their voices" (15). Roe researches past and present feminist collectives in Paris, Utrecht, Milan, Sydney, and Barcelona, and draws particular attention to storytelling and intentional conversations as part of imagining new collective practices and feminist alliances. As conversations around maternal bodies circulate, repeat, and expand, we must develop what Roe calls "bridging practices" (157), seeking connections across generations, geographies, and disciplines.

Whether parallel or intersecting, these efforts continue simply because although previous publications, exhibitions, and conferences have begun to make visible artistic expressions of maternity that are often marginalized or dismissed, progress remains to be made. Maternal bodies and experiences still are ignored, stigmatized, or censored. Meanwhile, cultural expectations of maternity create prejudices against women whose bodies and lives do not align—regardless of whether they have children—with those (generally fantastical) expectations. Indeed, a central organizing principle for our book is that whether a woman does or does not have children, maternity defines her. Our contributors examine maternity's centrality as a defining term of female identity, one that sets up bodies as inappropriate. At the same time, we seek to move the discussion beyond the personal and subjective. Although many of the artists and writers in this book come to these topics initially because of personal experiences, they leverage the personal to respond to, critique, or resist cultural and institutional

systems and expectations. Because of our interest in these larger systems, Charles and I were keen to incorporate discussions about design into this volume. We posed questions and sought discussions of design approaches that undo maternity's positioning as an inconvenience defining and disrupting the mother's life. We welcomed investigations of medical, technological, or commercial retail object design related to maternity, but we were also interested in systems design that considered how certain work or public environments might unconsciously prescribe, or proscribe, maternal bodies or behaviors.

Returning to our lengthy emails from early in the process, I see now how we shaped this book's direction through our extended exchange of ideas. We repeatedly circled back to the ideology of appropriateness around maternity, or as Charles articulated, "all the different ways in which something coded feminine is, over and over, inappropriate but the male complement isn't [and] how words like 'appropriate,' 'reasonable' and (increasingly) 'civil' are just covers for that ideological mechanism." Such coding inevitably leads to proscription of bodies, whether in artistic, academic, or cultural contexts, and Charles highlighted that in one of his messages: "the issue of freedom of expression is often lurking in the background [...], especially when it bumps up against social norms of what's 'acceptable,' 'reasonable,' etc." We debated whether this volume should focus exclusively on the mother's body or should consider other bodies tied to maternity. How do our cultures impose the expectation that all women's bodies are maternal bodies, regardless of whether they have children? How are babies' and children's bodies coded as appropriate or not, within their connection to maternity? This discussion led us to the wording of our title and subtitle—*Inappropriate Bodies: Art, Design, and Maternity*—which allows for a deeper understanding of whose bodies cultural expectations of maternity affect. In our emails, I see again our decision to address both art and design to broaden our perspective to consider how our built environments, and the objects that populate them, reinforce expectations of maternity while they implicitly negate nonconforming experiences:

Design really hasn't been part of the conversation that you and I have been having, and should be. Not only in terms of object design, although that could be interesting, but more so in terms of system design. For example, even though I work at a large art

and design university, surely one of the more flexible and accommodating work environments, the dream I had of bringing my baby boy to work with me was simply a non-starter. Sure, I brought him to one or two casual meetings on an emergency basis. But the idea that, for the first six months, he would be with me in his Baby Bjorn everywhere I went—simply not happening. But why not? (Reeve)

These initial conversations between editors circulated around our particular contexts; in other contexts, Charles bringing his son to work might have been received entirely differently. We do not presume that our situations represent those of artists and mothers the world over, so the essayists within this collection examine conflicted assumptions, expectations, and perceptions of maternity and the maternal body in a variety of artistic, cultural, and institutional contexts. Still, we acknowledge that these conversations only start to address some contexts. Religious societies, for example, leverage different maternal expectations than do secular ones—a topic raised in this volume primarily by Irene Pérez, writing about Catholic Spain. In highly militarized societies or countries at war, the maternal body and its potential progeny are often closely tied to nationalism, a point touched on here only by Shira Richter. Maternal expectations of South Asian women, as discussed by Ruchika Wason Singh, differ significantly from the contexts that many of our contributors address. In *To Become Two*, Alex Martinis Roe's discussion of affirmative relations privileges these types of differences and does not seek to elide them or pretend that we share universal experiences; rather, she suggests that new ways of being in relation engender solidarity, enabling "collective projects and relationships to come about through, not despite, difference, traversing the borders of identity politics" (64). In conversational modes, both those included here and the many that preceded this volume's inception, we speak but we also listen, and in listening deeply, we find difference but also commonality. And as we and these writers seek to make clear, the problematic question of what is an appropriate body offers a no-win situation for women in any place and, ultimately, reveals deep cultural discomfort with maternity. Depending on the context, a body that has realized its maternal potential may be inappropriate for its shape, physicality, or social condition. One must be fertile but not too fertile, have enough but not too many children, procreate at an age that is not

too young and not too old, display a baby bump of respectable but not grotesque size, and do one's utmost postpartum to regain an ideal prematernal size and shape. At the same time, a body of a certain age that has not realized its maternal potential may be equally inappropriate for failing to conform to gendered expectations and cultural norms. The only appropriate female body, it seems, is the young one—mature enough to be potentially maternal but young enough for the realization, or not, of that potential to remain in the future.

We intentionally include a range of writing formats, from scholarly essays to edited conversations to personal letters, each of which we understand as fitting for its particular context. Just as feminist artists have questioned what constitutes appropriate art, in terms of subject matter or medium, feminist academics have questioned what constitutes appropriate academic writing. Both of these initiatives to expand the scope of the appropriate have had institutional impact, as museum practices and academic standards broaden what they accept and protect as rigorous ways of making and knowing. The burgeoning field of auto-ethnography, for example, testifies to a widespread desire for academic writing to represent not just the life of the mind but the life of the body as well. Much feminist and maternal studies writing, building on the 1970s feminist mantra that "the personal is political," intentionally weaves together scholarly and personal narrative voices, incorporating bodily experiences to make visible what academic contexts so often have rendered invisible. Rather than grouping together particular writing formats, we intermingle essays, letters, and conversations: such stylistic messiness reflects our understanding that no one-size-fits-all prescription suits all scholarly exchange, just as there is no one-size-fits-all maternal body or experience. We gather the pieces that follow into three thematic sections: Body Politics, Family Practices, and By Design.

Body Politics

Women navigate the double-edged sword of maternal expectation in both art and cultural contexts, often focusing on the body's appearance and social positioning. The essays in this section address politics of nonconforming bodies and question the meaning, or even possibility, of conformity; they highlight artists whose practices push against problematic maternal expectations. Julia Hendrickson opens the section with an investigation of Lise Haller Baggesen's *Mothernism* installation at The Contemporary Austin, in Austin, Texas. After introducing Baggesen's project, whose conception the artist traces as an attempt to "locate the 'mother-shaped' hole in contemporary art discourse," Hendrickson analyzes how Baggesen situates the maternal figure at a particular intersection of feminism, science fiction, and disco. Hendrickson discusses the cultural negotiation of the maternal body that happens in shared public-private spaces like the museum, and concludes with a thoughtful reflection on how the staff at her particular museum engaged with larger societal and institutional questions around the maternal body because of Baggesen's installation.

Irene Pérez frames her contribution as a letter to her daughter. Reflecting on her experiences of body shaming and the navigation of maternal (in)appropriateness in a patriarchal setting, Pérez traces her ongoing conversations with her daughter about bodies, genders, and cultural expectations. Pérez's words, along with her artworks punctuating the text, speak to an intergenerational strength and solidarity between dissident bodies.

The next two contributions continue the theme of dissident bodies and address artistic projects of nonconformity and subversion of cultural expectation. Jennie Klein investigates the nonmaternal body addressed by Miriam Schaer. In photographs and artist books, the artist grapples with infertility, reproductive technologies, and harmful ideologies of motherhood. Schaer invokes feminist strategies throughout her work and tackles rigid patriarchal and cultural dictates that narrowly define maternal identity for women. Tina Kinsella's analysis of Micol Hebron's male nipple project—in which the artist shared a digital image of a male nipple on social media and invited viewers to paste it over images of female nipples, which are so often deemed inappropriate—investigates how Hebron's project satirized social prohibitions enacted on the maternal body and how it operated in

broader cultural and art historical contexts that simultaneously display and censor maternal bodies.

Shira Richter claims the maternal body as a means of intervention into cultural conventions and institutional systems. Richter invites us to consider her "motherbody model," a mindset and way of working that privileges collaboration over individualism. Taking issue with the art world's "star" system that raises one artist above the rest, Richter looks to embodied maternal experience for a foundation for alternative, feminist ways of working: her manifesto-like letter proposes that emphasizing relationships and collaborative enterprises as the end goal, rather than clawing one's way to the top and crushing others along the way, results in healthier, more satisfying, and more sustainable ways of working for all involved.

Lydia Gordon continues the investigation into non-normative maternity by considering Chelsea Knight's video art. Addressing work that moves between fiction and autobiography, motherhood and childlessness, Gordon highlights the maternal performativity in Knight's video as a lens through which to discuss maternal subjectivity, conflicted mother-daughter relationships, and uncomfortable and culturally inappropriate emotions of maternal desire and maternal ambivalence. Caroline Seck Langill's essay closes the section, foregrounding the often overlooked issue of disability by addressing work by Elizabeth MacKenzie, Martha Eleen, and Judith Scott. Using Doris Lessing's novel *The Fifth Child* as a frame, Langill explores how disability affects maternity and artistic practice, which raises issues of ambivalence, maternal physicality, disability advocacy, and child loss.

Family Practices

In 1992, Susan Bee and Mira Schor published a "forum," somewhere between a conversation and a group interview, called "On Motherhood, Art, and Apple Pie." Acknowledging and confronting a maternal taboo in the art world, Bee and Schor posed a series of straightforward, often practical, questions about how motherhood had affected artists' work, career, creativity, and reception by gallerists, dealers, critics, and fellow artists. Some respondents shared stories of hiding their maternal status and of receiving chilly receptions by curators after birth. Although this perceived maternal inappropriateness has not disappeared, the con-

versations and contemporary artists in this section are perhaps less concerned with appropriateness and more invested in changing systems to make life workable. Niku Kashef facilitates an extended conversation with artists whose practices openly involve their families. Offering varied examples of how artists negotiate work and family commitments, Kashef interviews Marni Kotak, who infamously gave birth in a Brooklyn art gallery and whose performance work closely follows the arc of her personal life; Courtney Kessel, whose collaborations with her daughter, Chloe Cash, have defined much of her artistic practice in recent years; Seth Kaufman, who wrestled with giving up an art career in the midst of the financial crisis and the onset of parenthood, only to rediscover a surprising new form of his practice; and Jamison Carter and Margaret Griffith, mixed media installation artists who have collaborated with each other in ways that welcome their two children into the process. Charles Reeve and Jess Dobkin follow this piece with an extended dialogue about Dobkin's performance art and its destabilization of heteronormative ideologies of motherhood. Interweaving topics of maternal identity, the maternal body as artistic material, sexuality, and sex work, they discuss what Dobkin characterizes as "playful approaches to taboos" in her performance work.

Deirdre Donoghue considers work by three artist-mothers— Weronika Zielinska-Klein, Courtney Kessel, and Sharon Stewart—in her concept of "maternal relational aesth-ethics," which she defines as an "interdisciplinary weaving together of aesthetics, ethics and maternal experiences of interrelatedness as a distinct approach for art-making." Aesthetically, these artists' works appear to have little in common, but Donoghue argues for links in how each has responded to maternity. In the "maternal relational aesth-ethics" that Donoghue suggests unite them, the artists have welcomed the interruption of maternity as a generative force, have explored greater attunement and modes of listening, and have engaged in practices of radical hospitality. While parts of Donoghue's essay address attunement with the environment, Alicia Harris more specifically considers relational possibilities between inanimate objects, humans, and other sentient beings as a mode of conveying kinship narratives. Harris discusses intersections of kinship, maternity, materiality, and Indigeneity in a comparison of exhibitions by Rose Simpson and Marie Watt, two artists from different

Native American backgrounds. Moving beyond narratives of personal maternal bodily experience, Harris addresses instead the corporeality of sculptural objects and how such corporeality facilitates the links of Indigenous family and kinship, present and ancestral.

To close the section, Terri Hawkes offers excerpts from an ongoing conversation with film and performance artists in the United Kingdom who create innovative structures to promote their work's integration with their family. The founders of the theatre company Prams in the Hall use their name to play on Cyril Connolly's infamous proclamation in his 1938 book *Enemies of Promise* that "there is no more somber enemy of good art than the pram in the hall." Similar attitudes have so pervaded art institutions in the decades since that Connolly is a regular foil for maternal artist-activists. Some artists who feel the art world shuns their family status prefer to create new structures rather than struggle for acceptance in existing institutions. Hawkes's conversation with the founders of Prams in the Hall, Raising Films, and the Mother House underscores the creative alternatives devised by these maternal artist-activists for rehearsals, studio spaces, and artist collectives.

By Design

As creative thinkers, artists and designers are well positioned to re-consider long-standing conventions and how practices and institutional spaces consciously or unconsciously reinscribe maternal expectations. The writers included in this third section question the design of spaces, objects, and practices, from museum interventions and curatorial approaches to the design of environments and products specifically centred on maternal bodies and their offspring. Doreen Balabanoff addresses what she terms "the inappropriate birthing body" in her analysis of the design of hospital birth environments. Tracing the architectural history of the hospital birth environment, along with an exploration of pharmacological and technological birth interventions, Balabanoff provocatively argues that the hospital birth environment itself renders the birthing body inappropriate—in her words, "a body that feels unknowing, uncertain, unsuitable for giving birth."

Heidi Overhill explores not the maternal body but its product—the baby—and how the baby as an idea informs all manner of consumer object design. Overhill posits that design features of our material

culture—miniaturization, portability, and cuteness—might be linked to human evolution and what she terms "baby lust," whereas the absence of infant and maternal bodies from design theory and literature suggests that, here again, such bodies are both desired and implicitly inappropriate.

Three pieces consider design and the maternal body in the contexts of artistic, curatorial, and scholarly practices. Ruchika Wason Singh shares about her efforts to redesign and expand opportunities for artist-mothers in Asia. Her Archive for Mapping Mother Artists in Asia, an online and face-to-face platform, intervenes in contexts of constraint. Using mapping, visibility, and mobility, Wason Singh documents the hitherto little discussed work of artist-mothers in Asia by creating an archive and art collection for the future, highlighting their work through online profiles and planned exhibitions, structuring short-term workshops and artist residencies to be accessible, and offering solidarity to those navigating familial and cultural expectations.

Amber Berson and Juliana Driever write about their recent curatorial project, *The Let Down Reflex*. Although they take care to discuss the exhibition's broad range of work and the intersections of art and family represented there, their larger mission is to move beyond accommodating families in the gallery space. As Berson and Driever write, their project concerns "access in a larger sense, and the disregard of alternative bodies of knowledge." They continue: "creating a space for families in cultural institutions is an accessibility issue that should concern everyone, regardless of parental status." In a transatlantic round-robin correspondence, "The Body in Letters," Lena Šimić, Emily Underwood-Lee, and I prioritize the letter form as an engaged, even intimate, format for scholarly exchange. We find commonality between the rhythms of epistolary time and maternal time—the extended time needed for giving and receiving care through our words and through our bodies. In slow conversations across time and space, we three artists question and together think through varied perceptions of inappropriateness—from maternal bodies and the representation of children to cycles of repetition and even the letter form itself as a mode of academic discourse.

Natalie Loveless concludes the section by facilitating a conversation with the artist-activists behind the collectives Cultural ReProducers, Invisible Spaces of Parenthood, and Enemies of Good Art. Coordinated

just after the 2016 U.S. presidential election and six months after the U.K.'s Brexit vote, the conversation underscores the continuing importance of maternal activism and resistance in precarious times. These collectives intervene in museum, public, and pedagogical spaces, create platforms for exchange, investigate possibilities for combining art and family, and encourage political artistic action. They do not so much accommodate the maternal body as rethink the larger questions of how our social and cultural institutions and expectations must change if maternal bodies are ever to become appropriate.

Looking Ahead

As in any collection of essays on a particular topic, we cannot claim that ours addresses every pertinent issue. Although maternal intersectional discussions addressing sexuality, race, marital status, and ability appear in this volume, other forms of bodies, other geographic-cultural contexts and their attendant maternal expectations, and other particular art and design analyses could be incorporated. Ours is but one more piece in a robust series of parallel and intersecting conversations, and we hope that future artists and writers will continue and further expand these discussions. Charles Reeve closes the volume with an afterword that not only reflects on specific contributions but also steps back to consider them in light of broader cultural and historical contexts by asking, "what was, is, and will be at stake in undoing the mothering body's (in)visibility?" At the same time, he ponders his own position as a male scholar and father of young children writing about the topic of maternity and inappropriate bodies. We all have our own progenitors who nurtured and nudged us towards the relevant discourses (art, history, feminism, not to mention feminist art history), and acknowledging that heritage surely must be, explicitly or not, part of the framing of any such discussion.

Erwin Schrödinger devised his scenario of the dead and alive cat as a thought experiment, a philosophical debate, and a paradox in his study of quantum mechanics. For Schrödinger, in other words, the both/and was entirely theoretical, the cat itself imagined. The both/and of maternity is far from theoretical. It is a lived reality, not a thought experiment, and, as such, it invites a continued thinking through. In the pieces that follow, artists and writers investigate the existence,

the duality, the inherent conflicts, and the potential ramifications of the maternal both/and—ideal and taboo, appropriate and inappropriate—in varied instances of art, design, and cultural context. We invite you to think with us.

Endnotes

1. A variety of articles on art and mothering also give grounding to subsequent work (Bee and Schor; Moravec; Bassas; Betterton). Bracha Ettinger's theory of the matrixial, articulated already in 1995, has since been taken up by a wide variety of artists, scholars, and theorists, some (including in this volume) in relation to contemporary discourses of art and mothering.

2. Some other group exhibitions that facilitated maternal conversations, many without accompanying publications, include *Generations* at AIR Gallery (New York, 1982); *Sacred Bond* at the Birmingham City Art Gallery (U.K., 1990); *Mothers* at Ikon Gallery (U.K., 1990); *Fertile Ground* at Agnes Etherington Art Centre (Kingston, Ontario, Canada, 1996) and Centennial Gallery (Oakville, Ontario, Canada, 1997); Signe Theill's traveling exhibition *Double Bind*, which premiered at Künstlerhaus Bethanian (Berlin, Germany, 2003); Jennifer Wroblewski's *Mother/mother-** at AIR Gallery (New York, US, 2009); and my exhibitions *Mothers* at WomanMade Gallery (Chicago, US, 2010) and *Postpartum* at Erman B. White Gallery (Kansas, US, 2013). Both Theill and Wroblewski wrote about their exhibitions in Chernick and Klein's *The M Word*.

3. ReMatriate Collective was founded by Jeneen Frei-Njootli in 2015. This social media-based decolonization movement seeks to combat stereotyping and disrespectful visual representation by putting Indigenous women in charge of how they are portrayed.

4. The many interdisciplinary conferences organized by Andrea O'Reilly, first through the Association for Research on Mothering and then through the Motherhood Initiative for Research and Community Involvement, and by Martha Joy Rose through the Museum of Motherhood, have been foundational for these conversations. Recent conferences and symposia specific to maternity and contemporary art, some of which also involved art exhibitions, installations, and films series, include the following: The Feminist

Art Project day of panels (The M Word), organized by Myrel Chernick and Jennie Klein, at College Art Association, Chicago, 2014; Complicated Labors: feminism, maternity, and creative practice, organized by Irene Lusztig, Santa Cruz, California, 2014; Motherhood and Creative Practice, organized by Elena Marchevska and Valerie Walkerdine, London, 2015; The Mothernists, organized by Deirdre Donoghue and Lise Haller Baggesen, Rotterdam, 2015; Mapping the Maternal: Art, Ethics, and the Anthropocene, organized by Natalie Loveless and Sheena Wilson, Edmonton, Alberta, 2016; The Mothernists II: Who Cares for the 21st Century?, organized by Deirdre Donoghue and Lise Haller Baggesen, Copenhagen, 2017; Maternal Attitude, organized by Zoe Gingell, Emily Underwood-Lee, and Eve Dent, Cardiff, Wales, 2018; and Oxytocin: Birthing the World and Oxytocin: Mothering the World symposia organized by Procreate Project (founder, Dyana Gravina) in London, 2017 and 2019.

5. For example, Amy Dignam's recent exhibition, *The M Word: Desperate Artwives,* 1-12 May, 2019 at One Paved Court in London, would appear to draw on Chernick and Klein's book and symposium but, as stated in a social media post, the reference was unintended and "completely coincidental" as the curator did not know the previous work ("Amy Dignam to 'The Mothernists'").

Works Cited

"Amy Dignam to 'The Mothernists'" closed group, *Facebook,* 2019, www.facebook.com/groups/906647359406482/?multi_permalinks =2595926167145251¬if_id=1554425058834004¬if_t=group_ activity. Accessed 5 Apr. 2019.

Bassas, Assumpta. "S.O.S.: Searching for the Mother in the Family Album." *n.paradoxa,* vol. 16, 2005, pp. 5-14.

Bee, Susan and Mira Schor. "Forum: On Motherhood, Art, and Apple Pie." *M/E/A/N/I/N/G,* no.12, 1992, pp. 3-42.

Betterton, Rosemary. "Promising Monsters: Pregnant Bodies, Artistic Subjectivity, and Maternal Imagination." *Hypatia,* vol. 21, no. 1, 2006, pp. 80-100.

Bright, Susan, editor. *Home Truths: Photography and Motherhood.* Photographers' Gallery, 2013.

Buller, Rachel Epp, editor. *Reconciling Art and Mothering.* Ashgate Publishing, 2012.

Chernick, Myrel, editor. *Maternal Metaphors: Artists / Mothers / Artwork.* The Rochester Contemporary, 2004.

Chernick, Myrel, and Jennie Klein, editors. *The M Word: Real Mothers in Contemporary Art.* Demeter Press, 2011.

Connolly, Cyril. *Enemies of Promise.* George Routledge and Sons, 1938.

Ettinger, Bracha. *The Matrixial Gaze.* Feminist Arts and Histories Network, 1995.

Liss, Andrea. "The Body in Question: Rethinking Motherhood, Alterity, and Desire." *New Feminist Criticism: Art, Identity, Action,* edited by Joanna Frueh et al., HarperCollins, 1994, pp. 80-96.

Liss, Andrea. "Maternal Rites: Feminist Strategies." *n.paradoxa,* vol. 14, 2004, pp. 24-31.

Liss, Andrea. *Feminist Art and the Maternal.* Minneapolis: University of Minnesota Press, 2009.

Loveless, Natalie, editor. *New Maternalisms.* FADO Performance Art Center, 2012.

Loveless, Natalie, editor. *New Maternalisms Chile: Maternidades y Nuevos Feminismos.* Santiago, National Museum of Fine Arts and Museo Arte Contemporaneo, Facultad de Artes, Universidad de Chile, 2014.

Loveless, Natalie, editor. *New Maternalisms Redux.* Department of Art and Design, University of Alberta, 2018.

Marchevska, Elena, and Valerie Walkerdine, editors. *Maternal Structures in Creative Work: Intergenerational Discussions on Motherhood and Art.* Routledge, 2019.

Matthews, Sandra, and Laura Wexler. *Pregnant Pictures.* London: Routledge, 2000.

Moravec, Michelle. "Mother Art: Feminism, Art, and Activism." *Journal of the Association for Research on Mothering,* vol. 5, no.1, 2003, pp. 69-77.

Reuschling, Felicita. *Beyond Re/Production. Mothering.* Kunstraum Kreuzberg/Bethanien, 2011.

Roe, Alex Martinis. *To Become Two: Propositions for Feminist Collective Practice.* Archive Books, 2018.

Šimić, Lena and Emily Underwood-Lee, editors. "On the Maternal." Special issue of *Performance Research,* vol. 22, no.4, 2017.

Šimić, Lena and Emily Underwood-Lee. *Live Art and Motherhood: A Study Room Guide on Live Art and the Maternal,* Live Art Development Agency, 2016, www.thisisliveart.co.uk/resources/catalogue/live-art-and-motherhood-a-study-room-guide-on-live-art-and-the-maternal/. Accessed 17 July 2019.

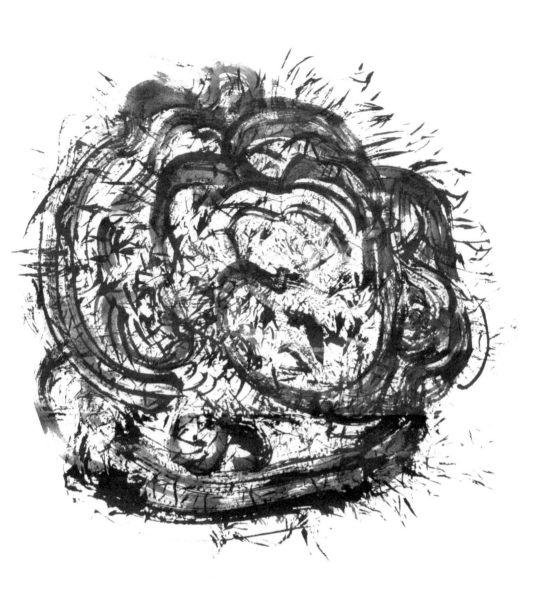

Part I
Body Politics

The Mother-Shaped Hole: Lise Haller Baggesen's *Mothernism*

Julia V. Hendrickson

"If Punk is dad ... Disco is your eternal mother, into whose pulsating bosom you can always return." (*Mothernism* 136)
—Lise Haller Baggesen

Introducing *Mothernism*

When not an object of desire—or in equal measures invisible —as a viewer, a subject, and as an artist, a woman's body in contemporary art is often inappropriate. It does not belong. A mother's body occupies an even more troubling space. In the contemporary art institution, the *maternal viewer* is merely tolerated: concessions (rather than standards) are made for strollers, play areas, changing stations, and breastfeeding spaces. Likewise, within contemporary art itself, the *maternal subject* is tolerated, albeit with some disdain. Setting aside the pervasive tidiness of the Virgin Mary's Immaculate Conception, in proportion to sexualized female nudes, just how many messy depictions of childbirth exist in major museum collections, much less appear regularly on view to the visiting public?[1] It is certainly a good omen for the place of motherhood in contemporary art that in 2015, curator (and newly minted father) Massimiliano Gioni organized a grandiose exhibition and catalogue on the iconography of

motherhood titled *The Great Mother: Women, Maternity, and Power in Art and Visual Culture, 1900–2015*, which was held at the Fondazione Nicola Trussardi in Milan. Yet, this major exhibition did not travel outside of Italy—perhaps such a show could only have been held in the country most known for its mother worship.

Much more than the viewer and subject in contemporary art, however, it is the *maternal artist* whose body is by far the most inappropriate in contemporary art. We continue to exist in a world where the female, the feminine, and the maternal are abject. It is difficult to accept the idea of the mother-artist, the maker who makes motherhood the mantra, the person who points the lens back at the mother-blind institution and says: *look, there are things to learn from here.* Society has told us the mother loses something of herself in childbirth, and in the art world, the maker-mama is assumed to have lost her creative self. Her presence among children infantilizes her artwork. Fear, of course, is the underlying factor, fear on an Oedipal scale. Fear of kitsch—Montessori colours, simplistic ideas. Fear of the body and its stretch marks, blood, fat, shit, and tears. Not surprisingly, fear of anything that could subvert the art market's status quo.

Danish-born artist-writer Lise Haller Baggesen[2] embraces these issues wholeheartedly in *Mothernism*, 2013–present, a hybrid and evolving audio-visual installation and text.[3] *Mothernism* highlights unchecked prejudice and attempts to stake a claim to a new, twenty-first-century possibility of being: a vibrant swirl of motherhood, feminism, and modernism. In the following essay, I first examine the *material context* for the installation, which most frequently takes the form of a tent surrounded by painted flags and soothing, colourful lights, and incorporates references to 1970s Danish interior design and Dutch therapy techniques. Then, I unpack the cultural context for this work, focusing on the roles that music, science fiction, and pop culture play in enticing the viewer to engage with motherhood in a contemporary art setting. Considering how Baggesen makes the case for a feminist "ethics of care," I explore *Mothernism*'s hybrid relationship to relational aesthetics, participatory art, and social practice—what could also be called "party as form." Subsequently, I outline the *historical context* for the project in relation to art history and contemporary art theory, and analyze the artist's specific mode of address: an alter ego who writes letters to her mother, sister, and children. Finally, I return to the mother in the contemporary art museum and offer examples of practical applications of what it means to be a Mothernist today.

What Is *Mothernism?*

Lise Haller Baggesen opens her book *Mothernism*—a purple object edged in the crisp silver of a fresh Wrigley's gum wrapper—with an account of a long drive on the German Autobahn, followed by an ode to Donna Summer's sultry disco style and to the lyrics from David Bowie's 1979 song "Fantastic Voyage" (17). 1979 was the International Year of the Child, the heyday of disco, and, for Baggesen, the touch-stone for her multifaceted project, which is situated (as she describes it) at "the intersection of feminism, science fiction, and disco" (*Mothernism* 17).[4]

Mothernism developed from the artist's ongoing attempts to organize her thoughts on motherhood in history, music, art, and personal exper-ience—or, in Baggesen's words, to "locate the 'mother-shaped' hole in contemporary art discourse" (*Mothernism* 17). Indeed, as Baggesen describes the term:

> The word "Mothernism" is an elision, associating both the good stuff—like mothering and modernism—but it also has some negative connotations, like sexism, ageism and abled-bodyism [*sic*], which are often directed at the maternal body. This body freaks a lot of people out, to be frank, in myriad ways the stereo-typical female body doesn't. I mean; it probably has stretch marks, for starters. Scars. Not to mention an (oceanic and slippery) interior. (qtd. in "Artist Spotlight")

Initially this project was conceived as a series of essay-letters written (and then read aloud) by one of Baggesen's artistic alter egos, Queen Leeba—an amalgam of "Donna Summer and a proto-feminist, Scandinavian love goddess"—and addressed to her children, sister, and mother (qtd. in Morris). Working through this alter-ego allowed Baggesen the freedom to use writing as an integral part of her visual studio practice: "the writing informed the work while it was being made and dared me to go places where I wouldn't have [g]one" (qtd. in Morris).

First exhibited in 2013 as an audio-visual installation that incorpo-rates recordings of the artist (as Queen Leeba) reading the letters aloud, and subsequently published as a book of the same name in 2014,[5] the *Mothernism* project has been presented in both U.S. and international venues.[6] Baggesen tailors the installation to each exhibition space in

the spirit of the project's nomadic, open-ended ethos, and she situates herself as an intermediary between the contemporary art institution and the viewer—offering up this environment to be used by the public as the need arises. Indeed, visitors are encouraged to activate the welcoming, multipurpose space as a platform for activities, from book browsing to breastfeeding, political debates to poetry readings. As an audio installation, epistolary manifesto, and "party as form," *Mothernism* is one twenty-first-century feminist's affectionate call to arms.

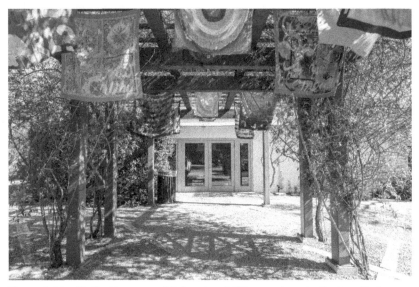

Figure 1. Lise Haller Baggesen, *Mothernism*, 2013–ongoing. Audio-installation. Dimensions variable. Total running time: 75:00. Installation view, Lise Haller Baggesen: *Mothernism*, The Contemporary Austin – Gatehouse Gallery at the Betty and Edward Marcus Sculpture Park at Laguna Gloria, 2016. Artwork © Lise Haller Baggesen. Image courtesy The Contemporary Austin. Photograph by Brian Fitzsimmons.

Viewers entering the *Mothernism* installation in Austin, Texas, first passed under an outdoor pergola covered in lush vines and painted banners waving in the breeze, and, upon entering the gallery space, were bathed in a warm purple light (Fig. 1). The gallery floor, soft and plush, was carpeted in a deep shade of eggplant. Around a corner lay a radiating white Buckminster Fuller-esque dome of a tent that filled the space. This cozy, safe haven was flanked by silk and cotton flags painted in bright shades of pink, orange, purple, and metallic silver. Some contained abstract circles and concentric rings. Others had statements

34

painted in flowing, silver script, such as "LIBERTÉ / ÉGALITÉ / MATERNITÉ" and "Let's mind / fuck and make / a beautiful / brain / child." Some even had Texas-specific slogans on them, such as "Wendy / Davis / is your / Homegirl." The room was illuminated by a slowly changing glow of blue-to-red light. Crouching down, viewers could enter the tent on their hands and knees, a playful, childlike action that effectively stripped all who entered of age, social status, and power. Inside, tiny fragments of light reflected off slowly spinning disco balls. One could reach out to flip through a series of books on the centre table or put on a pair of headphones. A soothing, lyrical Danish woman's voice would begin to tell a story filled with love, curiosity, passion, and advice. Visitors, young and old, sank into soft purple beanbag chairs or bounced gently on yoga balls. Leaning back, the viewer found their visual field filled with colour. On the wall behind the tent was an image of Earth from space and on top of that a silvery drawing. The effect of lying inside the tent and viewing the planet from the vantage point of the moon through a scrim of light and colourful flags was otherworldly (Bowie's 1969 "Space Oddity" came to mind). Once inside, everyone was equally submerged in the violet glow, and a sense of communal wonder and openness to discussion ensued (Fig. 2).

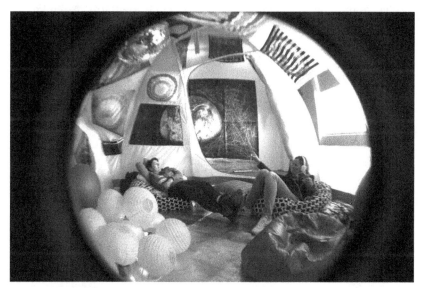

Figure 2. Lise Haller Baggesen, *Mothernism*, 2013–ongoing. Audio-installation. Dimensions variable. Running time: 75:00. Installation view, *Mothernism* (in action), Mana Contemporary, Chicago, 2014. Artwork and image © Lise Haller Baggesen. Courtesy the artist.

In *Mothernism*, the use of bright colours, soft surfaces, and soothing lights in immersive surroundings references a therapy technique first developed in the Netherlands in the 1970s for children with autism and other developmental disabilities: a controlled multi-sensory environment (MSE), or *Snoezelen* room. This word is combination of the Dutch verbs *snuffelen*—meaning to sniff, or colloquially, to poke around and inquire—and *doezelen*, meaning to doze or rest lightly and peacefully (Kinkead; Stephenson and Carter).

This kind of environment is also a nod to two major mid-century Danish artists with a love of saturated, luscious pop colour: Poul Gernes (1925–1996) and Verner Panton (1926–1998). Baggesen describes both artists as "united in a radical approach to colour theory as well as a design philosophy characterized by a social conscience with respect for the ordinary individual and its right to inhabit a meaningful, stimulating and nurturing environment" (*Mothernism* 141). A contemporary of the German conceptual artist Joseph Beuys, Gernes was a conceptual artist, a printmaker, and an abstract painter whose work Danish curator and gallerist Bibi Saugman says invites the viewer "into an ethical, socio-political project, in a playful, exuberant and popular universe where everyday life rhymes with well-being, and where pleasure and moderation go hand in hand." Gernes is best known for his public design of the interior of the Herlev Hospital from 1968 to 1976 in Copenhagen, a space of care that evokes the healing power of colour and is still considered Denmark's biggest artwork to date. Panton is famous for his furniture, lighting, and interior design, which he incorporated into all-encompassing displays, such as *Phantasy Landscape*, which was installed in 1970 at the *Visiona 2* exhibition in Cologne, Germany. In an essay included in a recent monograph on Panton, design curator Sabine Epple writes of *Phantasy Landscape* as "Panton's dream of the future," which Epple views as "an inhabitable sculpture" that complements "the inner life of people" (176). Indeed, Epple emphasizes the maternal connection to the space in her reference to German art historian Heino R. Möller, who wrote in 1981 of the installation as a "soft, warm protective cave," one that "evokes impressions of the mother's belly, of prenatal, intra-uterine contentedness" (qtd. in Epple 176). Whether or not Panton himself intended *Phantasy Landscape* to be quite so literally womblike is unclear, but for Baggesen's purposes, the maternal connection is evident—Gernes's blending of life, art, and ethics is a tactic

also taken up by Baggesen.

Since 2013, the *Mothernism* project has undergone many reincarnations, and reinvented itself for many spaces. In Chicago, visitors might have brushed through a triumphant entryway of flags before coming into a massive room with a glowing tent at the other end. In Philadelphia or New York, in galleries too small for the footprint of a big, welcoming tent, visitors might have swung on hammocks and listened to the stories on headphones while interior images of other *Mothernism* tents played on nearby screens. In rural Wisconsin, visitors may have entered the dank confines of an unfinished basement, only to find themselves submerged in the festive atmosphere of a subterranean youth club staged as a glitter beach party. In Elmhurst, Illinois, museum goers would have seen Baggesen's painted banners filling the building's Mies van der Rohe windows, subverting the building's mid-century modernist minimalism and flooding the space with a stained-glass effect of coloured light.

In all of these installations, the elements that have remained constant are the audio recordings, the archive of books, the wall drawing, and the painted flags. The books are mostly from Baggesen's personal library (or Queen Leeba's "Leebrary")—a collection of *Mothernism*'s primary texts that are offered up to nurture, educate, and stimulate intellectual cross-pollination and to acknowledge the project's matrilineage. The drawing—a rhizomic pattern of lines and names written in silver ink over a photographic image of Earth as seen from space—is what Baggesen refers to as a mind-map. A fascinating document for following the flow of the creative process, it illustrates a technique Baggesen used when writing the essays for *Mothernism*, one that allowed her to visually link her thoughts on motherhood in contemporary art to disparate people, places, and things throughout history. The silk banners are beautiful paintings in themselves, with political slogans and revisionist Color Field works: Baggesen's homage, or what she jokingly calls "cultural necrophilia" (qtd. in "Artist Spotlight"), to abstract pioneers such as Helen Frankenthaler, Poul Gernes, Hilma af Klint, Morris Louis, and Kenneth Noland.

Entering this room filled with colour and light evokes the experience of stepping into a painting, informed by Baggesen's formal training as a figurative painter in the Netherlands in the late 1990s.[7] In an interview about *Mothernism*, Baggesen notes the following: "I was

actually a figurative painter for a long time and I still regard myself as a figurative painter. In this kind of project the figure/ground relationship has changed of course" (qtd. in Morris). Rather than solely addressing the figure in painting, the *Mothernism* installation challenges Greenbergian ideals of "flatness" and upends them by inviting the viewer (figure) into Baggesen's painting-as-installation. If the pigment of a Morris Louis or Kenneth Noland colour field painting bursts vigorously across the unprimed cotton surface like the cold smack of an ocean spray, then the colour field of *Mothernism* pushes under the surface to the calm depths of the ocean floor, inviting and enveloping in its immensity. Rather than confronting what could be seen as the vertical, monolithic barrier of a canvas, the viewer is invited into the experience of a painting, with all the inherent colours, lights, shadows, and sounds (Fig. 3).

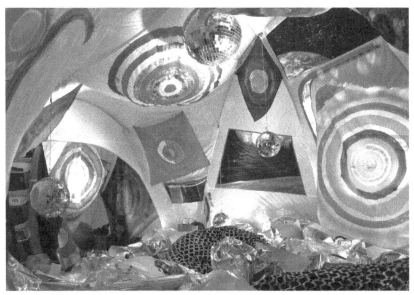

Figure 3. Lise Haller Baggesen, *Mothernism*, 2013–ongoing. Audio-installation. Dimensions variable. Running time: 75:00. Installation view, *Mothernism* (interior), Co-Prosperity Sphere, Chicago, 2013. Artwork and image © Lise Haller Baggesen. Artwork and image courtesy the artist. Photograph by Brian Fitzsimmons.

Feminism, Sci-Fi, Motherhood, and Disco

The popular "hooks" of the *Mothernism* project (to borrow a phrase from the music world)—the way they sneak around the eye rolls and through the glazed expressions when "feminism," "motherhood," and "contemporary art" are mentioned in the same sentence—are the two other key components to Baggesen's world: science fiction and disco. As referenced by art historian Gavin Parkinson, science fiction—which became a distinct genre in Western, English-speaking cultures in the 1920s and 1930s (led by writers like H.P. Lovecraft)—was at its height of popularity in the 1950s (thanks to writers like Philip K. Dick and Frank Herbert), when technology advances allowed space travel to seem like a real possibility. Disco, meanwhile, came of age in the 1970s and was as much a style of music as it was a cultural movement embracing inclusivity and encompassing both Black and queer cultures. These two themes, science fiction and disco, act as (borrowing from *Star Trek*) "universal translators"; they allow for a colourful entry into the mothernist conversation. As a mother might, it is as if the installation itself engages us in playful conversation: *Disco is open to all and fun to dance to—let's think about what that means. Science fiction is philosophical and imagines other worlds—how could the two relate?*

The combination of these areas of inquiry helps to ground the *Mothernism* project in academic discourse while engaging the audience's curiosity on a pop cultural level. While *Mothernism* touches on many different kinds of music throughout Baggesen's writings—and, indeed, musical lyrics are treated like poetry—the two musicians who hold the most importance for her are indisputably Donna Summer and David Bowie. The first album Baggesen purchased, which she did on the sly during one of her first big trips away from home, was by Donna Summer. And, as Baggesen describes in a 2015 video interview produced by the Chicago-based Poetry Foundation, Bowie's lyrics deeply resonated with her as a teenager growing up in rural Denmark: "when you're out in the sticks and nobody understands you, and you discover that David Bowie understands you, it can be a really profound moment" (qtd. in "The Unputdownable").

Brian Eno famously said to David Bowie after hearing "I Feel Love," Donna Summer's sultry, crooning disco track of 1977: "'I have heard the sound of the future'" (qtd. in *Mothernism* 116). Summer and Bowie (and Eno, for that matter) create music that seductively pulls the listener

in, which then paints a picture of another life, another world beyond this one. The allure of these musicians is in their otherworldliness and in their visual and aural ability to transport the listener to another place or time. In the same way, Baggesen describes her interest in science fiction as a "maternal voice projecting into the future," and she proposes that entering the space of *Mothernism* creates a "parallel timeline" and a "rethinking" of history, "instead of rolling over at the idea that we're at the end of history and capitalism won" (qtd. in "Q+A" 213). All of *Mothernism*'s components share a common investment in a future utopia, a time and a place where life just might get a little bit better for everyone.

This Is What a Mothernist Looks Like: A Feminist Ethics of Care

The question remains: in practical terms, what does it mean to *be* a Mothernist? One answer: to be a Mothernist is to have the inner capacity to care for someone, or something else, and to fight for those who cannot yet fight for themselves. For Baggesen, it is the next logical progression of feminism: the twenty-first-century wave. As writer and cultural critic Roxane Gay argues in her book *Bad Feminist*, many kinds of people have been at worst excluded from, and at best forgotten by, twentieth-century feminism (including women of colour, queer, and transgender women). Yet, Gay writes, "feminism's failings do not mean we should eschew feminism entirely.... We should disavow the failures of feminism without disavowing its many successes and how far we have come" (xiii). If contemporary feminism contests, on a basic level, that all people should be treated equally, Baggesen's *Mothernism* takes that one step further—all people should be cared for equally. This basic tenet—that people should all live according to an "ethics of care"—is a moral and philosophical theory that posits the self as fundamentally relational. This theory was first outlined in the early 1980s by Carol Gilligan and Nel Noddings and then challenged and elaborated upon by second- and third-wave feminists, such as Donna Haraway and Fiona Robinson (Sander-Staudt and Robinson).

If feminism's weakness is that it is too abstract, too loaded with decades of politicization, and filled with too many generations trying to reshape it on their own terms, *Mothernism*'s power is that, in accessing

motherhood, it is truly a universal language. As feminist poet Adrienne Rich reminds us, "All human life on this planet is born of woman" (11), and every living being is connected to someone who cared enough to help people come into existence and to continue to exist beyond their vulnerabilities. Rich makes the point that "physical motherhood is merely one dimension of our being" (284) and that "in the original matriarchal clan *all* females, of whatever age, were called 'mothers'— even little girls. Motherhood was a social rather than a physical function" (250).

Care and compassion are, theoretically, the ethical foundations for most major world religions and philosophies, yet in practice are so rarely implemented. *Mothernism* proposes this "radical" shift in perspective: care for this world and the people in it, as if they were your children. Place yourself in a mother's shoes. Ask: how can I help this grow? Is there space for mothering here? Is this safe for growth, conversation, or existence? Beyond its seductive aesthetics, this writer's primary interest in *Mothernism* stems from its inclusivity: biological and nonbiological mamas alike can be Mothernists, and are welcomed as such. Rich offers up alternate terms to the nonbiological mother such as the "unchilded" woman or, in the positive, "spirit-sister" (252). *Mothernism* is a philosophy open to all, as it spans race, gender, creed, and class. Biological motherhood is not a requirement; indeed, for *Mothernism*'s ideals to be effective, nonbiological mothers are a key component of this paradigm shift equation. Without naming this theory precisely, *Mothernism* makes the case that mothers, fathers, and their children alike—institutions and governments, even—should live with an ethics of care.

Equally, *Mothernism* asks us to consider an environmental perspective: in order to care for others, we must also care for the physical world around us. Baggesen emphasized this in her Austin installation and asked visitors to explore The Contemporary Austin's outdoor sculpture park with her by listening to a newly commissioned text written specifically for the site: *The Mothernist's Audio Guide to Laguna Gloria*.[8] Based on research related to the history of the architecture, grounds, and sculpture of the museum's Betty and Edward Marcus Sculpture Park at Laguna Gloria—and incorporating Baggesen's signature mélange of art history, pop culture, politics, and music—this walking audio tour invited visitors to uncover forgotten stories and explore the

historic site and its artwork in new ways. As Baggesen argues in *The Mothernist Audio Guide*, "Universally, the defense of ever tightening fists is that 'we cannot save the whole world.' Alas. If *we* cannot save the whole world, the whole world cannot be saved" (5). Indeed, as we witness with increasing regularity, children cannot survive, or thrive, in the future conditions that climate change supposes. From inside the mother-ship of the tent, *Mothernism* asks us to take a look outside and hum a little David Bowie. To see the Earth shining out there and to recognize the intricate web of connections between all of us. To work to ensure a safe space for generations to come. If space travel, as Brazilian painter Lygia Clark mused in 1960, is the natural progression of humanity's need to resolve "the vertical expression of its spirituality" (96), then from space we must look back at this earth with that same spirituality, with precepts that exist in every major religion—do unto others, practice no harm, love thy neighbour—and ask, from this perspective, from here, how, and whom, can I help grow?

Participatory Art and Party as Form

The acts of care and inclusivity triggered by Baggesen's words exemplify the all-encompassing power and purpose of the kind of project *Mothernism* represents. Baggesen created *Mothernism* to be, as she describes, "something that worked like a mama, something that would be nourishing and smothering and immersive—a total experience" (qtd. in "Q+A" 211). Yet although the extended effect it has on the surrounding community could be considered social (Beuys), relational (Bourriaud), or participatory (Bishop), *Mothernism* does not fit precisely into these neat art historical packages.

"Social sculpture," "relational aesthetics," and "participatory art" are all terms used with increasing regularity since the late 1990s when (predominantly male) artists, such as Carsten Höller, Pierre Huyghe, Philippe Parreno, and Rirkrit Tiravanija, began to push the boundaries of interactivity between artist, audience, and life. These descriptors fit into a web of vague art-world linguistics as attempts to categorize work that does not fit into an easily commodifiable or modernist lineage.[9] Consider, for example, art critic and theorist Lane Relyea's take on this social, relational art of the late twentieth-century in his 2013 book, *Your Everyday Art World*, an analysis of contemporary art and capitalism:

What seemed at the beginning of the 1990s to be an opposition between the apparitions of spectacle and the opacities of abject art's embodiment and trauma soon disappeared, as artists instead embraced a new 'middle' ground between the two—the realm of everyday life and common cultural exchange, of casual existence and informality. Not superstar celebrities or abject flesh but people wearing clothes, eating food, and hanging out with friends. (41)

In Relyea's perspective, what had been an art of spectacle and the body coalesced into a vaguely performative art of the casual quotidian. A glaring omission from his analysis, however, is the inclusion of an "everyday life" that relates to the realities of motherhood, family, or domesticity.

Nicholas Bourriaud first coined the phrase "relational aesthetics" in 1998 (although it was not translated from French into English until 2002). Citing contemporary artists Maurizio Cattelan and Gabriel Orozco as examples, Bourriaud describes "relational art" as "an art taking as its theoretical horizon the realm of human interactions and its social context, rather than the assertion of an independent and *private* symbolic space" (41). Furthermore, Bourriaud sets up the distinction that relational art has less to do with the physical constraints of the exhibition space and more to do with the temporal duration of such art, much like the experience of having a verbal discussion (41–42). Unfortunately, these simple dichotomies do not allow for a work like *Mothernism*, which is a form of contemporary art that encompasses everything Bourriaud describes: *social* human interaction within a *private*, symbolic space, and a space to be *walked* through as well as the experience of a lived *time*. *Mothernism*, coming from the mind and hand of a painter, is wholly an ode to the modernist, private, and independent experience of a work of art. You can enter it alone, read the books alone, and are encouraged to listen to the audio tracks alone through individual sets of headphones. It is your own private disco. Yet just as identity is always more multifaceted and complex than meets the eye— for example the artist-as-mother-as-feminist—*Mothernism* is *also* a stage for social interaction, where durational conversations about motherhood are wholeheartedly encouraged. Bourriaud, in his attempts to put a finger on the present moment in art, does not make space for a contradictory self (a unique pleasure of being human) or a multifaceted work of art.

If not relational, then what? *Mothernism* could equally be described in the context of what art historian Claire Bishop has labeled "participatory art." Indeed, in her book *Artificial Hells: Participatory Art and the Politics of Spectatorship*, Bishop writes, "Participatory art demands that we find new ways of analyzing art that are no longer linked solely to visuality, even though *form* remains a crucial vessel for communicating meaning" (7). This is perhaps the strongest link between participatory art and *Mothernism*, in that Baggesen's ideas take form in an audio-visual installation, but the meaning exists beyond the physical work in the context of her writing. Throughout *Artificial Hells*, Bishop focuses on the increased prevalence of the artist's "project," which is, as she writes, "the indicator of a renewed social awareness of artists in the 1990s" (215). Such projects aim "to replace the work of art as a finite object with an open-ended, post-studio, research-based, social process, extending over time and mutable in form" (74). Bishop's description would seem to apply to Baggesen's *Mothernism*, as the project is political, socially aware, research based, and ever evolving. Yet as flexible as Baggesen is with *Mothernism*'s mutability, the power of painting and specific objects of colour and visuality remain at the core of her visual interests. *Mothernism* is not *solely* a participatory work of art.

Clearly, in its book, audio, and installation forms, Baggesen's *Mothernism* is filled with subversive, social justice, and participatory elements that relate in some ways to Bourriaud's *and* Bishop's theories. In Chicago, Baggesen's current home, the related term "social practice" gets bandied about in equal measures.[10] Yet Baggesen refuses this label as well—perhaps because of what curator and writer Dieter Roelstraete describes in his contribution to the *Chicago Social Practice History Series* as "the paradigm's occasionally questionable humanitarianism" and "its undeniably paternalistic impulses" (49). Instead, Baggesen aims to create a space for joy and pleasure: "I believe the next feminist wave must be all about women's right to pleasure—the pleasure we take in our bodies, our sexuality, motherhood, leisure, and professional and intellectual pursuit" (qtd. in "Artist Spotlight"). The artist herself would prefer to label *Mothernism* as a kind of "party as form," a term coined by a friend and colleague of Baggesen's, curator Shannon Stratton, as the premise for a class.[11] Stratton elaborates on this idea in the following way:

I was feeling as though social practice as an "art form" was some-thing students studied at arm's length—through other artists' work, through theory, but maybe also through a presumed idea about what it meant to work socially without really studying what the social was. So Party as Form took the subject of being social—that is throwing and attending "parties"—as the foundation from which to build a "social practice" without ever having to use those terms. (qtd in "PAF")

This more glamorous, disco-infused, and celebratory designation opens up the possibilities for—in the queer cultural use of the term— "switching." A mother-artist can be this *and* that, rather than this *or* that. The visual and literary language of *Mothernism* offers both dominant didacticism and a passive, anticipatory presence. It allows for the possibility to consider simultaneous modalities of being and to engage in critical acts of becoming more self-aware. The intention, whatever the critical or art historical label, is for each visitor or reader to pass on concepts of *Mothernism* as a way of being in the world—to spark thought like wildfire and bring about positive change, all while having a great deal of fun.[12]

A Home, a Tent, a Room, a Womb

Mothernism's connection to social practice, Chicago style, actually has less to do with how the term applies to Baggesen's work and more to do with *Mothernism*'s matrilineage with other artists, makers, and activ-ists throughout the city who enact social practice in various ways. The installation form of *Mothernism* arose from a particular network of Chicago-based feminist curators, organizers, and artists whose lives intersected with Baggesen's as she worked on the project, and it bears a conceptual resemblance to many artist-run domestic spaces throughout the city. The most notable connection is to the Suburban, co-founded in 1999 in Oak Park, Illinois by Baggesen's mentor and thesis advisor Michelle Grabner and Grabner's husband Brad Killiam.[13] Other contemporary Chicago-area domestic exhibition spaces on the *Mothernism* family tree include The Green Lantern Gallery and Press, founded by Caroline Picard in 2005, and Sector 2337, founded by Picard and Devin King in 2014; 6018 North, founded by curator Tricia

Van Eyck in 2011; the front yard of Terrain Exhibitions, founded by the late artist Sabina Ott and writer John Paulett in 2011 as well; and the backyard patio of The Franklin, founded by artist Edra Soto and her partner Dan Sullivan in 2012.

From this domestic lineage, the "total experience" that Baggesen ascribes to *Mothernism* is also situated in a framework of immersive spaces in contemporary art—becoming something altogether familiar yet also radical and new. From the artist's studio to the conceptual installation, spaces housed within other spaces have a long lineage in twentieth-century art: Kurt Schwitters' *Merzbau*, 1937; Marcel Duchamp's *Étant donnés*, 1946–1966; Robert Therrien's rooms-within-rooms, 1984–2019; and Mika Rottenberg's video installations, 2011–present. As I have described, the *Mothernism* room-within-a-room most often takes the form of a tent, which offers a way for Baggesen to stage an intimate scene separate from the typically urban environment of the exhibition space. Just as her flags are also scarves—"protest chic" for the fashionable working mother who Baby Björns with the fabric by day, attends rallies with the banner at night, and discos on with the scarf into the morning, but who is equally happy to "lean out" of the twenty-four-hour economy and to sleep when the baby sleeps—*Mothernism* is both nimble and mobile, and can be installed quickly and can exist simultaneously in multiple cities at once. Conversely, the use of a tent could indicate a site of dissent, reminiscent of scenes of historical protest where tents, banners, and bodies have been used to political effect: such as the not-so-distant memory of the Occupy Wall Street movement that started in Zuccotti Park, New York, in 2011, or the now-almost-forgotten Greenham Common Women's Peace Camp in Berkshire, England, from 1981 to 2000.[14]

Specifically, in *Mothernism*, Baggesen references and pays homage to two no longer extant contemporary art works: British artist Tracey Emin's sculptural tent from 1995, *Everyone I Have Ever Slept With, 1963–1995*, and French artist Niki de Saint Phalle's massive sculptural installation, *Hon (She)—a cathedral*, 1966. The Emin tent is a small blue camping tent covered in the brightly coloured, appliquéd names of Emin's lovers, friends, relatives, and acquaintances who had lain beside her at one point or another. In her book, Baggesen describes this work by Emin as the place "where I would most like to rest my weary head," because, Baggesen continues, "the canopy opens itself up as a motherly

embrace in which we can curl up and forgive ourselves" (*Mothernism* 74–75). In similar homage, *Mothernism*'s womblike room references the now-mythological space claimed by Saint Phalle's *Hon* installation. Saint Phalle, along with her partner Jean Tinguely and friend Per Olof Ultvedt, staged a monumental sculpture in the galleries of the Moderna Museet in Stockholm: a gargantuan, supine, pregnant woman (a version of Saint Phalle's now-classic *Nana* figures) filling the museum's gallery at 77 by 20 by 33 feet (Andersson 59). Visitors could enter this figure through a door between the legs—a return voyage through the birth canal, or the physical embodiment of Gustave Courbet's 1866 painting *L'Origine du monde*—and experience what Patrik Andersson describes as a labyrinthine "night-club-like interior," which included a floor made of foam, strange kinetic sculpture by Tinguely, the sound of breaking glass, a Coca-Cola bar in the figure's breast, and parodies of contemporary film and art (59).[15] What a party! Staking a claim on institutional territories and confusing the boundaries between interior and exterior, *Mothernism* re-envisions and recreates these lost spaces of feminine sexuality, motherhood, and power.

Motherhood in Cultural Context: The Private-Public Relationship to the Pregnant Body

Baggesen's decision to write these feminist essays on motherhood, contemporary art, and music came about through her cultural experience as a Danish artist living in America, and as a young mother battling the occasional deep conservativism disguised as academic superiority that she found present in her graduate program in Visual Critical Studies at the School of the Art Institute of Chicago.[16] As Baggesen describes it, although gender and identity politics were being discussed in her graduate classes at length, "whenever I brought up how motherhood had influenced my art-making or my position in the art world or my thoughts on feminism, it was always shut down pretty quickly. There was this real notion of the mother being this bourgeois figure that you had to distance yourself from. It was very Freudian" (qtd. in "Q+A" 210). This experience, unfortunately, is not an unfamiliar one. Adrienne Rich describes her academic life in the mid-1970s in similar terms, as her colleagues had a "fundamental perceptual difficulty" in recognizing women's issues—what Rich calls "an

intellectual defect, which might be named 'patrivincialism' or 'patrio-chialism'" (16). Four decades later, in Baggesen's experience, the "idea of mothering [w]as a reactionary position incongruent with art school," and she took up the resistance she encountered as a challenge to create (qtd. in "Q+A" 211).

Similarly, in her award-winning memoir *The Argonauts*, contemporary poet and critic Maggie Nelson describes the same kind of systemic dismissal of a critical discussion of motherhood within academia that inspired *Mothernism*.[17] In a pivotal juncture in *The Argonauts*' narrative, Nelson describes a lecture she attended while in graduate school in 1998: a presentation by Lacanian scholar Jane Gallop, followed by a conversation between Gallop and art historian Rosalind Krauss. Nelson describes Gallop's presentation, which included nude photographs of the speaker as a subject with her young child:

> She was coupling this subjective position with that of being a mother, in an attempt to get at the experience of being photographed as a mother (another position generally assumed to be, as Gallop put it, 'troublingly personal, anecdotal, self-concerned'). She was taking on Barthes's *Camera Lucida*, and the way in which even in Barthes—delectable Barthes!—the mother remains the (photographed) object; the son the (writing) subject. 'The writer is someone who plays with his mother's body,' Barthes wrote. But sometimes the writer is also the mother (Möbius strip). (40)

Then, Krauss takes the stage, and as Nelson wryly quips: "The room thickened with the sound of one keenly intelligent woman taking another down. Dismembering her, really" (41). Krauss (as Nelson tells it), flings out such terms at Gallop as "mediocrity, naïveté, and soft-mindedness," and according to Nelson, "the tacit undercurrent of her argument ... was that Gallop's maternity had rotted her mind—besotted it with the narcissism that makes one think that an utterly ordinary experience shared by countless others is somehow unique, or uniquely interesting" (41). Krauss's pithy take-down of one woman's subjective, photographic depiction of an "utterly ordinary experience shared by countless others" seems almost laughable today, for just the following year, the popular blogging website LiveJournal was launched (1999), and only four years after Nelson recalls Krauss's comment, our

lives began to be inundated by the ordinary, subjective experiences of others through social media such as Friendster and LinkedIn (2002), MySpace (2003), Facebook (2004), YouTube (2005), Twitter (2006), and Instagram (2010). Today's present economy can now monetize those "utterly ordinary experiences" to the *nth* degree, and as Relyea describes, "Instead of being suppressed for the sake of getting work done, now the communicating and performing of subjectivity is itself put to work" (5).

However mistaken Krauss may have been about Gallop's subjective method, this single-minded, dismissive perspective of motherhood offered by Krauss—seared in Nelson's memory seventeen years after the fact—is not an outlier or a fluke. Krauss is considered by many to be one of the preeminent critical minds of the postmodernist art historical canon. This perspective is almost certainly shared (although, I would like to believe, unconsciously) by many other academics within the field. In a different context, in a different city, but similarly within a well-respected graduate academic program is the kind of mother-dismissive environment from which Baggesen's *Mothernism* arose.

Another example offers, perhaps, one possible interpretation of why Krauss might have reacted as she did and why it is so important that we look at motherhood in art and academia critically. Writing about the tenuous state of female reproductive rights in America today, Roxane Gay remarks on the disjunctive nature of pregnancy as it exists for a mother in both private (within the body) and public spheres (on the level of social interaction, government intervention, and abortion legislation): "In a perfect world, pregnancy would be an intimate experience shared by a woman and her partner alone, but for various reasons that is not possible. Pregnancy is an experience that invites public intervention and forces the female body into the public discourse. In many ways, pregnancy is the least private experience of a woman's life" (269). Maggie Nelson also comments on this private-public relationship to a woman's pregnant body, arguing that, in public, the pregnant body is seen as "obscene":

> It radiates a kind of smug autoeroticism: an intimate relation is going on—one that is visible to others, but that decisively excludes them.... It especially irritates the antiabortionists, who would prefer to pry apart the twofer earlier and earlier—twenty-four weeks, twenty weeks, twelve weeks, six weeks.... The sooner

you can pry the twofer apart, the sooner you can dispense with one constituent of the relationship: *the woman with rights.* (90)

Perhaps this private-public relationship to the pregnant body is how we start to get at the root of *why* motherhood has historically been considered so gauche a topic in contemporary art. As much as the larger art world pays lip service to the public realm of popular culture when individual artists serve a larger, more profitable purpose (Damien Hirst and Jeff Koons, for example), nonetheless the smaller, academic art world remains trapped under the thumb of that cantankerous father of mid-century contemporary art criticism, Clement Greenberg, and his utter loathing of pop culture's pinnacle: kitsch. If the public sphere marks the boundary of the distasteful realm of kitsch as separate from what is *not* kitsch (as art, Greenberg would call it avant-garde, whereas today it may be called critically acclaimed), then pregnancy and motherhood reside precisely in the centre of the public, and exist primarily as an aspect of pop culture. For what is more kitsch than Norman Rockwell's mothers and children, Anne Geddes's flower babies, or the Christian iconography of the Virgin Mary and baby Jesus? Motherhood, as we are regularly subjected to popular culture's depictions of it, is cheesy, vapid, and shallow. The pregnant body is something without a mind of its own that—we are told—should be regulated, legislated, and depersonalized by its government and medical practitioners.

The Mother in the Museum

Mothernism asks us to consider the personal (our individual relation-ships with mothers and motherhood) with the political (how mothers and motherhood exist in the world around us). For this reason, I will conclude here with my own perspective and share the impact that *Mothernism* has had on me and on the people around me. These exam-ples illustrate the practical implications of why it is so important to link motherhood to the ways in which we interact with the world around us: in our interpersonal relationships, in our workplace, in our politics, and in our contemporary art museums.

The power of *Mothernism* is its ability to activate like wildfire at its very invocation. In the months leading up to the exhibition's installa-tion at The Contemporary Austin, the internal mechanisms this work

set in motion were profound. Staff began reading the *Mothernism* book, and subsequently discussions of breastfeeding, feminism, reproductive rights, ability and disability, women's rights, and gun control all took place in advance of the opening. A number of significant changes occurred in and for the museum as a result. For example, with new Texas gun control laws coming into effect on 1 January 2016 ("New Laws"), museum staff established a formal written policy prohibiting open-carry weapons on museum property (significant in that one site of the museum stands on downtown Austin's historic Congress Avenue, just south of the state capitol building where the law was signed into effect). Additionally, staff definitively acknowledged that as an institution, the museum supports mothers who choose to breastfeed in public, a policy that is also state law but that had never been discussed (State of Texas). Finally, in a part of the country that is not known for its acceptance of difference—Houston having made national headlines in 2016 for upholding transphobic bathroom use policies (Ura)—staff decided to install a single-user and gender-neutral bathroom as part of a downtown building renovation project later in the year.

It can, of course, be problematic to ascribe therapeutic value to a work of art; religious overtones and complicated power dynamics immediately come to mind. But consider, for a moment, a simple precept of therapy, as in, a method of emotional healing practiced by therapists: before any work can be done, there must be a safe space to do it in. *Mothernism*, as an art installation, also applies. As an artist and a mother, not finding a safe space to be both in the art world, Lise Haller Baggesen set about to create a place where she was welcome. Similarly, empowered by the knowledge that a safe space was *defined*, employees at all levels within the museum worked to make the whole institution safer and more inclusive to all.

When *Mothernism* finally arrived in Austin, adults and children alike used the exhibition space with enthusiasm (Fig. 4). A group of local artist mothers gathered with their families to read and breastfeed in the tent. Some visitors took naps and used the space for rejuvenation. Museum docents shared memories of what it meant to be a woman in the 1970s disco-era. Young artists regularly held meetings on the beanbag chairs and yoga balls, and the museum's Teen Council elected to spend free time in this space whenever possible. And in a heartwarming indication of the exhibition's positive and lasting effects,

in August 2016 at the eighth annual Teen Convening conference held at the Institute of Contemporary Art, Boston (a conference that brings together the best teen museum educational programs in the country), *Mothernism* was offered up by two members of The Contemporary Austin's Teen Council as a representation of the museum. They presented *Mothernism* as their favourite exhibition, largely because of the safe space for dynamic and memorable conversation that the installation afforded, and, as they described, because of the teens' close relationship with their own mothers.

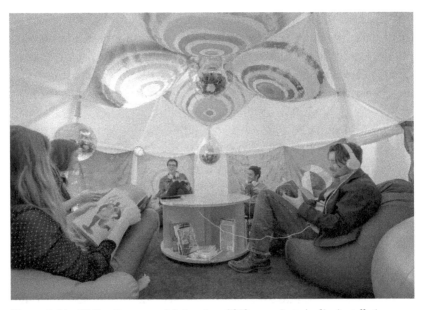

Figure 4. Lise Haller Baggesen, *Mothernism*, 2013–ongoing. Audio-installation. Dimensions variable. Total running time: 75:00. Installation view (in action), Lise Haller Baggesen: *Mothernism*, The Contemporary Austin – Gatehouse Gallery at the Betty and Edward Marcus Sculpture Park at Laguna Gloria, 2016. Artwork © Lise Haller Baggesen. Image courtesy The Contemporary Austin. Photograph by Brian Fitzsimmons.

Ultimately, the value in considering the mother-artist lies in the reminder of a feminist ethics of care. To care is to encourage growth and to nurture; to allow for messy mistakes and to keep going; to return to a conversation that never lands in the same place twice. As an unchilded / spirit-sister / nonbiological mother, the way that I deeply identify with *Mothernism* is as a curator from the very root of the word: to care for, to nurture, to help grow. As Baggesen herself argues, "ideally, mothers

and curators operate in similar ways by providing space and nourishment for those in their care to learn and grow" (qtd. in "Lise Haller Baggesen's Disco Feminism"). In this role, I can establish a feminist ethics of care on both the personal and political level, and work to enact it within the contemporary art institution. I am indebted to Baggesen's writing and art for its ability—by its sheer presence—to spark conversations, ignite change, and empower those who experience it to stand up for equality and care in our spheres of influence. For all of these reasons, and many more, I count *Mothernism* as a success. I look forward to its future effects and will continue to do my part to keep filling and reshaping the mother-shaped hole in contemporary art discourse.

Endnotes

1. There are, of course, some examples, but few: Kiki Smith's excreting and birthing women; Catherine Opie's graphic self-portraits with her child held to her mutilated body; Rineke Dijkstra's cool, detached depictions of women just after childbirth. I would love to see the Guerrilla Girls tackle this subject.

2. The Danish artist Lise Haller Baggesen was born 1969 in Aarhus, Denmark, and is based in Chicago, Illinois.

3. *Mothernism* (italicized) is, interchangeably, an exhibition created by Baggesen in 2013, which continues to have many different iterations; a collection of essays, published as a book in 2014; and a philosophy of being, which I will elaborate on throughout this essay. A Mothernist is someone who values motherhood, mothering, maternal creativity, and an ethics of care, and works towards positive change for mothers of all ages, races, genders, and beliefs.

4. Portions of this essay were originally written for and published in The Contemporary Austin's Winter/Spring 2016 exhibition guide, in conjunction with the exhibition Lise Haller Baggesen: *Mothernism*, which was on view at The Contemporary Austin's Gatehouse Gallery at the Betty and Edward Marcus Sculpture Park at Laguna Gloria in Austin, Texas from 13 February through 22 May 2016. I am grateful to Louis Grachos, The Contemporary Austin's executive director and CEO; Heather Pesanti, chief curator; as well as the entire museum staff for their support and encouragement of all things *Mothernism*.

5. I first encountered *Mothernism* in 2014 through Lise's writing. Living in Chicago at the time, in my job coordinating catalogue production at a local gallery, I worked regularly with the design team Sonnenzimmer (Nadine Nakanishi and Nick Butcher), who were also independently laying out the *Mothernism* book. They connected me with publisher Caroline Picard who needed copy editors for the text, and thus began one of the most enjoyable and enlightening editing experiences I have had to-date, each page filled with passionate, lyrical prose, and jam-packed with literary, artistic, and pop culture references.

6. As a testament to Baggesen's commitment to community engagement, social discourse, and a research-based practice, *Mothernism* has traveled extensively since 2013, with iterations at Ordinary Projects, Chicago; Mana Contemporary, Chicago; Vox Populi, Philadelphia; PrintRoom, Rotterdam; the Elmhurst Art Museum, Illinois; A.I.R. Gallery, New York; and The Elizabeth Foundation for the Arts, New York. Baggesen's project spawned the curatorial suite "3AM Maternal" for Vox Populi, and *Mothernism* has been presented at conferences internationally, including "The Mothernists," a conference held in various locations throughout Rotterdam in June 2015 in collaboration with the Dutch artist and research group m/other voices; the June 2015 conference "Motherhood and Creative Practice" held at London South Bank University; a lecture at the Rijksakademie in Amsterdam, also in June 2015. In May 2016, the installation served as "mother-ship" for the conference "Mapping the Maternal: Art, Ethics, and the Anthropocene" at the University of Alberta, Edmonton, Canada.

7. Baggesen studied at the Rijksakademie in Amsterdam from 1996 to 1997 with Belgian figurative painter Luc Tuymans, and in 2002, she was awarded the Royal Award for painting by the Royal Palace Amsterdam.

8. Baggesen worked on this text in the months leading up to the installation in Austin and recorded it onsite in February 2016. The audio guide was released to the public on 8 March 2016, International Women's Day. The audio recordings, as well as the text, can be found on The Contemporary Austin's website.

9. Whether or not many other, earlier kinds of art—Dada performances of the 1920s or Happenings of the 1970s, for instance—

also fall into this broad category is a question for another time (see Bishop).

10. The concept of "social practice" carries enough weight in Chicago that in 2014, the School of the Art Institute of Chicago started an imprint titled the *Chicago Social Practice History Series*, distributed by the University of Chicago Press and edited by Mary Jane Jacob and Kate Zeller. There are currently five volumes, on varying themes.

11. Stratton taught the class "Party as Form" at the Ox-Bow School of Art in Saugatuck, Michigan, in the summers of 2013 and 2014. Most recently the William and Mildred Lasdon Chief Curator at the Museum of Arts and Design, New York, Stratton was the founder and former executive director of Threewalls, a Chicago-based nonprofit arts organization.

12. Aptly, of Baggesen's work that has since followed *Mothernism*, titled *Hatorade Retrograde*, critic Matt Morris wrote for *Artforum* that her futuristic installation was "as if the world had fallen apart but the party persisted."

13. The Oak Park Suburban was an independent, internationally recognized artist exhibition space in a small building outside of Grabner and Killiam's former home, with a tentlike footprint of only 8 by 10 feet. In 2015, the Suburban was relocated with Grabner and Killiam to a new configuration in Milwaukee, Wisconsin. Since 2009, Grabner and Killiam have also run the Poor Farm, an exhibition space in Little Wolf, Wisconsin, and Poor Farm Press is their publishing imprint (which co-published *Mothernism* with Green Lantern Press, run by Caroline Picard in Chicago).

14. Margaretta Jolly devotes a fascinating chapter to feminist acts of letter writing and webs of communication in the Greenham Common Women's Peace Camp (113–28). Of the Occupy movement, Monica Westin and Rich Zito remind us that the symbolic staging of a tent in a public place remains within the U.S. First Amendment rights; however, it is the act of living inside the tent that can be countered by the state, and this act of domesticity resulted in the dispersal of the movement from Zuccotti Park.

15. Camille Morineau illustrates that with this work, Niki de Saint Phalle "took possession of public space" in the form of "a new type of sculpture, the body-house" (255). She would go on to construct

other monumental works with orifices for entryways, including *The Golem (Le Golem)*, 1972, in Jerusalem, with multiple red tongues that double as children's slides, and a massive sculpture park in Tuscany called *Tarot Garden*, 1979–2002, which was filled with humanoid buildings to be explored, inside and out.

16. Even before Baggesen moved to Chicago, however, another injustice started her on the path to creating this feminist project: "My gallery dumped me when I was seven months pregnant with my second child. It was almost like Oscar Wilde—one is a tragedy but two is unacceptable.... It's assumed that as soon as the baby moves in, your talent moves out" (qtd. in "Q+A" 213).

17. *The Argonauts* won the 2015 National Book Critics Circle Award. The publication of this remarkable book (Nelson's ninth) directly preceded Nelson's MacArthur Foundation fellowship in 2016.

Works Cited

Baggesen, Lise Haller. Interview by Kate Sierzputowski. "Lise Haller Baggesen's Disco Feminism." *Inside\Within*. March 2015, www.insidewithin.com/LiseHallerBaggesen.html. Accessed 27 Aug. 2016.

Baggesen, Lise Haller. Interview by Matt Morris. "Lise Haller Baggesen's *Mothernism*: Extended Web Exclusive Interview," *Newcity*, 16 Oct. 2014, art.newcity.com/2014/10/16/lise-haller-baggesens-mothernism-extended-web-exclusive-interview/. Accessed 27 Aug. 2016.

Baggesen, Lise Haller. Interview by Rebecca Marino. "Q+A with Lise Haller Baggesen." *Conflict of Interest*, vol. 1, Conflict of Interest, 2016, pp. 210–14.

Baggesen, Lise Haller. Interview by Weinberg/Newton Gallery. "Artist Spotlight: Lise Haller Baggesen." 28 May 2016, weinberg-newtongallery.com/conversations/artist-interview-lise-haller-baggesen-34/. Accessed 4 Aug. 2019.

Baggesen, Lise Haller. *Mothernism*. Green Lantern Press / Poor Farm Press, 2014.

Baggesen, Lise Haller. *The Mothernist's Audio Guide to Laguna Gloria*. The Contemporary Austin, 2016, thecontemporaryaustin.org/

static/media/2016/06/The-Mothernist27s-Audio-Guide-to-Laguna
-Gloria-FINAL.pdf. Accessed 27 Aug. 2016.

Baggesen, Lise Haller. "The Unputdownable." *The View From Here*, video by Hannah Welever, episode 2, Poetry Foundation, *YouTube*, 18 Aug. 2015, www.youtube.com/watch?v=y9Q90eNxes0. Accessed 27 Aug. 2016.

Bishop, Claire. *Artificial Hells: Participatory Art and the Politics of Spectatorship*. Verso, 2012.

Bourriaud, Nicolas. "Relational Aesthetics." *Ethics* edited by Walead Beshty, Whitechapel Gallery / The MIT Press, 2015, pp. 40–44.

Clark, Lygia. "Full Emptiness." *Ethics* edited by Walead Beshty, Whitechapel Gallery / The MIT Press, 2015, pp. 95–96.

Clark, T. J. "Clement Greenberg's Theory of Art." *Critical Inquiry*, vol. 9, no. 1. Sept. 1982, pp. 139–56, www.jstor.org.ezproxy.lib.utexas. edu/stable/1343277. Accessed 6 Sept. 2016.

Epple, Sabine. "Verner Panton as an Interior Designer." *Verner Panton: The Collected Works*, edited by Alexander von Vegesack and Mathias Remmele, Vitra Design Museum, 2000, pp. 158–76.

Gay, Roxane. *Bad Feminist*. Harper Perennial, 2014.

Gioni, Massimiliano, et. al. *The Great Mother: Women, Maternity, and Power in Art and Visual Culture, 1900–2015*. Fondazione Nicola Trussardi / Skira Editore S.p.A., 2015.

Jacob, Mary Jane, and Michelle Grabner, editors. *The Studio Reader: On the Space of Artists*. School of the Art Institute of Chicago / University of Chicago Press, 2010.

Jolly, Margaretta. *In Love and Struggle: Letters in Contemporary Feminism*. Columbia University Press, 2008.

Kinkead, Gwen. "A Room Comes Alive With Color and Sounds." *The New York Times*, 23 Dec. 2003, www.nytimes.com/2003/12/23/ health/a-room-comes-alive-with-color-and-sounds.html. Accessed 6 Sept. 2016.

Morineau, Camille. "Down with Salon Art! The Pioneering, Political, Feminist and Magical Public Work of Niki de Saint Phalle." *Niki de Saint Phalle*, edited by Guggenheim Bilbao / La Fábrica, 2015. pp. 254–59.

Morris, Matt. "Critics' Picks: Lise Haller Baggesen." *Artforum*, May 2016, artforum.com/picks/id=60198. Accessed 10 Aug. 2016.

Nelson, Maggie. *The Argonauts*. Graywolf Press, 2015.

"New Laws for Handgun Licensing Program (Formerly Known as Concealed Handgun Licensing): Summary of New Laws Passed in the 84th Regular Legislative Session That Impact Handgun Licensing." *Texas Department of Public Safety*, 2016, www.txdps.state.tx.us/rsd/chl/legal/newlegislation.htm. Accessed 3 Sept. 2016.

Nixon, Cheryl, and Louise Penner. "Materials of the 'Everyday' Woman Writer: Letter-Writing in Eighteenth-Century England and America." *Women and Things, 1750–1950: Gendered Material Strategies*, edited by Maureen Daly Goggin and Beth Fowkes Tobin, Ashgate, 2009, pp. 157–87.

Noddings, Nel. *The Maternal Factor: Two Paths to Morality*. University of California Press, 2010.

Parkinson, Gavin. *Futures of Surrealism: Myth, Science Fiction and Fantastic Art in France, 1936–1969*. Yale University Press, 2015.

Saugman, Bibi. "Flowers for Poul." Translated by Wordmaster. *Flowers for Poul. Galleri Bo Bjerggaard*, 2015, www.bjerggaard.com/assets/files/exhibitions/1210/Flowers-for-Poul-catalogue.pdf. Accessed 10 Sept. 2016.

Relyea, Lane. *Your Everyday Art World*. The MIT Press, 2013.

Rich, Adrienne. *Of Woman Born: Motherhood as Experience and Institution*. W.W. Norton & Company, Inc., 1976.

Robinson, Fiona. *The Ethics of Care: A Feminist Approach to Human Security*. Temple University Press, 2011, www.jstor.org.ezproxy.lib.utexas.edu/stable/j.cttl4bt8bq. Accessed 6 Sept. 2016.

Roelstraete, Dieter. "South Side Story: A European Curator's Adventures in Chicago." *Institutions and Imaginaries*, edited by Stephanie Smith, The School of the Art Institute of Chicago / University of Chicago Press, 2015. pp. 45–55.

Rosenberg, Judith Pierce, editor. *A Question of Balance: Artists and Writers on Motherhood.* Papier-Mache Press, 1995.

Sander-Staudt, Maureen. "Care Ethics." *The Internet Encyclopedia of Philosophy.* www.iep.utm.edu/care-eth/. Accessed 27 Aug. 2016.

State of Texas. "Health and Safety Code, Title 2: Health, Subtitle H: Public Health Provisions, Chapter 165: Breast-Feeding, Subchapter A. Breast-Feeding Rights and Policies." *State of Texas*, 1995, www.statutes.legis.state.tx.us/Docs/HS/htm/HS.165.htm. Accessed 3 Sept. 2016.

Stratton, Shannon. Interview by Zachary Cahill. "Exquisite Self-Reliance." *The Exhibitionist*, 10 Aug. 2015, the-exhibitionist.com/exquisite-self-reliance-zachary-cahill-talks-to-shannon-stratton/. Accessed 27 Aug. 2016.

Stratton, Shannon. "PAF." Received by Julia V. Hendrickson, 10 Sept. 2015. Email.

Stephenson, Jennifer, and Mark Carter. "Use of Multisensory Environments in Schools for Students with Severe Disabilities: Perceptions from Schools." *Education and Training in Autism and Developmental Disabilities*, vol. 46, no. 2 (June 2011), pp. 276–90, /www.jstor.org.ezproxy.lib.utexas.edu/stable/23879697. Accessed 6 Sept. 2016.

Ura, Alexa. "Bathroom Fears Flush Houston Discrimination Ordinance." *The Texas Tribune*, 3 Nov. 2015, www.texastribune.org/2015/11/03/houston-anti-discrimination-ordinance-early-voting/. Accessed 3 Sept. 2016.

Westin, Monica, and Rich Zito. "What Occupy's Tents Meant." *Vice*, 22 May 2012, motherboard.vice.com/read/on-the-phenomenology-of-tent-cities-or-occupy-after-occupancy. Accessed 10 Sept. 2016.

Chapter Two

Dear M: Blue Boys, Pink Girls and Other Myths

Irene Pérez

Dear M,
Did you know that since the moment we met each other I was surprised by the fact that your body and mind contain so much wisdom beyond the surface of your skin? Contrary to what I thought our relationship would be, I am learning many things from and because of you, many more than the things I have taught to you in these past eight years. This has been especially true when it comes to understanding my own body and the history of violence accumulated within it. And now I want to share this discovery with you.

Let me start by telling you a little story, one of those you like so much, one of those you ask for by saying, "Mama, tell me a story from when you were little." Although this one might go beyond those years, let me go ahead anyway.

I have told you that I do not have many memories of my childhood, although the reason why is a matter for another time. My existing memories are not long, detailed descriptions of events, but snippets of flashing images and feelings. And most of those feelings come in the form of sharp poignant pain derived from shame about two things: voicing my opinion and my body.

You know I am a feminist—"so am I!" you would respond to my statement—and feminism has helped me understand that what I lived through, the constant shaming of who I was, is a common practice in a patriarchal-ruled world. It is especially true in our culture that is in the Mediterranean culture of Spain. Here, from the time a baby is

born, it will hear unwanted opinions and statements about its body, especially if it is female. From family members, starting with its parents, to strangers in the street, everyone will feel entitled to express how the shape, colour, form, and volume of its body says something about who it is and will become.

You also know then that my story starts in the arms of my very young mother whose body was torn by the forceps that the doctor used to pull me out of her birth canal. It continues with my mother looking at me horrified, concerned about the damage those same forceps had done to my head and right cheek. Would I be disfigured for life? she wondered. Would I ever be beautiful? she worried.

My story continues through a childhood full of "Her legs aren't straight," or "Her ears are too big and stick out; she looks like Dumbo," or "Look at those big brown eyes, aren't they pretty even though they are not blue?"—and many more comments that I do not recall. But the painful violence of them I can feel has accumulated in my body.

The hardest part though was adolescence. When I was fourteen years old, one of my uncles told me that boys would go wild for my "juicy lips," while another constantly made fun of me, and said I had better take care of "that mustache of yours" soon if I was to attract any male attention; he repeated this to me for years, even after I was married. The worst part—even worse than being told as a young girl in the middle of the street by a man I did not know how he would like to "eat my tits"—was the constant reminder from my own mother that I was fat and should be on a diet. The idea planted in me was that my body was here to be an object, an object of male sexual desire, and my goal in life was to shape that object to satisfy them. From age twelve on, I endured the pain of waxing the hair from several parts of my body; the armpits were especially excruciating since they bled every time the wax was pulled and the hairs came off of the follicles. I dyed my hair so it would look nice and shiny, even though the ammonia from the dye caused irritations and lacerations on my scalp. I starved myself by following several diets my mother would prepare for me while she put rich and delicious meals on the dining table for my brothers.

Figure 1. *YOUR (pleasure) MY (pain)*, 2012, graphite, goauche and fabric on watercolor paper

The comments and unsolicited opinions about my body did not stop when I reached adulthood, as now the comments came mainly from me. By the time I had a partner—a man who really supported me lovingly and never made an objectifying remark about my body (a very uncommon thing in our culture)—my mind and my body had already internalized all the critique they had received, and it was now me who would not let myself forget how flawed I was. All this self-harm exploded in mental illness, and the medication I had to take to be able to wake up every morning contributed to significant weight gain. All of this happened when I was living in the U.S.—away from the family, friends, and people in the streets who had felt entitled to make comments about my size. This time, contrary to what I had experienced before, I felt good surrounded by friends of all shapes and colours who did not seem to mind how I looked. Nobody ever made a remark to me about my body. I felt accepted, and so I accepted myself.

M, I will always remember the day when I returned to Spain at age thirty-four after an eleven-year absence. My mother opened the door of her apartment, and right after saying hello, she felt inclined to let me know how ugly I looked because I was overweight and that my youngest brother thought so, too. Even my father, who I do not recall as ever having said anything about my body before, asked me to please lose some weight, for my sake, of course. Unfortunately, "my sake" did not include my emotional wellbeing.

Figure 2. Mirror, Mirror, 2011, lipstick on watercolor paper

You know that I discovered I was pregnant with you a month after we returned from the U.S. Not even that stopped the unsolicited comments about the shape of my body. But something changed. Something truly profound changed, even though I would not realize fully what that change was until three years later. During the pregnancy, I was completely at ease with my body. Yes, there was nausea, pain and bloating, but none of that made me feel ugly. I did not feel beautiful either, not in the sense everyone in my culture had told me I should be beautiful. I felt strong and delicate at the same time. I felt powerful. Most of all, I felt the only opinion that mattered about my body was mine. And right there and then, the seed of a new me was planted, the seed of me treating myself with loving respect.

Figure 3. *Ugly is an Ugly Word*, 2012, cross-stitch embroidery

You know that you were born prematurely a month before your due date. Labour was long, hard, and full of dangers and mishaps. There was obstetric violence performed on my body and yours, but I was able to stop them from using forceps on you and me. The doctor did not say a word to me in twenty-four hours, and at the end, he finally pulled you violently out of my birth canal with his bare hands and without warning. Whether it was the oxytocin or the new seed settling within me, I believed at all times that we would survive this trauma. I felt strong. My body knew all it needed was to be for you and for me.

My dearest M, when we first saw each other, your eyes were wide open. Your big blue eyes. You were born a blond girl with blue eyes, a rarity in our culture. I was surprised; I did not expect you to look like this. And right then and there, the seed took root without me realizing yet what it would become. What I did realize in the following days and months—when we would get a visit from family, friends, and neighbours or be stopped on the street by strangers who wanted to admire your big blue eyes—was that the story was starting all over again and I was now taking part in it from the other side.

Those first moments were troubling for me. I realized as I never had before how I, too, had had thoughts and made comments about other women's bodies. I realized, for instance, that embedded in me was the stereotype that blond-haired women are not intelligent. *Las rubias son tontas* (blond women are silly), the saying goes here in Spain. Beyond realizing how nonsensical that saying was, I had to stare into my blond-haired child's blue eyes to see my own patriarchal prejudice. That was the moment the seed started to crack and opened to let the first bud come out.

Figure 4. *1 to 3*, 2012, cross-stitch embroidery

You started talking, really making complete sentences, when you were only eighteen months old, and the first sentence coming out of your mouth was a question: *Qué és això?* (What is this?) You wanted to know about everything around you. You have a beautiful inquisitive mind that never stops wondering, which is, at times, exhausting to me. Most of my exhaustion comes from the frustration I feel at not being able to keep up with you. I must admit that it wears me out, as much as it fascinates me, all the questions you have for me. Without my realizing it at first, your questions started to make me ponder about things I had

wondered myself but had put in the very back of my mind. In looking for answers to give you, I found new answers for myself, as well as many, many more questions.

M, I believe you have a lot of questions about gender roles because at age four, you lived through an episode of gender discrimination and bullying in school. That was the moment when the roots of the seed within me grabbed hold, and even if somewhat insecurely, the first sprout made its way towards the open air. It was then when I became aware that I needed to be outspoken about the violence accumulating in our female bodies and that it was time to take action by changing the way my appearance still supported that violence.

You know that at age thirty-eight, I stopped dying my hair. The silver colour of my mane worried you. *No vull que et fagis velleta*, you cried. You were troubled by the idea that I was aging and would eventually die. As always, the conversation did not end there. We talked for hours over the course of several days about my hair and your fear and about my fear about showing my grey hair. I explained how thanks to you and your questions, I realized I was dying my hair because I was afraid of being an old woman and because being an old woman used to be revered in our culture but was now mocked and shameful. I told you about great grandma Isabel, my dearest *yaya*, and how she had white hair and how much her loving care meant to me. Connecting my white hair to our ancestor—a person who was meaningful for us—helped us to see my white hair and aging body from a place of gratitude and reverence.

Three years later, at age forty-one, I decided to shave my head. I had done that once before, ten years earlier while living in the U.S., and I had felt empowered by it, so I was looking for the same effect now in a moment when I felt weakened by my aging body and by a relapse into mental illness. Cutting my hair in such a drastic manner took you by surprise. It saddened you deeply. After all, caressing my wavy locks had calmed you at nighttime when you were a baby and could not fall asleep. You were emotionally connected to my hair. I made a braid, I tied it, and I put it in a special box, which you have treasured. That was the moment that a shoot from the original seed unfolded its first leaves with a message attached to them: my body is a treasure.

Figure 5. *Vellesa_Bellesa (Old Age Beauty)*, 2015, cross-stitch embroidery. Translation of the text in the art work: "I will not hide the gifts that time has given to my body."

Do you remember that right after we navigated together past the pain of your loss and the mourning of our connection through my hair, we talked about what it meant to construct our femininity around the look of our bodies? Was I less of a woman because my hair was now very short? Would I be less beautiful? Who decides what beauty means and what feminine is? As always, you had many questions for me, and in trying to give you an answer, I was (re)constructing myself. By the end of our three day-long conversations, you wanted to shave your head as well.

This came to me as a surprise. You also loved your long unruly hair. But, more of a surprise to myself was my immediate answer: No. What? Why? Wait. I explained to you that I was afraid of how you would be treated and that mama could take any comments about her short hair, but I was afraid that someone would hurt you because of the way you looked. "Mama, don't be afraid. I know you have taught me how to take care of myself. I believe what you said: my body is mine, and I get to decide." You answer was firm. But I had lied, hadn't I?

I forgot to throw into the mix that we not only live in a sexist society, we also live in an adult-centric one, and the decisions about your body are not fully yours yet. I needed to water the new plant, or it would wither before it could grow.

You accepted my proposal to wait for a year. "If by next summer you still want to shave your head, mama will do it gladly," I said. Fall passed, winter came and went, spring arrived and left, and finally summer was here again and you asked me to keep my promise. You were scared. Yes, I had that feeling, too. The gender norm rules from our patriarchal culture whispered fear of disapproval to us. So, first you decided to just shave half your head. Right after I finished, you ran up and down our apartment's hallway yelling, "I'm a rock star. I am brave. I am fierce, roar!" For a few days you wore that look, and everybody had positive, supportive comments for you.

The moment of truth came a few weeks after that first haircut. You wanted all your hair cut off completely, so, I shaved your whole head. The act itself was uneventful. It was June, during the summer break from school. You love the outdoors and spending time at the playground. And so, during the whole summer, every visit to a playground became a dissertation on gender norms. There was the time when your friend Ana, the one you usually played with at the playground in front of our apartment building, said she would not play with you, since you were no longer a girl. You asked me for help, and we talked to her about how each one of us three is feminine in a different way. She was surprised but glad we told her there were more options, and you played together again. Then came the time when a little boy followed you around asking why were you wearing pink leggings, since you were clearly a boy. Your dad asked him to please leave you alone. You cried with rage. And after many more comments and encounters, there was the time when you challenged a boy your age to stop calling you a boy, and he asked, "If you are a girl, why do you have a boy's face?" "You must be confused, my face is what I choose it to be, and not what you see in it," you answered. I was hurting for you, but most of all I was proud. I am proud and honoured to be your mother.

It is September now, the month of my birth. I love celebrating my birthday and aging. It is also the month when school starts here in Spain. You love your school and so you are happy and excited to return.

It has been a long summer filled with conversations about gender and about our bodies. Naively, I thought we might have closed this chapter. I should have known better, for this chapter is never closed for us as women, as it is not closed for many racialized and dissident bodies. Today, we read a book together in which a little girl asks while staring at herself in a mirror if she is pretty. We are both unsettled by the image and the text and so another of our conversations begins. We use words like self-esteem, body insecurity, binary thinking, and normal vs. normative.

Another long conversation lies before us, but before we continue, you stop and say, "Mama, thank you for educating me like this because this is the way I feel and think and I had no words for it." I cry, and with each one of your words and each one of my tears, I feel my wounds healing and my body becoming stronger. Branches come out of the main stem of this metaphorical plant that your body planted inside of mine.

My precious M, our journey through what our bodies bring us will continue. The experiences I have shared with you may be specific to our culture, but they are not unfamiliar to many women around the world. I write this letter in an attempt to go beyond exposing or even denouncing what we live through. I wanted to leave a record of how we live through these experiences in the hope that we might break free from the expectations placed on our bodies and from the violence that accumulates in them. And so, we keep on travelling this path together, where I can clearly see your seed—full of wisdom, strength and power—taking root right next to mine.

Mama I.

Chapter Three

The Mother Without Child/ The Child Without Mother: Miriam Schaer's Interrogation of Maternal Ideology, Reproductive Trauma, and Death

Jennie Klein

"Part of coming to terms with Infertility, I've come to realize, is understanding just how pervasive it is in controlling not only your body but your life, your future, your plans.

Now about that hold button. It's just so difficult to disconnect entirely. Preparing indefinitely for an outcome that Infertility hijacked has thrown me for a loop. I'm a little like a prisoner being released after a 12 year sentence. I hardly know how to act."

— Pamela Tsigdinos ("Please Hold for the Children")

"I always thought I'd have a child,
but I also knew there were problems.
I didn't really think too much about it.
After a couple of rounds
of infertility treatments that didn't work, my husband said
"maybe we should just focus on us. If it happens, great,
if not-that's ok too."
I began to focus on my work, my art, my life.
A gynecologist at the time said to me:
"Make a decision: have children or not.
If you can't have them biologically
consider other options.
But if you are not going to have children,
live a life you can't if you do have children."
—Miriam Schaer (*The Presence of Their Absence*)

For the past several years, Miriam Schaer has been making work about not being a mother. Schaer foregrounds the ambiguity of being biologically childless despite the brave new world of reproductive technology and, at the same time, forces us to question what it means to be a mother and how that term may be defined. A brief experience with fertility treatments and the advice of a compassionate doctor motivated Schaer to explore infertility and not being a mother in her work in order to question the universal and limiting ideology of motherhood that transcends the distinctions of class, race, nationality, ethnicity, and gender identity. Schaer began embroidering white baby clothes with insensitive statements made about childbearing to women experiencing infertility. Schaer obtained a number of hyper-realistic baby dolls and dressed them in embroidered garments, with the idea that the statements on the clothing were part and parcel of the ideology that produced these realistic dolls, many of which were handmade (to enhance the verisimilitude), expensive, and consumed primarily by upper-middle-class white women. Schaer photographed herself with and without these dolls, and showed the photographs to her mother Ida, who had recently been diagnosed with dementia. Schaer purchased a sleeping baby doll named Tabitha for Ida, and then photographed Ida with Tabitha and with her adult children. When Ida passed away, Schaer became both a mother without a child and a child without a

mother. This motivated Schaer to question the ideology of the maternal, an identity to which women are expected to aspire even as their status is undermined because they are mothers. Unlike most accounts of infertility in which the author blames feminism for making her think she could have it all, Schaer actively invokes her feminism and feminist strategies of artmaking in order to engage with a patriarchal ideology that limits rather than expands women's options. Schaer's artistic interpretations of infertility, the ideology of motherhood, and the stifling expectations that come with what it means to be a mother can be understood within the history of reproductive technologies and within feminist explorations of maternal identity, with and without children.[1]

ART (Artificial Reproductive Technologies) as a Feminist Strategy?

In the 1970s, at the height of second-wave feminism, the nascent fertility industry was initially embraced by feminists. When, in 1970, Shulamith Firestone called for an end to the tyranny of the biological family through the use of reproductive technology, she, and her readers, could never have envisioned the brave new world of egg freezing, test tube babies, and surrogates in India that has come about almost fifty years later. Firestone saw ART as freeing up women to pursue their goals without fear that they would wait too long to have children. In 1976, Adrienne Rich, the mother of three sons, published *Of Woman Born: Motherhood as Experience*, in which she argues that there are "two meanings of motherhood ... the *potential relationship* of any woman to her powers of reproduction and to children; and the *institution*, which aims at ensuring that that potential—and all women—shall remain under male control." The institution of motherhood, according to Rich, alienates women from their bodies. Echoing Firestone, Rich argues that "women are controlled by lashing us to our bodies." With the birth of Louise Brown, the first test tube baby, still two years away, Rich in 1976 could envision a world in which access to birth control, abortion, and reproductive healthcare would free women to realize their potential.

The close association between feminism and reproductive treatments in the 1970s may explain why contemporary writers, many of them

self-identified feminists, still hold feminism accountable for the condition of infertility rather than the institution of motherhood, of which the infertility industry is a part. Miriam Zoll, in her memoir *Cracked Open: Liberty, Fertility, and the Pursuit of High Tech Babies* (2013), actually blames feminism—with its promise that women can have it all—for the infertility crisis. Zoll writes that "to learn later, after painful personal experience, that the vast majority of reproductive technologies do not, in fact, result in live births is a double tragedy. Not only are we coping with the loss of a deep primal desire to birth offspring, we must also come to terms with the fact that we built our entire 'women-can-finally-have-it-all' adult life on an illusion."

Or consider Ariel Levy, writer for *The New Yorker*, whose formative years were spent experimenting sexually, culturally, and chemically in New York City. Writing her memoir on the other side of forty and a rather horrific second trimester miscarriage, Levy frequently referenced the promise of feminism, which had not been delivered: "Women of my generation were given the lavish gift of our own agency by feminism—a belief that we could decide for ourselves how we would live, what would become of us" (69). Ironically, according to Levy, her friends became deeply regretful that they had chosen not to have children earlier in life when they turned forty and realized that their fertility had declined steeply. As Levy put it, "Fertility meant nothing to us in our twenties ... and then—abruptly, horrifyingly—it became urgent" (85). Levy's feminist friends probably felt adrift because there are no books on infertility as a feminist concern (unlike Suzy Orbach's *Fat Is a Feminist Issue*). Instead, infertility is seen as a personal and even embarrassing issue, hence the title of Pamela Tsigdinos' book: *Silent Sorority*.

The treatment of infertility has become a multibillion dollar industry—in which those with the financial wherewithal can purchase eggs, semen, and wombs from those whose lives are considerably more precarious—and has little in common with the utopian world of female equality envisioned by Firestone. The reproductive technologies that Firestone celebrated have been realized, albeit not with the results that Firestone envisioned. Far from being liberated from reproductive tyranny, as Firestone optimistically predicted, women—or at least predominantly Caucasian, affluent, married, and primarily heterosexual ones living in the developed world—have become even more enslaved

to the imperative of the biological family, in part because of the seduc-
tiveness of the availability of ART, which have a statistically low chance
of being successful once a woman is past forty. The test tube baby,
which Firestone thought could potentially eliminate male supremacy in
the family, has simply reinforced the imperative to reproduce within
the structure of the nuclear family, even, or especially, when it comes
to same-sex couples. Childlessness has become the purview of the
affluent who can afford the increasingly invasive procedures that often
do not result in a baby.

Even after many rounds of in-vitro fertilization, donor eggs, culled
sperm, and doctor's visits, no pregnancy is often the result. Infertility
is a condition that has no prejudices. It afflicts men and women of all
nationalities, ethnicities, religious beliefs, racial backgrounds, and class
circumstances equally. That said, infertility is disproportionately visible
among upper-middle-class, well-educated, primarily Caucasian or
Caucasian-identified women, largely because this is the group that has
the means to pay for the numerous treatments and to access the
technology as well as the level of education to write about their exper-
iences with reproductive technologies, infertility, and the medical
world. Tsigdinos in many ways represents the growing population of
upper-middle-class women who are beginning to publicly acknowledge
the trauma that infertility has caused them. Tsigdinos was twenty-nine
years old and working as a marketer for a venture capitalist company in
Northern California when she decided to have children. She tried for
eleven years to get pregnant before she and her husband Alex made the
decision to stop trying in 2007. Feeling alone and alienated, Tsigdinos
turned to the Internet and discovered an online community of women
who had had the same experiences as she had. Like these women, she
turned to blogging, which allowed her to participate in the community
of women with infertility and eventually move on from the trauma that
she felt ("Identity Lost and Found"). Tsigdinos's first blog, *Coming to
Terms: Barren and Beautiful*, which ran from 2007 to 2015, chronicled
her journey from anger to acceptance of infertility. As well, the blog
chronicled the transformation of Tsigdinos from bereft childless
mother to infertility superstar commentator. By the time that she
ended *Coming to Terms* and started the website and blog *Silent Sorority* in
2009 (the two blogs overlapped by several years) Tsigdinos had been
the subject of a feature article in the *New York Times* (Barrow; Tsigdinos,

"Struggling to Accept"), the author of a book about her experiences (*Silent Sorority*), and the author, subject, and commentator of numerous interviews, podcasts, and articles about the trauma and prevalence of infertility, most of which are linked on her blogs and website.

Tsigdinos, whose pain and trauma were so palpable that she began to cry when interviewed for *The New York Times* in 2008, was able to come to terms with her grief by becoming an activist and a writer, whereas Schaer did what she had always done—making art, writing books, creating installations, and doing performances—about her experiences. On the surface, Tsigdinos and Schaer seemed to have quite a bit in common; both are educated, upper-middle-class women who experienced infertility. By the time she published *Silent Sorority*, Tsigdinos had become an outspoken critic of infertility treatments, which, as she noted in an article co-authored with Miriam Zoll for *The New York Times*, was a $4 billion a year industry in 2013. Noting that the global failure rate of assisted reproductive cycles was 77%, Tsigdinos and Zoll conclude in their article that "it's no wonder that, fueled by magical thinking, the glorification of parenthood and a cultural narrative that relentlessly endorses assisted reproductive technology, those of us going through treatments often turn into 'fertility junkies.'" Buoyed by the can-do optimism of American culture, women who chose to walk away from fertility treatments before exploring all of their options often consider themselves weak and are often considered weak by a society that values heterosexual reproduction as long as it was middle class.

Like Tsigdinos, Schaer and her partner eventually chose to stop the infertility treatments and to be childless by choice. Schaer has also been critical of the sociocultural circumstances that push women into the increasingly invasive fertility treatments that do not work. Schaer ended the treatments after only a few attempts, and quickly moved on and immersed herself in her artmaking and teaching. Schaer took agency from her decision, preferring to call herself childless by choice rather than by accident. Even more importantly, Schaer has constructed her own childlessness through the agency of her feminism and has used that feminism as scaffolding for her life as an educator and artist. Schaer's work can be seen as operating from the position of "the mother without child," which Elaine Tuttle Hansen has defined as a woman who wants children but cannot become pregnant and give

birth to a biological child and who is considered infertile or barren because her body does not work rather than because she chooses not to have children (431). Tuttle Hansen argues that "the 'good' woman and mother can speak only to erase her authority, to renounce possession, to disown her desire; a mother is someone who sacrifices something she has and wants, or is willing to do so, for the good of another" (448). The mother without child provides an alternative to this patriarchal narrative of self-sacrifice that started with the story of King Solomon, who in his so-called wisdom suggested that the child be cut in half, for, as Tuttle Hansen argues, it frees feminists to focus on the mother "and in doing so to see her as a multifaceted and changeable subject" (447). Tuttle Hansen argues that "the mother without child ... can subvert these categories of criminal or victim, bad or good mother, by not fitting comfortably into either or by occupying both at the same time" (451). Schaer's work should be understood as operating from the ambiguous position of mother and not-mother, a position that questions the role of mother from a feminist position. Schaer neither laments her childless state nor embraces it; rather, she unpacks the ideological construction of childlessness today.

Babies (Not) on Board?

Schaer relates in her autobiographical artist's book *The Presence of their Absence* how her decision not to pursue expensive reproductive technologies permitted her to realize that childless women were actively discriminated against (26-27). Embracing her role as the mother without child, Schaer suggests that "the most radical notion of motherhood, one might argue, is not to have children in the first place" (48-49). Stung by the often insensitive comments made regarding her decision to not have children, a decision that in Schaer's case would have potentially involved compromising her health and financial security, Schaer began collecting comments made to childless women through interviews, research, and her own personal experience. Schaer embroidered these comments with red thread (like a scarlet letter) onto pristine white baby garments, and she worked on this series while commuting between Columbia College in Chicago, where she worked, and Brooklyn, where she lived. She often found herself in conversation with women who responded to her work:

Often, I chatted with women while working on the embroidery pieces, which are very portable, as I commuted to and from my teaching position at Columbia College Chicago. The responses I got were very strong. Many women, often those with children, shared with me their own stories about having felt trapped or seduced by the myth of "having it all." Others told me about the pressures they experienced to have children before they had children, from family members and others in their communities. Lately, more gay and lesbian friends have spoken with me about the recent pressure they have felt to have children. ("Babies (Not) On Board")

Schaer's method of researching "*Babies (Not) On Board*" by sharing her experiences with women while commuting harks back to the early days of feminist art when consciousness raising informed artmaking practices, although infertility was never an issue for women artists, who viewed having children as something separate from being an artist. The material for much of the feminist art work in the early 1970s came from consciousness-raising sessions. At CalArts (California Institute for the Arts in Valencia) and then for the Woman's Building, which was founded as an alternative feminist art center and school in downtown Los Angeles in 1973, Judy Chicago, who was the pioneer of feminist art education, encouraged her students to recognize that problems they had dismissed as personal were, in fact, the result of patriarchal ideology. Infertility was not really considered an issue, particularly since Chicago had chosen not to have children. Menstruation, abuse, rape, female bonding, feminine despondency, and entrapment figured much more prominently in second wave feminist art than the role of the mother. In fact, at this point in time, being a feminist artist meant actively refusing to have children, even as the feminist art movement embraced a wide variety of female experiences. Laura Silagi, who had moved to Los Angeles to study at the Feminist Studio Workshop, the educational component of the Los Angeles Woman's Building that was founded by Chicago, along with art historian Arlene Raven and graphic designer Sheila de Bretteville, was shocked to discover that children were not welcome at this feminist institution (Chernick and Klein, 1). Along with Helen Million Ruby, who was told by Chicago that woman artists were expected to not have children, Silagi founded the collective Mother Art, whose first project was to

make playground equipment for the children who came to the Woman's Building (Chernick and Klein).

In the early 1970s, feminists and feminist artists did not openly lament their infertility, since enslavement to the ideological demands of the biological, heterosexual, and patriarchal construction of the family was viewed by many feminists as a large part of the problem. Thanks to the feminist art movement, women artists slowly began to break the art world's glass ceiling and have their work included in major museums, biennales, and art galleries. Almost none of these women had children, or if they did, they kept that aspect of their life hidden. In 1992, almost twenty years after Silagi and Million Ruby created a Woman's Building playground for their children, Susan Bee and Mira Schor edited an issue of *M/E/A/N/I/N/G* on the topic of motherhood, art, and artists. They approached a diverse group of artists and asked them how the experience of motherhood had affected their work. Many artists were overjoyed to be asked to contribute. A small but significant minority were not overjoyed, however. The editors noted in their introduction that "more than one artist wondered how we'd found out that she *had* a child, so separate had children been kept from the artworld" (Bee and Schor 200).

In the antichild environment of the art world, Schaer's embroidered white christening dresses, pinafores, smocks, onesies, and shirts and shorts seem out of place. And, indeed, these are not objects made with art world success in mind; rather, they are objects made for a community of women who understand the pain that comes with being told that "childless women lack an essential humanity" or from reading embroidered on a pale baby blue coverall that "you may not have kids and not care about the future of our planet, but I do, so recycle." These comments are so insensitive and boorish that it seems as though they must have been made in the 1950s, prior to second-wave feminism. Yet these comments were made quite recently to Schaer and to the women that she interviewed. Sociologist Gail Letherby has argued that because motherhood is a public experience—affecting not just the woman but her partner, parents, relatives and friends—people have felt justified in giving advice about where, when, and how to have children. Noting that this advice implies that women who are either voluntarily or involuntarily childless have not reflected on the reasons for their childlessness, Letherby points out that "the decision not to have, or the

realisation that having may not be possible, may also cause some pain, and in this case advice will be not only unnecessary and unwanted but cruel" (527).

Picturing Childlessness

Two related photo series, *The Presence of Their Absence: The Portraits* and *The Presence of Their Absence: Self-Portraits,* grew out of Schaer's desire to display the embroidered baby garments that comprised *Babies (Not) on Board* in a situation that at least approximated the actual context for which the clothing had been intended. For *The Portraits,* Schaer obtained four lifelike baby dolls and three toddler-sized mannequins (for the larger garments), and she arranged for professional studio portraits to be taken of these ersatz children, all wearing embroidered texts that contradicted their existence. A cut above the standard studio portraits of babies and toddlers, these images, which are housed in a red portfolio box with the title of the series and Schaer's name embossed on the cover, are both beautifully crafted and eerily lifelike, particularly in the case of the realistic babies, which look like actual babies in the photographs. These dolls were made to be collected by adults rather than played with by children. It is, therefore, appropriate that Schaer has them model her *Babies (Not) On Board* clothing line—a one-of-a-kind outfit for a doll that looks like he or she is from a parallel but different reality. And, in fact, they are from a different reality: the world of the childless, but not by choice.

The *Portraits* are quite intimate: each portrait is overlaid with a piece of protective onionskin paper onto which one of the statements embroidered on the clothing has been printed. The *Self-Portraits,* on the other hand, are large scale prints in which Schaer, dressed in black clothing, poses with her doll family in a studio setting. Several of these portraits appear to be normal (i.e., those of Schaer cradling one of the realistic looking babies and those of Schaer standing in the centre of her children). Even these photographs are not quite right, however. Rather than looking solicitously or with concern at her children, Schaer stares straight ahead at the camera, playing the role of the artist and social commentator instead of the mother. In many of the photographs, Schaer does her best to make it clear that the dolls are inanimate objects, as she throws them around, walks away from them,

or holds them up under their arms as though they were a hunting trophy rather than a baby. Despite their frontal presentation and oversized format, the *Self-Portraits* are a performance—the divesting of the ideology of infertility, as well as the expectation that all women are mothers, or supposed to be mothers, whether or not that is the case.

Figure 1. Miriam Schaer, *The Presence of Their Absence #35,* 2015. Digital C print. Photo credit: Chelsea Shilling and Miriam Schaer. © Miriam Schaer

The Self-Portraits, then, are meant to indicate the arbitrary ideological construction of childhood and women's roles in relationship to that construction. Nevertheless, they have been misread as simply being about Schaer's own experience with fertility. Schaer included a guest book for comments and names at her 2013 solo exhibition *Babies (Not) On Board: The Last Prejudice.*[2] Most of the comments were supportive, but several visitors became angry at Schaer for critiquing the ideological construction of childlessness. One comment suggested that Schaer was being "rude" to people who could have children, while another opined that "most of the citizens on the planet don't or are not really interested in your 'inner struggle.'" As sociologists and theorists such as Margarete Sandelowski and Letherby have argued, the ideology of

infertility and childlessness is such that women who are either voluntarily or involuntarily childless are viewed as childlike themselves for refusing to grow up and take on the accepted role of the mother.

Even more insidious is the association between women's right to reproductive freedom and infertility. Women are actively encouraged to blame themselves for their infertility, which to this day remains a condition due to often multiple and unknown causes. Over thirty years earlier, Sandelowski demonstrated that "embedded within" the new urgency about infertility was "a renewed concern about women's autonomy and the reproductive price of women's expanded freedoms" (476), which is the price women pay for putting their own needs and desires ahead of the reproductive imperative (476). This ideological construction of infertility, expressed by the unknown commentator in Schaer's guest book, has been constructed as a "failure of volition" on the part of the woman trying to conceive—something was either done or not done to result in no children. What is more, this discourse is not specific to the late twentieth-century and the burgeoning field of ART. Sandelowski traces the suggestion that women were to blame for infertility back to the late nineteenth-century, just as increased public attention was being directed towards educational and occupational opportunities for women (482). The response to Schaer's work makes clear just how entrenched is the idea that infertility is the fault of the woman.

Challenging the Ideological Construct of Infertility

Schaer, however, refused to be wracked with guilt about her inability to conceive. She was angry at the way in which society expected all women to be mothers and also at the way society made childless women feel somehow less than adequate, especially if they were childless by choice. Letherby has shown how the ideology of infertility is bolstered by the discourses of social loss, biological identity, and medical hope, which "support the dominant social order with motherhood being *every* woman's goal" ("Other than Mother" 362). This is despite the fact that "motherhood is considered less appropriate for single women, divorced women, black women, disabled women, and women from lower socio-economic groups" ("Other than Mother" 362). In her 2015 artist's book *The Presence of Their Absence: Society's Bias Against Women*

Without Children, Schaer challenged an entrenched ideological construction that was particularly punishing to women who could not conceive. This slender book includes Schaer's story, along with quotations from a wide variety of experts about how infertility is understood and disparaged in various cultural contexts. Several of the images from *Self-Portraits* are either reproduced or restaged for the book, and there are two new series of photographs, both of them made using only the realistic looking dolls. The first series shows Schaer dressed entirely in black and playing with the dolls on the playground of South Loop Elementary School; she throws them in the air and poses them on playground equipment. The playground photos serve as the backdrop to Schaer's personal account of infertility (Fig 1). In the middle of the book is her statement for *Baby Not On Board* and is accompanied by the silhouettes of a baby-shaped book binder's board—similar to how candy boxes are fabricated—that when placed together form the letter M.

The second series of photographs, made again with the realistic dolls, show Schaer looking into the window of the American Girl Place in the Chicago Loop while holding one of the dolls. Here, Schaer confronts the ideology of mandatory motherhood and reproduction that permeates the developed and undeveloped worlds. The American Girl dolls, which are very expensive, are ostensibly made for children. As Schaer carries her baby and thinks about the Bitty Babies for sale at American Girl Place, one cannot help but be reminded of the incommensurability of Schaer, who by this time looks too old to be the biological mother of such a young baby, and the doll itself. Schaer deliberately performs the inappropriate mother cited above by Letherby, a mother that does not necessarily have a husband, has not given birth, and holds not a real child but only the facsimile of a child. The running narrative along the bottom of the pages shifts from Schaer's decision to cease ART treatments to a discussion of the astonishing prejudice that she and her husband experienced when people learned they were childless. This narrative is reinforced with quotations and sayings from different countries condemning infertile women. In the concluding pages, Schaer takes the leap and politicizes childlessness, noting that women's health clinics that perform abortions are subject to legal and extralegal actions. "Is domestic terrorism part of the price of deciding not to have a child?" Schaer asks (86).

Ida/Naomi and Reborn Babies

As she was completing *The Portraits*, Schaer showed the images to her eighty-nine-year-old mother Ida, a former maternity nurse who was just beginning to exhibit signs of dementia. Ida was very taken with the photographs of the dolls. Schaer purchased a doll for Ida, which Ida named Tabitha. Like the dolls in Schaer's *Portraits*, Tabitha looked a lot like a real baby. And Ida, who had always loved babies and small dogs, treated her as such (Schaer, *The Key Is in the Window*). Schaer began to photograph Ida, Tabitha, and herself, and put these photographs together into a portfolio that she titled *The Key Is in the Window* after Allen Ginsberg's poem *Kaddish*, written in honour of his mother Naomi Ginsberg, who suffered for most of her life from mental illness. When she passed away in 1956, Ginsberg was not present at her funeral and learned later that the Kaddish, or Jewish prayer for the dead, was not said because too few men were present. Two years later, Ginsberg performed the prayer for his mother with his friend Zev Putterman. The following day, he began writing *Kaddish* (Asher).

Like Ginsberg's *Kaddish*, Schaer's *The Key Is in the Window* is a prayer for the dead made for Ida, who passed away in December 2014 as Schaer was completing the series. In Ginsberg's *Kaddish*, the key in the window is Naomi's final destination as she moved through her troubled life, a way out of her life into another world:

> Toward education marriage nervous breakdown, operation, teaching school, and
>> learning to be mad, in a dream—what is this life?
> Toward the Key in the window—and the great Key lays its head of light on top of
> Manhattan,
>> and over the floor, and lays down on the sidewalk—in a single vast beam

The key was also in Naomi's advice to Ginsberg in a posthumous letter in which she responded to *Howl*: "The key is in the window, the key is in the sunlight at the window—I have the key—Get married Allen don't take drugs—the key is in the bars, in the sunlight in the window." Ida's life was nowhere near as troubled and dysfunctional as that of Naomi Ginsberg, whose delusional ravings and desire for

heterosexual normativity were translated by Ginsberg into an ecstatic vision of altered maternal consciousness. Ida was a good wife, a good mother, a good nurse, and a good housekeeper. Unlike Naomi, whose craziness in *Kaddish* was transcendent and mythological (as well as misdiagnosed), Ida's dementia was banal and sad—the endpoint of what had been a long and productive life. Ironically, the anchor to her previous existence was Tabitha, the doll that Ida was sure was Jewish. By the time that Schaer gifted Tabitha to Ida, Ida had had to relocate from Buffalo, NY, to an assisted living centre—Belmont Village—located in the outskirts of Chicago, where Schaer's sister and Ida's primary caretaker lived.

As Ida journeyed towards death, "that remedy all singers dream of," as Ginsberg put it in *Kaddish*, Schaer channeled her sorrow into making her art, just as she had earlier when she realized that she was not going to have children. From the images of *The Key Is in the Window*, Schaer made the series *(W)hole Transformations* (2014-15) and the artist's book *(w)hole: A Life in Parts* (2017). For *(W)hole Transformations*, Schaer physically manipulated the photographs from *The Key Is in the Window*—stapling, sewing, lacing, and peeling the prints. The photo collages that resulted from this process were put back together and displayed in fancy frames much like the frames that Ida had used to display pictures of her family. The pictures contained within the frame are still Ida and her family, albeit a different family that included Tabitha. The frames become containing devices that hold together what remains of Ida Schaer; the fragmentation of the images is a reflection of Ida's increasingly fragmented reality. Schaer exhibited this series twice: *(w)hole* in Berlin in 2014, while Ida was still alive, and *(w)hole II* in 2015.[3] By 2015, Ida had passed, and Schaer was grappling with how and what she remembered of Ida, and what Ida had remembered of her own life by the end. The framed pictures were installed on a dresser—an appropriate choice, as most of Ida's possessions from the life she had led in Buffalo, NY, were stored in her dresser drawers at the Belmont Village. Schaer's book, *(w)hole: A Life in Parts*, which was finished two years later, is therefore Schaer's attempt to remember who and what Ida had been prior to the onset of dementia. Overshadowing her memories of her mother as a young woman were the more recent memories of a mother who was no longer present, a mother who in extreme old age had become the child of both Schaer and her younger sister Susie.

Figure 2. Miriam Schaer, *Ida and Tabitha #39*, 2014. Digital C print.
© Miriam Schaer

The key, or link, to Ida's life is the doll Tabitha. Ida's response to Tabitha is both natural—Ida was both a mother and a baby nurse—and unnatural—Ida can no longer distinguish between an artificial doll and a real baby (Fig. 2). When Schaer decided to purchase this doll for her mother, she was probably not aware of the growing world and culture of reborns, dolls that are so realistic that it is sometimes difficult to tell them apart from living and breathing babies. A reborn doll is one that is hand crafted, painted, stuffed, and often scented so that they look, feel, and smell like a real infant. Costing anywhere from several hundred to several thousand dollars, reborns are avidly collected by mostly women, often as a way of filling a void. The tiny counterpart to the hyperreal sex dolls that are primarily "used" by men, the reborns have birth certificates and are "adopted" rather than sold. Women who have lost a child or who cannot conceive have purchased these reborn dolls as a means of consolation, as is the case with Mary Shallcross, a Canadian with a heart condition who is unable to carry a child. The subject of an article on reborns by Alexandra Shimo for the Canadian publication *Maclean's*, Shallcross, who takes her reborn doll Victoria out in public, purchased the doll at the suggestion of her mother (Shimo 49)

Women such as Shallcross, who desire their own child so much that they carry around a realistic doll, are viewed as unnatural and excessive if the comments posted after the article are any indication of public sentiment. And while there is a growing movement to gift the elderly who suffer from dementia with a hyper-real baby, that movement has been criticized as well. There is something rather creepy about these dolls, particularly those that, like Tabitha, sleep in perpetuity. Tabitha's eyes will never open, her sparse hair will never grow in, and yet, in the pictures from *The Key in the Window* it is clear from Ida's body language that the feel and look of Tabitha reignited her memory of what it was to be a mother and a maternity nurse. Ida folds over the doll, knowing instinctively how to hold her, what to say to her, and how to care for her. She coos over Tabitha along with Schaer, who carefully takes her from her mother and makes sure to support her head. According to Shimo, reborns are constructed so that their heads, like those of newborns, need support (48). When not called upon to be a baby, Tabitha rests on Ida's bed next to an antique doll of the kind that Ida and Schaer enjoyed collecting and refurbishing when Schaer was growing up.

Reborns are disturbing, but there is something slyly subversive about them as well—an ersatz performance of motherhood and maternity that is all the more compelling because it is done unself-consciously and even unintentionally. This could explain why there is a growing YouTube community of reborn videos, with popular YouTube series such as *LoveMyRebornBaby*, hosted by a nineteen-year-old woman from Denmark named Sabrina, which draws thousands of viewers. Like sex dolls, the reborn dolls make a lot of people very uncomfortable, even as they are used by some women to help grieve the loss of a child. Reborn dolls allow their users to remake or rewrite history, to become the mother that they have wanted to be, and to do so with an object that is more than real. There is an element of cosplay—one of the most popular subjects is cleaning up after a big poop event that always takes place off-screen—that points to the artificiality of these dolls, how they are used, and what they say about the pronatal ideological structure that seems to be a ubiquitous global phenomenon. It is telling that Schaer first performed maternity using these hyper-real dolls, and then, through Schaer's gift of the doll, Ida could perform, however imperfectly, who and what she used to be. In this context, it is significant that Schaer's nascent body of work is

concerned with an exploration of Ida's notebook, in which it is clear that Ida is trying to remember who she was, as she writes her name repeatedly and clearly in the pages of the notebook.

In foregrounding Ida's obsession with the doll, Schaer suggests that the institution of motherhood creates this obsession and then blames women for not being able to handle an inability to have children. Schaer also transforms her mother's dementia from the sad descent into forgetfulness and childlikeness into a more excessive kind of madness. To collect and use these dolls, as opposed to the antique dolls that Schaer and Ida collected and restored when Schaer was younger, is to become the unnatural mother, the mother without a child, and, at the same time, the mother driven mad due to her inability to reproduce. By invoking Ginsberg's mother, Schaer attempts to wrest Naomi and Ida away from the patriarchal construction of their madness and dementia via the agency of Tabitha, the tired doll.

Ginsberg's farewell to Naomi will no doubt resonate with Schaer, as she realizes her new project, a series of prints of Ida's bathrobe with her face superimposed on the image while Tabitha slumbers nearby: "There, rest. No more suffering for you. I know where you've gone, it's good"(*Kaddish*).

Endnotes

1. Schaer details these struggles in her two self-published books.
2. *Babies (Not) On Board: The Last Prejudice* was curated by Florence Alfano McEwin for Western Wyoming Community College, Rock Springs, WY.
3. *(w)hole II* was part of *Alternative Maternals-London*, part of the 2015 London Motherhood and Creative Practice Conference organized by Elena Marchevska and Valerie Walkerdine.

Works Cited

Asher, Levi. "Kaddish." *Literary Kicks*. 18 Oct., 1994. http://www.litkicks.com/Kaddish. Accessed 19 June 2017.

Barrow, Karen. "Facing Life Without Children When it Isn't By Choice." *The New York Times*, 10 June 2008, www.nytimes.com/2008/06/10/health/10iht-10pati.13598254.html. Accessed 28 July 2019.

Bee, Susan, and Mira Schor. "From the *M/E/A/N/I/N/G* Forum: On Motherhood, Art, and Apple Pie, 1992." *Mother Reader: Essential Writings on Motherhood*, edited by Moyra Davey, Seven Stories Press, 2001, pp. 199-210.

Chernick, Myrel, and Jennie Klein. *The M Word: Real Mothers in Contemporary Art*. Demeter Press, 2011.

Firestone, Shulamith. *The Dialectic of Sex: The Case for a Feminist Revolution*. Bantam Books, 1971.

Ginsberg, Allen. *Kaddish: for Naomi Ginsberg 1894-1956. Poetry Foundation*, 1958, www.poetryfoundation.org/poems-and-poets/poems/detail/49313. Accessed 28 July 2019.

Ginsberg, Naomi. "Letter to Allen Ginsberg in response to *Howl*." Lewis Hyde and Allen Ginsberg. *On the Poetry of Allen Ginsberg*. University of Michigan Press, 1984, pp. 426-27.

Letherby, Gail. "Mother or Not, Mother or What? Problems of Definition and Identity." *Women's Studies International Forum*, vol. 17, no. 5, 1994, pp. 525-32.

Letherby, Gail. "Other than Mother and Mothers As Others: The Experience of Motherhood and Non-Motherhood in Relation to 'Infertility' and 'Involuntary Childlessness.'" *Women's Studies International Forum*, vol. 22, no. 3, 1999, pp. 359-72.

Levy, Ariel. *The Rules Do Not Apply: A Memoir*. Random House Publishing Group. 2017.

Orbach, Susie. *Fat Is a Feminist Issue: The Anti-Diet Guide to Permanent Weight Loss*. Paddington Press, 1978.

Rich, Adrienne. *Of Woman Born: Motherhood as Experience and Institution*. W.W. Norton and Company, Kindle Edition, 1986.

Sandelowski, Margarete J. "Failures of Volition: Female Agency and Infertility in Historical Perspective." *Signs*, vol. 15, no. 3, 1990, pp. 475-99.

Sabrina. *LoveMyRebornBaby*. YouTube. www.youtube.com/channel/UCZ7jrpFx6CSGRxdWh1UlljQ 21 June 2017.

Schaer, Miriam. "Babies (Not) on Board: The Last Prejudice?" *Miriam Schaer*, www.miriamschaer.com/babies-not-on-board/. Accessed 28 July 2019.

Schaer, Miriam. "The Key is in the Window." *Miriam Schaer,* www. miriamschaer.com/the-key-is-in-the-window/ Accessed 28 July 2019.

Schaer, Miriam. *The Presence of Their Absence.* Ariadne's Thread. 2015.

Schaer, Miriam. *The Presence of Their Absence: The Portraits.* 2013, Portrait Portfolio.

Schaer, Miriam. *(W)hole: A Life in Parts.* Ariadne's Thread. 2017.

Shimo, Alexandra. "It's Not a Doll. It's a Baby. You Don't 'Buy' a Reborn. You Adopt One. For some Women, 'It Fills a Void.'" *Maclean's,* 2008, archive.macleans.ca/article/2008/4/7/its-not-a-doll-its-a-baby. Accessed 28 July 2019.

Tsigdinos, Pamela Mahoney. "Identity Lost and Found After Infertility and Failed IVF." *Silent Sorority: Infertility Survivors Finally Heard,* 3 Feb. 2017, blog.silentsorority.com/identity/. Accessed 28 July 2019.

Tsigdinos, Pamela Mahoney. "Please Hold for the Children." *Coming to Terms: Barren and Beautiful,* 1 Oct. 2007. www.coming2terms.com /2007/10/01/please-hold-for-the-children/ 17 May 2017.

Tsigdinos, Pamela Mahoney. *Silent Sorority: A (Barren) Woman Gets Busy, Angry, Lost and Found.* Book Surge, 2009.

Tsigdinos, Pamela Mahoney. "Struggling to Accept a Life Without Children: Patient Voices: Infertility." *The New York Times,* 10 June 2008, www.nytimes.com/2008/06/10/health/10pati.html. Accessed 28 July 2019.

Tuttle, Elaine Hanson. "A Sketch in Progress: Introducing the Mother without Child." *Maternal Theory: Essential Readings,* edited by Andrea O'Reilly, Demeter Press, 2007, pp. 431-59.

Zoll, Miriam. *Cracked Open: Liberty, Fertility, and the Pursuit of High Tech Babies.* Interlink Publishing. Kindle Edition. 2013.

Zoll, Miriam, and Pamela Tsigdinos. "Selling the Fantasy of Fertility." *The New York Times,* 11 Sept. 2013, www.nytimes.com/2013/09/12/ opinion/selling-the-fantasy-of-fertility.html. Accessed 28 July 2019.

Chapter Four

The Artistic Practice of Micol Hebron: Provoking a Performative Heuristics of the Maternal Body

Tina Kinsella

Art, Eroticization, and the Female Breast

THIS IS A MALE NIPPLE:

If you are going to post pictures of topless women, please use this acceptable male nipple template to to cover over the unacceptable female nipples.

(Simply Cut, Resize and Paste)

THANK YOU FOR HELPING TO MAKE THE WORLD A SAFER PLACE.

Figure 1. Micol Hebron's *Male Nipple Pasty* (2014)

In *Feminist Art and the Maternal* (2009), Andrea Liss observes that the maternal body is "most cruelly posed at the intersection of the visible and the invisible, the public and the intimate" (xviii). Perhaps of all Micol Hebron's works, the male nipple project (Fig. 1) speaks most directly to these social and cultural prohibitions enacted upon and through the maternal body. In June 2014, Hebron posted a simple digital pasty of a male nipple to her Facebook page with the following comment: "Here you go – you can use this to make any photo of a topless woman acceptable for the interwebs! Use this 'acceptable (male) nipple template,' duplicate, resize and paste as needed to cover the offending female nipples, with socially acceptable male nipples (like a digital pasty). You're welcome." ("Exclusive"). It was a year before the pasty went viral to become an Internet sensation with women using Hebron's male nipple on their social media accounts to draw attention to the double standards pertaining to social networks' policies on nudity. An article in *The Huffington Post* by Rachel Moss reports that Facebook updated its nudity policy in 2015 to include the posting of "Brelfies" (breastfeeding selfies). The images then allowed were of "actively" breastfeeding mothers whose child is "latched on," thereby not showing the mother's nipple, as well as photographs of post-mastectomy breasts, where the nipple has been surgically removed (Moss).[1] The result of these social media network policies was that the real-life female nipple was effectively prohibited from visibility on these social media networks.

Although Facebook has recently updated its community standards policy to include uncovered female nipples in the context of "breast-feeding, birth giving and after-birth moments" ("Community Standards"), it is unclear whether Instagram's policy, which permits "women actively breastfeeding," can display uncovered nipples in this context ("Community Guidelines").[2] At the same time, such social media sites permit the distribution of images of female nudes from the art history canon with their female nipples clearly visible. Indeed, art history abounds with images of lactating women with their nipples on display: The Renaissance Madonna offers the maternal breast to the infant Jesus; breastfeeding mothers of the new bourgeois class are prevalent in postrevolutionary French painting; and Mary Cassatt produced many intimate portrayals of the maternal sphere at the turn of the twentieth century. These images, some of which may seem subversive from a contemporary perspective, suggest that within a

historical context, the act of breastfeeding was considered an entirely natural phenomenon. Not only does Hebron's digital pasty of a male nipple invite us to consider the present-day governmental practices that produce the contemporary sociocultural anxiety surrounding breast-feeding in public in many Western societies, it also highlights the ways in which social media networks police images of the female nipple. It appears that women's breasts are not the problem; rather, it is the visible maternal nipple itself that is still taboo.

Soon after Hebron disseminated her male nipple project, articles appeared in media outlets such as *Hyperallergic*, the *Huffington Post*, and *BuzzFeed* referencing the multiple ways in which social media users had deployed the digital pasty to subversive effect. Subsequently, a slew of features appeared online laden with historical representations of women breastfeeding. One article brought together a collection of photographs of mothers breastfeeding in public during the first half of the twentieth century, thereby suggesting that the semiotic and signifying processes that link the breastfeeding nipple to an erotic economy is a relatively recent one. The images were captioned with titles such as the following: *A Mother Feeding Her Baby at a Chattanooga Bus Stop—1943*; *A Mother Feeding Her Baby at the Beach—1930s, Depression-era Breastfeeding*; *French Mothers in Paris Doctors Waiting Room—1946*; and even *Breastfeeding on Sesame Street—1977* (Southern Disposition). All these photographs showed women comfortably breastfeeding their babies in public environments without undue attention from passersby.

Figure 2. *Breastfeeding at an Outdoor Meeting*

A particularly memorable image in the montage entitled *Breastfeeding at an Outdoor Meeting* (Fig. 2), shows two women seated in front of a group of men in an open-air setting. One of the women sits casually with her blouse wide open, and her breast is clearly exposed; a child, who is certainly not an infant, is nonchalantly semi-latched-on. The two women and all the men look into the distance and smile; they are possibly at some community event that they are all interested in observing. Nobody looks at the breastfeeding woman. The tagline to the photograph satirically reads, "Look at all those men ... they're having a hard time controlling themselves," which highlights the contemporary ideological double bind that eroticizes the female breast through hyper-visualization while simultaneously banishing the maternal nipple from visibility. Nowadays, the breastfeeding mother is largely invisible in popular culture and is certainly unacceptable under any terms of reference to female sexuality. Although lactation is one evident indicator of sexual maturity, the breastfeeding mother usually appears as a part of the iconography that equates women with having a natural propensity for motherhood simply because of her biological capacity. Most female breasts, small or large, are quite soft, and the only time they resemble the hardened form—often surgically enhanced for the purposes of pornographic imagery—is when they are full with milk. Therefore, it is ironic that the breast, which is so privileged for viewing pleasure, is so entirely disassociated from one of its main functions: breastfeeding. Hebron argues the following:

> When there are restrictions imposed upon women's bodies, as with the nudity clauses on Facebook or Instagram, what we are doing, implicitly, is admitting that we sexualize and objectify women's bodies and that they are "dangerous" and therefore must be controlled, limited and regulated. Male bodies are not managed in this way. And, with each act of censorship, the female body is problematized even further (qtd. in Hanson).

An article by Priscilla Frank in *The Huffington Post* entitled "The Nipples of Art History Get an Instagram-Friendly Makeover" features Hebron's male nipple pasted over the breasts on display in an array of canonical artworks—including Titian's *Venus of Urbino* (1538), Rembrandt's *Bathsheba at Her Bath* (1654), Francisco Goya's *La Maja Desnuda* (1800), Edouard Manet's *Olympia* (1863), Pablo Picasso's *Les demoiselles*

d'Avignon (1907), and Amedeo Modigliani's *Red Nude* (1917). The text accompanying these images (Figs. 3, 4) with the *Male Nipple Pasty* reads as follows: "Behold, for your viewing pleasure, art history made kosher for the Internet police, thanks to a few handy pasties. Share the images below as you please on your social media channels. They're just harmless male teats!" (qtd. in Frank).

Figure 3. Titian's *Venus of Urbino* (1538) with Hebron's *Male Nipple Digital Pasty*

Figure 4. Amedeo Modigliani's *Red Nude* (1917) with Hebron's *Male Nipple Digital Pasty*

Every image chosen for the nipple pasty treatment features a female nude painted or photographed by a male artist. Not only does this particular use of Hebron's *Male Nipple Pasty* draw our attention to those sociocultural norms governing how the male and female body are made visible and allowed access to visibility in differential ways, it also provokes reflection on how women's breasts are objectified and, thereby, eroticized in artistic media, visual culture, and Western societies more broadly considered. As Alyce Mahon observes, masculinity is associated with the principles of logic, rationality, linearity, solidity, and contemplation. These masculine principles are poised against and privileged above such characteristics as "emotionality, irrationality, fluidity and sensorial pleasure," which are perceived as feminine and deemed to be "natural, sensual, and attractive," yet are still understood as in need of control "through masculine reason in the name of civilization" (Mahon 40). Mahon argues that in Western art, these gendered polarities create their own "erotic frisson" (40) by situating the (male) artist as mediator between culture and nature (woman). In this way, as Lynda Nead suggests, through the genre of the nude, artistic form contains and controls the actual leaky female naked body that otherwise constantly threatens to transgress its corporeal boundaries. Nead concludes that although the female nude is suggestive of a certain eroticism, it nevertheless remains a signifier for a safe, nontransgressive form of female sexuality. Placed upon these female nudes, Hebron's *Male Nipple Pasty* emphasizes the dynamic between the eroticization of the female body through artistic media and the perceived feminine passivity of the maternal body. The genre of the nude eviscerates the sexuality and desire of the female subject who is represented as object through artistic mediation acquiesces to the projected desires of the viewer. In this way, the placement of Hebron's *Male Nipple Pasty* onto canonical paintings of the female nude makes visible the heterosexual and heteronormative operation of the desirous male gaze within art history. Placing the pasty onto the painted breasts of iconic female nudes can also be considered a feminist device that satirizes the social dynamics within which femininity is produced and represented by a culture that singularly privileges an economy of male creativity, desire, and inspiration.

Similarly, the images of breastfeeding mothers that populate the canon of art history reflect and perpetuate this dynamic between the

active male viewing subject and the supposed passivity of the viewed female object. Such images depict a serene mother and child engaged in a mutually satisfying act that suggests that the act of breastfeeding is not only a natural phenomenon but a comfortable and easy task. However, as Liss observes, even though "breastfeeding is one of the most intersubjective acts performed between mother and child" (74), it is not always an easily accomplished task for any or all mothers. For many women, the physical act of breastfeeding requires sustained effort and considerable discomfort, which can produce feelings of inadequacy.

In addition to these already existing pressures, within a present-day context, stories emerge almost daily of women being shamed for breastfeeding in public. Although the breastfeeding woman forms no part of the acceptable popular cultural repertoire for the sign of sex, when she does appear, her lactation processes are reformulated and fetishized to form part of the marginal content of certain fetish porn-ography images. In this way, the signifying and semiotic practices and processes that culturally mediate the act of breastfeeding produce entirely mixed messages. As the maternal body complicates discrete distinctions between the private and public sphere, so do social media sites, and people's relationship to and use of such networks similarly breach divisions between intimate and communal zones. Being a digital tool deployed through these social media forums, Hebron's *Male Nipple Pasty* draws our attention to what is and is not allowed to be seen in the public and private domain, thereby placing in contention what belongs our contemporary sociocultural visual landscapes.

Heuristic Performativity and the Maternal Body in Hebron's Artistic Practice

Deriving from the Ancient Greek "εὑρίσκω," the word "heuristic" means to find or discover new knowledge through flexible, practical, and experiential processes rather than through precise, algorithmic, and scientific methods. Finding connections between things that already exist or that one already knows, a heuristic methodology allows us to see familiar things differently by way of an appeal to noncognitive modes of understanding. Revealing the hegemonic signifying and semiotic processes the maternal body is subject to, Hebron's *Male*

97

Nipple Pasty is a heuristic solicitation that asks us to reconsider the ways in which the maternal body is visually mediated and represented. Such a heuristic approach to artistic practice relies upon the agential capacity that Judith Butler affords the body with her theory of gender performativity. Butler's theory suggests that the sexed and gendered body is a contingent locus that is culturally, socially, and discursively constructed by way of repetitive, stylized acts that take place in time. Although the temporal repetition of these acts seems to lend a natural, ontological cohesion to the body, Butler suggests that the very fact that these sociocultural norms are continually reproduced through such stylized corporeal acts is evidence of the instability of said norms. Hebron's simple pasty of a male nipple surfaces and reframes the complex sociocultural discourses and historical signifying processes within which the female breast and the breastfeeding maternal body, most particularly, are situated. Reframing the ideological and conceptual constraints that are imposed upon the maternal body, the digital production and dissemination of the pasty provokes a performative heuristics of the maternal body by experientially revealing that these ideological and conceptual norms are in fact contingent. This performative, heuristic move enables the viewer or user of the digital pasty to participate in the generation of new knowledge about the politics of visual representation that the maternal corpus is subject to. This analysis of the heuristic and performative methodology provoked by the pasty provides a generative context for the following discussion of an earlier work by Hebron, *Incubo* (1997), which also draws upon the signifying capacities and semiotics of the maternal body in various ways.

Figure 5. Micol Hebron's *Incubo* (1997)

Incubo was a multimedia work incorporating video, installation, and performance; it aimed, according to Hebron, to comment on "domestic space, the creative process, and my role as a female artist as an analogy for women's roles in society (mother, nurturer, sex object, etc.)" ("*Incubo*," 1997). For this piece, Hebron's art studio was stylized to represent a stark, domestic interior with particular reference to the kitchen through the use of white linoleum, yellow walls, and "neat white moulding board at the base of the walls" ("*Incubo*," 1997). The colour chosen by Hebron for the walls referenced Sigmund Freud's proposition that yellow was the colour of hysteria. Of course, the colour yellow had already been linked to hysteria in Charlotte Perkins Gilman's short novel *The Yellow Wallpaper* (1899), which provides a literary chronicle for postpartum psychosis induced by confinement following a pregnancy.

The title *Incubo* makes etymological reference to both the noun incubus and the verb incubate, thus referencing a proper name for something and an act of doing. "Incubate" derives from the Latin *"incubates"* (the past participle of *"incubare"*), meaning to "to lie upon" or "to brood," which that shaped the common usage of the term "incubation" from the seventeenth century, which meant "to hatch," "to lie on," or "to rest on"; it was understood quite literally to mean "to sit upon eggs" ("Incubate"). In the thirteenth-century, Augustine used "incubus" with reference to the Latin *"incubo"* to refer to a "nightmare" or to "one who lies down on (the sleeper)"—an "imaginary being or demon, credited with causing nightmares," who in male form "consorts with women in their sleep" ("Incubus"). The resonance between the etymological complexity of the title of this piece and Hebron's staging of the performance is clear. Shelves distributed around Hebron's studio displayed two televisions on which a video loop played. One television showed a series of hands holding an egg being punctured by a pin and the other monitor showed two hands holding an egg up to a mouth and blowing the contents contained in the shell out of a small hole. In the middle of the room, Hebron constructed the following:

> ... a large nest of scrap metal. The nest was approximately 7 feet across and 5 feet deep, and it was suspended from the ceiling. The inside of the nest was lined with feathers, and I lay in it, naked, for the duration of the show (2 days). There were plastic tubes that ran throughout the nest and into and out of every orifice of my body (ears, nose, mouth, anus, vagina). ("*Incubo*, 1997")

Hebron's fabricated nest also references the incubators that preterm or sickly newborn babies are placed into; these technological apparatuses recreate an artificial nurturing environment for the infant as a stand-in for the maternal womb. By situating herself in this nest, Hebron effectively resituates herself in the womb, and in this way, the tubes going in and out of her body reference the sustaining materiality of the mother's body as well as the artist's subsequent and continued corporeal displacement from it. As Hebron directs our attention to the absent maternal corpus, the maternal body is evoked as an intangible presence. The womblike nest that Hebron both situates and presents

herself to the viewer in disturbs any concrete division installed between private and public space. Crossing over the porous thresholds of Hebron's prone body, the tubes remind us of the feeding and monitoring devices inserted into those babies placed into incubators within a medical setting. The looping videos displayed on the TV monitors of eggs being punctured recall Liss's remarks about the boundaries of visibility and invisibility that the maternal body is entirely poised over. The needle inserted into and out of the eggs as well as the mouths breathing the contents of the egg through a hole also provoke the outside-inside dynamic that the plane of visibility produces.

Hebron's decision to situate *Incubo* in a fabricated domestic setting within her own art studio also draws our attention to the complicated, impossible division that has been historically constructed between femininity and creativity. Griselda Pollock has argued the following:

> All of us are already possessed by the culture within which we live, have been trained and educated, and practise as cultural analysts. We become "personal" with implanted ideas and beliefs. We are trained to see canonically, and may ... speak with a borrowed voice, not even knowing what we do, and from whom the voice is borrowed. (156)

She thus notes "the fears and conflicts that assail those who have tried to conjoin creativity and femininity within patriarchal culture" (156). Hebron's *Incubo* does not seek to resolve this impasse; rather, it presents us with an ideological context for the prohibition of joining creativity and femininity by which the feminine is put on the side of nature (reproductive capacity) and the masculine on the side of culture (artistic creativity). As Sherry B. Ortner has argued, due to their proximity to bodily processes, such as lactation and breastfeeding, female subjects are perceived as closer to nature and thereby in opposition to culture:

> Since it is in direct relation to a particular pregnancy with a particular child that the mother's body goes through its lactation processes, the nursing relationship between mother and child is seen as a "natural" bond and all other feeding arrangements as unnatural and makeshift. Mothers and their children, culture seems to feel, belong together. (77)

In this way, "woman's confinement to the domestic family context" is considered a "natural" extension of her "lactation processes" (Ortner 77). Liss suggests that the taboos brought to bear on the matter of the mother continue because notions of motherhood and femininity are "still laden with assumptions of naturalness and passivity" (xvii). This signifying chain that situates woman on the side of nature, passivity, and receptivity also links her to the domestic sphere by virtue of her reproductive capacity. However, this signifying chain that points towards the maternal body elides the fact that breastfeeding is both an act of maternal care and a form of female labour that by being confined to the domestic sphere, is made invisible. Physical, social, and cultural limitations are placed on the role of women by the imposed signifying assignation between nature, the maternal body, and the domestic sphere. The domestic domain is thus posed as woman's natural habitat in which the intimate acts of pregnancy, childbirthing, and breast-feeding should privately take place. Silvia Federici argues that women's reproductive labour has long been exploited by the systems of governmentality that operate through capitalist economy and the state:

> ... by denying women control over their bodies, the state deprived them of the most fundamental condition for physical and psychological integrity and degraded maternity to the status of forced labor, in addition to confining women to procreate against their will or (as a feminist song from the 1970s had it) forcing them to "produce children for the state," only in part defined women's function in the new sexual division of labor. (92)

According to Federici, "women's history" is "class history" (14) because of the mechanisms of control that have traditionally been asserted over the reproductive body. Terminology that directs the "'female biologic role'" towards "the physiological completion of the reproductive cycle" fails to acknowledge that processes of reproduction and its attendant labour are "nevertheless culturally embedded" (Hausman 77). Hebron's *Incubo* makes visible the domestic space as a place of labour and artistic endeavour. Performing the ideological contexts within which the maternal body is situated from within her own studio, Hebron shines a spotlight on the social and historical context within which the maternal body has been culturally embedded and is thereby elaborated. Her work corresponds with the investigation

into the politics of representation undertaken by performance artists of the 1960s and 1970s who interrogated the sociocultural processes framing the sexed and gendered body in the art history canon. In an iterative manner, Hebron's *Incubo* places the maternal body as a privileged locus, which reveals the signifying and semiotic practices and processes that produce a sexed and gendered body in the visual sphere.

As with the *Male Nipple Pasty*, *Incubo* can also be considered as an artistic practice that provokes a performative heuristic approach to the politics of representation as well as the economies of labour within which the maternal body is situated. Reinvigorating the circuits of desire informing our collective imaginaries, shaping the production of subjectivity, and producing possibilities for agency, the *Male Nipple Digital Pasty* and *Incubo* not only open up "the circuits of desire informing artistic production and reception" (Jones 5), but they also surface the corporeal effects of these desirous circuits by making visible the discursive and ideological constraints that have historically affected the maternal body. By way of an appeal to the maternal body that previously has been situated as a site of paltry knowledge and limited experience, both the *Male Nipple Pasty* and *Incubo* evoke potentially transformative effects by revealing the maternal body as an unstable locus capable of resisting systemic prohibition and structural regulation. Reshuffling and rebooting the signifying and semiotic economies to which the maternal body is subject, these works enact a pragmatic heuristic model of performative knowledge generation through the mode of interactive encounter, which allows viewers (as participants) to learn something for themselves. In so doing, Hebron's *Male Nipple Pasty* and her performance work *Incubo* reframe the complex sociocultural discourses and historical signifying processes within which the breastfeeding body and the maternal body are situated. Being uneasily poised at the juncture over which the boundaries between the visible and invisible as well as the public and private are both instituted and invigilated, Hebron's *Male Nipple Pasty* and *Incubo* deploy performative devices that heuristically reveal the maternal body as the very site at which sociocultural taboos and prohibitions are regulated.

Endnotes

1. Facebook initially changed its guidelines to allow images of women actively breastfeeding in 2014, with Instagram following suit in 2015.

2. Facebook also allows images of female nipples for "health-related situations (for example, post-mastectomy, breast cancer awareness or gender confirmation surgery or an act of protest" ("Community Standards"), and Instagram currently states that "some photos of female nipples" are acceptable including "photos of post-mastectomy scarring" as well as women actively breastfeeding ("Community Guidelines").

Works Cited

Butler, Judith. *Gender Trouble*. Routledge, 1990.

Butler, Judith. *Bodies That Matter: On the Discursive Limits of Sex*. Routledge, 1993.

Butler, Judith. *Undoing Gender*. Routledge, 2004.

"Community Guidelines" *Instagram*, 2019, help.instagram.com /477434105621119/. Accessed 28 July 2019.

"Community Standards" *Facebook*, 2019, m.facebook.com/community standards/adult_nudity_sexual_activity/. Accessed 28 July 2019.

Hanson, Brittany. "Male Nipple Template to FreeTheNipple and Micol Hebron Go Viral." *Chapman,* 22 July 2019, /blogs.chapman.edu/ happenings/2015/07/22/male-nipple-template-to-freethenipple- and-micol-hebron-go-viral/. Accessed 28 July 2019.

"Exclusive: 'Male Nipple Template' Takes on Social Media Sexism." *Milk xyz*, 2019, milk.xyz/articles/4115-Exclusive-Male-Nipple- Template-Takes-On-Social-Media-Sexism/. Accessed 15 Aug. 2019.

Hausman, Bernice, L. *Mother's Milk: Breastfeeding Controversies in American Culture*. Routledge, 2003.

"Incubate." *Etymonline*, 2019, www.etymonline.com/word/incubate. Accessed 15 Aug. 2019.

"*Incubo, 1997*." Michol Hebron, 2016, micolhebron.artcodeinc.com/ pages/incubo-1997/. Accessed 28 July 2019.

"Incubus." Etymonline, 2019, www.etymonline.com/word/incubus. Accessed 15 Aug. 2019.

Jones, Amelia. *Body Art/Performing the Subject*. University of Minnesota Press, 1998.

Liss, Andrea. *Feminist Art & the Maternal*. University of Minnesota Press, 2009.

Moss, Rachel. "Facebook Clarifies Nudity Policy: Breastfeeding Photos Are Allowed (As Long as You Can't See Any Nipples)." The Huffington Post, 16 Mar 2015, www.huffingtonpost.co.uk /2015/ 03/16/breastfeeding-facebook-nudity-policy_n_6877208.html. Accessed 28 July 2019.

Nead, Lynda. *The Female Nude: Art, Obscenity and Sexuality*. Routledge, 1992.

Ortner, Sherry, B. "Is Female to Male as Nature is to Culture?" *Woman, Culture and Society*, edited by M. Z. Rosaldo and L. Lamphere. Stanford University Press, 1974, pp. 68-87.

Pollock, Griselda. *Differencing the Canon: Feminist Desire and the Writing of Art's Histories*. Routledge, 1999.

Southern Disposition. "25 Historical Images that Normalize Breastfeeding." *Buzzfeed*, 2 Feb. 2014. www.buzzfeed.com/southern disposition/25-historical-images-that-normalize-breastfeeding-jlw6? utm_term=.wiQ9GayMB#.mp9VjMg6e. Accessed 28 July 2019.

Chapter Five

The Motherbody Model: An Invitation for a Care-Based Work Ethic

Shira Richter

D ear friends and colleagues, art world, and work world: There is
an alternative ethics to being in the work world—for artists,
for women, for mothers, and for all of us, really. Over the
course of two decades of studying the socioeconomic, political, cultural,
and evolutionary status of the maternal—while working on my own as
well as working with others, caring for children, family, partners and
elders, friends, animals, and even plants, and devoting time for the
environment, social causes, muse, soul and spirit—I have experienced
how this conscious care practice is both misunderstood and missing in
the human-made structures of society and economics. Like many of us,
I have come to realize that our current work ethics are neither healthy
nor sustainable, so, I propose we try the motherbody model.[1]

I offer this as a simplified (but not simple) version of cooperation
because our mother tongue, before words, is visual (Shlain 45).
Hence, the motherbody could function as a symbol or metaphor, which
is needed in order to remember complex ideas. The maternal body is
useful because it embodies knowledge about our basic and shared
human dependency, connectivity, vulnerability, and diversity. Instead
of casting the motherbody aside in the name of professionalism, or
hiding the Mother Hole in our CV's (the part in our work experience
that is unpaid mother/care -work), we can reinstate it as representative
of experience-based knowledge. Some would call that sustainability,

but the word sustainability, which has recently become fashionable (which is a good thing!), is a bit abstract and usually implies ecological sustainability and rarely touches on the complex ways of relational caring that go into creating, producing, and growing one's own "private" family tree.

What does this body tell us? Well, contrary to the popular axiom stating the aloneness of a human's entrance into the world (manifested in phrases such as "we are born alone; we die alone" [Jordan 47]), we *do not* come into this world unaccompanied but fully escorted and enveloped by a female body.[2] This is important. We tend to forget this and romanticize the tragic solitary journey of human existence. And since the words "woman" and "mother" are recently being erased from texts about pregnancy and labour and replaced with such words as "pregnant individual,"[3] this needs to be repeated: we all enter this world through the female biological body:

> I remember sitting there, after having these two people come out of my body, this new life, with my body all wrecked and exhausted, hurting and bleeding, seeing all these people around me. I was thinking—He came out of the body of a woman, he came out of the body of a woman, so did he—and suddenly you realize that the whole of humanity came out from between your legs. (Richter, "Mama"; see also Ettinger, "(M)Other Re-spect" 10)

Secondly, it takes two biological sexes—male and female—to create a new human, whose birth is the result of thousands of genes from generations of ancestors; it is kind of difficult to use the word "I" while knowing how many people live on inside of you, isn't it?

Cooperative Relationships Ground this Creation

Our wellbeing is inseparable from the other's wellbeing. (Notice the pronoun "we" inside the word "well.") For instance, pregnant mothers are monitored because their behaviour influences the fetus's health. And guess what? A fetus, as well as a baby and child, influence the mother's health as well. The mother does not exist in a vacuum either: she is embedded in an environment, influenced by it, and reacts to it. This fascinating mutual co-dependency—or co-emergence, as Bracha Ettinger calls it ("Matrixial Trans-Subjectivity" 218)—does not stop at

a mother-child relationship; many parents have witnessed how even one distressed child or person can wreak havoc on the lives of many others. So instead of individualizing and privatizing pain (or joy, or success) how about we treat it as communal pain (or success) and thus- as communal responsibility (or achievement).

"Self-help" and "self-care" are prescribed as the remedies for so much suffering, but it is now becoming known that human evolution is anchored in communal and relational caring practices that treat the individual as part of a bigger network; Sarah Blaffer Hrdy calls this "to care and to share is to survive" (11). Privatizing and personalizing care remedies—or focusing on the individual (like in classic private psy-chology practice) without taking into account the larger sociopolitical, economic, and gender context—merely disguises the innate lack of communal responsibility and care in the foundations and systems of our cultures. Our deep yearning for this "brand" of belonging can be seen in the way businesses, organizations, and politicians try to make themselves attractive by branding themselves as "a family" (also in the case of the Israeli military) or as supporting family values. However, close scrutiny of these so-called families expose a contradiction be-tween the actual practices employed in the work world and the values we try to incorporate in our family life.[4]

This Motherbody Is Not Just a Pretty Body. She Also Has a Brain!

Neurologists have discovered that women's brains are rewired (Re-modelled?) when we cross the big divide from woman to mother. Although some prefer to stress the similarities between the male and female brain (Joel and Fine), those who focus on the mother brain state that "motherhood brings the most dramatic brain changes of a woman's life" and argue that science has neglected the mother brain (Conaboy). Changes of this scope do not occur in a male/father brain; thus, "mommy brain fog," which is feared by many women and seen as a sign of malfunctioning, is actually a major rebooting of our brains for the task ahead. Our brain does not stop thinking; it is just occupied with thinking about other things.[5] Even though Kate Moses's revolutionary book *Mothers Who Think* was published in 1999, Conaboy's article from 2018 demonstrates how doctors are still reluctant to disclose information

about the vast changes that a mother's brain undergoes. Their reasoning for withholding this information implies it will hurt women in some way,[6] but I believe this information is a key to understanding the fascinating care capacities developed by a mother-body.

Animal researchers have recently discovered that female mother deer react to the cries of several different mammal offspring, as their care is not exclusive to their own species. According to Susan Lingle and Tobias Riede, "mule deer and white-tailed deer will respond to the distress calls of babies outside their own species, including humans, as long as those cries fall within the same frequency range as young deer" (qtd. in Zielinski). Also, the discovery of microchimerism—how a motherbody keeps and stores the DNA of her children in her own body (Rowland)—expands the notion of our connectivity. This remodels the mother as a kind of remote control "app" and could explain the eerie intuitions some mothers experience when something happens to their child, even from afar. Hence, the hard wiring of maternal care is finally being treated as a subject worthy of serious investigation, and not only as a cultural construction.[7]

Yet cultures and workplaces continue to deem a mother's knowledge inappropriate and marginal, an obstacle to overcome rather than a treasure to invest in and to investigate. But this knowledge can and should be used in the work world: it can strengthen relationships and build people up, instead of tearing them down in the name of competition.

Here is an example of how the systems separate us: a couple transitioning into parenthood goes through one of life's biggest and most demanding changes, and this unit needs a lot of support and assistance. The two, who have connected as a couple for the precise purpose of being there for each other, must disconnect at the exact time when they need to be together more than ever. In Israel, after the birth of a single child, the father/partner receives only a week off, which is deducted from his rights to sick leave. (In the case of twins, he is entitled to two weeks.) However, instead of receiving a substantial time off work to nurse and care for his new identity and relational dynamics, the father or partner expands his work hours in order to support the unit economically (Gafni and Siniver). The woman, healing from childbirth, needs all her energy for breastfeeding (or breast-healing) and infant caregiving; instead, she is condemned to sleep deprivation, isolation, and exclusion from her partner and from the public, adult, and formal

world of work. When or if the mother reenters the world of paid labour, she depends on many other women, or "Allo parents" as evolutionary psychologist Blaffer Hrdy calls them. Sometimes these other women, who care for our children (or parents), have left their own children in order to be paid to care for ours.[8] Because, as Marilyn Waring's work has taught us, managing and sustaining one's own household and family is of little or no importance in economic terms. This is what the capitalist economy forces upon us: division and separation at the exact time togetherness is most required. I call this **A Divisive Economy.**[9]

How do we define success? Mothers say that each child is a world of its own. As a mother of twins, I have experienced how two babies of the same gender, born from the same woman at the same time, differ from each other as much as two people born into two different families; they have different growth rhythms, personalities, talents, and needs (Rich Harris). Whereas any gardener will tell you that each plant, like each child, needs its own specific growing grounds and environmental conditions, and grows at its own pace, as an artist and academic I see that our one-size-fits-all definition of success does not allow for real diversity.

In the art world, not unlike the academic and business world, success usually means **MORE**: more money, more new material, more "likes", more academic papers and books, and more solo exhibitions (Pilling; Waring). Cooperating with the demand for more in order to be valued means that we have swallowed the greed pill at the expense of the meaning pill. The economic world disguises this greed with the word "growth" because a good economy is one with a very specific growth pattern, characterized by higher numbers, and more of them.

I meet this greed and demand for more all the time, and it produces a ranking system that creates division and pain. However, the motherbody model offers other possibilities for the art world. The art market is based on a rigid star system. As art school students, we learn individualism and to value solo studio practice above collaboration; in effect, we learn to aspire to stardom. A star system operates in contrast to a collaborative system, in which there is no star. How can I, a feminist artist and activist, enjoy my stardom if it excludes most of the women artists around me? How can I ignore this?

I prefer a system in which *the relationship* is the star; in which we aim to strengthen connectivity and diminish competitiveness. How

can we do that? By looking at our families. For instance, encouraging our children to compete against each other is not considered good parenting; in fact, some cultures believe that twins are a godly omen, and the health of the entire community depends on treating them equally (Estés 86; Adewumi). So why is competition considered a good policy in the art or business world?

Although the Internet is full of memes, articles, and videos teaching us that "happiness is not caring what others think of you," how does one do this in an art world that asks for a CV, which is actually a list of what *others* think of you? An artist's CV indicates which gallery exhibited your work, which acknowledged curator or academic wrote about your work, or even which wealthy collector paid money for your work. It continues with which institution educated you, or gave you a grant, which art magazine featured your work, and so on. In effect, a CV is a name-dropping list. Furthermore, the star system hierarchy displays its preference in the tradition of listing solo shows before group shows. And, of course, a CV should never include information about your mothering and parenting work.[10] This is so ingrained in us that even at feminist and maternal studies academic conferences, very few presenters (including me!) mention their parental status when introducing themselves.

Motherbody consciousness comes when we—humans, artists, women, and mothers—understand, collectively, that we have swallowed the bait of capitalism and internalized the mechanisms of our dominant competitive and hierarchical cultures, without realizing how they hurt, divide, exclude, devalue and isolate many of us. In order to defy this, we can define and perform everyday practices based on what the motherbody teaches us.

But first, I would like to address the common misconception that the focus on mothering and mothers is too essentialist, meaning that it implies women should go back to being caregivers and mothers and leave the competitive work force, or that women are natural nurturers, or that competition is inherently bad. No, this is not what I mean. I mean that work force ethics and values need to change. If you do not agree, think about your own children for a moment: what kind of work world do you want them to encounter? A winner-takes-all economy (Frank and Cook)?

We do not need more women forcing themselves to be like men, which is what I see in neoliberal feminism. This only strengthens the competitive work culture. What we need are institutional laws and

people from the formal work force that will incorporate more ethical practices in the work place. For this purpose, the motherbody is a symbol that embodies "true north."[11]

Thus, rather than relegating maternal knowledge and experience to the sleepy suburbs or devising ways to omit mothering and parenting work from a CV or deeming it inappropriate, I suggest the motherbody be our compass: a symbol that serves as a beacon, a lighthouse, and as a physical and visual reminder to reconsider our practices and their connection (or disconnection) to our values, because, as it turns out, we tend to forget. It's not our fault; the infrastructure of everyday institutional behaviour is infused with these divisive practices that throw dust in our eyes. We are coerced into what I call speaking "boxish," a term I use for institutional and corporate ethics:

> Anyone who works in an institution needs to know that although s/he wakes up as a human being, and kisses his/her children as a mother/father/parent, and her/his partner as a wo/man, the moment s/he enters an institution s/he becomes the institution and a collaborator of the institution, and a prisoner of the institution who executes the priorities of the institution in which children, humanity, friendship, family values, warmth and care, equality and mutual responsibility, solidarity and compassion—are of a lower priority and value. And s/he doesn't notice how she isn't speaking English or Hebrew anymore, she's speaking—BOXISH, and seeing boxish, and even thinking—boxish. (Richter, "Speaking Boxish")[12]

In order to counter this, let us remember the words written by one of America's Mother Day initiators, Julia Ward Howe, in her initial Mother's Day proclamation. I invoke her antiwar spirit because I live in a conflict zone and believe that a conscious Mother challenges war, the infrastructure of the most divisive competitive practice of all:

> For too long the ambition of rulers has been allowed to barter the dear interests of *domestic life* for the bloody exchanges of the battlefield.... But women need no longer be made party to proceedings which fill the globe with grief and horror.... My dream was of a mighty and august congress of mothers which should constitute a new point of departure for the regeneration of society by *the elimination of the selfish and brutal elements which lead to war and bloodshed.* (Howe 148-149, my emphasis)

From Performance Lecture "*Conscious Mother/Care-work challenges the infrastructure of war*" Presented at the Foreign ministry of Berlin (2018) for the Canaan Conference 1325 accord.

The Motherbody Model—Practical Actions for Creating Solidarity

I suggest the following motherbody proclamations as an invitation to adjust our everyday thinking and doing, to nurture relationships over stardom, and to value human growth over the greedy growth of the economy—in short, to put our so-called money where our family value mouth is:

- When the world says that the knowledge of women, mothers, othermothers, and caretakers is not worthy or valuable, we include and value it.

- When the world says mothers are to be marginalized, we put them front and centre.

- When the world says mothers can and should do it alone, we say mothers and parents cannot, and argue that they need support from each other, from larger family units, and from society.

- When the world says women do not support one another, we choose to support one another.
- When the world says not to pay artists, we find ways to pay them.
- When the world says not to support a person or artist because of the politics of the nation she happens to live in, we support her and realize that she suffers from the politics as well. The more we empower her, the stronger she will feel in her own culture and keep working for transformation and change. [13]
- When the world says more is better, we say, meaning and relationships are better.
- When the world says use professional jargon, we say we prefer clarity and understanding over academic terms only a few understand. Art world and academic jargon can alienate or seem condescending to people who come from other disciplines; thus, important knowledge does not reach the wider community.
- When the world says we are being naive or too optimistic, we say maybe, but we have put this disposition into practice and have experienced its power. [14]
- When the world says you are only valuable if you earn money or are famous, we say that we try to value, appreciate, and notice every being we meet. Yes, this means slowing down. This means practicing mindfulness.
- When the world says you can only cite academics or famous people, we cite the people who have inspired us. Precisely because women's knowledge has been discredited, devalued, and stolen for so many centuries, we will make an effort to quote our mothers, daughters, sisters, brothers, and friends. [15]
- When the world demands success and leadership, we challenge how those terms are defined.
- When the art world says young is better, we show how hollow this notion is, as famous dead male white European artists are still getting most of the recognition and spotlight. Succeeding generations need one another and depend upon one another.
- When the world says that mothers who perform unpaid work have nothing to write in their CV, we say mothers have valuable life experience and knowledge about the complex ongoing agility, which is needed in order to assess the real growth needs of human society.

- When the world demands that we organize according to hierarchies, we organize according to caring, intimacy, and inclusion, because a healthy community rests on our interconnectedness.

- When the world blames mothers for every challenging family dynamic (Hook) upholding us to impossible idealistic standards, we say, this is a backwards compliment, which points to our enormous influence on others. If we are so central, is it not time society treated us with matching reverence and support?

These are a few starters. There are more, of course.[16]

The motherbody model gives us an alternative visual roadmap that challenges prescribed thought systems and work practices from the past. Would you like to join us?

Sincerely yours,

Shira Richter
Herzliya, Israel

Endnotes

1. The motherbody concept has many mothers. It developed over the course of my interdisciplinary, interactive, political, artistic research on the status of mothers and while I performed my own mothering work. The concept was also developed through working in collaboration with Natalie Macellaio and Lesli Robertson, artist-mothers and creators of The Mother Load project (Dallas, U.S.), and it was further influenced by collaborating with the m/other voices foundation by Deirdre Donoghue of Rotterdam, The Netherlands.

2. Twins and other multiples don't enter life alone, either; in fact, they start interacting in the womb (Castiello et al.).

3. For the purpose of inclusivity, in 2014, the word "woman" was erased from the Midwives Alliance of North America's (MANA) core competencies document and replaced with "pregnant individual" and "birthing parent" ("Use of Inclusive Language"). I have narrated this historical erasure and appropriation in a visual lecture titled "Hot Potato Called Mama" that was prepared for The Mother Load project and debuted at the Dallas Museum of Art in 2014.

4. The good news is that in some businesses, the traditional way of firing employees is being challenged (Siegel).

5. Naomi Wolf pointed this out in *Misconceptions* by referring to "mommy fog" as a brain occupied with thinking about the numerous concerns a new baby introduces into our lives.

6. In the article, Conaboy goes on to explore the many possible reasons accurate information about pregnancy and birth is still withheld from women.

7. Epigenetic and telepathy researcher Rupert Sheldrake has an interesting hypothesis about the nature and development of telepathy; he studies its role in the relationship between mothers and babies. His focus is the physical phenomenon of breastmilk "let down" that occurs in a human mother when she is far from her baby.

8. This is not a new practice. Royals and the aristocracy had wet nurses for their children, who, in turn, gave their babies over to other wet nurses.

9. "Divisive Economy" is the title of a Visual Lecture I created and presented at the Van Leer Jerusalem institute in 2018. The occasion was the publication of the book *Gender and Capitalism, Feminist Encounters with Market Culture* (Brayer-Garb et al.), in which I published an artwork.

10. The Sustainable Arts Foundation, which focuses on the mother-artist, is an exception to this.

11. In Judaism, a mother is considered closer to god because she is God's co-creator on earth. Although Judaism and other monotheistic religions used this "godliness" as an excuse to exclude the mother from the public sphere, current-day Jewish religious feminists prove we have matured and can reclaim this notion without abandoning human complexity.

12. *Speaking Boxish* is a visual performance lecture by Shira Richter, based on a series of her drawings, presented at the Berlin Ministry of foreign affairs during the Canaan Conference- Women's 1325 accord. 2018

13. This point alludes to the Boycott, Divestment, Sanctions Movement and its suspicious targeting of individual academics or artists, especially those who openly criticize their own countries' politics.

14. The Mothernist conference in Rotterdam 2015, held by the m/other voices foundation, put equality into practice by challenging the

usual hierarchies of academic conferences. For instance, there were no parallel events that force speakers and performers to compete for audiences, and all participants were present during the whole conference. The conference arranged for shared living quarters in order to connect the public and personal in practice. The solidarity and friendships that emerged there have continued to produce numerous cooperative projects, including this paper.

15. Dr. Uki Maroshek Klarman, who is both a friend and the academic director of the Adam Institute for Democracy and Peace, taught me this.

16. Recent mother-artist collaborative projects in several countries have been developing alternative systems according to similar values: The Mother Load Project by Leslie Underwood Robertson and Natali Macellaio (Dallas, Texas); The Motherhood Initiative for Research and Community Involvement (MIRCI) and Demeter Press by Andrea O'Reilly (Toronto, Canada); The m/other voices foundation by Deirdre Donoghue (Rotterdam, The Netherlands); The Mother-nists Conferences One and Two, initiated by Deirdre Donoghue and Lise Haller Baggesen (Rotterdam and Copenhagen); Desperate Artwives initiated by Amy Dignam and Susan Merrick (London); Procreate Project by Dyana Gravina (London); The Mother Day Project by Sarah Black and Esther Wilson (Liverpool, U.K.); and The Institute for the Art and Practice of Dissent at Home by Dr. Lena Simic (Liverpool, U.K.).

Works Cited

Adewumi, James. "Twins in West African Culture and Society of the Iron Age." *Artifacts* issue 9, April 2014, artifactsjournal.missouri.edu/2014/03/twins-in-west-african-culture-and-society-of-the-iron-age/. Accessed 29 July 2019.

Blaffer Hrdy, Sarah. *Mothers and Others: The Evolutionary Origins of Mutual Understanding.* Belknap, 2011.

Castiello, U. et al. "Wired to Be Social: The Ontogeny of Human Interaction." *PLoS ONE* vol. 5, no. 10, 2010, p. e13199.

Conaboy, Chelsea. "Motherhood Brings the Most Dramatic Brain Changes of a Woman's Life." *The Boston Globe*, 17 July 2018, www.

bostonglobe.com/magazine/2018/07/17/pregnant-women-care-ignores-one-most-profound-changes-new-mom-faces/CF5wyPOb5EGCcZ8fzLUWbP/story.html. Accessed 29 July 2019.

Estés, Clarissa Pinkola. *Women Who Run with the Wolves: Myths and Stories of the Wild Woman Archetype.* Houghton Mifflin, 1992.

Ettinger, Bracha L. "Matrixial Trans-Subjectivity." *Theory, Culture & Society*, vol. 23, no. 2-3, 2006, pp. 218-222.

Ettinger, Bracha L. "(M)Other Re-spect: Maternal Subjectivity, the Ready-made Mother-monster and The Ethics of Respecting." *Studies in the Maternal*, vol. 2, no. 1, 2010, pp.1-24.

Frank, Robert H., and Philip J. Cook. *The Winner-take-all Society: Why the Few at the Top Get So Much More than the Rest of Us.* Penguin Books, 1995.

Gafni, Dalit, and Erez Siniver. "The Motherhood Penalty: Is It a Wage-Dependent Family Decision?" *The B.E. Journal of Economic Analysis & Policy, De Gruyter*, vol. 18, no. 4, 2018, pp. 1-18.

Hook, Misty K. "Mother Blame: Psychology's Shame." *The Psychological Hook*, www.thepsychologicalhook.com/mother-blame/. Accessed 29 July 2019.

Howe, Julia Ward. "The Change in the Position of Women." *The Woman Suffrage Movement*, edited by Florence Howe Hall, Dana Estes and Company, 1913, pp. 136-151.

Joel, Daphna, and Cordelia Fine. "Can We Finally Stop Talking About 'Male' and 'Female' Brains?" *The New York Times*, 3 Dec. 2018, www.nytimes.com/2018/12/03/opinion/male-female-brains-mosaic.html. Accessed 29 July 2019.

Jordan, Judith V. "Relational Awareness: Transforming Disconnection." *The Complexity of Connection*, edited by Judith V. Jordan et al.. Guilford Press, 2004, pp. 47-63.

Moses, Kate. *Mothers Who Think: A Salon Book.* Villard, 1999.

Pilling, David. *The Growth Delusion.* Bloomsbury Publishing, 2019.

Rich Harris, Judith. *No Two Alike: Human Nature and Human Individuality.* W.W. Norton & Co., 2006.

Richter, Shira. "Divisive Economy." *Gender and Capitalism: Feminist Encounters with Market Culture* Book Launch, 15 Feb. 2018, The Van Leer Jerusalem Institute, Israel.

Richter, Shira. "Hot Potato Called Mama." *The Motherload Project* By Leslie Underwood Robertson and Natalie Macellio, 2014, The Dallas Museum of Art, Texas.

Richter, Shira. "Mama: Motherhood around the Globe—Heroes, an Interview." Global Fund for Women, 2012, mama.globalfund forwomen.org/heroes/shira-richter. Accessed 20 March, 2019.

Richter, Shira. "Speaking Boxish." Canaan Conference "Women's 1325 Accord", 30 Oct. 2018, The Ministry of Foreign Affairs, Berlin.

Rowland, Katherine. "We are Multitudes." *Aeon*, 11 Jan. 2018, aeon.co/ essays/microchimerism-how-pregnancy-changes-the-mothers-very-dna. Accessed 29 July 2019.

Sheldrake, Rupert. *Apparent Telepathy between Babies and Nursing Mothers—A Survey. Richard Sheldrake*, www.sheldrake.org/research/ telepathy/apparent-telepathy-between-babies-and-nursing-mothers -a-survey. Accessed 29 July 2019

Shlain, Leonard. *The Alphabet Versus the Goddess: The Conflict Between Word and Image.* Penguin, 1999.

Siegel, David. "A More Humane Approach to Firing People." *Harvard Business Review*, 21 Aug. 2018, hbr.org/2018/08/a-more-humane -approach-to-firing-people. Accessed 20 March, 2019.

"Use of Inclusive Language." *Midwives Alliance of North America*, www. mana.org/healthcare-policy/use-of-inclusive-language. Accessed 20 March, 2019.

Waring, Marilyn. *Counting for Nothing: What Men Value and What Women Are Worth.* University of Toronto Press, 2016.

Wolf, Naomi. *Misconceptions: Truth, Lies, and the Unexpected on the Journey to Motherhood.* Anchor Books, 2001.

Zielinski, Sarah. "Mama deer respond to the cries of human babies." *ScienceNews*, 17 Sep. 2014, www.sciencenews.org/blog/wild-things/ mama-deer-respond-cries-human-babies. Accessed 29 July 2019.

Chapter Six

Mother or Not: Parafictional Motherhood in the Work of Chelsea Knight

Lydia Gordon

"The parafictional mobilizes two contradictory assumptions in traditional understandings of aesthetic: that art reveals truth, and that art is a space apart from reality."—Carrie Lambert-Beatty (Grabner 48)

"Why should I be limited to my own biography?"—Eleanor Antin (Broude, et al. 167)

Artists increasingly bring visibility to marginalized experiences of the human condition by offering us a different way of viewing and being in the world. The subject of motherhood offers a rich exploration for some artists who ask the question: what constitutes a mother? By representing maternity alongside nonmaternity, art projects can offer us a space in between to consider new, non-normative maternal categories. In moving image, artworks that present the artist playing a mother role for the camera yet reveal her own biography as a nonmother push against what this volume examines as the centrality of maternity as defining identity. Representations of non-normative maternal positions begin to do the hard work of unpacking maternal prejudices against nonmothers; they ask important questions about the power of art, truth, and subjectivity.

Chelsea Knight's *The Breath We Took* (2013)[1] wavers between documentary and fiction. Each layer of the film presents a story of a woman negotiating her identity while resisting norms of femininity, marriage, and motherhood. The work's formal arrangements include an amalgamation of unconvincing narratives and subjectivities interwoven with biographical information and documentary styles. For the viewer, *The Breath We Took* shares the anxious story of the artist becoming a mother while trying to accept her own mother's hatred of motherhood.

This essay traces *The Breath We Took*'s representations of maternal ambivalence, anxiety, and performativity. By utilizing the writing of Carrie Lambert-Beatty and Mark Nash on video, performance, and the quality of truth in art, I argue that *The Breath We Took* reveals useful, plural, and necessary entry points for the viewer within the massive category of the mother. Viewing the work fuels the following question: Can a maternal desire extend beyond the socially constructed necessity to have a baby to become a mother? I am not a mother and, therefore, wonder why Knight's performance of maternal anxieties and ambivalence offer useful points of engagement to me as a viewer and critic. As Eleanor Antin suggests in the quotation that opens this essay, a practice necessary for attaining a deeper knowing of self and place in the world is that of fantasizing you are someone else (qtd. in Broude et al. 167). Through this essay, I interrogate not only the representations of the layers within maternal intersubjectivity in Knight's work but specifically what is at stake when the artist raises issues of maternal desires by stepping away from the autobiographical, leaning outside the realm of the real, and into the realm of the parafictional.

Breath opens with a long shot of a suburban home, where tall symmetrical hedges line the yellow house's exterior. A neighbour's chimney pokes out in the top right corner of the frame. The melodic sound of a woman's voice carries the viewer into an interior scene,[2] where, moments later, a young girl around the age of nine slowly walks through a domestic space. She does not face us. Her red hair is pulled back in a ponytail. She is rather pale. The following cuts lead the viewer into rooms filled with framed portraits of babies, brides, and artwork, which capture several female generations in moments of traditional marriage and motherhood. One black-and-white photo depicts a young girl smiling. We then see her portrait on her wedding day.

At fifty-three seconds, the singing stops and a close-up of Knight's mother takes over the frame. Slowly shaking her head, the mother says, "I absolutely hated motherhood. I was not cut out to be a mother. There was nothing about it I enjoyed. Nothing." Almost immediately, *The Breath We Took* confronts the viewer with the mother's experience of hating motherhood. As the work continues, Knight dives deeper into her mother's feminist political consciousness. The viewer sees, and hears, the mother explain her position for navigating a complicated maternal subjectivity, one that negotiates love as well hate. In one scene, the mother exclaims to a female friend, "and interestingly enough I never wanted to have kids because I was totally opposed to raising kids in the nuclear family. I just thought that was the craziest thing in the world."

This essay is situated within this mother and adult daughter relationship and its tension. Throughout *Breath*, the subjects' conversations take place around the kitchen table, in the bedroom, and on the porch—domestic and intimate spaces that set the stage for examining social dynamics through body language, verbal, and nonverbal exchanges. In the opening scene, the mother sits with Knight and a friend at a dining table. Knight and her mother sit on the same side of the table, a dynamic that allows the viewer to read their expressions as constantly rubbing up against each other and creating friction. Knight's maternal anxiety runs parallel to her mother's ambivalence in *The Breath We Took* as both women unpack their experiences throughout the video. Whereas the mother has the benefit of historical distance, Knight negotiates maternal subjectivity in the (video's) present. The mother speaks with the benefit of hindsight and delivers her thoughts on motherhood directly and confidently. Knight's response to her mother's narrative here remains passive as her mother becomes more and more aggressive in her verbal delivery. The viewer observes a power play.

Knight displays uncomfortable and unpredictable emotions throughout the scenes with her mother. When her mother says, "It was probably the worst birth ever, and the reason you are an only child. And it's only a miracle I didn't hate you afterward," Knight stares into the camera, breaking the fourth wall. Her position during this difficult moment slips between indifferent and curious, problematic and fixed. She squirms, unsure how to react, if at all, to her mother's words. In

popularized cultural representations, daughters react against over-bearing mothers who love too hard and too much. How do daughters cope with ambivalent mothers, where feelings of hate are outwardly manifested alongside love?

Knight's discomfort translates into her solo scenes. In one such scene, the camera cuts to a close up of her sitting in a wicker chair; a breeze blows through the curtains behind her, and there are sounds of children playing in the background. Gazing directly into the camera, she discloses, "I do feel like I'm acting sometimes or I'm doing a performance ... I don't know exactly what kind of performance it is." Is Knight performing as a mother? Is her daughter the little girl from the opening shots? Unsure in this moment, Knight searches for language to answer a question that we, the audience, did not hear. Her brow is furrowed. Her eyes squint slightly. Her tone is soft yet urgent. In stark contrast to her mother's cadence, Knight's expression of her own maternal position appears unclear, and I would argue, a little unbelievable.

The child from the opening scene gives us a clue into Knight's performance and representations of truth. We come to know her as Pemma. Pemma and Knight display a close bond, a representation of a mother-daughter connection. Although Knight and Pemma share many intimate moments throughout *Breath*, in fact, Knight is not a mother, and Pemma is a hired actor. In this scene, Knight continues to shift in her seat and declares to the viewer that her anxiety is located within the action of becoming a mother or birthing a baby. Pemma's birth is brought up again towards the end of the work, where it is Pemma who recites to Knight, "I remember my birth. I remember breathing for the first time, like butterflies." *The Breath We Took*'s location between fact and fiction is murky.

The appearance of Pemma's father (who is really a friend of the artist) further tests the viewer's assumption that Pemma is Knight's biological daughter. The viewer sees little of Pemma's father throughout the work. However, in an unconvincing and rather emotionless therapy session, Knight and Pemma's father debate their different styles of communicating with Pemma. They talk of performing their roles in either a cynical or sincere way. Knight thinks she is aware that she is performing with Pemma and, therefore, comes across as cynical. The father thinks he is more natural at communicating with Pemma, as he

is less aware of himself, which makes his performance seem more sincere. Their questions about parental performance while performing for the artwork have a doubling effect. The artist formally constructs *The Breath We Took* to present moments of scripted performance alongside documentation of her own mother's experience. Knight offers a multiplicity of positions within this complex web of maternal performances to create useful and engaging moments for the viewer, whether she is a mother or not.

Although the viewer may continue to ask, "Is she a real mother? Is that her daughter?" throughout the work, Knight's fluctuating positions as an anxious mother and passive daughter create a multi-faceted, productive way to think about maternal representations. By focusing on Knight's performance and constructed identity, comp-licated subjectivities and non-normative maternal desires are present and at play. Arguably, it is through artistic practice that the artist negotiates a response to maternal ambivalence while coping with her limited position—a position of the adult daughter as well as a childfree woman. Knight's performance as a mother problematizes art's location between reality and make-believe.

Reading these scenes and the entirety of *The Breath We Took* through the conceptual framework of parafiction illuminates the work's formal location between documentary film practice and fantasy.[3] Carrie Lambert-Beatty[4] defines parafiction as "related to but not quite a member of the category of fiction as established in literature and drama. It remains a bit outside. It does not perform its procedures in hygienic clinics of literature, but has one foot in the field of the real. Which is a nice way, of course, to say that instead of simply telling a story, it tells a lie" ("Make-Believe: Parafiction and Plausibility" 54).

Lambert-Beatty discusses Michael Blum's project *A Tribute to Safiye Behar* for the 2005 Istanbul Biennial. For this work, Blum built an apartment museum to tell the story of Behar, a Turkish-Jewish woman who worked alongside Turkey's Mustafa Kemal Ataturk during the 1923 founding of the Republic. Blum created an entire installation to show viewers how the unknown Safiye Behar importantly participated in the secularization of Turkey and influenced the national enactment of women's rights. Blum constructed blurry photographs and placed fake artifacts in vitrines throughout the apartment to convince the viewer that Safiye Behar was a critical figure in Turkey's founding. As

the artist meticulously substantiated her story through fabricated documentation, the art installation started to raise questions of knowledge: how could Istanbul Biennial visitors not know about Safiye Behar? People simply left bewildered (Lambert-Beatty, 54).

Blum's intervention into, and questioning of, the founding story of the Turkish Republic illuminates how art can poke holes and dismantle a history's metanarrative. For the viewer, *A Tribute to Safiye Behar* creates a space to criticize the nation-state, the way things seem to be, while offering a host of possibilities, the way things could be.

Similar to experiencing *The Breath We Took*, viewers of *A Tribute to Safiye Behar* were not made aware of any falsities or lies within the narratives presented. For both works, only after the viewing experience is complete, where "fictions have been experienced as facts," does skepticism begin to percolate (Lambert-Beatty, 54). Blum's project was presented in a city apartment, straddling the ambiguous line between art and life, but *The Breath We Took* was shown in a designated art space. The gallery setting of *The Breath We Took* helps the viewer to recognize the fiction in parafiction.[5] The viewer can choose to recognize Knight and her conflicted narratives as key components to complicating the mother category, or not.

By using documentary styles of filming, Knight performs as a mother. Mark Nash has written extensively about a "documentary turn" in contemporary art. Like Lambert-Beatty, Nash explores how artists use moving-image to question art's relationship to reality. Rather than focus on the tension between reality and fiction, he concerns himself with the artist's role in these projects. Artists tap into new realities and propose new situations. Nash argues that artists' "border-crossing" between fiction, documentary, reality, and fantasy fuels their work as critical.

Knight's "border-crossing" in *The Breath We Took* provides a framework for the viewer's reception. According to Nash's contextualization of video work that pushes the documentary turn, the artist must engage with an element of social reality and provide a space for social change. Knight needs to engage an established context in order to convince her viewer that some element of *The Breath We Took* documents an existing social situation. She does so by selecting her mother as the first narrator in the work.

Her mother's story is a familiar one. As Knight's mother communicates her disdain for motherhood, the work becomes severed from its opening scenes of melodic music and pictures of smiling families. The viewer hears a white noise as the mother talks, almost an echo. Are we, the audience, experiencing raw footage, a home movie? Who else is in the room? The mother's remarks seem off the cuff in their delivery, as if someone had just asked her a question. She does not address the camera as she speaks; it is as if the viewer observes a private conversation. We hear that she was a young mother in the 1970s and a supporter of the Women's Movement. We come to understand the mother's maternal experiences as deeply complicated and formed within the context of great political awareness. The video's aestheticization of her history latches onto bodies of knowledge that exist in social reality. Her statements exist within the art piece but are also grounded in tenets of second-wave feminism. As Lambert-Beatty states of parafictional work, the mother's situation is tethered to the "world as it is being lived" (54). The viewer can recognize and digest her situation as one existing outside of the artwork and within individuals who came of age in the 1970s.

The mother's position both within and outside the work invites the viewer to engage with the contested space between fiction and fantasy. This chasm created by the artist's "border- crossing" toggles the viewer between boundaries of maternal fantasies and realities. Within this parafictional artwork, such distinctions remain ambiguous. In Knight's first scene as a (sort-of) mother, she talks to the camera about the fear she felt when she became a mother, appearing uncomfortable and her gaze meets the viewer's. Her breaking of the fourth wall shifts the viewer as voyeur to the viewer as participant. The viewer is no longer concerned with the boundaries between what exists as a potential reality outside the work versus what exists within the work; rather, they are concerned with what Knight's performance does in the domain of art. Knight's investigation of her mother's ambivalence is troubled by her own performance as a fictional mother. The artist's intermittent "border-crossing" helps us think about the paradoxes at play. As parafiction, the work's unstable location between reality and fiction and between art and life "mobilizes two contradictory assumptions in traditional understandings of aesthetic: that art reveals truth, and that art is a space apart from reality" (Grabner 48). *The*

Breath We Took can tap the maternal desires and fantasies of the viewers. The act of viewing the video allows them to explore feelings of indifference and empathy towards Knight's mother, where within might lie questions about their own maternal intersubjectivity. Perhaps, then, these feelings can bring forth a conscious desire to negotiate, and even accept, one's own ambivalence.

Knight's work addresses maternal ambivalence, indifference, and overall anxiety in ways that prod viewers yet also keep them at a safe distance. Although these experiences and emotions linger outside of normative maternal culture, even seen as taboo, Knight represents them modestly and in a subtle explication. Neither Knight nor her mother ever speaks directly about hating her offspring. Whereas much writing on maternal ambivalence defines the child as the object of a mother's hate and love, this direct line from subject to object, from mother to daughter, is muted in Knight's work. Knight refrains from crossing the line of what is socially acceptable. Refreshingly frank, however, is how her mother speaks in front of Knight and how Knight appears indifferent. At the dinner scene, Knight barely flinches as her mother recalls her birth. Representing an adult daughter perspective, Knight reacts ambiguously towards her mother. She appears totally disengaged with her mother's sentiments in this moment: she chews her food, eyes focused on the cake in front of her, and then concentrates on sipping her beverage. She does not face her mother or respond in any physical or vocal manner. And yet, right before her mother says these words, Knight looks directly into the camera. She does this again immediately after her mother speaks. Her eyes meet the viewers' seemingly to ask, "Did you hear that?" Although the viewer can imagine Knight's potential emotional response through these subtle cues, they cannot see any visible consequences of her mother's remarks. Knight's struggle, if there is one, appears only below the surface.

Therefore, in experiencing representations of non-normative maternal subjectivities in an art piece, we, the viewers, can recognize ourselves more fully. *The Breath We Took* can validate maternal ambivalent feelings and aid in the acknowledgment of anxieties that are otherwise deemed inconvenient for society. Since the categories "woman" and "mother" are already massive, involving a breadth of intersectional identities, behaviours and self-representations, outward expressions of non-normative emotional responses can intersect with

viewers at different cross-sections of their identities. The compelling representations in *The Breath We Took* create, as Lambert-Beatty argues, "specific multiplicities" (73) through the parafictional apparatus.

Art's meanings are produced through encounters with its spectators and a parafictional reading of *The Breath We Took* tethers the complexities of motherhood, womanhood, and daughterhood to its viewers. These viewers and their desires remain individualized, avoiding a collapse along the spectrum of receptions. The questions Knight raises address each viewer right where they are—as a mother, non-mother, stepmother, adoptive mother, caretaker, nurturer, childfree person, daughter, estranged daughter, artist, and so on—without running the risk of producing sameness among experiences. The viewers' collective experiences may be found in, and fostered by, common desires for representations of non-normative maternal anxieties, fantasies, and needs. Such representations create a model that favours complexity, presenting the maternal category as restlessly plural as well as ever expanding.

Endnotes

1. *The Breath We Took* is a single-channel video Knight shot using a Canon 60D. The immaterial medium is the moving image presented by a single display mode, either a monitor or projection. The work was shown at Aspect Ratio (Chicago, IL) from 3 May through 1 June 2013. The duration of the video is just shy of twenty-three minutes and includes several moments of narration by different subjects.

2. The song is titled "If I Keep a Green Bough in My Heart," written in 1987 by Kathy Wonson Eddy from the self-published CD *The Singing Bird Will Come*. The text is from a traditional Chinese proverb. The music is soprano and flute.

3. The interest in art's intersection with our current age of alternative facts, fake news, and "truthiness" has resulted in several major exhibitions. Major recent exhibitions include Contemporary Arts Museum Houston's 2014 *More Real Than Reality Itself*; the Minneapolis Institute of Art's 2013 *More Real?*; *The Cinema Effect: Illusion, Reality, and the Moving Image, Part 1: Dreams; Part 2: Realisms*, in 2008 at the Hirshhorn Museum, Washington D.C.; *Come and Go: Fiction and Reality*, November 2007 through June 2008, at the Gulbenkian Foundation, Lisbon; Mark Nash's 2004 *Experiments*

with Truth exhibition at The Fabric Workshop and Museum, Philadelphia; and Nash's work in 2002's *documenta 11.*

4. Carrie Lambert-Beatty championed this idea in her 2009 *October* article "Make- Believe: Parafiction and Plausibility," although her ideas were originally presented at ThreeWalls Gallery and DePaul University in Chicago, as well as the Institute of Fine Arts, New York in *Talking With Your Mouth Full: New Language for Socially Engaged Art,* edited by Elizabeth Chodos, Green Lantern Press, 2008, pp. 54-75. Lambert-Beatty's subsequent *October* essay was reprinted again in 2013 in a broader conversation.

5. Located at 119 N. Peoria, Chicago, Aspect Ratio held the solo exhibition of *Chelsea Knight: The Breath We Took.* The gallery held a Friday night opening; otherwise, the space was open Thursday by appointment, 1:00-6:00 PM on Fridays, and 12:00-5:00 PM on Saturdays. The Chicago exhibition of Knight's work was presented in a small, dark room on loop. *The Breath We Took* was shown in a black painted room, whereas its corresponding materials, the list of credits and press release, were available to the viewer in an adjacent white painted room. An HD projector and two speakers were used. Besides a small light in the front of the gallery, there was no additional lighting used during the exhibition, and the projection of the work served as the main source of light in the gallery.

Works Cited

Armstrong, Elizabeth, et al.*More Real?: Art in the Age of Truthiness.* DelMonico Books, Prestel, 2012.

Broude, Norma, et al.*The Power of Feminist Art: the American Movement of the 1970s, History and Impact.* Harry N. Abrams, 1996.

Grabner, Michelle. "On Bullshit, Lies, Truthiness, and Parafiction." X-TRA, vol. 11, no. 3. 2009, pp. 48-54, http://x-traonline.org/article/on-bullshit-lies-truthiness-and-parafiction/. Accessed 13 September 2016.

Knight, Chelsea."Breath Final web." Vimeo, 2013, vimeo.com/65991899. Accessed 29 July 2019.

Lambert-Beatty, Carrie. "Make-Believe: Parafiction and Plausibility." *October,* vol. 129, 2009, pp. 51–84., doi:10.1162/octo.2009.129.1.51.

Nash, Mark. "Reality in the Age of Aesthetics."*Frieze*, 1 Apr. 2008, frieze.com/article/reality-age-aesthetics. Accessed 29 July 2019.

Wonson Eddy, Kathy. "Re: Kathy's song." *The Singing Bird Will Come.* Received by Lydia Gordon. 26 September 2016.

Chapter Seven

Baby Mine: Artists, Maternity, and Disability

Caroline Seck Langill

"Little one when you play
Don't you mind what they say
Let those eyes sparkle and shine
Never a tear, baby of mine"[1]

Four mothers—one fictional, one absent, two present—one daughter, three artists are all bound to their children and/or their art through love and disability. By looking at the work of artists for whom contemporary debates around disability have strong theoretical and personal applications, this chapter will delineate how art can help to navigate the ethical challenges that can arise through the lived experience of maternity and disability. Doris Lessing's novel *The Fifth Child* provides a pivot for this discussion with its tight narrative regarding responsibility for children with disabilities; it explores questions of maternity and duty to care in ways that few other narratives have achieved.

Over the past decade, the borders delineating art practice, its objects, and its makers have shifted dramatically. Increasing scrutiny of the Western canon and the movement of previously excluded actors from periphery to centre have raised questions around the ethics of inclusion within the art system (Gates; hooks). Feeling this process deeply, BIPOC (Black, Indigenous, and people of colour) communities have come to demand equal access to gallery representation, exhibition, and collection of their art. In parallel with these shifts in the art world

power dynamics, people living with diverse abilities and their advocates have also demanded equal representation in this new milieu. Two artists—Elizabeth Mackenzie and Martha Eleen—who are deeply invested mothers of children with disabilities refused to let them have a marginalized position in society. Their actions will be mapped out against the ambivalence of Lessing's protagonist. Additionally, Judith Scott's surprising textile practice provides an astonishing third counter-narrative to Lessing, demonstrating how art, in the wake of institutional trauma, can be liberating for both caregiver and practitioner.

The Fifth Child tells the story of Harriet and David Lovatt, their meeting, and their impressive plans to move to a rural town within commuting distance of London, U.K.. Integral to their life-changing decision is their plan to have a large family, and despite their fragility and meager resources, they imagine themselves surrounded by children frolicking around their country home's garden. The couple generally succeeds, but during Harriet's pregnancy with her fifth child, she becomes acutely aware of a discordant body occupying her womb. It becomes clear soon after his birth that Ben has intellectual disabilities, is growing faster than her other children did, and is not integrating well with them. Family life becomes increasingly difficult for the Lovatts as Ben matures, and, eventually, under duress, Harriet agrees to have him institutionalized. Her discomfort with this decision gets the better of her, despite pressure from her immediate family to stay the course. She eventually retrieves Ben from the home, where she finds him confined under solitary and appalling circumstances. The lives of Harriet and David are inevitably changed upon Ben's return, as he remains under his mother's care. Lessing's novel, which affectively realizes the anxiety and dread of pre- and postpartum maternity, is not so different from similar maternal narratives that emerged during the mid to late twentieth century. Even the mother in Walt Disney's Dumbo (1941) found herself isolated with her elephant calf, whose ears were well beyond their expected range.

Literary scholar Rosemary Garland Thomson brings a feminist disability studies lens to her research for its insistence on unsettling normative representations, as she notes that disability studies scholars seek to denaturalize disability and "the cultural encoding of these extraordinary bodies" (The Beauty and the Freak 5). Such scholars "[understand] disability as a system of exclusions that stigmatizes human differences ... uncovers communities and identities that the bodies we

consider disabled have produced ... reveals discriminatory attitudes and practices directed at those bodies ... exposes disability as a social category of analysis [and] frames disability as an effect of power relations" (Thomson, *Extraordinary Bodies* 1558). Most significantly, this theoretical framework defines disability from a social rather than medical perspective, stressing "disability as a vector of socially constructed identity and a form of embodiment that interacts with both the material and the social environments" (Thomson, *Feminist Disability Studies* 1559). More a product of rules and regulations of how bodies should behave in public and private realms than a property of bodies, disability can be seen as interpretation rather than description (Thomson, *Extraordinary Bodies* 6). In *Extraordinary Bodies*, Thomson draws a correlation between the deviance of the female body and the disabled body, and she argues for a historical precedence through Aristotle's claims in his fourth book of *Generation of Animals* of the following: "anyone that does not take after his parents, is really in a way a monstrosity, since in these cases Nature has in a way strayed from the generic type. The first beginning of this deviation is when a female is formed instead of a male" (15). This shared inferiority of the disabled and female body is an exaggeration of sorts, but it serves this discussion of maternity and disability by demonstrating a historical precedence for the entwining of misogyny and bias against women, and those who experience neural and genetic diversity.

As it stands, maternity elicits extreme physical changes in the body of the mother in order to carry and birth a child. Anthropologist Sarah Hrdy speaks to the biological shifts the body endures as the fetus develops. She also notes that as well as depleting essential nutrients in the maternal body, pregnancy also causes hormone alterations with the fetus by secreting an enzyme that blocks the mother's immune system in order to ensure her body will not reject the alien organism (94). If the fetus does come to term, then labour and delivery elicit further changes by creating new neural pathways, such as the heightening of smell and hearing (94). Hrdy cannily affirms that "when a new mother says ... that the birth of her first baby transformed her, she is not speaking just metaphorically" (95). Given these physiological modifications of the mother during pregnancy, it is not surprising to read about the extreme emotions Harriet endures as she forges ahead through her trimesters in *The Fifth Child*: "Her time was endurance, containing pain. Phantoms and chimeras inhabited her brain" (41).

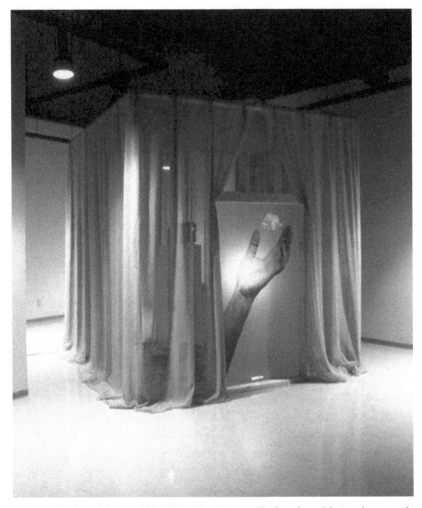

Figure 1: *Radiant Monster,* 1996, 8' x 8' x 8' (overall), Lumber, fabric, photograph on mylar, fetal ultrasound video loop with intrauterine audio, text slides, video projector, slide projectors, slide dissolve unit, a/v cart, speakers, lamp.

In 1994, artist Elizabeth MacKenzie gave birth to her son Jack, who was born with severe brain damage and died at four months. Her work *Radiant Monster* (1996-1998) refers to the experience of carrying her son, bringing him to term, and discovering his condition only at birth (Fig. 1). Departing from her oeuvre of large drawings presented directly on gallery walls, Mackenzie, in this instance, created an installation wherein a small square room supported by a wooden armature provided

a structure for drapery—in reference to Piero della Francesca's fifteenth-century fresco *Madonna del Parto*—with the drapes parted to reveal a large photograph on Mylar of a mother's hand extended towards a delicately placed projection of a fetal ultrasound. Seven phrases appeared at the bottom of the image providing a cascading and cumulative effect regarding the continuum of emotions evoked for the mother: INVISIBLE-STRANGER-MINE; THIS-RADIANT-MONSTER; HER-DREADED-BELOVED; THAT-ENCHANTING-TYRANT; OUR-DANGEROUS-ANGEL; THESE-DAZZLING-FICTIONS; an ADORABLE-DEMON-YOU. Emanating from the room was an audio tape of blood rushing through veins, a sound inaudible to the human ear, but apparently soothing to the fetus. Having used a moving ultrasound image of my daughter in the womb for a video work, I am well aware of the compelling nature of these images. Hauntingly reminiscent of the x-ray, the blue glowing facsimile brings what was previously an abstract concept, the body within the body, into reality. Phantasmagoric in its effect, this vehicle of medical surveillance also conveys critical data concerning fetal health and, based on gross morphological characteristics, gender. The process of undergoing a transabdominal ultrasound is bewildering at the best of times; a technician performs what is ultimately an intimate act—placing a warm gel on the mother's belly and then producing a sonogram of the fetus by moving a transducer back and forth across the mother's protruding abdomen. In writing about this work, MacKenzie notes the affordances of reproductive technologies to increase not only women's choices regarding motherhood but also the opportunities for medical intervention (MacKenzie). In the late twentieth century, women found themselves spoiled for choice, pulled in one direction by medical expertise and progress and in the other by newly empowered midwifery options. As MacKenzie notes, images of pregnancy "rarely acknowledge the complexity of the lived experience of this state.... Apart from the cataclysmic affect it has on your body, rarely it is simply a time of unalloyed joyful anticipation." For this artist, *Radiant Monster* "represents the ambivalent feelings I have experienced in response to real and imagined pregnancies and children.... I wanted to express a continuum between the desire and the anxiety that the contemplation and experience of maternity evokes."

A year after Jack's death MacKenzie reflected on her son's short life, and in the following passage, she acknowledges the difficulty in moving on from the intense experience Jack brought to her family:

> Jack was born with severe brain damage which occurred sometime before birth. There's a good possibility that I will never know why this terrible thing happened to him, and I find that over time I can accept that. I no longer view my pregnancy obsessively trying to recall each possibility that might have placed my unborn child at risk. It just happened. The geneticist tells us that the possibility of it happening again to us, should we be able to muster the courage to have another child, is no greater than for anyone else.[2]

The first two weeks of Jack's life were spent in intensive care, the next six were spent in the pediatric ward, and the remainder of his life, two months, was spent at home. Jack's father, Bruce Grenville, poetically referred to the effect of his son's life on his family in a catalogue essay for the exhibition *Death in the Family*, mounted at Presentation House in 1997, which covered the strong links between photography and death. His comments on his relationship with his son act as intertitles throughout his essay, and they describe the daily rhythms of life with Jack revealing that his parents were able to come to some semblance of normalcy over their baby's time at home. These comments append the essay as a means to create a chronology of love and care over his son's short life, but he begins at the end and moves back in time: "November 12: It's hard to keep him warm. Layers of socks and sleepers, a cap, a blanket and a quilt" (27); "October 2: Jack takes such pleasure in his morning bath and feed, when all is done he closes his eyes and presses his body into mine" (29); and "September 14: Jack came home today. It seems so easy. It seems so hard" (30). In MacKenzie's subsequent writings and Grenville's intervention within his essay, the identity of their son is fully formed. Their compassionate approach to these representations and their attitude towards their son was one of unconditional love. They disallow a reading of disability as a "flaw, lack or excess," which is more often than not society's response (Thomson, *Feminist Disability Studies* 1558). In *The Fifth Child*, Lessing describes the child in Thomson's terms primarily through the attitude of the father who eventually gives his wife an ultimatum: "It's either

him or us" (74). The deep distinction between the Lovatt family and Mackenzie's is evident in several watercolours about Jack, which palpably express her love for her son. These delicate paintings of her son's face remove him from the medical identity to which culture relegated him. For these parents, who bravely went on to have two more children, Jack remains present through MacKenzie's insistence on evoking her memories of him in her art.

Figure 2. Elizabeth MacKenzie, *Baby (series)*, 2010. Watercolour.

In her interrogation of maternity and the visual arts, sociologist Rosemary Betterton questions the types of representational practices that bring some maternal bodies into visibility but not others. Her project is to "demonstrate the power of the visual in shaping the cultural imaginary of maternal bodies" (4). For Betterton, one cannot assume motherhood is the outcome, since many pregnancies are terminated or end with a miscarried or stillborn child. Therefore, a distinction can be made between the pregnant body and the postpartum body (4). Betterton reads MacKenzie's installation *Radiant Monster* as standing in for the maternal body: "This is an encounter with what may become a child on the threshold of becoming a maternal subject" (16). MacKenzie has emphasized how instrumental her children have been to the creation of her own cultural imaginary. In 2000, in conjunction with the conference First Person Plural, which focused on artist mothers, MacKenzie produced a compilation videotape titled *DELIVERY: Artist Mothers on Tape*.[3]

Shot over three days, it highlights the experiences of artists for whom maternity has affected their artistic practice. In the tape, MacKenzie speaks about her daughters Lucy (11) and Alice (5) making a case for the passion and love she feels for her children as directly connected to her passion for her art practice, with the converse also true—her maternal struggles relate to her artistic struggles. MacKenzie does not name her son in the short clip included in the feature-length documentary, focusing instead on her living children. Jack's "corporeal difference" is invisible (Thomson, *Extraordinary Bodies* 7). David Mitchell and Sharon Snyder, professors of disability and human development, argue that "while disabled populations are firmly entrenched on the outer margins of social power and cultural value, the disabled body also serves as raw material out of which other socially disempowered communities make themselves visible" (6). One of these populations is women. Marginalized within the culture, they can bring attention to their situation through the disabled body, but MacKenzie eschews this opportunity and only recently decides to make the history of her son's life more visible and apparent. The paintings of Jack emerge fourteen years after his death, and there is little to associate her original work, *Radiant Monster*, with the complexity of her experience with him.

In 2011, Martha Eleen produced a series of representational and figurative works about her son Gabe and his world (Fig. 3). Working in

a suite format, Eleen included sixteen paintings in the series titled *I, Huck*. They depict his caregivers, Gabe asleep with his technology, as well as his collection of radios, telephones, and wiring. Gabe's world is represented as busy, rich with interests and intimate relationships. By acknowledging her son's very active existence, Eleen provides an opportunity for the viewer to witness the trust and love embedded in his social life.

Figure 3. Martha Eleen, *The World*, 2011, oil on wood, 30' x 30.'

Eleen, who lives and works in Toronto, raised her son Gabe West with the assistance of care-givers and friends. Gabe lived with multiple disabilities—cerebral palsy, extreme epilepsy, and blindness—and depended on a wheelchair for mobility. Eleen, much like MacKenzie, has asserted that her identity as Gabe's mother was deeply enmeshed

with her identity as an artist. Her life, integrated as it was with her son's, was also her art. Gabe, born in 1976, died in 2015. His tenderly written obituary is suggestive of the rich life this man led: "Pioneer social inclusion activist, food bank volunteer, master of comic timing, intrepid transit enthusiast, analog radio lover, sweet singer" ("Obituary").

There is another line in the obituary which acknowledges Gabe's caregivers and the kinship they felt for him, "His loving supporters Kristina, Jordan, Jackson and Lisa follow a long legacy of attendants whose lives have been changed by this intimate relationship, many of whom have become a circle of lifelong friends" ("Obituary"). Eleen's references to the deep love that people had for Gabe reflect the life she created for her son, despite difficulties encountered at every turn. Surrounded by community, Gabe and his mother avoided the isolation wrought upon Hillary Lovatt as she strongly advocated for her own son in the face of tremendous consequences. Towards the end of *The Fifth Child* Hillary ponders Ben's retrieval from institutional life which sealed her future fate: "Did he ever remember now that she—his mother, but what did that mean to him?—had found him in that place, and brought him home? Had found him a poor creature half dead in a strait-jacket? Did he know that because she had brought him home, this house had emptied itself, and everyone had gone away, leaving her alone?" (131).

Eleen's recent exhibition *Watershed* (Fig. 4) features non-representational paintings whose subtle and muted blocks of colour become increasingly complex on closer inspection. Although they are paintings, their marks display echoes of pastel sticks and the pressure of their application draws the viewers' eyes across and into the canvas, leaving them with a sense of urgency balanced with calm. For Eleen, these abstract works depart from years of painting the land around her as well as creating documents of Toronto and its environs. They signal a change and act as an ambivalent threshold between endless negotiations with institutions to advocate for her son, and her life without Gabe who is deeply present in the works as a reagent for their production.

Figure 4. Martha Eleen, *Watershed #5*, 2017, oil on wood, 48" x 48."

Eleen has spent much of her life advocating for Gabe with the education system, the medical establishment, and social services; she has publicly described her frustration with the medical system in relation to its "disability bias." This process was relentless for the entirety of her son's life. Within his obituary lies a final declaration of the belief that "Gabe died from complications of poor medical guidance over many years" ("Obituary"). Once again, there is a deep contrast to Lessing's character who succumbed to the pressure to institutionalize and then found herself at a loss for support once Ben was back in the family home. Whereas Eleen encountered constant resistance to but persevered in her advocacy for Gabe, Hillary Lovatt was a woman of her time—silent, encumbered by duty, and at service to the needs of her family rather than her own. Eleen's agency in documenting

extensively both her son's and her struggles within the network of services we all take for granted and assume are our right under the social contract shows that the system is still flawed, but it is a far cry from that of mid-twentieth-century Britain. According to philosopher Martha Nussbaum, the social contract is contingent upon a rough equality of power and resources (29). Speaking from a North American perspective, Nussbaum notes the social contract assumes both parties are free and independent, so in turn the social contract "does not include people with severe and atypical physical and mental impairments" (15). In Canada, the social contract is based on labour and a citizen's ability to integrate with the work force in order to pay the taxes that act as an assurance that the state will provide assistance should one be unable to participate as a worker. Nussbaum's argument of the contingency of a citizen's welfare being dependent on an equality of power and resources holds in this country despite our differing governance. However, if one cannot work, the equality of the relationship between the citizen and the state dissolves, leading to a paternalistic and welfare-based relationship for the person in question. Eleen has had to think outside the box to raise her son, having encountered many barriers to his welfare. Gabe was her constant companion. He socialized with her friends. Her relationship to him was as an equal, and it was remarkable how welcome Gabe was in any social setting when with her. The decision to eschew institutionalization meant Gabe's life became Eleen's life, and this deep relationship is evident in her paintings. In 2008, Eleen produced a series of etchings about Gabe. An art critic writing about this work received this response from Eleen after questioning how they should refer to Gabe and his disabilities:

> If you must use medical labels, which refer not to Gabe, but to measurements of normalcy, please know that it will obscure information about Gabe. This is the whole point of the work, to offer another lens, when our language is so embedded with assumptions about his value. You used the word "affliction" ... be careful what you mean by that ... his only 'affliction' is that people don't see that he's perfect just as he is: His vulnerability is an opportunity for us to realize our humanity. (qtd. in Dault)

Eleen's fierce insistence on her son's full participation in her life and the lives of those he has encountered suggests the deficit lies not with those with disabilities but with a culture that privileges the able bodied. Eleen's acute observation regarding assumptions about Gabe's identity and value in the world resonates with feminist disability studies' methodology and echoes the words of philosopher Eva Kittay, whose daughter has cognitive disabilities: "She failed to fit the definition of 'man' or 'personhood' or 'moral agent' or ... a subject due justice. Yet I never treated her as anything but a person, and although I did not expect moral agency from her, she radiated sweetness and light, harmony and, dare I say it, goodness; that is goodness in the sense of lack of malice, anger, or any sort of viciousness." As a philosopher, Kittay found little within philosophical theories of justice that reflected her relationship with her daughter. She further argues that human beings are bound to "inextricable interdependence" beginning from the time of birth. Dependent on networks of care, regardless of whether one is a single parent, the trust and cooperation that emerge out of such dependency relationships are essential to the formation of a just society. For Kittay, the needs of disabled people must be included if a theory of justice is deemed adequate: "By centering a theory of justice on the inevitability of human dependency and the inextricable nature of our interdependence, we can then look at the fact of human dependency anew."

Kittay's position regarding the "inextricable interdependence" of human beings is supported by Joyce Scott, sister of deceased textile artist Judith Scott, whose recent acclaim has come with touring retrospectives of her artwork and her inclusion in *Viva arte Viva* at the 2017 Venice Biennale. Judith Scott, born in 1943 with Down's syndrome, and her twin sister Joyce were inseparable throughout the seven years they had together before the decision was taken to institutionalize Judith. Deaf as a result of a bout with scarlet fever, Judith was wrongly assumed to have suffered from added developmental challenges beyond those normally associated with Down's. She remained a ward of the state for thirty-five years until Joyce—against the advice of their mother—retrieved her sister and brought her home to California where Judith was enrolled in the Creative Growth Art Center in Oakland. At this point, Joyce took up the role of mother for Judith, who still required intense care and supervision given her disabilities. Joyce replaced the mother, the mother who bound her

daughter to institutional life for the majority of her existence. It was at the Creative Growth Art Centre that Judith Scott's intense involvement with textiles began, after a chance encounter with a visiting fibre artist. From this time forwards, she participated in a vigorous relationship with textiles, producing surprising works that pushed fibre art's boundaries throughout the remaining years of her life.

At the *Venice Biennale*, her cocoon-like tightly bound textiles, lively and plump with agency, perched atop numerous plinths, were a satisfying reward for those who had taken the long walk down the Arsenale. The label text for Scott's untitled works, produced between 1988 and 2004 (Fig. 5), describes an artist unconcerned with display: "Far from considering the pieces she produced as future museum works, the artist has never given any indication of a preferred mode of presentation for any of them" (Scott). The description goes on, and were the audience not familiar with her circumstances, they would assume she was able bodied until the last sentence: "The artist was born with Down's syndrome."[4] Was it necessary to educate the audience regarding this artist's chromosomal circumstance? Is there value in confronting the audience's expectations? Regardless, the statement becomes a challenging caveat to these astonishing works, and then perhaps for the viewer, a lynchpin, an excuse, a lack.

Figure 5. Judith Scott, *Untitled 1988-2004*, twenty sculptures, Venice Biennale, 2017.

There are parallels between this and Lessing's story of Harriet Lovatt. The pressure to institutionalize children with diverse abilities was just as strong in the late twentieth century as it was decades earlier. Scott's parents acted on medical and pastoral advice when they made the decision to place her in what her sister has referred to as "Dickensian institutions for the disabled and discarded" (Scott). Her mother no doubt anticipated a life like Harriet Lovatt's, and she may have experienced similar frustrations to that character had she allowed Judith to remain at home.

Art historian John MacGregor was one of Judith Scott's early champions, despite taking the surprising position that she had no real sense of the final outcome of her work or knew anything at all about sculpture (MacGregor 33, 92). By comparison, literature scholar Tobin Siebers has suggested that "the work of Judith Scott challenges the absolute rupture between mental disability and art and applies critical pressure on intelligence as the standard for identifying artists" (545). In his writing on Scott, Siebers questions our assumptions of art as an experience of genius and autonomy. Siebers's situatedness, as a survivor of poliomyelitis and as someone who has written extensively on his own experience as someone with physical disabilities, facilitates his perception of Scott's work as a means to reconsider art and aesthetics and to see disability "as a value in its own right important to future conceptions of what art is" ("Disability Aesthetics" 546).

Much like Siebers, critical theorist Eve Sedgwick saw Scott's work as enormously insightful and, in fact, used an image of Scott by photographer Leon A. Borenstein embracing one of her sculptures as the cover image for her book on affect, *Touching Feeling*, citing the photograph as a catalyst for the book's assemblage (22). An advocate for Scott as an artist, Sedgwick refutes MacGregor's assumptions regarding Scott's lack of agency in the creation of her art, particularly his hypothesis that her lack of language rendered all of Scott's artistic activity "unconscious" (MacGregor 106, 111). Despite her acknowledgement that Scott's troubling history and isolation from language has piqued public interest in her work, Sedgwick's makes a lucid tribute to Scott's brilliance: "But the obvious fullness of her aesthetic consciousness, her stubbornly confident access to autotelic production, her artist's ability to continue asking new, troubling questions of her materials will be difficult and satisfying for them to answer—these privileges seem to radiate at some angle that is orthogonal to the axis of disability" (24).

Figure 6. Detail.

Judith Scott's method of production often revolved around other objects, literally (Fig. 6). Sometimes things are visible as they peek through the wool and twine they are bound within, but some have been discovered via X-ray that antediluvian technology still in use. It is difficult to reconcile the parallel between the pathologizing, and subsequent institutionalization of the disabled body, and this invasion of privacy of the hidden things within Scott's work even if it is driven by the best of intentions. Nonetheless, all manner of objects nestle within the bound layers of yarn and twine, even a wedding ring. There are no stories attached to these things that may or may not have held particular resonance for the artist. They vibrate from within the sculptures, acting as evidence of the site of construction and ciphers of the artist's everyday choices as she negotiated her noninstitutional world. Judith Scott's story has many gaps, including one of twenty

years where there are no records of her activity within the institution she was housed in, a tragic reality of Scott's life acknowledged by her sister Joyce: "Judy is a secret and who I am is a secret, even to myself" (Joyce Scott qtd. in Frank). All people have secrets, but the narratives surrounding the lives of people living with disabilities are somehow even less visible than the secrets we all hold dear and close. According to Tobin Siebers, "The solitude of the disabled is crushing" (1998). Siebers's testimonial is heart-wrenching in its admission of his own relentless persecution in the public sphere. "Everyone is a different wound healed over. But the wounds of the disabled often refuse to heal. They are not like cuts or bruises or broken bones. They are disabled wounds—that is what makes them so hard to accept by the firm and infirm alike—but they define who we are, nevertheless. My withered limb is who I am. It is right for me" (qtd. in "My Withered Limb").

In the cases discussed herein, mothers are secondarily wounded and also entwined with the potential solitude of their children, even in the case of Joyce Scott who though not the birth mother becomes, as of 1968, the maternal guardian of her sister Judith. Disability is the constellation around which MacKenzie's, Eleen's, and Scott's respective art practices revolve—with love, trauma, and death as points of contact for these complex stories of maternity and disability. Sedgwick cited her identification with Scott as less a subject of lack than as "the holder of some obscure treasure, as a person receptively held by it" (24). Eleen and MacKenzie share their refusal to succumb to societal pressures and hide their children away. Instead, they mark their insistence on inclusion for their sons with artworks that externalize and publicly display the significance they had on their lives, thereby providing counter-narratives to Lessing's story of maternal shame and seclusion. Like Kittay, they fiercely advocate for equal justice for their kin. Joyce Scott's advocacy as guardian of her sister in life, and of her sister's legacy in death, reminds us that diversity of abilities can bring great gifts. The Scott twins' story shows that mothers such as Hillary Lovatt were not only fictional. Although information about Judith Scott's mother is scant, the twenty-year gap in her daughter's record of institutionalization, facilitated by her decision to put her child in the hands of the state, is incredibly worrisome when matched against the horrors Lessing evokes in *The Fifth Child*. By my calculation, Lessing's protagonist and Judith Scott

would have been born around the same time. Lessing's novel was published in the late 1980s when MacKenzie and Eleen were emerging as artists, but it is set in the sixties, a decade likely encapsulated by Judith Scott's lost years. Woven together, these four stories suggest new avenues for advocacy and social change, and they use art as a means to track and address the shifting landscape of maternity with respect to the culture's response to disability, thereby reifying the theoretical scaffold put forth by feminist disability studies.

Endnotes

1. Lyrics from *Baby Mine* (1941), a song featured in the Walt Disney film *Dumbo*. Music by Frank Churchill, lyrics Ned Washington.

2. This is from Mackenzie's personal archive regarding her son, released to me through personal communication.

3. The *First Person Plural* symposium, 26-28 May 26-28—hosted by MAWA focused on the multiple roles held by artist mothers and the impact they have on art practice. It was a unique weekend where women could share their most intimate experiences of mothering entwined with artmaking.

4. Label text for Judith Scott, 1943-2005, Venice Biennale 2017.

Works Cited

Betterton, Rosemary. *Maternal Bodies in the Visual Arts.* Manchester University Press, 2014.

Dault, Gary Michael. "It's Raining Glass—And Motherly Love." *Globe and Mail*, 7 June 2008. www.theglobeandmail.com/arts/its-raining-glass---and-motherly-love/article720138/. Accessed 15 Aug. 2019.

Frank, Priscilla. "The Beautiful Story Of An Artist With Down Syndrome Who Never Spoke A Word," *Huffpost*, 9 June 2016, www.huffingtonpost.ca/entry/judith-scott-joyce-scott-art_us_57c9cdafe4b0e60d31df1b2c. Accessed 5 Aug. 2019.

Gates, Henry Louis. *Loose Cannons: Notes on the Culture Wars.* Oxford, 1993.

Grenville, Bruce. "Mortality: Death and the Time-based Image," *Death and the Family*, Presentation House Gallery, 1997.

Hooks, Bell. *Feminist Theory: From the Margin to the Centre.* South End Press, 1984.

Hrdy, Sarah Blaffer. *Mother Nature: A History of Mothers, Infants, and Natural Selection.* Pantheon Books, 1999.

Kittay, Eva Feder. "Centering Justice on Dependency and Recovering Freedom." *Hypatia*, vol. 30, no. 1, 2015, 285-91, onlinelibrary.wiley. com.ocadu.idm.oclc.org/doi/10.1111/hypa.12131/full. Accessed 5 Aug. 2018.

MacKenzie, Elizabeth. "Negotiating Doubt: Radiant Monster (1996-98)." *Elizabeth MacKenzie*, blogs.eciad.ca/elizabethmackenzie/?page_id=1190. Accessed 27 August 2017.

Nussbaum, Martha. *Frontiers of Justice: Disability, Nationality, Species Membership.* Harvard University Press, 2006.

"Obituary." Toronto Star, 2019, www.legacy.com/obituaries/thestar/ obituary.aspx?pid=177062098. Accessed 5 Aug. 2019.

MacGregor, John M. *Metamorphosis—The Fiber Art of Judith Scott: The Outsider Artist and the Experience of Down's Syndrome.* Creative Growth Art Centre, 1999.

Mitchell, David T., and Sharon L. Snyder. *Cultural Locations of Disability.* University of Chicago, 2005.

Scott, Joyce. "Entwined: Judith Scott & Joyce Wallace Scott." *GRANTA 140: State of Mind / The Online Edition.* 13 Oct. 2017. granta.com/ entwined/. Accessed 9 Aug. 19.

Sedgwick, Eve.*Touching Feeling: Affect, Pedagogy, Performativity.* Duke University Press, 2003.

Siebers, Tobin. "Disability Aesthetics," *PMLA*, vol. 120, no. 2, 2005, pp. 542-46.

Siebers, Tobin. "My Withered Limb," *Disability, Art, and Culture (Part One).* vol 37, no. 2, 1998, hdl.handle.net/2027/spo.act2080. 0037. 202. Accessed on 5 Aug. 2019.

Thomson, Rosemarie Garland. *Extraordinary Bodies: Figuring Physical Disability in American Culture and Literature.* Columbia University Press, 1997.

Thomson, Rosemarie Garland. *Feminist Disability Studies.* Signs, Winter 2005.

Part II
Family Practices

Chapter Eight

The Durational Performance of the Parent-Artist and Other Subversive Acts

Niku Kashef

W ell before I became a parent, I grappled with the question of how to balance art practice and motherhood. How does a person who is never off the clock balance art and life? My research led me to curate an annual public series of panel discussions with artists, curators, cultural producers, and educators to talk about their experiences, support systems, lifestyles, the still prevalent taboos of the parent-artist, and how these individuals have navigated these waters. Repeated ideas emerged in these panels. The artist-parent would often return to the deliberate yet sometimes exhausting and sometimes mundane actions required of parenthood as source material in their art practice. For these artists, life is art, and art is life.

In my own practice, the family snapshot has been transformed into the creation of visual panoramas and purpose-based interventions informed by the incremental separation of parent and child—sharing my body, breastfeeding, then toddling, then walking, and then running away—and the chain of days my daughter spends entirely with her father hundreds of miles from our home, a total visual and physical separation. These questions arise for me: What are the effects of parenthood on art practice, and how do they affect creative express-ion? What part of parenthood is excluded? What part is made public? Do our children become a part of the work? Do we make our choices from a need for survival, from a logical response to circumstance, or

from a desire to subvert a societal expectation? As a way to further explore these questions, I invited five artists into dialogue.

Marni Kotak re-contextualizes parenthood as performance art. In *The Birth of Baby X*, she created her ideal birthing center in a gallery space and performed the birth publicly. In *Raising Baby X*, she continues the performance of motherhood-as-art until her son turns 18.

Courtney Kessel investigates collaboration with her daughter, Chloé, as a visible, changeable aspect of mothering. In the annually performed piece *In Balance With*, Kessel physically balances herself and her daughter along with objects from their life into a durational performance on a seesaw.

Seth Kaufman's practice has been expansive in the fields of performing arts, architecture, sculpture, and photography. His works have both been inspired by his role as father and grown into a practice that blurs the lines of where art meets everyday life with his daughter as collaborator. In his *PB&J* series, each morning he stands at his mother's heirloom cutting board to create unique sculptural peanut butter-and-jelly sandwiches for his daughter.

Jamison Carter and Margaret Griffith met in graduate school at Cranbrook Academy of Art in 1999. They have independent practices and have also collaborated together on works that allow for their two children to be a part of the process. They work in installation, sculpture, and drawing. While Griffith's work considers fragility and impermanence, Carter's current works offer mediation between material and maker, process and intervention.

In the questions posed, I was interested in how historic expectations of the parent and child differ from the various techniques contemporary artist-parents use to incorporate children in their work. How did they subvert expectations of what is appropriate? How was parenting used as a laboratory for exploring conceptual frameworks? Did their children become labour, helpers, collaborators? Was there an element of novelty or play? And finally, how did parenting rituals as techniques inform new works?

Marni Kotak

Niku: How have you engaged with, been inspired by and incorporated your son, his birth and your parenting in your practice?

Marni: I have consistently created performance art about my real-life experiences, so when I found out that I was pregnant in early 2011, I started to make work about this new and exciting experience and began to plan my birth as a public performance. I did a photo performance in front of the Buckingham Fountain and Congress Hotel in Chicago called *Pregnant Pookie*, enjoying the changes in my body; and a series of public baby showers beginning with one in Troy, NY, as part of a residency program at the Contemporary Art Center: Woodside; *You Are My Baby* at the LUMEN video/performance festival in Staten Island, where viewers could project images of their face onto my pregnant belly via a live-feed camera hooked to my cell phone; and *Advice for the Mom-to-Be* at Grace Exhibition Space in Brooklyn, NY, where audience members could offer me advice on how best to raise my son.

I met Elle Burchill and Andrea Monti of Microscope Gallery at an exhibition/performance I did in January 2011 before I learned that I was pregnant, and we began planning an exhibition for October 2011 of entirely different content. When I found out I was pregnant, I began imagining venues in which I could hold my son's birth as a performance. I told Elle, and she suggested that I do the birth at Microscope. I said, "Don't joke about it because I actually will." And she wasn't joking. The *Birth of Baby X* (Fig. 1) was scheduled for October 2011 around my due date and would be the launch of *Raising Baby X*, the ongoing performance of motherhood as art until my child grows into adulthood, roughly age eighteen.

Niku: Was this a trajectory you had expected prior to becoming a parent? Was this change a disruption for you? How was it when you first incorporated your son in your work and how has this shifted over the years?

Marni: I have been treating my real life as performance art for nearly two decades. I call these works "found performances," with a reference to Duchamp's found objects, as the performances are found from everyday life. My earliest works were photo performances of me engaged in various activities, such as showering, eating oysters, or rolling around naked in sugar. During the height of the Internet boom in the late 1990s, I created a work called *Livesystems.net* where I sold my

daily activities as products online. Around 2005, I began to reenact
past experiences as performances, such as *My Grandfather's Funeral*
(2009), *Sunny Blue Plymouth (Losing My Virginity)* (2010), and *How To
French Kiss* (2008).

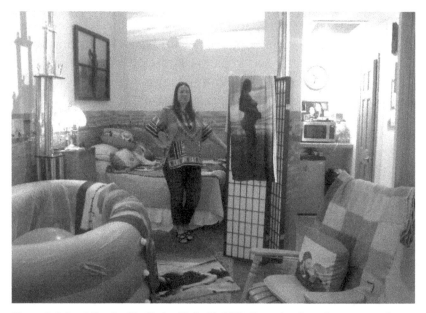

Figure 1. Marni Kotak, *The Birth of Baby X,* 2011. Durational performance and
installation. Image courtesy of the artist and Microscope Gallery.

I wasn't planning to have a child but once I did, I knew that I would do
this as a performance. As birth and raising a child are essentially
creation itself, I see these as the highest form of the work I do.

The Birth of Baby X was a durational performance conducted from 8
October through 7 November at Microscope Gallery in Brooklyn, New
York, culminating in the live birth of my baby boy Ajax on 25 October
2011. The entire gallery installation created my ideal homebirth centre,
including an inflatable birthing pool, the rocking chair my mother
used to rock me to sleep, my grandmother's bed upon which Baby X
was conceived, a shower stall with a curtain covered in photos from my
baby showers, an altar to Baby X's ultrasound, a kitchenette, and a
video projection. Also in the exhibition were two ten-foot trophies—
one dedicated to Baby X for being born, the other to me for giving
birth.

Raising Baby X, currently in its eighth year, is an ongoing performance art project in which I present the everyday act of raising my child as a work of art. The long-term project will encompass the overall span of Ajax's life from birth through attending college and developing an independent life. The performance takes many aspects of raising Ajax into consideration (food, education, clothing, healthcare, playtime, discipline, etc.) and incorporates photos, sculptures, journals, and video shot from Ajax's point of view.

The project has involved various public performances and exhibitions, including *Raising Baby X: Playtime!* (2013), a public playdate with Ajax; *Mad Meds* (2014), a solo exhibition about my attempt to withdraw from medications prescribed for postpartum depression; an ongoing series of annual public birthday party performances; and *Treehouse* (2017), where I created a treehouse in the gallery to spend quality time with my son as we recovered from a recent fire in our family's home.

Niku: Were there taboos surrounding parenting-art and birth in the contemporary art community and in your social community? Have you experienced any setbacks and prejudices about this parenting work?

Marni: I actually feel like the world embraced the *Birth of Baby X*. Although there was a lot of negative press, there was international interest in and positive support for the project. Birth, as an intense experience that involves pushing the body to its limits, follows in the tradition of performance art by such artists as Marina Abramovic, Chris Burden, and Carolee Schneemann. Ultimately, as Ajax was born healthy, I believe the project was viewed in a positive light, even though birth is typically viewed as something to be done in private, and in U.S. society, is highly medicalized.

I have found that *Raising Baby X* is more taboo in our culture, a project I actually feel is more significant, as it involves the entire eighteen years or so of raising a baby into young adulthood. Initially, when I announced the start of the project, I was accused of turning my son's life into some kind of *Truman Show*. This was something I did not want to do at all, so I decided that I would empower him by having him wear the camera. Since about three-months-old, I have been outfitting him regularly with a chest-mounted GoPro camera capturing the intricacies of his childhood from his own point of view.

Motherhood has largely been ignored in the history of art, even though it is so central and important to our lives. How our caregivers

raise us is crucial to how we will live our adult lives. *Raising Baby X* elevates parenting, normally observed as a commonplace element of life, to the level of high art.

Niku: How has your measurement for success in your practice changed since becoming a parent?

Marni: In the beginning, I was very focused on *Raising Baby X* as an art performance and its public presentations. For his birthday parties, I have staged elaborate public performances, even involving a marching band. Over time, I have come back to focus on the everyday act of raising my son first and to create the art out of this process. Many of the daily aspects of raising a child are somewhat mundane, so in order to elevate commonplace activities, I wear gold dresses and other beautiful attire at home. Ajax often helps me to style my hair, in this sense treating the private performance of motherhood, viewed only by Ajax and my husband Jason, as I would a public event.

Niku: Is this practice inappropriate? How does your collaboration/performance perhaps not align with societal and art world expectations of the artist and parent?

Marni: I think the way that I use my real life as the performance itself, even incorporating birth and parenting as art, is challenging for people to get their heads around. Where does one draw the line between life and art? For me, the two are intertwined. My understanding of this life-art fusion is inspired by artists such as Linda Montano and Allan Kaprow, and my work with parenting as art is also influenced by pioneers in this field such as Mary Kelly and Mierle Laderman Ukeles.

Courtney Kessel

Niku: In your practice, how have you engaged with, been inspired by, and incorporated your daughter?

Courtney: I started grad school as a single thirty-five-year-old mother, going through a divorce. Chloe was four when I moved to Athens, Ohio, to attend Ohio University. Prior to grad school and the divorce, I had considered homeschooling, but as I was attending school myself and no one else was around to help care for a small child, I put her in preschool and childcare. My first year of school was largely scheduled so that most of my class and studio time happened while she was being cared for. During a studio visit, a professor asked me why I don't create out of my own specificity of being slightly older and a

mother. At that time, I began researching the maternal in art, mother artists, and feminist maternal. Some of the very first books that I could find included Andrea Liss's *Feminist Art and the Maternal*, Myrel Chernick and Jennie Klein's *The M Word*, and Moyra Davey's *The Mother Reader* followed by *Of Woman Born, The Mother Knot*, and *Second Sex*. All along, I had been studying feminism and French feminism. If the second wave of feminism promoted women having the option of choosing family or career, the third must surely be about the merging of those things. This is when I decided to blend my experiences together. I had a drawing from an older sketchbook of a seesaw with me at one end and dirt or rocks at the other to balance. I thought about changing that to include Chloe and items from home as the weight to be balanced, which came to be the annual piece, *In Balance With* (Fig. 2). After minimal practice and no concept of how the piece would end, I asked a small group of fifteen to twenty people (fellow grads, professors, and friends) to attend this trial performance. During the performance, I checked in with her to see if she needed anything, but it wasn't until we reached a balance that I asked if she was ok or wanted to come down. She sat there playing with her Littlest Pet Shop toys and said no, she was fine. That is when I realized the piece would be over when she was ready for it to be, which is a continued reflection of being both a mother and an artist. My work can only continue until I am interrupted by her needs. This is true for both domestic tasks and studio practice.

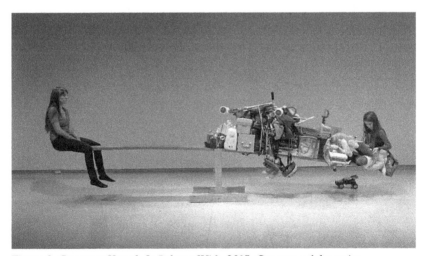

Figure 2. Courtney Kessel, *In Balance With*, 2015. Courtesy of the artist.

At this same time, I started to record sounds from home and put everything into one unedited track titled "Symphony of the Domestic."One morning she had a temper tantrum, so I recorded it. We were both going to be late for school, me for a 9:00 a.m. class I was teaching and she for kindergarten. When I finally arrived slightly tardy, I told the students about why I was late and said that I had proof if they wanted to hear. They unanimously (and maybe sadistically) said they did, so I played the recorded tantrum for them. Hearing my daughter's seven-minute crying and screaming "I hate you, mom" then dwindling to "I need you, mom" in the very public space of the university classroom, I realized a shift from private to public, shocked at how differently this experience could be for others. These two pieces were both in my MFA thesis exhibition, *Performing Visibility*. The conceptual underpinnings were to present these moments of subjective mothering, caregiving, and continual empathizing for an Other in the public sphere of the gallery and museum, which in most instances only show idealized images of the Madonna and Child (depicted predominantly by men).

Niku: Was this a trajectory you had expected prior to becoming a parent? Did you feel this change was a disruption for you? If so, how was it when you first incorporated your daughter in your work, and how has this shifted over time?

Courtney: I had not done work like this prior to having a child. Incorporating my experience of being a mother into my work bridged multiple aspects of my life. Since then, many instances from life have informed the work. For example, I was folding laundry and noticed that her clothes looked just like mine except for the fact that they were smaller. This sketch became the wall sculpture, *Cut From the Same*. She is much older now (fourteen), and our collaborations, performances, and inspirations reflect that. The work that I am currently researching involves coming-of-age rituals performed throughout the world, which generally prepare a young girl for marriage and/or motherhood (i.e., caring for others and looking good). In October 2017 in Copenhagen, I performed *A Blessing, A Wish, A Spell for the Next Generation*. In the months prior, I asked women artists and art historians who I knew, and some who I didn't, to contribute a text for a girl turning thirteen. This could be song lyrics, an action to be performed, a letter, a recipe, a prayer, a spell, which would offer words of wisdom during this significant time. Along with the texts, participants could offer an

object that is symbolic to the text or not. A book, which documents all of the texts, objects, anthropological research, and additional essays, is under way. My impetus for this project was to provide wisdom and advice from a collective feminist global voice that would prepare a girl for becoming a person of the world, not just a mother or wife, should she so choose.

Niku: Were there taboos surrounding parenting-art in the contemporary art community and in your social community? Have you experienced any setbacks and prejudices about this parenting work?

Courtney: The funny thing about engaging in this subject matter is that I received a lot of attention, with many international shows at first and now, slowly, more national ones. However, I now have the sense that my work is being ghettoized into shows that only include women artists or focus on maternal, family practice, or feminist themes. A fellow mother artist said to me recently that she is going to start saying no to exhibitions that are all female or mother specific, which makes sense to me. How can we create a shift in the contemporary art world if we are essentially making work just for and about ourselves? There is a shift happening (and within my lifetime), but it is very slow.

Niku: Do you see the work about parenting as collaboration?

Courtney: When I first started making work about the subjective maternal in 2010, it was definitely not collaboration, as my daughter was only six years old. Our interactions became sketches for future works or pieces in which we performed an idea for the camera or that I interpreted through sculptures or performances.

The work was a combination of natural interactions with my daughter framed and recontextualized by attempting to fill the "mother-shaped hole in contemporary art" [quoted from *Mothernism*, Lise Haller Baggessen] and a sort of protest. The protest was performing the visibility that women artists from the second wave did not have the ability to do. They could have a family and a career, but they were expected to leave the proverbial pram in the hallway outside the hallowed space of the gallery or museum. The two exceptions I think of from that time are Mary Kelly's *Post-Partum Document* and Mierle Laderman Ukeles' *Maintenance Art*.

Niku: Has your measurement for success in your practice changed since becoming a parent, and if so, how?

Courtney: I don't know if it has changed so much as it has become

more important. Since I have a daughter, I feel that the work I am doing is important for her, the next generation of women growing up in a very strange, frighteningly accessible, Internet, and social media culture. For this reason, I attempt to have as much candid conversation and availability to her as possible. My work is shifting to reflect the ever-changing work of motherhood.

Niku: Is this practice inappropriate—meaning how does your collaboration, performance, and inspiration perhaps not align with societal and art world expectations of the artist and parent?

Courtney: During my MFA thesis defense, one of my male committee members suggested that one piece could be taken as exploitative. This video was of just my daughter's head and hair as she lay in the bathtub with water submerging all but her face. None of the work showed any nudity. She gazes at the camera, as she allows the movements of her head to sway her hair under the water. I edited the video to have a soft cameo circling her head (and allowed the video to play forward then in reverse, creating a sort of otherworldliness). I included this piece in my thesis, as it directly reflected the maternal gaze back into the camera. These are the moments that could only happen in the comfort of home with the safety of having mom nearby. I defended my choice by stating that, as her mother, I don't make her do any of this work with me. We are really and truly doing this together. It's fun and smart (I think) and is constantly changing. Who knows where the inspiration for the next work will come from.

Seth Kaufman

Niku: How did becoming a partner and parent affect your art practice?

Seth: The act of getting married and having children was very impactful, as it also coincided with the economic crash, a sort of double whammy. I was realizing that Magdalena and I were going to stay together (it was clear there was nowhere else to go), and I remember that I looked at her and felt stuck. I had never thought in my life I would end up anywhere; I never had a destination. This was the first time in my adult life that I knew that this person was the place to go; this person was the only way I could grow and develop and expand and become fully who I had to be in cooperation. There was no question that she was my other.

My art practice was very much my own thing, part of my own trajectory—my world, my whims, my passions, my dedication, my focus. Now I had to consider how I could do whatever I want to do with another person in the scenario.

In terms of being an artist and sharing a life, I couldn't have had a better experience. It was really that change in myself. At the time, I didn't want a child, but I knew that she did, and I wanted to see her have this experience, and I knew she wanted to have this with me.

Niku: So you made a collaborative art piece?

Seth: So we made a collaborative art piece. And I thought the collaborative art piece would be largely her responsibility. I know that seems naïve. I thought, "I'll be around, I'm sure," but that changed very quickly, partially because conception was problematic and was fraught with a genetic disorder, which made us predisposed to having difficult pregnancies and very sick babies. The wake-up call came very quickly, because watching someone have an experience turned into having to watch a life-and-death struggle for years. That was almost completely the end of my art career. I didn't know what to say or what to do or how to make art out of the situation. To this day, I have a very difficult time justifying making any thing because I don't think anything rises to the significance of holding a child who is taking its first and last breath in your arms. It becomes very difficult to negotiate objects after that. Conceptually, what do I make? What do I create? We did go on to have a healthy baby, who is so fabulous.

Niku: You and your wife, Magdalena Consuelo Garcia, started The Knowing Garden Community School together. How did you first begin to combine your family into your art practice?

Seth: Magdalena was an elementary school teacher in the public school system and was looking for an alternative situation for our daughter. She would go to alternative preschools and talk to parents, and these people all got together at a very primary time and basically launched a school.

As an artist, I had always thought that I was at the top of the discussion. Artists are encouraged to think that we are the creators. The title "artist" is the most special of the special: there is no finer pursuit. I wasn't thinking about all the fine pursuits of others in the world, until I realized that I'm not the tip of the spear; I'm the handle. I have a community-leader wife. I thought, "What if she's not here to support

my career; what if I'm second fiddle? What if I'm at the back of the orchestra helping the thing move along?" That was the impetus for how the school started. My ego was confronted, and I needed that grounding and to recognize this humility for my growth.

Many years went by when I was scrambling around making things. I lost a dealer who was one of the most prominent in the art world. So when the art market and economy crashed, I was without a dealer (and income), and I had a family and I couldn't think of what to do. I began to pour myself into my child, my wife, the school, her practice, and creating a nest. The survival of the family unit became critical. One of my first creative disciplines was architecture, and we renovated two houses, tore down a house, and built a new house. At that time, my creative practice was nesting, building an environment for us to live in a way where I felt I could be of best service to my family and sharing my creativity through design and architecture. At that point, I had almost no career, no ideas. Massive projects were coming to conclusion, but I had a beautiful nest.... There I was making breakfast and trying to squeeze out as much identity as I could; I was grasping at the identity of "fine artist" and I thought, "This could be the end."

I was at the cutting board making sandwiches, cutting them up—grasping for something. I had been making and cutting sandwiches for years before I ever photographed them. I think that sharing my enthusiasm for a visual language was a part of entertaining my child, and I remember the day when I was looking down and realized, "This is my practice." I stood there and knew that I should photograph these pieces. I knew this was a commitment to going back into the world as an artist whose practice involved serving his family, and there was no place that I knew of in the art world for that sort of art. I didn't know of anyone of any consequence who would make food-art for his or her kid and consider it a design practice. I knew at that point I was reentering the market with peanut butter and jelly sandwich designs (Fig. 3). I posted the first ones, and there was a lot of response to them, but it was scary as I was really judging myself and feeling that the people who take their work seriously in the art world were not taking my work very seriously, and that was okay.

Figure 3. Seth Kaufman, 25 PB&J Photos, inkjet print on MDO plywood. Courtesy of the artist.

Niku: You say the work wasn't taken seriously. Was there pushback?

Seth: A lot of people responded to the work via social media, but it became one of those things that was sort of "You're the guy that makes food art, oh there's a lady who does origami, you have to check out this YouTube channel." I realized the definition of "artist" is very loose. I've always said the definition of an artist is a person who makes art and pursues a career making art. It's not the making but the pursuing of a career and the identity of that.

As with the *PB&J* work, I've never had an idea that is fully executed as initially conceptualized; it has always been an interpretation of the environment and my place in that moment. I don't just design sandwiches and cut them: I step up to the board, and they are very

much an experience, a total immersion. I'm having the mystique of the artist experience in a peanut butter and jelly. I didn't know I would ever return to having a career making visual images and art. I didn't realize that posting and printing these images for sale was enough of an affirmation that I was an artist.

This work can also become a bit of an albatross. My daughter this morning made a piece of toast and spread some peanut butter and took it to school. She knows I can make this for her, but she made her own. I think that becomes a metaphor for all of our interactions. My practice is living and breathing, both in relationship to her and not in relationship to her. But when it is in relationship with her, it puts on a lot of pressure. I want to share my creative view and also be a dad and appreciate her creative work. I have to be willing to not ask "would you like me to make you a peanut butter and jelly sandwich?" If she would like me to, she will ask. I have to be willing to offer an opportunity for a photograph but not judge her for not being in the mood. My daughter is a very much part of my practice now, but I have to be careful not to put that pressure on her.

Niku: At this time, would you consider the relationship with your daughter to be a volitional collaboration involving play, sharing, and growth?

Seth: She is now very much a collaborator, but at the beginning, she was my inspiration. She can now say, "Dad, look at this." There are also a lot of opportunities that I miss because she is not interested in my practice in that moment. I have to be careful that she does not become a subject or trained. There is a moment I have to be present and play and be her father and let her lead. And she is discovering her own practice. Sometimes she doesn't need a mentor; she needs me as a dad even if it is cool having an in-house mentor. I have college students who are doing the same exercises, and I'm having the same conversations with them that I'm having with a twelve-year-old. I make sure to be cognizant that I'm not always a college professor and am also a dad. It becomes very deliberate. I have to be sensitive to the different expectations and needs that she has.

Niku: Has your measurement of success in your practice changed from when you first became an artist to when you went back to the cutting board?

Seth: Initially perhaps it was sales and notoriety, and I think to

some extent a desire to be completely self-indulgent. There is something really nice about getting public recognition for doing whatever you want to do. I make stuff that people buy; there is license there, and it is also a slippery slope. At the point at which I think I was very immature as an artist the measure of success was how much self-indulgence I could have. I could roll out of bed, light a cigarette, start working, go to the studio, pack up some work, and have the shippers come and get it. The more I could make a living doing whatever I wanted to do and serving no one other than the people who were buying the work and the gallery system that was selling the work was pretty satisfying. But I can't survive doing that because it's a closed movement, a dead end to spiritual growth for me and to becoming a person of service who brings love and light to the world, which I believe comes as a part of collaboration. I don't know that I've ever done that in an isolated move. I don't know that it is even possible. My measure of success has radically changed almost regardless of my career and type of work.

With the cutting board work, I was relieved to know that I didn't have to stop calling myself an artist. At the point at which I took that first photograph, it was sheer relief to know that I'm still an artist and I'm a dad and I'm a partner.

I now have no question of whether I am an artist. There is no ambiguity there. I'm fluid in my ability to be at the tip of the spear as well as a team member and not front and centre. I can celebrate and support others, my daughter, my partner. I have no expectations about being an artist in the world. My aspiration is to make what I want for the purpose of serving, without self-indulgence. I do find that I criticize myself, though, and slow my creative process down because I think there is no market for this work.

Once the pieces didn't go viral and no publisher or gallery came around, once there was a thud (monetarily), aside from a few peers and contemporaries who understood the necessity and criticality of the work, it became more difficult to sustain that fluidity. With social media, I have to be careful it's not a need to receive positive reinforcement and praise. I have no stake in whether the works are taken seriously based on "likes," let alone whether a publisher wants to work with me. So, my aspiration as an artist is to engage with my community out of service—to bring the totality of myself to it with no expectation of remuneration or even the approval of my daughter. I'm making work

because it feels like I should be.

Niku: Does your practice perhaps not align with the societal expectation of an artist or what is expected of a parent?

Seth: One of the first large-scale projects I did was the pedophile project, where I did a search for pedophiles in my area based on zip code and I was amazed that within a mile radius there were thirty pedophiles living. I took all thirty of these faces, merged them into a composite face, and then reproduced that template thirty times for the twentieth anniversary show at the Armory Center. Doing a piece about the thirty pedophiles who lived in our vicinity is probably out of the bounds of making work about having a child and doesn't align of what is expected of an artist-parent.

Margaret Griffith and Jamison Carter

Niku: Would you describe how you have both engaged with, been inspired by, and/or incorporated your children into your art practices? And has having children affected or shifted your academic research and art practice?

Margaret: Our studio practice is incorporated into our home life and always has been. We have studios adjacent to our house, so our daughters are aware of what we make, do, and create in our spaces all the time. My practice has been influenced by my physical environment, which became more evident when we bought our first house and installed a gate for privacy and safety when Josie and Abby were young. In regards to research, perhaps no, but the art practice has changed. My studio time is built around their school and social schedule. I work as much as I can on the weekends when they have downtime and as educators, we both take summers off and have winter break. I use that time to work on my art. It's a huge balancing act. We have had our children participate in some of our projects such as the mud prints I mention below. Our eight-year-old, Abby, loves to draw in our studios and we always have paper and such for her. She also likes to mimic what we do, such as copying a pattern on tracing paper (part of my process) or drawing coloured lines on black paper like her dad.

Jamison: I agree with all things above, but can add that Josie, our eleven-year-old, has been drawing from anime and manga for the past few years. She sometimes makes four or five drawings in a day. And

she is hard on herself! She certainly has a standard she is trying to achieve, which I think she learned from seeing us push in the studio. It's a normal thing to them. I've always known I was going to have a family, and I did imagine at one point an at-home studio. And now we have it. I don't think we have ever seen our home life and art practice as purposefully separate. With Margaret and I both being artists, it's already woven into the fabric of the family dynamic.

Niku: Was this a trajectory you had expected prior to becoming a parent? Was this change an inconvenience or disruption for either of you? How have things shifted since you first incorporated your children and your family into your work?

Margaret: It was clear to me that having a studio at home was the only way I could be a productive artist and mother. For a spell my studio was a room inside the house, next to the kids' room, so if they needed anything or if I wanted to work during their naps or after bedtime, I could be available for them. The disruption is really about moving the hours around of when and how you work. For example, we both used to always have Sundays as studio days. Now, maybe we work for a little while on a Sunday, but we also might be going for a family bike ride. We did have the girls help us on a collaborative project for an exhibition at Descanso Gardens. We coated aluminum gate replicas with mud and matte medium and then made prints of them onto paper. They helped us cover them with mud and seemed to enjoy the process. What kid doesn't want to play with mud? (Fig. 4)

Figure 4. Jamison Carter and Margaret Griffith, *Earthen Gates*, 2015. Soil and Acrylic binder on paper, 18' x 6-1/2'. Photo courtesy of the artists.

Jamison: Becoming a parent is absolutely a disruption. If it's not, then you aren't parenting right. It's definitely not an inconvenience. There were times when Margaret and I shared an at-home studio. I was the Art Department tech at Occidental College and basically used the art department as my studio for a couple of years. I also rented spaces nearby once the kids got a little older. I'd stop at the studio on my way home from one of my teaching gigs and work for a couple of hours. Everything was planned; there was very little time for play in the studio. While driving, I'm planning what I want to get accomplished.

Niku: Were there taboos surrounding parenting in the contemporary art community and in your social community? Have you experienced any setbacks and prejudices?

Margaret: When I was pregnant with our first child, Josephine, I waited quite a while before I told my gallerist. We knew of only one other artist couple that had a child at the time, and they were only a few months ahead of us. It was unknown territory for us, and we were just starting our art careers at the same time.

When I did finally tell her, I was relieved and happy to find that she was excited and very supportive. My contract did not change, and I had additional exhibitions subsequently (and a second child). I haven't experienced any setbacks or prejudices that I am aware of.

Jamison: I concur. I imagine there is some part of the art world that might think this way, but I believe it's quickly shrinking. The only setbacks might be that we didn't get to go to the party that lasted until 6:00 a.m.

Niku: Do you see the children and family structure as potential collaborators?

Margaret: Jamison and I have collaborated on three projects together since becoming parents. Our children have been able to watch that process unfold, and we have included them in the process when we could. I also think as they get older they will be able to have a greater dialogue with us regarding our work.

Jamison: Additionally, both children have expressed great interest in materials and processes, so they are learning and could be incorporated into the work on a more practical level.

Niku: Has your measurement for success in your practice changed since becoming a parent, and if so, how? How has the family dynamic shifted to support and be a part of your art practice?

Margaret: I had a small solo exhibition when Josie was a newborn, and I felt successful just for completing the work on time. The family dynamic is one that requires flexibility and patience in order to support our art practice. Not that either one of us has totally mastered it. We do take turns a lot, and if one of us has a deadline or gallery/show obligations, we work to help each other by taking care of family needs for that period of time.

Jamison: In the big picture, no. My family is part of my success. I have had periods of frustration about needing or wanting to be in the studio but also needing or wanting to be with the kids. It's made me evaluate the expectations I have in the short run about my practice, but I don't think having a family will hold me from getting anywhere I would have gotten without them. I think the family dynamic has changed in that when we include each other and our kids in the process (at least peripherally), it creates transparency and allows all the family members to become emotionally invested—allowing for a stronger bond.

Niku: Are there ways that you have perceived your family dynamic to be inappropriate or not in alignment with societal or art world expectations of how the artist, academic, and parent should be?

Margaret: I have no idea how it should be, but I know a lot of successful artists who are parents, and others who are not. I think in the past, historically speaking, there were fewer female artists who were also mothers, which perhaps came out of the feminist movement. But I think changes are happening in a positive way. Last year, a curator asked me if I needed housing while installing a piece in Houston that could accommodate not just myself and my husband but also our kids. I loved that she considered my entire family, and I think that's a shift in the right direction.

Jamison: Being in Los Angeles is certainly a big part of why our artist family can happily exist. The culture is accepting of it, which is why we are here. We are both from North Carolina, and as progressive and beautiful as parts of it are, our lifestyle would not be possible there. Our family has two working parents (something that could be societal-ly frowned upon due to extremely dated but very real conservative val-ues), both tenured professors in the community colleges able to eke out a middle-class existence. Jobs in education do appear from time to time, but both of us finding teaching jobs at the same time? Unlikely. It took

a lot of work to get there, but we both set our sights on teaching because it does afford what artists need, time and a living wage. Los Angeles and a few other cities have the avenues for us to engage in our ambition. With less opportunity, ambition starts to feel like a dream, something less attainable and frivolous because of a lack of support, which is what I see when I go back to visit. The sheer amount of opportunity in Los Angeles for teaching and showing work—the community that has supported and fed us, the creative momentum in this city—is what has helped us survive and continue to climb the ladder. That ladder or career arc does not exist in most places and would exist in a very different way in Northern California.

Conclusion

In our conversations, some through-lines appeared: parenting as a form of extended durational performance wherein mundane rituals could become source material; whimsical actions elevated as art practice; a sense of play; and parent-artists sensitive to a volitional equity for their children, allowing them to opt-out or direct the resulting work in some way. Some of the artists overtly challenge societal and art-world expectations of appropriateness, but all sense that in the intermingling of art and life, there is greater opportunity for growth for both parents and children.

I am reminded of this passage from Seth Kaufman's *PB&J* work. He writes the following:

> "Husband" and "Father," titles I am awakened to at 5:30 A.M. and before anyone calls me "Artist"; Not remembering the last time I burned creative till dawn and slept in, day after day.

> Now, coming-to, vision blurred, hips squared up to the heirloom cutting board where my mother once chopped, preparing to fulfill yet another high-pitched and petulant request for PB&J to be packed neatly into a tiny pink backpack.

> For decades, I forged an identity and with singleness of purpose, explored deep whims to produce precious objects and cultural capital.

> Now, post global collapse and art dealer condolences, I find myself planted in the persistent accountability of nesting and a

remittent yet reasonable need for my simple affection, day after day.

As alien as it is perfect; As perfect as if every single personal and professional achievement, indulgence, rapture and regret each bent then straightened, now strengthens me for this daily ritual and in this moment I am equally present as Husband, Father, and Artist, to serve.

There is such beauty to the deeply difficult truth that neither the artist nor the parent is ever off the clock. These roles are each, as Kaufman writes, "equally present." This grand durational performance as parent is messy and full of "shoulds." These artists find their balance and sustained practice from that hidden and imperfect real-life position, a place between an often unseen vulnerability and a very public strength through the radical subversive actions of being both parent and artist.

Work Cited

Kaufman, Seth. "Artist's Statement." Seth Kaufman, sethkaufman.com/pbj/#. Accessed 6 Aug. 2019.

Chapter Nine

Inside/Outside/Beside the Mothering Machine: A Conversation with Jess Dobkin

Charles Reeve

I met Jess Dobkin in 2006, when the gallery I ran at the Ontario College of Art and Design (now OCAD University) hosted the first iteration of *The Lactation Station Breast Milk Bar* as a co-presentation with FADO Performance Art Centre, curated by Paul Coulliard (Fig. 1). This landmark work turned the gallery into a chi-chi tasting bar but with two key differences: it invited audiences of all ages (ample stroller parking, for example), and patrons sampled breastmilk, not wine or scotch. Everyone involved had to roll up their sleeves—the publicity kept media relations on their toes, concerns about right-wing and anti-gay objectors put the school's security services on alert, and Jess had her hands full with organizing the props, deftly handling media requests, and working with lactating mothers to prepare the breastmilk samples.

In the years since, *The Lactation Station* has become the gift that keeps on giving. Aside from the enormous response at the time (over three hundred people attended the event, with about one hundred people sampling the wares), the piece was subsequently restaged in 2012 (curated by Miriam Ginestier and presented by Studio 303 at OFFTA in Montreal) and 2016 (curated by Natalie Loveless and presented by New Maternalisms at the University of Alberta's FAB Gallery in Edmonton);

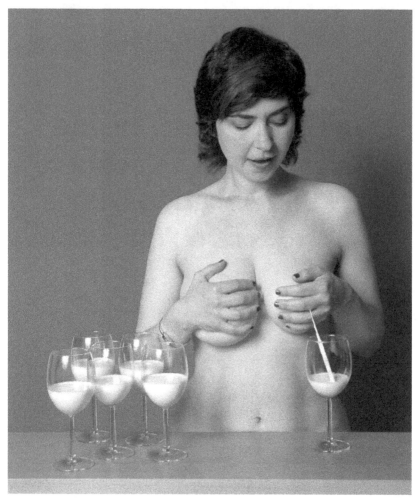

Figure 1. Jess Dobkin, *The Lactation Station Breast Milk Bar*, 2006. Promotional image announcing the public tasting. Photo: David Hawe.

it has also generated numerous scholarly articles (Aristarkhova; Dobkin; Reeve; van Esterik; Reinhardt; Buller). But its longevity has also highlighted what made *The Lactation Station* a success. Although serving breastmilk was bound to attract attention, the work's lengthy afterlife followed from Jess's thoughtful positioning and commentary. Rather than arguing that in some sense people ought to try the breast-milk, Jess framed it as a conversation about not only motherhood but also—as we discuss below—many other things as well: taste, trust, intimacy, amazement.

I've come to think of this careful holding and provoking of multiple responses at once as Dobkin's trademark—a series of devices typically deployed with more than a dash of humour to unsettle the putatively self-evident (of course we don't drink breastmilk, except that many of us have). In this conversation, we take up mothering as an aspect of her biography and subtheme of her art practice in the context of the bigger questions about sexuality around which her practice often revolves.

Reeve: Many of us spend our early adulthood protesting against the bourgeois, heteronormative formation, only to find ourselves sutured into at least some fundamental aspects of it and wondering what happened—and why we find it deeply rewarding. Could you talk a bit about your journey before we get into some of the ways that your performances over the years have destabilized and reconstructed those ideologies?

Dobkin: By the time I was in high school I knew that I wasn't straight, even if it took a couple more years to come out publically and self-identify as a lesbian. In some ways, it was a difficult and painful process, at a time where you didn't see rainbow flags in store windows, pride marches sponsored by national banks, or queer and trans characters on TV and in movies—but it was also an incredibly liberating time for me. In questioning my sexuality, other questioning of social norms and conventions simultaneously opened up. I had a way of opting out and connecting with communities that were exploring uncharted territory and forging their own futures. This also aligned with my development as an artist, with queerness and art as intersecting projects of liberation, resistance, and experimentation—all grounded in community. Aspects of my journey are also tied to childhood trauma where I simply did not envision a future self; I didn't imagine that I would survive to reach adulthood. But I did, and as my childhood receded further into the past, I woke up to realize that I've been here a long time and that maybe my life is going to continue for a while. I began to find a cautious trust in the future and then think about previously unthinkable things, like having kids. But the possibility of parenting also came to me later because when I was growing up, I didn't know any openly queer adults creating families. I didn't have any role models. I remember reading Minnie Bruce Pratt's poetry where she powerfully describes the anguish of being separated from her children because she's a lesbian and

similar stories of lesbians losing custody of their children. And now, thirty years later, the gay baby boom is on. In the turn of one generation, queer families are becoming an accepted norm. I'm proud and amazed by this progress—that my teen daughter's friends swoon over RuPaul and my het [heterosexual] neighbours wish me a happy Pride, but there's also a sadness in the loss of that radical, marginal, magical space: the time before we were invited to live like everyone else. Because I never wanted to live like everyone else. I wanted to stay weird (Fig. 2).

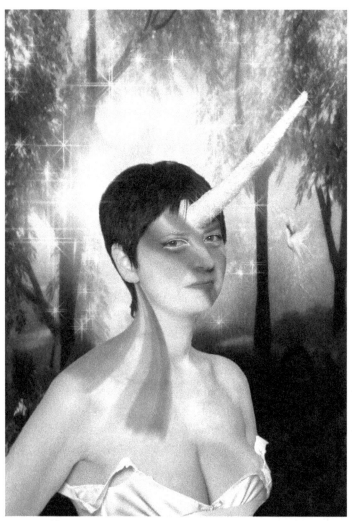

Figure 2. Jess Dobkin, *Everything I've Got,* 2010. Promotional image announcing the live performance. Photo: David Hawe.

Reeve: I mentioned marriage, kids, and family deliberately, as many of your works have directly or implicitly address those themes: marriage (*An Ontario Bride Seeks American Wives*, 2003; *Marry Me*, 2004); kids (*The Lactation Station Breast Milk Bar*, 2006; *Being Green*, 2009; *Free Childcare Provided*, 2013); and family (*Imagined Family Portraits*, launched in 2007). Some of this relates to things going on at the time, such as the progress of marriage equality in Canada in the early part of this century, and some of this relates to things in your life, like thinking about what it would mean to bring a kid into your life.

Dobkin: My experience as an adult child informs a lot of my work: trying to understand and heal my dysfunctional and disrupted lineage, learning to tap into spirit before and beyond the constructed story of my life. I don't have a relationship with my family of origin. My family is my daughter, my partner, and my chosen loved ones that are sisters, aunts, uncles, and cousins—my relations, not my relatives. In my work and life, a wounded part of me will probably always long for connection to a blood line, notwithstanding its personal and political problems. That bruise might always be tender...I'm interested in the crossroads of motherhood and childhood. Often when motherhood is discussed, it seems totally divorced from the experience of having been a child. It doesn't acknowledge that all of us—mothers included—are children. Motherhood is most compelling for me when I straddle both experiences simultaneously, of being an adult child who parents. My experience is also rooted in having my daughter as a single parent, which, again, doesn't conform to the heteronormative expectation of a two-parent family. That has been shifting as I've been with my partner for six years, as we queerly and creatively define our relationship and our family, and tussle with the awkwardness of limiting vocabulary and narrow constructs that are available to us.

Reeve: That last point—about limiting vocabulary and narrow constructs—strikes me as important. It makes me think about how the early pieces addressing marriage tend to feel to me like attempts to recode that institution as something not necessarily linked to heteronormativity. For instance, if married people let each other in line at the post office or buy each other ice cream, why should only straight people enjoy that sweetness?

Dobkin: Sure. Part of what I'm doing is responding to current political events, finding ways to process my experience and generate a

wider conversation. I'm commenting on the social, economic, and legal privilege of straight married couples, but also questioning why this hierarchy exists at all. Why should the decision to partner grant such benefits? Why shouldn't we all care for and support each other regardless of relationship or marital status? But I also feel hopeful that other family models are being actively explored and becoming more visible. So many families—most, maybe—don't fit the two-parent-heteronormative paradigm, which we must remember is a social construction designed and enforced by the patriarchy. If we prioritized what is best for children and women, our young would be raised in tribes, clans, villages.

Reeve: Yes, there's real value in rethinking the privilege accorded to that two-parent heteronormative paradigm: is it really as self-evident, as fantastic, as is widely assumed? I think that's why I'm interested in your works that seem to me to merge the act of sex with having children (for example, *Being Green*, where, as you've commented, having had a child made the puppetry possible) and then on the other hand separate them (I think of *Fee for Service* and *Power Ball*). Is there a doubled motion there, wherein a piece like *Being Green* wants to link motherhood to what some people might see as the extreme sexual practice of fisting, while *Fee for Service* wants to radically deinstrumentalize sex, to decouple sex from reproduction as absolutely as possible?

Dobkin: No, I don't think so. For me, all of them are similarly playful approaches to taboos—and expressions of women's sexual power and agency. I've wanted to create space to perform all aspects of myself simultaneously—to be a lover, parent, pervert, and puppet. I want to make performances exploring sex with all aspects and experiences invited—pleasure, power, trauma, parenthood, relationships, sex work, aging. These would be the search engine key words.

I'm amused that it was my daughter's birth that paved the way for my lover's fist in *Being Green*, but I'm not sure that audiences would necessarily make the parenting connection in that performance. It's certainly there for me, alongside a return to my own childhood love of Kermit the Frog and all his Muppet pals. *Fee for Service* and *Power Ball* are both performances about transactional sex, but they also relate and are inspired by my experience as a parent, too. I created *Fee for Service* for Nuit Blanche, an all-night cultural event where I performed from

7:00 p.m. until sunrise the following morning. I remember thinking how hilarious it was that Nuit Blanche was promoting the event as a thrilling adventure to stay up all night. At the time, I was a single mom of a fifteen-month-old baby, so my relationship with the deep hours of the night was well worn, having endured marathons of sleepless nights. For that event, I also considered the invisible and marginalized voices and experiences of people who occupy the night—including shift workers, street workers, people who are homeless, and new parents, among others. And interested in what it would mean to perform sex work in a gallery context, especially in light of the legal challenge to decriminalize prostitution in Canada. And again, as in the Kermit piece, my daughter's birth paved way for the pencil sharpener in *Fee for Service!* My sexual behaviour and expression have always been divorced from procreation, and it has been very freeing that I can have all the sex I want without any risk of getting pregnant. And conversely, my experience of getting pregnant was completely clinical—actually in a clinic. Now that I'm in my late 40s, I'm turning my attention to menopause, the next stage of women's life cycle that is systematically dishonored and denied. I'm now thinking about my relationship to my body as a middle-aged woman and my body in performance.

Reeve: Thinking about your changing relationship to your body in performance reminds me of another thread I'd like to bring into this conversation, namely, the concern you've shown over the years about the precarious status of the artist (*Artists' Soup Kitchen*, 2012; *Affirmations for Artists*, 2012; *Performance Artist for Hire*, 2013; *The Performance Art Army*, 2014; *The Artist-Run Newsstand*, 2015-16). One piece we discussed several years ago that never got off the ground—the politics were too complicated—but which I find enormously interesting involved bringing that concern together with the instrumentalization of sex as exchange. The idea was to create a dinner for a select group of high-end art supporters, the dinner being paid for by the proceeds of sex work performed by the artists. This piece strikes me as hugely upping the ante of Andrea Fraser's *Untitled* (2003) because we were thinking of it in the context of sex work being much more prominent among university students—art students in particular—than anyone tends to acknowledge. Of course I'm aware of the discourse that positions sex work as a career like any other, but I also have a sense that it keeps on being an issue because that is not most sex workers'

experience of it. So in that context, this idea struck me as a lament that was compelling because it would have catalogued so much that's gone wrong. Is there a way out of this? Is there an upside to this? I think of humour as a crucial part of your palette, but I find it hard to see humour in this scenario.

Dobkin: I guess I don't frame sex work in that way. I hope that the projects and performances I've created about sex work speak to the complexity of it. Much like motherhood—and much like being an artist—it isn't a monolithic identity. It is as unique and personal as being an artist, a parent, a teacher. I think women experience so much that has gone wrong in any career they find themselves in. If you are a sex worker, artist, TV producer, bus driver, doctor or teacher, you will be vulnerable to sexual harassment and violence and that is what is now, finally, in the public discourse. I think there are interesting connections for me both personally and conceptually between sex work and performance art. I've sometimes described sex work as the performance art practice that pays well. I can't and would never try to speak about others' experience of sex work. As with anything, I'm only authorized to mine my own history and memory, and even that is plenty of tangle and riddle to wrestle with. But as much as I'm interested in taboos, I'm even more interested in intimacies, intersections, and synergies: the ways that motherhood and sex work align, even though we live in a culture where a conversation bridging those two identities is considered scandalous. But of course so many sex workers are also mothers. Of course many artists are sex workers. And sometimes most taboo and invisible of all—artists are sometimes mothers.

But now getting back to that proposed work. I dream of presenting that project in many permutations. In many respects, it is a conversation about labour and comes out of my interest in initiating opportunities for dialogues that we don't have in public. It's another taboo to talk about income, and even if you know someone's job title, it's rarer to know how they spend the hours of their day, what excites them in their work, what are the obstacles, experiments or risks. The version I proposed to a festival was a potluck dinner of twelve people where each person would contribute a dish that cost the equivalent of one hour of their earned income. When presenting the dish to the group, they would describe in detail what they did during that hour that paid

for the dish. The twelve participants would come from a variety of work—perhaps a teacher, caregiver, politician, sex worker, hairdresser, accountant, medical secretary, plumber, and so on—and they would engage in a conversation about labour. I'm curious about people's inner lives, their challenges, quirks, and passions. And I'm a lesbian, so I love a potluck and respect it as an art form.

I have another version that I want to do at a university, where the twelve participants would be affiliated with the university—an undergrad, grad student, sessional instructor, staff, technician, dean, faculty, etc. But it wouldn't be contextualized as a statement of inequality or hierarchy, but an opportunity to break bread and listen, to understand each other better. I think that in a university, there are many students who have no idea what a dean does in a day's work and what their issues look like, in the same way that faculty might not be tuned in to students. And I think most people don't understand the exploitative and unjust load that sessional instructors are shouldering. If they did, the system would need to change. I still want to do this project. And thinking about it now brings me to an issue I'm always reckoning with in my practice of working within or without institutional structures and support—that this might be a project that I need to organize myself, independently, and not expect it to be curated by a festival or gallery.

Reeve: I want to circle back to something you hinted at a moment ago, about your body changing and, for instance, how you think about sex has shifted in relation to that and ask you about whether there's a link to how you think about your body as your artistic medium. For many years, going back at least to *The Two Boobs (in Hanging Out)* (2003), partial or complete nudity has been, along with humour, one of your more important tools. Has the meaning of that changed for you over the years? Does the premothering body mean something different from the postmothering body?

Dobkin: I continue to think about my body as a material, and I'm also thinking more about how I engage and communicate—through my body—with other bodies. Performance for me has always been about a dynamic exchange with an audience, and I've been thinking a lot about who is in that audience and the need to expand our language and tools for communication. My relationship with my body continues to evolve through time and cycles, and there's more creative space for

discovery when I understand it as a vessel, something I borrow that isn't necessarily mine, but something that has been lent to me. Perhaps as I'm saying this, I'm already a puppet. But I don't carry "pre" and "post" markers in terms of mothering. There have been so many other tracks of time and experience, perhaps that is but one of them. I do see the "pre" and "post" of motherhood in relation to my time and commitment. Becoming a parent has required such dedication and energy, and there are many barriers for artists who are also parents. I was saying to someone the other day that there should be a budget line in art council grant applications for childcare—and for eldercare.

In terms of humour, I recognize that it is subjective. I appreciate that audiences will have varying responses to my work, and that's what makes the conversation compelling. Sometimes in my work, I'm sending out a call to find my people, sending up the signal to find the folks who share my questions, vulnerabilities, outrage, whatever. Along with that, it's important not to underestimate an audience's maturity and depth. People want to engage. We are inherently curious and interested, even if it sometimes gets masked by fear or defensiveness. Making a performance, like any act of connection or attempt at intimacy is a leap of faith. It is a risk, and it doesn't feel safe. And we must seek out and create these spaces—to experiment, to imagine what is possible, to consider new ways of being.

Works Cited

Aristarkhova, Irina. "Being of the Breast: Jess Dobkin's *Lactation Station Breast Milk Bar.*" *New Maternalisms Redux*, edited by Natalie Loveless, University of Alberta, 2018, pp. 78-107.

Buller, Rachel Epp. "Performing the Breastfeeding Body: Lactivism and Art Interventions." *Studies in the Maternal,* special issue on *The Everyday Maternal Practice: Activist Structures in Creative Work*, vol. 8, no. 2, 2016, pp. 1-15.

Dobkin, Jess. "Performing with Mother's Milk: *The Lactation Station Breast Milk Bar.*" *Intimacy Across Visceral and Digital Performance*, edited by Maria Chatzichristodoulou and Rachel Zerihan, Palgrave Macmillan, 2012, pp. 62-73.

Reeve, Charles. "The Kindness of Human Milk: Jess Dobkin's *Lactation Station Breastmilk Bar." Gastronomica,* vol. 9, no.1, 2009, pp. 66-73.

Reeve, Charles. "Jess Dobkin: Mom, Dyke, Frog." *Reconciling Art and Mothering,* edited by Rachel Epp Buller, Ashgate, 2012, pp. 125-33.

Reinhardt, Anthony. "Expressing Herself about Breast Milk." *Globe and Mail,* 13 July 2006, A12.

Van Esterik, Penny. "Vintage Breast Milk: Exploring the Discursive Limits of Feminine Fluids." *Canadian Theatre Review,* vol. 137, 2009, pp. 20-23.

In Search of The Maternal: Towards Microchimeric Bodies and Maternal Relational Aesth-ethics

Deirdre M. Donoghue

Introduction: Among Nouns, Verbs, and Attributes

> "Thank you for your kind note. I won't be able to attend, I have too much on my plate these days, and probably I am not on the (mailing) list because everyone in the world knows that, while I am a caring person, I lack maternal-ity ;-)."[1]

What is this "maternal-ity" to which the writer above refers? Moreover, what is this "maternal-ity" that "everyone in the world" knows about? In short, who are these knowers and what is this singular "maternal-ity"? Is it something physical, found only in bodies that have carried, cared for, or given birth? Is it an essentially feminine quality tied to these same bodies and other bodies that demonstrate a desire and willingness to care and nurture for a dependent other? Is it an attitude or a practice of peaceful and ethical co-existence with an "other"? Is it perhaps a concept connecting various notions or a metaphor for something else? A noun? A verb? An attribute?

In the following chapter, I consider what the maternal may be when defined and performed from within the actual, embodied practices of

mothers, and how this may function within the aesthetic field of cultural production. I map the works and creative processes of conceptual artist Weronika Zielinska-Klein (PL), visual and performance artist Courtney Kessel (USA), and sound artist Sharon Renee Stewart (USA) as exemplifying aspects of what I propose here as "maternal relational aesth-ethics." Furthermore, I explore what kind of aesthetic, social, and political relations their ways of working have produced and proposed; finally I introduce the phenomenon of "microchimerism" as a conceptual tool for the rethinking of the maternal as a particular kind of movement and intensity and as an attitude of attunement that extends beyond sexual difference.

Maternal Relational Aesth-ethics

I propose the term "maternal relational aesth-ethics" to refer to an interdisciplinary weaving together of aesthetics, ethics, and maternal experiences as a distinct approach for artmaking. This term addresses the rising number of artist-mothers whose artistic processes engage with their maternal experiences and subjectivities. This phenomenon has expanded in recent years because of structures that support and make visible artist-mothers and their art works, enabling their works and perspectives to circulate in contemporary critical debates about subjectivity, care, and the Anthropocene. These structures, as I identify them, have been initiated by other mother-artists, mother-activists, and mother-scholars, many of whom have either come of age as daughters of second-wave-feminist mothers or who themselves became mothers during the second wave.[2]

What I call "maternal relational aesth-ethics" considers aesthetic creation as active cultural production and as a practice of affective world-making. Artists whom I consider as working in maternal relational aesth-ethics understand (to various degrees) their creative processes and practices as part of, and in conversation with, a larger force field of cultural and interpersonal relations. They also aim to be sensitive about the ethical implications of their artworks and creative processes. They consider the material, performative, and affective aesthetic gestures together with their ethical implications. Moreover, rather than working from the subject position of modernity's individual autonomous subject, which aligns with Western art history's figure of the autonomous

artistic genius, maternal relational aesth-ethics aligns with maternal and matrixial models of subjectivity, both which radically connect to severality and relationality (Baraitser; Ettinger). My parameters for locating a work of art – or an artistic process- in the field of maternal relational aesth-ethics are as follows: (1) the artist embraces a maternal subjectivity of being at once singular and several, accepting this maternal condition of multiplicity as a site for artistic creation, and embraces it as a methodology for creative process and aesthetic production; (2) the artist stays with and makes artwork on/from the porous threshold of maternal intersubjectivity. These parameters, and the above-mentioned ethical-aesthetic considerations, form the main tenets through which maternal relational aesth-ethics aims to offer a feminist counterpoint to relational aesthetics through a feminist maternal lens.[3]

In this chapter, at times, I pair the words "mother" and "artist" in different orders. For example, when emphasizing maternal labour and agency above artistic action, I use the term "mother-artist," whereas when emphasizing artistic action above mothering, I use the term "artist-mother." I turn first to the aesthetic implications that such shifts regarding subjectivity and self/other relations have brought about in the artistic processes of Zielinska-Klein, Kessel, and Stewart.

Hospitality as Ethical and Creative Responsiveness in the Work of Weronika Zielinska-Klein

In considering the work of Weronika Zielinska-Klein, a conceptual artist and a mother of two living in the Netherlands, I focus on how two types of labour—mothering and artmaking—co-exist and inform each other as creative forces in her art practice. In Zielinska's art practice, "maternal-ity" becomes palpable at moments of ethical and creative responsiveness to social and personal change and in welcoming new (to her) aesthetic forms.

Prior to becoming a mother, Zielinska studied classic fine art techniques at the Constantin Brancusi National High School for Fine Arts, Szczecin, Poland (1998-2003), followed by a bachelor's degree program in fine arts at The Willem de Kooning Academy Rotterdam (2005-2009). Her medium was oil painting, and her work largely consisted of figurative paintings inspired by visual details lifted out from media images and found photographic footage: "I would always ... basically

paint from pictures [photographs] that I made myself or that I found from somewhere in newspapers and ... at the same time, I would also always combine them in installations and refer to this sort of image creation" (Personal interview).

While finishing her bachelor's program, Zielinska became pregnant with her first child, Bruno. As the pregnancy advanced and her body transformed and expanded, it began to affect the physicality of how she worked. This, in turn, gave way to several small transformative incidents through which Zielinska's art practice shifted from figurative painting to a socially and politically engaged aesthetic practice. For example, Zielinska began wearing a large mask to protect the unborn baby from the chemical fumes in the paints (Fig. 1): "I never had an object like this. I was never thinking about this [before]. I mean, I really liked the smell also.... But I had to get used to it, and it was fine. It was something different and I knew why I was doing it" (Personal interview). She also had to reduce how long she stood in front of the canvas. Out of necessity, Zielinska began adapting her working practices, which led her to new insights and critical questions about the art she made. A third body of knowledge was forming into being between her, the canvas, and the space of the artwork.

Figure 1. Weronika Zielinska, seven months pregnant, August, 2009.

The canvases filling her apartment—she could not afford a studio—suddenly seemed cumbersome, and Zielinska began questioning her production of these sizable objects. It became clear that she could not have paints and chemical fumes at home once the baby arrived, but without a studio, she would have to either keep producing art at home or stop making art. Twelve months postpartum, Zielinska's art-working space had shrunk to simply a desk in her apartment (Fig. 2).

Figure 2. Weronika Zielinska's art-working space, 2011. In the background is a painting by Zielinska called *Untitled* (2010). In the foreground, Bruno can be seen on the laptop's screen.

To be close to and care for her infant son while maintaining an artistic practice, Zielinska the artist-mother moved her desk-studio into a vacant room in the middle of the family's apartment, where she could create a space that would accommodate both of their needs:

> It was an odd room right in the middle of our home that we never used. I had always felt really uncomfortable in it, but now I began exploring the space and possibilities what to do with it.... I tried making installation[s]. I brought all the stuff that I needed, but I just couldn't paint there. I also didn't feel like I was doing the right thing, so I started to wonder what is the meaning of this space? How can we turn it into something that I am also happy about? If we don't use it for our purpose as family, [if] I cannot use it for my purpose as being an individual artist, maybe I can share it with others? (Personal interview)

Around this time, Zielinska encountered a photograph documenting Marcel Broodthaers's[4] work *The Museum of Modern Art, Department of Eagles* (1968), a semi-fictional institution that Broodthaers opened up in his own house, taking on the role of the museum director. One of the photographs from Broodthaers's work struck Zielinska in its uncanny resemblance of the "odd room" where she now worked. So she reenacted Broodthaers's installation in her apartment and photographed the result, calling the image *After Broodthaers* (Fig. 3). This aesthetic gesture turned out to be yet another relevant incident in the transformation of Zielinska's creative process and thinking: "What I saw in that picture when I found it.... I saw my house there. I saw the room there that I had in my house. [Broodthaers] had this room in [his] house and he called it a museum and then he invited other artists and called it a museum" (Personal interview).

Figure 3. Weronika Zielinska, *After Broodthaers, Département des Aigles- Section XVII*, 1969. 2010, digital print.

The process through which Zielinska created *After Broodthaers* (2010) emerged from a series of encounters and events that amounted to her maternal practice of care cross-pollinating with her creative artistic process, each practice informing the other. Consequently, Zielinska's choices of artistic material moved from oil on canvas and the making of objects towards a new type of aesthetic form and social relationality. Fascinated by Broodthaers's blurring of the borders between public and private spaces, Zielinska the artist-mother explored these relations from within her immediate, embodied experience as a mother and artist.

In January 2011, Zielinska opened the "odd room" in the family's home and called it the *Guestroom Project*, inviting artists to work in the private space of the family home for up to two weeks at a time (Figs. 4 and 5). Artists were invited to take a break from their regular working space and work on something new, either alone or with Zielinska. They could not sleep over or use the home's other spaces, but got their own key and could come and go from early morning to late evening, sometimes having dinner with the family. Each working period concluded with a public moment, when the domestic space was opened up further to allow a small audience to enter the family's home. The formats of these events changed to suit each project: "Sometimes they were exhibition openings with beer and snacks, sometimes more like round-table

situations or performance events" (Personal interview). Thus, the audience for these invitation-only events—consisting of guests invited by the resident artist and Zielinska—visited a private home and witnessed the family's domestic narratives while participating in a public event as the guests of the artist hosting them. Together they all were the guests of Zielinska and her family, who themselves were both guests and hosts.

This stretching and questioning of the contours of hospitality in the *Guestroom Project* became recognizable in Zielinska's art once she became a mother and added the continuous care for a dependent other alongside her daily art practice. Although Zielinska did not frame her art practice through a maternal lens, it seems clear that this artistic project came about through her affirmative approach to both her maternal care work and her artistic practice and by her allowing these two to not only co-exist but actively affect each other. As such, the concept of hospitality is characteristic of Zielinska's maternal relational aesth-ethics; its aesthetic and ethical implications include creatively queering hospitality through a socially engaged participatory art.

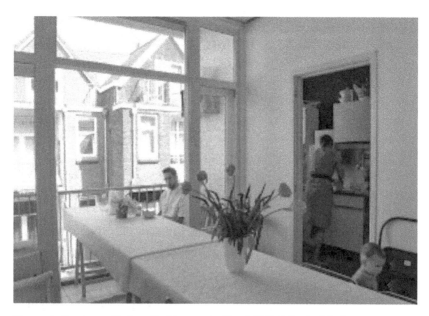

Figure 4. *Guestroom Project:* Resident artist Esmé Valk is in the kitchen (background) preparing for her performance *This Place Would Be Perfect If Only It Had an Ocean View.* Zielinska's partner, Mark Klein, sits outside on the balcony, while Zielinska's son Bruno plays in the foreground. April, 2011.

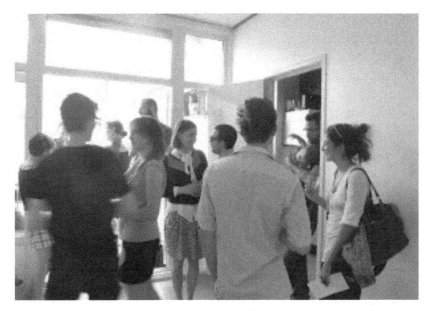

Figure 5. *Guestroom Project.* Audience members fill the space. Bruno and Mark Klein lean against their kitchen door looking at the strangers in their house. May, 2011.

After eight months, Zielinska closed the *Guestroom Project.* In its place, she rented a small shop and turned it into a nonprofit art space called *Upominki,* a name which in her native Polish means "small gifts" and is often given to small shops selling bric-a-brac (Fig. 6). However, instead of selling knick-knacks, *Upominki* experimented with hospitality as a form of alternative economic exchange. Whereas in the *Guestroom Project,* hospitality had been setup, lived, and explored largely as a one directional movement, with *Upominki,* Zielinska now aspired to explore hospitality as a two-way movement of reciprocal exchange and space sharing:

> I developed a certain model, through which I would claim shared responsibility and stated interest. From the beginning I would rather keep it [*Upominki*] like ... not so much for myself, but more ... try to call it that it is belonging to more people than only me ... to get rid of this idea of what is mine and what is not mine and what is yours. (Personal interview)

Zielinska outfitted the space with simple living utilities, a separate studio, and an exhibition space with a storefront window connecting it

to local residents. At *Upominki*, Zielinska offered free working space to artists in the form of month-long residencies and exhibition space for showing their artworks. In exchange, artists contributed to *Upominki*'s upkeep in different ways: making a small contribution by selling a piece of art on *Upominki*'s website; organizing events to raise money for the space's upkeep; or donating labour to *Upominki* by painting a wall, fixing a leaking tap, or doing other daily maintenance. "Instead of me giving someone the space [I would be] receiving something for the space ... whatever ... money ... or functional objects ... or hours of labour" (Personal interview).

Upominki, as with *Guest Room* project, represents a shift in Zielinska's art practice. Tracing Zielinska's practice before, during, and after she became a mother shows clear connections between her maternal experience, practice, and aesthetic choices. The moments when she opened up her artistic practice, allowing it to cross-pollinate with her maternal practice and thinking, are when her maternal practice became part of her artistic method, moving the latter towards an aesth-ethic practice.

Figure 6. Upominki. The foreground features *Steps Twice*, a functional art work by French artist Ghislain Amar, created and donated to Upominki in May 2013.

Being One and Several in the Work of Courtney Kessel

Similar to Zielinska, American artist Courtney Kessel explores the blurring of lines between domestic and public spheres. A mother, artist, academic, and arts administrator in Athens, Ohio, Kessel works in sculpture, performance, video, and sound. Through what she calls "performing invisibility," Kessel attempts to make visible what "is usually not seen because it takes place at home and without an audience." She goes on to say that "this is my practice. I don't have time to go to studio; my studio has been largely at home and in makeshift spaces" (Kessel, *The Eternal Maternal*").

Balancing the roles of mother, gallery director, and internationally exhibiting artist has shaped Kessel's art practice in very particular ways. Working around and with her child, Kessel takes the maternal material of the everyday as artistic material. Kessel's daughter, Chloé Clevenger, has become an active collaborator, sometimes through her presence, sometimes through her absence: "The point is that, that very specific experience of being a mother, while different for everyone, is still all about another person! No matter when or where we go, that other is always a part of our lives" (*Kessel*, "Interview with Christina LaMaster").

Sharing Space (2012), a video work consisting of three short scenes, is one example of Kessel's maternal co-existence with Clevenger finding aesthetic form through a simple daily act and its subsequent reenactment on video. As with most of Kessel's works, *Sharing Space* originated in a simple encounter between mother and daughter: "We were at a restaurant and she got cold. So sitting on my lap, she struck her arms in the cardigan that I was wearing. We reperformed this action in front of the camera" (Kessel, "The Eternal Maternal"). The resulting video triptych frames Kessel in a white cubelike space, seated on a chair, and facing the camera. Clevenger, also facing the camera, sits on Kessel's lap. For two minutes, divided into three scenes of moving image, we witness Clevenger slipping, pushing, and gliding in and out of the clothes that Kessel wears. Sometimes the two figures transform into a two-headed hybrid creature; other times, they move apart into two perfectly complete, separate beings. Wrapped inside the cloth's elasticity, their two bodies are enveloped by a common sack of cloth-skin and appear as a one-bodied, chimeric beast—at once singular and several (Figs. 7, 8, and 9).

Figures 7, 8, and 9. Still frames from Courtney Kessel, *Sharing Space*, 2012.

In *Sharing Space*, the interaction between the two bodies makes "maternal-ity" visible—the maternal body here is not only Kessel's physical body but also the space and intensity of interaction between these two porous agents. Through the playful, creative, and repeated activity of becoming at once one and multiple, singular and several, Kessel's work locates the maternal body as a site for the possibility of a more porous notion of subjectivity. It transforms form not by bending into the rules of one or the other but by welcoming new space, materiality, and temporality—not a loss of identity but a hospitable emergence of maternal space made visible through an aesth-ethic practice that embraces interruptions to the (notion of) self.

Another scene in *Sharing Space* shows Clevenger and Kessel swaddled together in a shirt that covers their upper bodies like a thin, stretchy membrane. Moving their arms, held together by the shirt's long sleeves, they adjust their bodies to fit together inside the supple cloth. As they awkwardly move their joined together bodies across the screen, it briefly becomes hard to say whether the girl is carrying the woman on her back or the woman is growing out of the girl's back; whether the girl is an appendix hanging down from the woman's front; or whether this polymorphous form is one creature with four legs and two heads (Fig. 10).

Figure 10. Still frame from Courtney Kessel, *Sharing Space*, 2012.

Figure 11. Still frame from Courtney Kessel, *Sharing Space*, 2012.

Still another scene of their conjoined bodies reveals the fleeting gesture of an almost kiss (Fig. 11). Their faces almost caress each other, and their lips nearly touch, enacting complete trust and openness. The image evokes Luce Irigaray's feminist theorizing of the lips as giving way to both bodily and psychic openness and co-creation:

> The kiss allows an exchange to take place without demarcations. It becomes impossible to distinguish whose fluid is which, or where it comes from. This means that it is very different from the concepts of ownership and property. There can be no mastery if the kiss is to remain one of mutual openness and vulnerability rather than domination of one by the other. (qtd. in Canters and Jantzen 108)

In becoming Clevenger's mother, Kessel adjusted both the social organization of her everyday life to accommodate the newborn infant and her creative practice to accommodate life and artmaking's new rhythms, patterns, and spaces. This deep interrelationality with another has ever since been the generative, performative, and political motor to Kessel's artistic practice and work, integrating it into maternal relational aesth-ethics.

Becoming Porous through Acts of Listening and a Practice of Attunement in the Work of Sharon Stewart

American-born Sharon Stewart, based in the Netherlands, is a composer, sound artist, music pedagogue, and a certified Deep Listening® teacher, poet, and mother. She explores "acts of listening" and "embodied responsiveness" as creative strategies for making art. Stewart primarily collects her sound material by making field recordings, which she develops for a specific context in a framework of collaborative artistic design. Stewart places no hierarchical divisions or aesthetic value judgments between the social and cultural spheres of the sonic materials that she collects, but certain elements reoccur in her creative methodology of collecting and assembling materials. These elements include a particular opening up or softening of one's edges that welcomes interruptions and interpenetrations (a word that Stewart often uses when discussing her collaborative, creative process) as integral to the creative process. Another element is the act of listening, a porous becoming or becoming porous in an encounter's shared space. Finally, the element of attunement gives form to the singular encounter-event.

For the performance piece *Alice in 'Audiotenland* (2012), a collaboration with the Dutch dance collective CCCompass (Creative Collective Compass), Stewart recorded sounds from the city of Arnhem, assembling the collected sonic elements according to various themes descriptive of their sonic qualities (splashes 'n bubbles, glass 'n chimes, ticks 'n rips, rolling things) and then working them into four short compositions for the dancers. Electronic manipulation and unfamiliar juxtapositions of the collected sound bites—inside/outside, intimate/distant, animal/machine—make these pieces into humorous sonic fantasy worlds through which the Audioot, a magical creature who creates and controls sonic worlds, leads Alice. In this nonlinear and continually interrelational creative collaborative process, Stewart responded to the performers' narrative and durational frameworks by adding temporal elements and atmospheres through the layering of sounds and through "working with silence to leave space for the voice of the dance and the imagination of the audience" (Stewart, "Interview with Jez Riley French").

These acts of 'opening up or as softening one's edges, listening, and attunement are grounded in Stewart's practice of Deep Listening®, a set of exercises developed by American composer, performer, author, and

academic Pauline Oliveros (1932-2016), which consists of "bodywork, sonic meditations, interactive performance, listening to the sounds of daily life, nature, one's own thoughts, imagination and dreams, and listening to listening itself" ("How Many Sounds"). Oliveros designed these exercises to "inspire both trained and untrained musicians to practice the art of listening and responding to environmental conditions in solo and ensemble situations" ("How Many Sounds") and explore "the difference between the involuntary nature of hearing and the voluntary selective nature—exclusive and inclusive—of listening" ("How Many Sounds").

Strikingly, however, Stewart's practice as a mother already incorporated many characteristics of Deep Listening® before she knew about Oliveros's exercises. As a trained pianist, Stewart had developed a discipline of listening up to a point, but the birth of her children prompted her to adapt her listening strategies to connect and communicate with her sons, who had very different ways of being in and with the world:

> My primary level of relationship with my children was through touch. Because my firstborn was not always appreciative of physical touch and closeness I needed to shift to understand his language. My younger son was much more open and available to touch and made it easier for me to connect with him nonverbally. To create that basis of harmony, or simply 'being-with' was harder for me to experience with my older son. *(Stewart, Skype Conversation")*

Another account of her early mothering experience demonstrates how her maternal experience of listening to the other became a transformative co-creative force:

> During my mothering, I became fascinated by the non-verbal information that was provided by my child: the excitement in breath and heartbeat that proceeded feeding or communicative engagement; the endless possibilities of creating sounds with the lips, tongue, throat, hands and feet; the way my children would respond to melody and the incredible drive I felt to turn daily interactions into song and dance for them. (Stewart, "m/other voices")

Stewart's creative practice performs maternal relational aesth-ethics, making it traceable through her cultivation of receptivity as an artistic methodology and her incorporation of sound as a fluid, free circulating, and affective aesthetic material.

Traversing Boundaries: Interruptions and Acts of Radical Maternal Hospitality

Looking at the works and practices of Zielinska, Kessel, and Stewart along an axis of maternal and artistic labour brings out similarities in their creative thinking and working methods. Each artist, in her creative processes, embraces maternal experience and subjectivity as informative and welcomes interruption as generative. Rather than trying to reduce or eradicate the tension born in moments of alterity and difference, they all approach it as a relationship. And further commonalities unite their distinct practices: attunement towards the "other" and the environment as well as a practice of radical hospitality.

Examining maternal subjectivity as a set of ethical relations with the (postbirth) child, Lisa Baraitser in *Maternal Encounters: The Ethics of Interruption* defines the maternal subject as one of constant interruption. By looking at interruptions as the "appearance of difference that dislodges the Same from itself; difference understood as a breach in the fabric of the Same" (69), Baraitser formulates "interruption" as both destabilizing and productive. Baraitser's formulation of the maternal subject is extremely valuable for (aesthetic) world making because it contrasts radically to modernity's legacy of the individual autonomous subject and the figure of the artist as a sole genius. Additionally, when imagined as an interface of "co-poietic transformational potentiality" (Ettinger 703), Baraitser's model becomes all the more pertinent and useful, as the age of the Capitalocene urges us to imagine new ways of being in and with the world.

Zielinska, Kessel, and Stewart welcome interruption by performing acts of hospitality as part of a creative and generative relationality with an "other" without trying to reduce difference and otherness. They face and experience the creative tension and challenge posed to them when traversing the boundaries between "self" and "other" stitching between their own frames of reference and the terra incognita of the

"other" in a continuous practice of porosity. Thus, their creative processes and aesthetic practices make visible an ethics of relationality centred on care and accountability. In a Levinasian sense of the "face-to-face" encounter, the appearance of interruption in these artists' works acts as the invitation into an ethical relation with the "other."[5] The facing of the "appearance of difference" (Baraitser 69) brings forth an aesth-ethic relationality in their creative processes. Yet, as I suggest below, the notion of "self' and "other" as separate entities that such reading requires may not fully account for the feminist and maternal perspectives of mothers.

Interruptions cannot be considered without also considering hospitality. "Is not hospitality an interruption of the self?" (51) asks Jacques Derrida, introducing an understanding of hospitality as an interruption and a deconstruction of the 'at-home'—"a breach in the fabric of the Same," as Baraitser (69) puts it. For both Derrida and Baraitser, interruptions carry creative potential. However, for Derrida, hospitality seems disruptive, to be managed by laying out rules and conditions—which ultimately reduce otherness—and asserting an imbalance of power, agency, and vulnerability to the relations between the parties. Alternatively, Derrida's brand of 'unconditional', or 'absolute hospitality', molds hospitality as an altruistic and self-sacrificial force where the one offering hospitality gives up all control of his 'home', country or nation, only to arrive at an aporic deadlock, for one cannot give what one does not have.[6] When considering hospitality in relation to the creative aesthetic processes of Kessel, Stewart and Zielinska, the Derridean model of 'conditional' and 'absolute' hospitality as arranged around a paradigm of 'conditional tolerance' / 'self-sacrifice', simply does not offer a usable model.[7] By contrast, the hospitality at work in the creative aesthetic processes of Zielinska, Kessel, and Stewart must be understood as taking place and form through radical, maternal acts of hospitality. Situated and embodied maternal acts of welcoming interruption and maternal acts of attunement point to maternal aesthetics as a relational ethical practice grounded in relationships and care alongside affective, aesth-ethic processes.

Seeking a theoretical framework to untangle and support a concept of hospitality in relation to the maternal, we can turn to Irina Aristarkhova's figuration of hospitality as matrixial and maternal acts. Asserting a need to reconfigure the Western conventions of 'hospitality'

such as we have inherited from Immanuel Kant (1795), Emmanuel Levinas (1969, 1998), and Derrida (1999, 2000, 2005), Aristarkhova proposes hospitality as a potentially "profound and transformational concept in our understanding of self and other, and in conceptualizing ethics, if it turns to reckon with the maternal" (164).[8]

Levinas and Derrida structure their discourse on hospitality on femininity / Woman, her openness, her ability to expect and welcome unconditionally. However just as intentionality and mutual agency are integral elements of their structure of hospitality as they progress, this cycle, although starting with the feminine/ woman and being born with her, does not include feminine agency. The maternal, confused with and metaphorically replaced by the feminine, gives matter to hospitality, makes it possible, produces its interiority and exteriority, but has no empirical place or role in hospitality. (43)

Opposing the relation of femininity/woman as appropriated by Levinas and Derrida as an inherent characteristic of hospitality, Aristarkhova highlights the cost of such a configuration to actual women, calling for a reconfiguration of hospitality as "acts of hospitality" instead (43). Connecting maternal agency and hospitality, Aristarkhova assigns hospitality (back) to the maternal; opposes feminine "one way and essential giving as passive and involuntary" (45); and designates agency to "so-called empirical women" (45). Her approach to hospitality allows for a new understanding of the maternal as a conscious and active practice of welcoming the "other" rather than seeing it as a hollow, passive container for an essentially feminine quality or as a naïve and fixed physiological state of being. Through this model of hospitality, as proposed and reframed by Aristarkhova as "maternal acts of hospitality," we may also better read, contextualize, and understand the works of Zielinska, Kessel, and Stewart as well as the aesthetic, social, and political relations produced and proposed by their ways of working.

Towards Microchimeric Bodies

The boundaries that delimit individual entities are permeable, not fixed, which means that organisms and their various environments—social, cultural, and political as well as physical—are constituted by their mutual influence and impact on each other ... Bodies do not stop at their edges of their skins and are not contained neatly and sharply within them (Sullivan 2).

What worlds and social and political possibilities are generated by these artistic practices and processes performed from within a maternal subjectivity and theoretical parameters as laid out above? What knowledge do such aesth-ethic processes generate? Consider the phenomenon of "microchimerism," which is a term from cellular biology that inherits its name from the ancient Greek *Chimaera*—Lycia's mythological, three-headed, fire-breathing, female beast—and describes the common phenomenon of genetically distinct cells passing from the fetus, through the placenta, into the maternal circulation (Bianchi et al.).[9] Since maternal cells also pass into the fetus, this two-way, nonlinear and non-reciprocal movement of living cells crossing back and forth from one entity to the other destabilizes the notion of the placenta separating two distinct entities. This opens up an understanding of a more porous and expanded notion of the self. "Far from being pure-bred individuals composed of a single genetic cell line, our bodies are cellular mongrels, teeming with cells from our mothers, maybe even from grandparents and siblings" (Ainsworth). In fact, we are all microchimeras. Mapping the cross-pollination of maternal encounters and artistic labour in the practices of Zielinska, Kessel, and Stewart shows how their maternal encounters have entered the circulation of their artistic practices, affecting their aesthetic processes and the social and political domains generated. In each of their practices, the maternal relation operates as a microchimeric attitude of receptiveness and hospitality towards a constantly emerging otherness, a generative porosity of sorts. As such, their creative processes model an understanding of the maternal as an aesth-ethic attunement towards the other and our being with and in the world, and offer models of maternal practice as an aest-ethic discipline in the production of knowledge. Their artistic processes challenge the traditional artistic subjectivity of the autonomous, individual genius by experimenting with more porous understandings of the self. Through their work, we come to see a mother as a thinker and producer rather than a receptacle for the continuation of life in which then great things can happen. We see the maternal as a generative, performative, social, and material—affective and political force, not an inherent, essential quality of feminine embodied space.

Travelling back to the email at this chapter's start, whose writer affirms herself as a "caring person" only to distance herself from the maternal by a pronounced move of claiming to "lack maternal-ity," I

once again ask: what is this "maternal-ity" that the writer refers to? What is this "maternal-ity" that "everyone in the world" knows about? And although I can only assume that by "maternal-ity," she intends its commonplace meaning of a female who carries, births, cares for, perhaps desires children—a woman in relation to her children—I conclude by offering a counter image, asserting "maternal-ity" as an aesth-ethical attunement and responsiveness to our being in and with the world.

Endnotes

1. The message was sent to me in response to an invitation to attend a reading group where maternal theory was being read alongside some key continental philosophers as part of a one-year long artistic research project—(M)other Voices: The Maternal as an Attitude, Maternal Thinking and the Production of Time and Knowledge—hosted by Witte de With Centre for Contemporary Art, 2013-2014.

2. Examples of such structures include (amongst many others) scholarly journals such as *Mamsie: Studies in the Maternal* and the *Performance Research: A Journal of The Performing Arts*' recent special edition "On Maternal" (2017); activist networks, such Cultural Reproducers in Chicago, A.M.M.A.A in New Delhi, Mother Voices in Rotterdam and Desperate Artwives and Mother House in London; as well as exhibitions and symposia including the *New Maternalisms* series of exhibitions in Toronto, (2014), Santiago (2014) and Edmonton (2016).

3. A more in-depth discussion on maternal relational aesth-ethics as it relates to and differs from Nicolas Bourriaud's *Relational Aesthetics* (Les presses du reel, 1998) can be found in my forthcoming doctoral dissertation "Doing Maternal in The Aesthetic Field." Department of Gender Studies, Institute for Cultural Inquiry, Faculty of Humanities, Utrecht University, The Netherlands.

4. Marcel Broodthaers, poet, film-maker, artist (1924-1976) often worked with found objects and used whatever was at hand for his raw materials. He is associated with the spread of both installation art as well as institutional critique, in which the relationship between artworks, the artist, and the museum is the focus.

5. For Emmanuel Levinas's it is the 'face-to-face' relation which calls humans into an ethical relationship of responsibility for each other. Emmanuel Levinas, Totality and Infinity: An Essay on Exteriority, Duquesne University Press, 1969.

6. "Aporia"—from the Greek "*aporos*" (a-"without" + poros-"passage") meaning "impassable"—refers to an irresolvable internal contradiction or logical disjunction in a text, argument, or theory. In his writings, the deconstructionist Jacques Derrida explains "aporia" as a situation in which the elements that make a thing possible are also the very same ones that make it impossible. Thus for Derrida the concept of 'hospitality' is an aporia—a logical fallacy and a contradiction in terms.

7. It could be argued of course that Derrida (1999, 2000, 2005) arrives at these two types of hospitality precisely because he is deconstructing a masculine version of hospitality. It could also be argued that his work of deconstruction in itself already contributes to the dismantling of the pre-existing, dominant masculinist ways in which we think about our being in the world and our relations to others. In Derrida's own words: "[t]he figure of the philosopher is, for me, always a masculine figure. This is one of the reasons I undertook the deconstruction of philosophy. All the deconstruction of phallogocentricism is the deconstruction of what one calls philosophy, which since its inception, has always been linked to a paternal figure." (Derrida, a documentary directed by Kirby Dick and Amy Ziering Kofman, Jane Doe Films, 2002.) However, whereas Derrida's skilful and important work of deconstruction does create space/s for new thought, the limit of deconstruction is of course that it does not in itself offer an alternative (feminine or other) model to hold onto. "

8. Other examples of theoretical models with which to rethink hospitality as a practice of negotiating difference and the self-other relations through a feminine maternal lens can be found for example in the work of the French biologist Hélène Rouch (1987, 1993) whose writing on placental economy as a biological function opens up ways to understand the placenta as a mediating space for both mother and fetus. Indeed, Rouch's work has influenced, among others, Luce Irigaray (1993), Maria Fannin (2014), and Kelly Oliver (1994, 1998), as well as Irina Aristarkhova. However, I have here chosen to work

with Aristarkhova's figuration of maternal acts because of its focus on feminine agency and actual embodied women.

9. The exact role and effect of fetal cells in maternal circulation is not conclusive, but there is evidence to show that fetal cells can function both to repair a mother's health, as well as to deteriorate it (Schute).

Works Cited

Aristarkhova, Irina. *Hospitality of the Matrix: Philosophy, Biomedicine and Culture.* Columbia University Press, 2012.

Baraitser, Lisa. *Maternal Encounters: The Ethics of Interruption.* London: Routledge, 2009.

Bianchi, D.W., et al. "Male Fetal Progenitor Cells Persist in Maternal Blood for as Long as 27 Years Postpartum." *Proceedings of the National Academy of Sciences of The United States of America*, vol. 93, no. 2, 1996, pp. 705-8.

Bourriaud, Nicolas. *Relational Asthetics.* Translated by Simon Pleasance et al., Les presses du reel, 2002.

Canters, Hanneke, and Grace M. Jantzen. *Forever Fluid: A Reading of Luce Irigaray's Elemental Passions.* Manchester University Press, 2005.

Derrida, Jacques. *Adieu,* Translated by Pascale-Anne Brault and Micheal Naas, Stanford University Press, 1999.

Derrida, Jacques. *Of Hospitality.* Translated by Rachel Bowlby, Stanford University Press, 2000.

Derrida, Jacques. *The Principle of Hospitality,* Parallax Vol. 11, Issue. 1, 2005, pp. 6-9.

"How Many Sounds Can You Hear All at Once?" Deep Listening, deeplistening.org/. Accessed 6 Aug. 2019.

Ettinger, Bracha L. "Copoiesis." *Ephmera Journal*, vol. 5, 2005, pp. 703-13.

Fannin, Maria. "Placental Relations." *Feminist Theory*, vol. 15, no. 3, 2014, pp. 289-306.

Irigaray, Luce. *Je, Tu, Nous.* Routledge Classics, 1993.

Kant, Immanuel. *Perpetual Peace: A Philosophical Essay.* 1795. Translated by Mary Cambell Smith, Cosimo, 2005.

Kessel, Courtney. "Interview with Christina LaMaster." *Cultural Re-Producers*, 2015, www.culturalreproducers.org/2015/06/interview-courtney-kessel.html. Accessed 6 Aug. 2019.

Kessel, Courtney. "The Eternal Maternal." *Mother Voices*, 2015, www.mothervoices.org. www.mothervoices.org/column/2015/9/21/eternal-maternal. Accessed 6 Aug. 2019.

Levinas, Emmanuel. *Otherwise Than Being*. Translated by Alphonso Lingis, Duguesne University Press. 1998.

Levinas, Emmanuel. *Totality and Infinity: An Essay on Exteriority*. Translated by Alphonso Lingis, Duguesne University Press, 1969.

Shute, Nancy. "Beyond Birth; A Child's Cells May Help or Harm the Mother Long After Delivery." *Scientific American*, 30 April 2010, www.scientificamerican.com/article/fetal-cells-microchimerism/. Accessed 6 Aug. 2019.

Stewart, Sharon. "Interview with Jez Riley French." Verdureen Graved, January 2017,

verdureengraved.bandcamp.com/album/2017-1. Accessed 6 Aug. 2019. Stewart, Sharon. "M/other Voices Foundation for Art, Research, Dialogue and Community Involvement." *Mother Voices*, 2015, www.mothervoices.org/calendar-of-activities/2015/4/20/field-trip. Accessed 6 Aug. 2019.

Stewart, Sharon. Skype conversation with Deirdre M. Donoghue. August 2016.

Sullivan, Shannon. *Living Across and Through Skins: Transactional Bodies, Pragmatism and Feminism*, Indiana University Press, 2001.

Zielinska, Weronika. Personal interview. 21 Nov. 2017.

Chapter 11

These Objects Call Us Back: Kinship Materiality in Native America

Alicia Harris (Assiniboine)

O bjects have power. Their material components archive stories and narratives, expressing diverse histories and heritages while underwriting those objects' inherent meaning and value. Key examples of this pattern exist in the works of contemporary Native American mixed-media artists Rose Simpson (Santa Clara Pueblo) and Marie Watt (Seneca). Both artists foreground intimacy, maternity and paternity, and familial connection by exploring and exploiting raw material to consider issues of kinship. For both Simpson and Watt, materials contain meaning beyond their immediate objecthood and form references to cultural matters. Simpson's 2016 exhibition *Ground* and Watt's 2012 *Skywalker/Skyscraper* both show how materiality can communicate eloquently about Indigeneity and about kinship's physical realities. Although these artists come from different Indigenous back-grounds, their exhibitions form a trans-tribal discussion about these themes that reflects Indian Country's diversity while highlighting common themes of kinship, maternity, and materiality.

Both exhibitions are remarkable as thoughtful, distinctive examples of embodied history, as they use material components to evoke kinship systems. Framing materialist art history with a kinship lens allows for the possibility of an Indigenous methodology in which inanimate matter and human families, individuals, and other sentient beings are connected in relation to each other. These exhibitions demonstrate that

paradigm while also engaging themes of generational heritage, maternity and paternity, and the function of family across time. Speaking of Anishinaabe material culture, Anishinaabe and Kanien'kehá:ka curator Alexandra Kahsenni:io Nahwegahbow demonstrates value in this Indigenous paradigm:

> Applying this culturally based narrative framework to a study of material culture is consistent with current leading Indigenous scholarship surrounding holistic health and well-being. This approach allows for a more comprehensive examination of the wider expressive potential of Anishinaabe-made objects, and is grounded in distinctive cultural understandings. Using this narrative structure to frame the intergenerational exchange of knowledge between mothers and daughters, as well as grand-mothers and granddaughters, makes clear the ways in which these four stages are deeply linked. (100)

For Indigenous communities, objects speak to and call back memories. Meaning is rooted in historical objects and in the materials of other entities, as art historian Ruth Phillips suggests in her evocatively titled essay "Things Anishinaabe: Art, Agency, and Exchange Across Time." Though focused on Anishinaabe art, many of Phillips's arguments function broadly in other Indigenous communities. For example, she argues that "concepts of materiality and spirit that the Anishinaabeg have evolved over the centuries resonate with such theories for the idea that agency is located not solely in human beings, but is *also distributed across material*" (53, my emphasis) and goes on to argue that "things both make and carry history" (53). Such a framework is not unique to Native American art or to the works Simpson and Watt. But these artists' materials specifically and explicitly reference ancestral forms and the bodies of kin, as materials form compendia of familial significance through materiality.[1]

With *Ground*, shown at Pomona College in California, Simpson pens a love letter to materiality, the archival impulse, and the histories inscribed in each. By pairing Simpson's sculptural work with historical Native American objects in the Pomona College Museum of Art's collection, *Ground* links her art to historical objects. It creates space for dialogue about place and memory—powerful components of Indigeneity and kinship—and calls for a consideration of meaning rooted in materiality, conjoining past and present in the gallery.

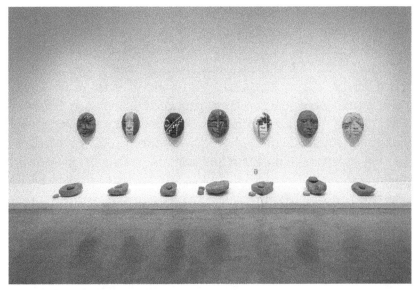

Figure 1. Rose B. Simpson, *Ground*, 2016. ©Rose B. Simpson, courtesy Pomona College Museum of Art.

For Simpson, objects take on themes of kinship, demonstrating Indigenous peoples' relational existence to the world; each shape indexes ancestral handling of material. Speaking in the introduction to the exhibition's catalogue of the historical objects in the show, Simpson writes the following:

> These weighted relics represent the work of nourishment—not only of the body but also of the soul. They remind us where nourishment comes from and the sacredness and ceremony of work. They speak of the work of women, the power within our hands, and the capacity to wear down even stone with our physical energy, dedication and intention. They represent not only the feminine aspect of production but also the act of creation—the intimacy in the moment when one stone embraces the other, the mating and friction of the two, a sacred communion.

By displaying historical objects alongside her art, Simpson situates herself as both responding to and inheriting the traditions evinced in those ancient objects with their stories of creation and sustenance made by ancestors: mothers, fathers, and grandparents, in a word, kin.

An emphasis on the nurturing and female aspects of those ancestral relations positions Simpson as an inheritor of that maternal tradition and emplaces her work in a millennia-long continuum of creation.

Ground, thus, embodies the generative mandate for both masculine and feminine energy to create. While not directly or obviously displayed, balanced human propagative force still inheres in Simpson's work. Creative, gendered energies balance and reciprocate to produce Indigenous cultures. Each object's physical reality links generations across a slipstream of time. For Simpson, her art's material elements combine to make connections to kinship and spiritual power: an object-embodied spirit calls to generations of people, deeply from the grave, from archival boxes and drawers too cabinets in museum basements.

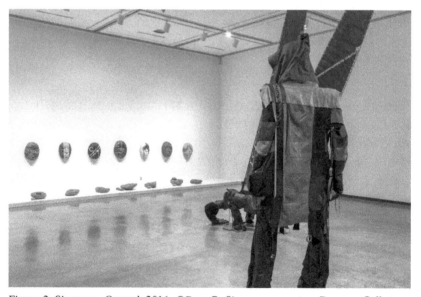

Figure 2. Simpson, *Ground*, 2016. ©Rose B. Simpson, courtesy Pomona College Museum of Art.

Families link the present to the past. This is the root of human (and nonhuman) society, both genetically and culturally. In *Ground*, a large sculptural figure stands fully upright, gazing towards the ancestral objects paired with Simpson's masks (Fig. 2). He witnesses the contact zone of past and contemporary objects, all made of material literally drawn up out of the ground. Clay masks peer out evocatively from the

wall, hovering above ancient stone beads, mortars and disks. A second large figure has one hand lost deep in the gallery floor, evoking a search for ancestral knowledge and emplaced belonging, her hunched body engrossed in reaching deep into the ground, our collective mother (Fig. 3). Massive wings rise from her bent back, suggesting her powerful kinetic potential. Eventually, she will rise up, equipped with the wisdom she has excavated.

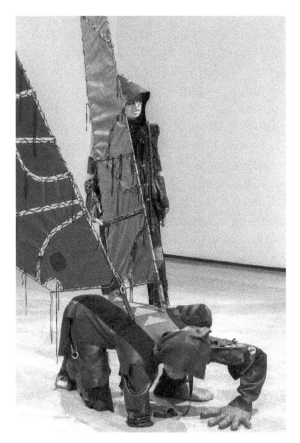

Figure 3. caption: Simpson, *Ground*, 2016. ©Rose B. Simpson, courtesy Pomona College Museum of Art.

Writing in the *Ground* catalogue, Kathleen Stewart Howe, director of the Pomona College Museum of Art, considers the austerity of Western archival practice relative to Indigenous objects. Addressing this austerity was one of the primary stimuli for the exhibition:

We as a museum understand and care for objects that are long separated from their makers, and whose makers have been written out of histories. We recognized that the ways in which museums identify and present Native works reinforce that gulf. The specificity of a unique object, crafted at a particular place and time by an individual, is obscured by an identification that cites a culture, which may have extended over hundreds of square miles and thrived for centuries.

Bringing objects out of storage and into conversation with Simpson's new objects is an Indigenizing act that calls into question Western archival practice. By overtly rejecting the Western binary of utilitarian-beautiful, Simpson provides a contour for the phenomenological experience of looking at the objects she selected for this exhibition.[2] Each piece from the Pomona collection displayed in *Ground* had a function, was at work in its time. By rejecting the utility-beauty binary, Simpson creates space to appreciate the beauty inherent in those gendered functional energies that gave birth to Indigenous cultures and nurture them still.

Finally, the very materiality of the works in this exhibition centres them as Indigenous. By linking to ancestral objects and creating new pieces for the show, Simpson uses grounded materials. Although many of the ancestral objects are from the Hohokam civilization rather than Simpson's Santa Clara Pueblo family, a narrative of emergence from the earth, common to both Hohokam and Puebloan creation stories, links them.[3] For the Hohokam, the earth and humankind come from the flesh of the first man, Juhwertamahkai the Doctor of the Earth.[4] For Puebloan peoples, creation stories involve emerging from the ground in an act that parallels human emergence from the birth canal (Kirchoff). In using clay and stone in the production of *Ground*, including the sculptural and archival elements, Simpson draws on a land and place-based ethics in relation to the world in order to communicate Indigenous links to the land via ancestral claim. Those ancestors who gave birth to Indigenous cultures gave birth to Indigenous nations and created those objects in *Ground*. Thematically, this characteristic draws on comparable ideas about nonhuman material kinships found in Indigenous arts and cultures across the world (Booth).

The theme of shared relations across materials is also evident in the work of Seneca artist, Marie Watt. In ways similar to Simpson, Watt

enacts the specific history of her own community and ancestral ties through the creative use of art objects. In her 2012 exhibition *Skywalker/Skyscraper* at PDX Contemporary Art in Seattle, Watt uses objects as reference to history, again centring a discourse about ancestors and family on materiality. *Skywalker/Skyscraper* places utilitarian objects in an aesthetic context, drawing meaning from the characteristics of each material component. The works in *Skywalker/Skyscraper* include totemic stacks of wool blankets, wall hangings, and industrially-sourced I-beams, such as those used in the construction of skyscrapers (Fig. 4). Iconic towers of steel and wool stand stalwartly around the gallery, backed by elegantly draped wall hangings.

Figure 4. Marie Watt, installation of *Skywalker/Skyscraper*, 2012, at PDX Contemporary. Image courtesy of the artist at PDX Contemporary]

As with *Ground*, the materials in *Skywalker/Skyscraper* take on gendered qualities as well as the history of Watt's personal experiences as an Indigenous woman. As in Simpson's exhibition, the material qualities of Watt's work carry stories about her Indigenous community. The standing totemic structures recall family crest totem poles ubiquitous in the Pacific Northwest, where Watt grew up. The materials evoke her Iroquoian ancestors' histories, though removed from the Iroquois Confederacy homeland, Watt remains vitally linked to her ancestors.

Reflecting on the making of *Skywalker*/Skyscraper, Watt says the following:

> Two years ago, I moved from the Brooklyn neighborhood in Portland, Oregon, to the Brooklyn borough of New York City.
>
> The conifers and totem poles of my Pacific Northwest upbringing have been replaced by skyscrapers and scaffolds.
>
> One interesting coincidence in moving to Brooklyn is that the border of Cobble Hill (where I live) and Gowanus (where I keep my studio), is where Iroquois ironworkers and their families settled in the 1950s, when most of Manhattan's skyscrapers were being built. These Iroquois were called "skywalkers" due to their ability to work on the high steel without safety harnesses.
>
> I am interested in the mythic and magical space that towers occupy. *Skywalker/Skyscraper* meditates on the human pre-occupation with "reaching" this space, and the long history of myths and stories that emanate from it.

The steel I-beams that form each structure's core carry narratives of the Iroquois steel workers who helped build New York City's massive skyscrapers during the twentieth century. Participating in a primarily male-gendered tradition, these steel workers contributed to the construction of nearly every bridge and skyscraper in New York City. The architecture of the modern American city contains the memories of Iroquois fathers, uncles, brothers, and grandfathers. New scholarship suggests that the skywalkers' work reflects the gendered dynamics in precontact warrior societies, which structured life for the Mohawk, Seneca, Cayuga, and other members of the Iroquois Confederacy (Curtis). Watt's use of materials intimates traditional gender balance and the value of Iroquoian kinship structures, balancing masculine and feminine energies.

In an innovative essay, Fiona Green argues that Iroquois steel workers and the rising Manhattan skyline have long filled the American imagination. Green argues that the imaginative association of Indigenous peoples with skyscrapers predates the visible presence of Iroquois labour force in art, poetry, and literature. The tension between the perceived primitive natures of Indians, called into sharp relief with the rising cityscape, has long expressed American modernity's paradox.

Rooted in this history, Watt's standing forms embody object-based memory and tell some of the Iroquois community's history. This embodiment motivates the show's title, *Skywalker/Skyscraper.*

Watt takes a uniquely storied approach to her materials, seeing I-beams as rooted in Seneca kinship and cultural history. Rather than being an end unto themselves, as a number of mid-century artists suggested through minimalist creations, Watt's I-beams allude to those workers whose memory is not visible in contemporary art discourse and who may further remain invisible in popular thought about Indigeneity, despite their crucial contributions to American urban fabric and American modernity. In selecting materials situated both urbanity and specific Iroquois history, Watt's oeuvre reminds us that Indigenous people are still here and have always been viable contributors to society.

Watt balances the gendered identity of Seneca and Indigenous materiality by combining masculine steel I-beams with soft, feminine wool—the juxtaposition creating a balance of gendered materiality. Wool blankets have a ubiquitous history with the Indigenous peoples in North America. Across the continent, commercial exchange centred on the pressed wool trade cloth of the Hudson's Bay Company. Backed by British royal charter, the Hudson's Bay Company (which once owned 15 percent of the world's land) inherently served the British Empire's colonial objectives. The company exported North American furs, primarily beaver, to satisfy European taste, and utilized pre-existing trade networks long established in Indigenous communities. In exchange for the furs and access to trade relationships, Hudson's Bay supplied wool to Native peoples. Thus, wool blankets rapidly became deeply ingrained into many North American Indigenous communities. Iroquoian communities quickly incorporated beaded wool skirts and leggings into traditional women's dress. Wool came to represent status, wealth, and belonging, and it still evokes memories of trade and stature for many Native American and First Nations peoples. Especially for Native people in the northeastern U.S. and along the American-Canadian border, including Watt's own Seneca community, the history of contact with European settlement and trade is visibly woven into the wool of trade cloth.

But even more specific to Seneca tradition, and Watt's experiences, the towers of blankets form sculptural access to this world for

Atahensic, (Sky-Woman). Central to Iroquoian narratives and creation myths, Atahensic fell from the sky and gave birth to the first woman, thus becoming the grandmother of the Iroquois nations, (Each community has a slight variation in their myth surrounding Atahensic.) She gave plants and animals to the people and taught them how to use those things to survive (Jenkins et al. 140). Ultimately, Atahensic is a nurturer and a grandmother. Watt's stacks of blankets return this favour, reaching upwards to soften Atahensic's landing following her fall from a hole in the sky—gestures of kindness to this storied matriarch and culture hero. The blankets thus simultaneously call up the history of exchange and kinship in North America while physically extending an offering in the gallery towards the Iroquoian cultural hero.

The wall hangings in *Skywalker/Skyscraper* function as entrées to a discussion about materiality and objecthood. In *Skywalker/Skyscraper (Portal)* (2012) (Fig. 5), strips of wool pool together and are unified by individual stitches made by multiple people Watt brought together from the local community. The communal aspect of Watt's work emphasizes the value of social engagement and collectivism in Indigenous communities. The work's title, *Portal*, refers to the hole that Sky Woman fell through on her way to the earth. The pieces of wool used in this work also direct attention to the value of individuals functioning as part of the greater whole; the complexity of this relationship is represented in how the abstract design can only be seen at a distance, at which point the individual characteristics are obscured.

Figure 5. Marie Watt, *Skywalker/Skyscraper (Portal)*, 2012. Reclaimed wool blankets and thread, 90" x 228". Image courtesy of the artist and PDX Contemporary.

Furthermore, blankets connote intimacy and domestic comfort. Community members donated the blankets in *Skywalker/Skyscraper*. Families across time have comforted themselves under the objects on display in Watt's creation. The use of donated wool suggests that Watt's materials contain literal family memories and histories, enshrining and archiving them. As with *Ground*, the materiality of Watt's sculptures is utilitarian first, but it nevertheless forms an aesthetic reference to community, family, home, and heritage.

And so the whole unifies the wool and steel parts. Gendered in their respective ways, each material communicates different ideas about Iroquois heritage, each necessary to their history and culture. The softness of Iroquoian womanhood represented in wool cloth wraps protectively around the masculine steel centre embodied in the I-beam. Each contributes importantly to a narrative about identity, presence, and resilience. Together, the two components function as an expression of gender parity, of the need for both gendered forces to birth a culture, and of the duality of kinship networks.

Watt's artworks perpetuate the ideals of community in inviting people to help her sew the components together. Watt invites contributors to participate regardless of sewing experience, identity, or ability, drawing on both a communal Indigenous tradition and one of feminist artists and creators from the twentieth century. Objects reflect a communal effort, with visible contact zones emphasizing the hands and work of individual contributors. This parallels the hand-crafted ancestral objects showcased in Simpson's *Ground* and reflects the collective character of Indigenous communities, and both nod towards the communal work of women.

Both *Ground* and *Skywalker/Skyscraper* communicate Indigenous notions of kinship. As each exhibition gives tribute to ancestral knowledge, action, and intelligence, it shapes and enhances Indigenous beliefs about gender and ongoing connections to kin. Viewed together, these shows demonstrate the diverse ways Native American women artists reject the austerity of Western museum practices and the obscuring of Indigenous histories in public places. Both artists advocate for a uniquely Indigenous understanding of kinship, which extends to material objects. Their exhibitions reflect the diversity of belief and practice in contemporary Indigenous life, which link living peoples with their history and ancestral epistemologies, as a core value in both

Puebloan and Iroquoian cultures. Simpson's and Watt's exhibitions are united in their thoughtful attention to materials under this paradigm. Although Watt and Simpson are from different communities, a trans-tribal approach to their work reveals common understandings of kinship, materiality, and shared values between these groups. Finally, these exhibitions express Indigenous kinship networks, both beyond and through materiality. They show how the sensual material of art objects carries significance and embodies history. Grounded in culture while reaching for the sky and the future, Simpson and Watt use objects to call Native people back, and remind us of who we always have been.

Endnotes

1. The idea of "objecthood" as a means unto itself was developed most prominently in Michael Fried's influential 1967 essay "Art and Objecthood." Indigenous artists problematize the erasure of objects and materials' ability to hold and make meaning beyond their formal qualities, as connectivity to material is a critical element of many Indigenous worldviews and cosmologies.

2. See *Sensible Objects: Colonialism, Museums and Material Culture*, edited by Elizabeth Edwards, Chris Gosden, and Ruth Phillips, for a discussion on decolonial materiality in museum practices. This text comes from a symposium that explored the ways material culture and social practice endows objects with meaning and the clash that attends those processes under colonial incursion. One of the key takeaways from this text is a challenge to the privileged position of the sense of vision in analytics of material culture. This ethic is harmonious with Simpson's decisions about which objects to include, as she rejects the utility-/beauty binary.

3. Hohokam are ancestors of contemporary Tohono O'odham, Pima, Maricopa, and Akimel O'odham nations.

4. One of the earliest written English-language accounts of Pima creation narratives is contained in *The Norton Anthology of English Literature*, Fifth Edition.

Works Cited

Booth, Annie L. "We Are the Land: Native American Views of Nature." *Nature Across Cultures: Views of Nature and the Environment in Non-Western Cultures*, edited by Helaine Selin, Kluner Academic Publishers, 2003, pp. 329-349.

Curtis, Anthony. *Warriors of the Skyline: A Gendered Study of Mohawk Warrior Culture.* Thesis. Marshall University, 2015, mds.marshall.edu/etd/52. Accessed 7 Aug. 2019.

Edwards, Elizabeth, et al, eds. *Sensible Objects: Colonialism, Museums and Material Culture.* New York: Berg, 2006.

Fried, Michael. "Art and Objecthood." *Artforum*, vol. 5, no. 10, June 1967, pp. 12-23.

Green, Fiona. "The Iroquois on the Girder: Poetry, Modernity and the Indian Ironworker." *Critical Quarterly*, vol. 55, no. 2, July 2013, pp. 2-25.

Howe, Kathleen Stewart. "Breaking Ground." *Ground* exhibition catalogue. Pomona College Museum of Art, 2016.

Jenkins, Willis, et al,. eds. *Routledge Handbook of Religion and Ecology.* Routledge, 2016.

Kahesenni:io, Alexandra. "From Great-Grandmothers to Great-Granddaughters: 'Moving Life' in Baby Carriers and Birchbark Sneakers." *RACAR: revue d'art canadienne/ Canadian Art Review*, vol. 42, no. 2, 2017, pp. 100-07.

Kirchoff, Paul. "Gatherers and Farmers in the Greater Southwest: A Problem in Classification." *American Anthropologist*, vol. 56, no. 4, 1954, pp. 529-50.

Phillips, Ruth. "Things Anishinaabe: Art, Agency, and Exchange Across Time." *Before and After the Horizon: Anishinaabe Artists of the Great Lakes*, edited by David Penney and Gerald McMaster, National Museum of the American Indian, 2013, pp. 51-69.

Simpson, Rose. "Introduction." *Ground* exhibition catalogue. Pomona College Museum of Art, 2016.

Watt, Marie. *"Skywalker/Skyscraper* Artist's Statement." *PDX Contemporary Art*, 2012, pdxcontemporaryart.com/skywalker skyscraper. Accessed 7 Aug. 2019.

"Other"[1] Mother-Artists' Acts of Resistance in the U.K.

Terri Hawkes (Canada/U.S.) in conversation
with Dyana Gravina (England/Italy),
Anna Ehnold-Danailov (England/Germany),
and Line Langebek (England/Denmark)

Pregnant Introductions

*T*erri: *Since the birth of my twins in 2000, I have been a Toronto-based mother, writer, director, actor, activist, and academic— spending time, thought, and ink focusing on how to support mothers in the performing arts in their maternal practice, their artistic practice, and that sticky space in between. In 2011, through Andrea O'Reilly's MIRCI and Demeter Press, I discovered some inspiring women dedicated to both their artistic practice and their practice of mothering, each process informing the other. In August 2017, I reignited conversations with three U.K.-based mother-artist-activists I had met on this path. This discourse began in spring 2015, on a three-conference tour[2]; the gift I received was a sisterhood of travelling mother-artists—an international group of passionate mother-artist-academics.[3] In London, I witnessed a presentation by Anna Ehnold-Danailov (artistic director) and Cassie Raine (actor) of the mother-centred theatre company Prams in the Hall. The "Prams" team, like my other sister-mother-artists, defines new ways to combine motherwork and artistic work, breaks boundaries, and builds bridges to*

create design alternatives—fresh (or recycled) ways of conceiving rehearsals, studios, collectives, and institutions in a way that considers life situations and artistic needs. When fellow sister traveller Rachel Epp Buller asked me to chronicle my thoughts around Prams in the Hall for Inappropriate Bodies, I proposed we honour a movement that seemed larger than Prams—one that included other sites of resistance in the mother-artist world of the U.K.. The 2016 Toronto International Film Festival led me to Hope Dickson Leach and London-based screenwriter Line Langebek whose campaign organisation Raising Films advocates for parents in film and television. Hopping across the pond, I met Line and witnessed Prams in the Hall's use of a pop-up mother-child friendly studio space (launched by Dyana Gravina and Amy Dignam) called The Mother House. One year later, I had the good fortune to bring together three of these U.K.-based mother-artist-activists: Anna (Prams in the Hall; Parents and Carers in Performing Arts Campaign), Line (Raising Films), and Dyana (Mother House; Procreate Project). We met in Dyana's cozy London home, sharing food, espresso, and the international life journeys that had brought us together from Italy, Germany, Denmark, and Canada. Ironically, none of us brought our children to this meeting, highlighting the challenges of combining motherwork with artistic work. Our discourse centred around the shared maternal and creative life experiences that had led each of us to participate in creating unique models and reimagining structures in theatre, film, television, visual art, and performance art. Our caffeine-fuelled conversation launched into childcare costs, artists' income, maternal identity, professional dis-crimination, social constructions of "the mother," and gendered labour.

The Birth of a Sisterhood
Brixton Hill, London, U.K.—August 2017

Maternal, Artistic, and Activist Journeys

Terri: *I asked Anna, Line, and Dyana about their maternal and artistic journeys and what prompted them to create new ways to address the challenges of combining motherwork with artistic work.*

Anna: I'm a theatre director in Germany. When I fell pregnant [it was] unplanned; I went into it naively but soon realized my practice couldn't continue the way I wanted it. I wasn't freely available anymore; I couldn't rehearse in the evenings or whenever needed. A further barrier was that I had a chip on my shoulder about not showing that I was a mom—not admitting I had caring responsibilities. These opportunities didn't fit in because my partner was the main earner, and he works in technical theatre—all hours. Childcare was unaffordable. There was no way to share caregiving, which created considerable frustration. I turned down a lot of work because it wasn't financially viable.

Line: In Denmark and Germany, the cost of child care is completely different.

Anna: So, many things kept me from working. Then another opportunity came up, a show about Medea's pregnancy, which I thought I would have to turn down. But in a way it was perfect. I remember being upset, thinking there must be other women who struggle to continue to work creatively. That led me to put a call out for actresses who are also mothers and who might be in the same situation, as it was an all-female cast. I invited them to bring their children to the casting and the rehearsals. I also moved the rehearsals into my front room, so we saved on rehearsal space costs and had everything we needed: toys, beds, kitchen, high chairs, changing mats, TV. I got an incredible response from women saying, "I'm glad to see this opportunity—it gives me hope for the future." That was the first time I looked into this world of theatre makers who are mothers—and found a lot of women needing that support. That's how Prams in the Hall was born—as an experiment that, I warned everyone, could fail.[4] And if it failed, we'd have to present it as research and development and talk about the process. However, it didn't fail.

Many discoveries followed. I saw a focus in rehearsals that I hadn't seen before. Fitting rehearsals in between the demands of the kids meant everybody threw themselves at work. Second discovery: the children genuinely informed the process. One actress was breastfeeding

while reciting the script; another had an anger scene—but with her two-year-old beside her, yelling wasn't an option, so she had to rein it in while playing with him. The process even informed the set design: the toys that were there for the kids who constantly played around us became part of the piece—wooden train tracks, Lego bricks, you name it. And the sound design. We did a rehearsal once without children. We all loved it, but missed the intensity of the sound, the voices, the constant noise we were working against. So the final sound design included the children laughing, shouting and screaming, the noisy toys, the constant interruptions calling for mom. The piece portrayed the process and was well received. Therefore, we decided to continue working that way, inviting parents to bring their children to the process if they wanted and work around company members' caring commitments.

Terri: Line, perhaps you could give some background about your path to maternal and artistic work alongside your activist work with Raising Films?

Line: I became a mother in 2014, partly deliberately but wasn't planned that it happened so quickly that I wasn't ready for it. And I didn't tell people; I specifically didn't put it on Facebook or anything. My partner thought that was really weird, but I said: "Trust me—I don't want people not ringing me up." And when my daughter was born, three female colleagues got in touch to say they were pregnant and had the same fear.

Anna: There's an assumption that women, specifically, can't do the work. Men aren't asked if having a baby at home will keep them from doing the job. But with women, actors and stage managers share this preconception: "She just had a baby, so she won't want a job because it might be too much."

Line: But women have this preconception in them as well. That's why I thought everything would go on as it had. Then slowly I got behind with stuff, the constant lack of hours. I think people assume that writers can work from home, don't need that space—"she'll just be in the corner." I think they get it now. I have a space for my laptop but being surrounded by toys means I lack space up here [points to head]. I lack the mental space. So I was finding my way but not always declaring I was a mother. For example, when my daughter was eight weeks, a BBC radio producer called who didn't know I'd been pregnant

and asked how things were going—well, I didn't tell him I had a baby. He needed a new pitch document to send the commissioner, and I just said "yeah." This trying to come to terms with being a mom was important to Raising Films.

So, we are five Raising Films founders (Line Langebek, Hope Dickson Leach, Nicky Bentham, Jessica Levick, and So Mayer).[5] Our first conversation happened because Nicky and Hope met at an event and got talking about this issue. Hope e-mailed people and found we knew each other, and while we're not all activists, we're all interested in the issue. So we started making a plan. I primarily work in film and TV, but there's an overlap [looks to Anna]. Some people work in theatre, but until now we've focused on parents—but really on the carer side of that. Not caregiving of children necessarily, but also for siblings and parents. Changing social systems requires going beyond mothers to include dads, for example, or people who aren't parents but might have to care for their parents, because our current systems will also block them. Ideally, Raising Films will do it ourselves out of a job, but that will take time. Part of our current work comes from a conference we did in February 2017 with key industry decision makers. We sent them off afterwards with check lists for each sector, (Raising Films has recently carried out a Carers Survey whose results launched in June 2019) asking things like: "what can you do if you encounter issues of being a parent and carer?[6] and "what can you ask other people to do?" You also need to change those systems—British Film Institute, BBC, Film Four, ITV, and Channel 4. Anyone who faces it knows child care is prohibitively expensive.

Terri: It seems many activist threads exist in television and film here in London, some of which seek to make the maternal more visible—from pregnancy—by using those media. You've partnered with several actors and institutions and seem to be making headway, even though women, particularly mothers, remain underrepresented in television and film. Dyana—you're a visual artist working alongside other visual artists. How does your maternal and artistic journey link to Mother House and Procreate Project?

Dyana: I come from the performing arts. I started dancing at three years old but had back issues at the age of thirteen, so I moved into a twelve-year career in production in different fields—music festivals, theatre, cinema, art directing in clubs—back in Italy. In 2013, I got

pregnant through a relationship with my ex-partner. It was totally unplanned and a lot of struggle. I was in shock, as I thought I'd never have kids. I was work addicted, always looking to the future: career, goals. Despite my doubts, I kept the baby, and this also should be discussed openly. I considered an abortion because I thought becoming a mother would completely and negatively change my life and career path. When my partner left for a few weeks, I went to my mom, who was very supportive. Seeing Regis's heartbeat during my ultrasound made me decide I couldn't deal with an abortion. So I left everything I had in four boxes in Rome and moved to London, where my partner lived. I didn't know anyone but had lots of hopes that my outgoing personality and skills would make finding a job easy. I wasn't thinking that I would eventually have a bump. I had no morning sickness; I felt fine. Those energies transformed, but to my surprise, I couldn't get a job. I found myself very lonely in one room because my partner was out a lot. I cried frequently, frenetically sent out hundreds of CVs and, if I was lucky enough to get an interview, even for an unpaid position, they would turn me down at the end when I said I was pregnant.

Line: Before three months you're not legally obliged to say it.

Anna: No, you're not obliged to say it at all.

Dyana: Since it didn't bother me, I thought it wouldn't bother them. Then, at five months, as my body started transforming hugely, a very creative process began—from my body straight to my brain. I felt a rush, like I was always high, very physical and intense, and a flood of ideas. It was not what I expected! But when I Googled "creativity during pregnancy" everything I saw was about a negative cloud around pregnancy. Only one neuroscientist, the University of Richmond's Craig Kinsley, researched pregnancy's links to increased feelings of creativity. So I've decided to organize an event with lots of pregnant women making all sorts of live art and interventions in one evening: all these artists with their bumps as a testimony to this hugely creative, dynamic state of body and mind. I'm looking for a venue and collaborators. I thought that an organization that supported pregnant artists existed but found nothing, not in the U.K., not anywhere. There are no institutions to support women artists during this crucial time in their lives and careers. So, being crazy on hormones and feeling omnipotent, I decided to build that institution—which I've been doing since then.

I think my experience is slightly unusual because although I was in

a relationship, I felt like a single parent, even when I was pregnant. Those circumstances enforced my desire to cultivate and understand my mother practice and reclaim the rights of being a mother privately and publicly. So I started with working on my understanding of what being a mother means, what creative practice means. I started researching knowledge to sustain my instinct for attachment, the needs and rights of being with my child, and the modern studies on attachment parenting, [all which] made me feel validated. That research and the connections I made with like-minded mothers gave me strength to cultivate my artistic practice, integrating it with my mother practice almost constantly. Maintaining an artistic practice in front of my child was crucial to me. I thought how I could show him my work as an artist and facilitator—this was an important process I had to do myself. Becoming a mother didn't affect my dance and movement practice because I had moved on from that way before my pregnancy. Rather, it enriched my need and confidence as a performance artist because it aligned and clarified my priorities, gave me a better understanding of who I am, what I like to do. I became disconnected from outside interventions and found a clear, new space. The research I led and the space I created weren't only personal: I felt responsible to do that not just for me and my life but for social change. I'm putting my child into the work and have the responsibility to do a good job there. I need to do this, and I have the right to be who I am as a woman and artist, and he has the right to see that. That integration came organically and fed everything I'd done so far. But I understood very soon that I couldn't be a lone voice in front of big buildings, that the collective would make a difference because creating a new model of institution would help me reach other institutions that recognize institutional work and structure but don't give space and voice to someone working alone.

Organizations Supporting Mother-Artists

Terri: *I steered the conversation towards what their organizations did specifically to support mother-artists.*

Anna: Through Prams I opened my radar and connected to other struggling artist-parents. I went to a meeting of another network, Mothers Who Make,[7] and left that thinking, "Something needs to be

done so women in the performing arts don't have to invent the wheel over and over." That's where the idea for PiPA (Parents and Carers in Performing Arts)[8] came from. Actor Cassie Raine and I had the idea of a collective that makes change institutionally, not just through creative work, as a way to stop this talent drain. So we went to Equity [the actors' union] to meet the general secretary and the women's committee, who gave us a bit of seed funding. That's how we did the first meeting at Young Vic in October 2015, which showed the big demand for change. We started a think tank to form an idea of what this campaign should be and decided that working with organizations instead of individuals would be most effective. We're going to try to effect change from the top, so it will filter down to people who need it.

Line: Do you know an organization called Julie's Bicycle[9] that does something similar but focused on climate change? They talk to media organizations about how they can make change; the model is interesting.

Anna: They help track how much energy organizations use and how to be more efficient and environmentally sustainable. When PiPA launched a research project, we decided we needed data to prove a problem exists. So we applied for funding for a U.K.-wide survey focused on theatre and including parents, carers, and those considered not to have caring possibilities to locate barriers. Then we worked with fifteen theatre organizations across the U.K. to test potential solutions for problems the survey identified: recruitment, casting, everything; how to make touring accessible for parents or carers; how to support freelancers. We are compiling the data now, and we'll launch a theatre industry best practice charter in October.[10] Next year, we will work with theatres to create a toolkit and business support program. We will continue to advocate for parents and carers, and move into the music and dance industries. We consider Raising Films a sister organization.

Line: I used to think that statistics are boring but then realized that data is everything.

Dyana: Who analyzes your data?

Anna: We work with Royal Central School of Speech and Drama, which is particularly great because the university also gave us support and funding. It paid for the researchers and some of our work, and can help access funds that we can't on our own. In fact, our partners found it important to link with a university.

Line: It legitimizes the project.

Dyana: What is the model of Raising Films?

Line: We're a community organization, not a charity—too many admin issues. Five of us are the founders and have an advisory board: a casting director, people who can advise on next stages. We have ambassadors like Charlotte Riley [British actor and writer], Alice Lowe (British director, writer and actor) and Manjinder Virk [British actor and director]. Sarah Solemani [British actor and writer] has done a lot for us, getting us publicity by carrying the sign for us on the red carpet for *Bridget Jones*. The conference was the next step. We also have run schemes to connect women with mentors while their children are in crèche [daycare]. The British Film Institute funds CLOSR[11] and pays for the women to come for two days. We also have online hangouts and meetings. People who may have dropped out of the experience can bring a specific project and get advice over nine months: "How do I advance that project and combine it with being a parent?" So, we are looking to run a residential like those in the U.S., some of which include childcare.[12] There is COVE[13] in Scotland, but that's not a crèche[14] and currently is project based; Laura Giles works ad hoc because we've run out of funding, so we're looking at more funding[15] and at creating a sustainable model.

We raised money through crowdfunding initially, when we were a platform for interviews and testimonials, for people to write from the heart. Like one director, a mother, talked about sitting inside an office in LA, waiting for a big meeting while her partner sat in the car with the baby—when suddenly the car alarm went off. And there she was, not having told anyone she had a child, trying to be calm. And there are stories from the BFI and British Council from top-level women about that feeling when you're in a meeting and it's five o'clock and you're sitting on your hands and have to pick your child up. We want to create a space to not see this as a problem. And we wonder if this links to diversity. Is part of the reason these issues aren't recognized the lack of representation of women? But still, it's a shift from ten years ago, when women felt they always had to present themselves as at the top of their game.

Dyana: I created a business plan based on what I knew when I was pregnant. I worked first on a production of this not-yet-existing platform then became a mother, so organically the focus shifted organically from pregnancy to motherhood. Four years later, Procreate Project[16]

supports production, acknowledgment, and recognition for contemporary artists, and we hope to develop a sustainable organizational model that won't rely on public funding. Currently, there are a few productions, and we have been collaborating and supporting hundreds of artists internationally. One especially successful production is The Mother House[17]—an artists' studio for mothers with integrated childcare, which welcomes children in the work space. It works like a gym membership: people pay for studio space and childcare; it's flexible, based on needs and schedule. We hope to replicate it nationally and internationally, but it's about spreading the opportunity, not making money, and about responding to inquiries from around the world about how to open their own Mother House studio.[18]

And then Oxytocin[19] in June 2017 brought together arts, health professions, academia, and activism for a fantastic exchange and acknowledgment of each other's work: all these people supporting mother-artists and working towards healthier families and women and, thus, supporting artistic development. Now we want to turn it into a festival. In terms of sustainability, we plan to keep Procreate Project a community interest company, and we're thinking of platforms to generate revenue and sustainability while creating financial opportunities for artists. So now, we sell art online and at art fairs. We have an open conversation with the Museum of Motherhood [USA][20] to organize short online courses on the maternal, from different perspectives and fields of study. There are endless possibilities to legitimize maternal studies and create more consciousness and knowledge, which change requires.

Organizational Structure

Terri: *Pondering how institutional structures perpetuate certain social expectations and exclusions around maternal status made me wonder how the women sought not just to accommodate their situations but to make changes in structural design (i.e., how institutions do things).*

Anna: Working with children in the room—and allowing others to do the same and being open about it—was key for me. Being open about having children, making that part of my practice, is a big change in addressing institutional barriers, at least perceived ones. It's how I address these issues. If I were up for a directing job, I would say, "I

have children and I have to pick them up."

Paradoxically, working around my children so much made me realize that PiPA kept me from having enough time for my children. I learned to juggle, to set boundaries—but for my work rather than, as it used to be, for my motherhood. For example, I work part time. If someone wants to call after two o'clock, I often say, "That's fine, but my little one will be in the room when we talk." It's a bit like Line said. Being clear and open about the parameters has taught me that most people can adjust. And that takes my fear away and helps me lead by example.

Institutionally, the challenge is seeing where organizations struggle, which differs for each organization. Interestingly, organizations often perceive themselves as doing well, which complicates pushing them to go further. If they already have things in place, you often have to prove to them that they might not reach far enough.

Line: What I'm doing institutionally relates to Raising Films. It's about creating space for me. I'm looking at how the creative process starts—talking to people about how they like to work, thinking about how I like to work, setting parameters. For example, I worked with a director who would send e-mails all night long, so when I woke up there would be ten e-mails. I'd be wondering what the thread was because this person didn't have kids and could stay up 'til three in the morning. So I suggested that they send me things consolidated in a Word document, so I didn't feel overwhelmed. Becoming a mother forced me to learn to create parameters and barriers and to learn to say "no." And talking to a psychologist about the creative process re-inforced these ideas.

Dyana: The first barriers are in our heads. To give a practical example: when we started the Mother House, I thought it would be a regular studio space with a crèche on the side; this is how we were raised—making work meant someone else caring for your child. So some barriers were mental, and some were financial: not having money to start a crèche and pay staff. Then I thought: why not replicate the model I have in the house on the outside? The mental structures imposed by society make separation and exclusion seem necessary. So those barriers need to be disrupted first to allow time to improvise and explore new ways—like working with new materials. For example, some artists at the Mother House thought they would use the studio

just to network because their practice wasn't child friendly but started exploring new, more child-friendly materials. One artist created big pieces using chairs, fabrics, and cling film, which was a huge artistic development for her. She allowed her barriers to break down so she could explore different materials, and the children around also would engage with the work. Overcoming mental limits requires a safe, dedicated space in which to work and allow potential to be unlocked and that process to flow. I often feel like the lone voice in the community saying that, but children often react well to artistic work being integrated with mother-work. Chaos becomes silence. At the Mother House, we work with children, who are free to access the work place and observe their mothers and other women outside a domestic environment.

Terri: Were there barriers and/or challenges with the kids?

Dyana: No, because the children rarely come in the space. They feel accepted, so they don't need constant attention. When they come into the studio, it's to observe—quiet observation and curiosity. It is beautiful.

Anna: It's beautiful when it works; but I think the mother-child relationship matters. In my workshops, it works best when the children and the adults both feel relaxed. A worrying mother also creates barrier. You must trust that your child will come and go, which I think is, in any case, a step within everyone's parenting.

Dyana: That's why I had to do that personal work. With the Mother House, it's sort of a natural selection of the parenting approaches of the artists in our studio. However, many people changed their mind. One of the most concerned artists initially thought she needed to bring child care. But at the end of her first day she started crying and said, "I can't believe I've read an entire script, and [my child] was just happy there and playing."

Anna: I agree. If the children can allow it, they can influence your artistic practice unexpectedly through materials and working patterns. Throwing out these personal systems you've got in place really opens up the artists. And children make that easy because they throw out everything. I used to become a different person when working away from my children: Anna the director. But my children are around; they remind me that I am me in my core elements; I can't pretend. If something annoys me, my kids get it out of me; they make me truthful

to myself, which can be hard and make me vulnerable in front of other people. Letting go is a gamble but can bring interesting results. Actors who had stock characters find they cannot access those characters because somebody is reminding them that they are a person. Sometimes, though, after a few days, the children become a little gang. They start to look out for each other, create their own thing, and enjoy playing away from their parents. They look forward to coming to Mother House for that. So, it's useful to children; they grow up in something we don't have anymore.

Line: Studies show play has changed in twenty years—that different ages and generations play differently.

Anna: It doesn't work when children don't connect. For example, we once had a big workshop in which two siblings were terrorizing their mom and being disruptive to the adults and other children in the room. The situation became challenging. It was unusual behaviour, and the mother apologized. I told her that if she continued coming, the kids might learn to integrate, but she was anxious from the start and unfortunately did not come back. I don't know her personally so can't say more about it, but I have seen it fail badly when children were unsettled and too young. Or when there are no other children in the room. For example, once when we changed rehearsal hours to school hours, one performer brought a very young child and of course that child was bored stiff without any support structure for them. The child wanted to be with Mom constantly, which was challenging for the mom and for the child. So we learned from that. This prototype needs time and structure to work so that children grow together.

Dyana: Now the model includes an educator and other children. I was concerned about going to Stroud [site of the second Mother House pilot project]. I was wondering if the model had only worked because of the beautiful London venue. But after two successful weeks in Stroud, I became confident that the model can work anywhere. It's not about having the children in the room; they are indirectly participating in this context around it. Adding a dedicated and inspiring person curating the children's room creates stimulation and makes them feel this space is also for them. It's not just about the mothers—it's about a safe space to engage and be part of each other's practices.

Institutional Design

Terri: *I asked the women about the financial and legislative feasibility of their proposed shifts in institutional design. As an extension of that, they segued into key musings around fathers' roles as parents and activists, returning us to the ever-present context of social expectations.*

Line: With Raising Films, we've been working with the BFI (the British Film Institute) to set up a fund so that small indie productions, which don't have money to have crèches on sets, can support fund childcare for directors and crew, people who [unlike screenwriters like me] have to be on set. But as for institutions: in some ways I haven't adjusted because they haven't. I haven't yet said, "I need to leave at four" or "I need to go away." But sometimes I've found, where possible, it's helpful to go away and spend three days to meet a deadline rather than spending two weeks in between the toys and nursery pickups. It's a mental shift—I'm still learning. But you can do a lot in an hour.

Dyana: With The Mother House, I want to combine a financially sustainable business model with rates that artists can afford; we all know our financial struggles. Integrating childcare into The Mother House prototype is part of that because it splits shared responsibilities fifty-fifty between the artists and the educator. Another idea is to have [an] Ofsted [Office for Standards in Education, Children's Services and Skills][21] registered team at The Mother House, so lower-income artists can claim tax credit support and child care vouchers. But the main issue is that what artists pay at the moment is not financially sustainable, so we are seeking other revenues sources, like opening separate spaces for other public programs and activities.

Line: For a lot of people, these options can't work full time. And then there are unpredictables: just today, I put my daughter in nursery for the whole day because I had another meeting with a guy who does not have children, who cancelled last minute. So that's just wasted money for me.

And that speaks to how financial structures and hiring practices haven't changed in ten years, even where women are at the top. Instead, people say they want to change things for the next generation because then they don't have to admit that what they've done for the last ten years isn't working—that in terms of who's getting hired, the numbers haven't changed. When you ask people to count, they have to look at who [they were] hiring. Otherwise, people don't think. For

example, a theatre company might say their casting calls are open to everyone, but then it turns out that the casting is always on the second floor, without disability access.

Anna: Yes—enabling others matters. Trying things out, enabling yourself while helping others explore where they might fit in. And the more I investigate this problem from a governmental perspective, with women struggling, the more I realize that fathers need to be involved in this conversation, involved in taking parental leave, for example.

Line: Pregnant Then Screwed[22] helps moms with their rights, and they're lobbying for shared parental leave. Sweden actually makes sure that parents do this. Here it sort of exists but not really because it's unpaid.

Anna: In Sweden, if men don't take it, both parents lose it. The employers know and expect that both men and women will disappear for a while when they become parents. It's crucial to include men to encourage and enable fathers to bring up their babies.[23]

Dyana: Someone at the arts council recently asked why our facility is women only. Why not a Parent House? And naturally I support a vision of a future where parents are equal and women have the same opportunities as male artists—but that's not today's reality. I'm not taking fathers out of the picture; I'm just trying fill a gap and create more opportunities for women artists. The statistics are clear. I'm not changing the world. I'm creating a safe space for frustrated, talented people who deserve it, who would otherwise be at home. But our model doesn't suit everyone: someone else might need something different.

Line: One hopes that ten years hence we won't exist, or The Mother House will have become The Parent House. But we've got a ways to go. At a film festival recently, a woman asked me who was caring for the baby and was amazed when I said his father was. So men still become heroes for doing the job that women do every day because so few men do it.

Dyana: Spaces reserved for women and their kids remove that judgment because everyone there gets it. You don't have to justify combining working with mothering.

Anna: It's empowering.

Dyana: It's empowering and children learn from it—and men too. One guy, an artist, started out questioning the women-only policy but after visiting the studio to help us set up saw that all these women

working together, sharing skills, promoted a real intimacy. In another case, the husband of one of our artists saw the benefits that this artist and her child got from the Mother House. She flourished; she made a huge amount of work in the ten days she was in the space. And after the first few days with us, when she put her frustrations and feelings in her drawings, her son went from hitting her, which often happens, to kissing her on her lips for the first time in eighteen months. She relaxed, her kid became more confident, and the husband was so excited about what happened in just a few days that he wanted to help develop the business plan. The pleasure and health of a woman in a safe space benefits everyone.

What Worked?

Terri: *I wanted to know about the mother-artists' successes and what the rest of us could learn from their experience, strength, and hope.*

Anna: Always have points of integration, like everyone coming together to have lunch or watch a show. The kids love it, and it emphasizes that everyone belongs here; it's our time together.

Line: I'm often alone, so my experience has been different. Certain work, like scriptwriting, I can't do with my daughter in the room. Yet, in other ways, I have to collaborate. As a screenwriter, I need the team. Those basics haven't changed, but I do think more now about ensuring my collaborators understand who I am as a creative person. I couldn't work with someone who doesn't understand who I am as a mom. They must allow me to be that and not call me at two in the morning, for example. And conversely, if we don't need to sit down and write, we sometimes meet in the park so the children can play. We don't waste the time we have without the children—for example, we use that time for focused writing, not for meetings.

It doesn't always work—like one situation where a collaborator's kid was a bit older than my daughter. But there also were surprises the other way, like when she was young, I would be really touched by slightly older women who would tell me to bring her to meetings and then someone would take her for a walk. Having been through it, they understood. So I've discovered a sisterhood with women who are ten or twenty years older than me.

Anna: I need collaboration to create. Conversations and surroundings inspire me. But, like Line, I think I've become more specific about my collaborators. My time and attention span both are more limited. But I'm also more open than before about exploring different ways to collaborate rather than repeating the same things. PiPA, for example, collaborates on everything. Without different organizations on board, we couldn't do anything. Collaboration with children for Prams in The Hall is integral to how we work and to the project—meaning that we take them into account and they benefit as much as we benefit them. So, certainly, we work while they're at school, but they really see the bigger picture: they are allowed to inform the work and be in the process.

Terri: Line, what about collaboration with your daughter?

Line: We haven't collaborated much, but perhaps will do more when she's older. But there is playing, which creates enforced breaks that can be helpful—those half hour enforced breaks that keep me from staying hunched over the keyboard for too long. And also I've become interested in writing for children. The Danish TV project is team written specifically for younger teenagers, about a quest of identity with a climate change theme underneath. The opportunity to discuss something important with children excites me, and I like the idea of writing something my daughter can watch ... unlike some of my other projects, which she shouldn't see for a couple of years—at least!

Terri: Dyana, how has collaboration figured into your creative work and motherwork?

Dyana: Collaboration with other women has become crucial to expand the Procreate Project. But it's also become important on a personal level. For example, recently I was missing some elements for a movement project and women in Stroud helped me immortalize that moment and offered me materials. That supportive network of like-minded women can share rhythm and experience and facilitate inspiration and artistic development. And the collaboration with my child was everything. Collaborating and negotiating with him made everything happen. So now everything I do is about collaboration, which has helped me achieve results that otherwise I wouldn't have achieved.

Line: A collaboration can also be that someone allows you to go away or go into another room.

Dyana: In that sense I feel I collaborate all the time. During *Oxytocin* I had to present in front of a hundred people. I told my son that "Mommy was about to do something important," and at the end he said "Bravo, Mommy," and I was really proud.

Line: That reminds me of the one collaboration I had with my daughter. A year after Chantal Ackerman [Belgian film director and writer] took her own life, Alexa Seligman, a film producer I was working with, and I saw a call for papers for a tribute conference. We proposed a work called "An Exquisite Corpse," which started as a conversation. But Alexa had just had a baby, so we decided to shoot little videos on our iPhones that would respond to each other: a minute in a forest or something. We edited them together into a short film accompanied by letters we wrote to each other, and our kids were in it in various ways.

Anna: And course, while it might seem obvious, I do want to add that we ended up where we are because of our children.

Dyana: Yes—the biggest collaboration!

Anna: I so much want my practice, and your work and your work, to make obvious that getting pregnant put us all on this path.

Postpartum Activist Energies

Terri: *Nine months later, in April 2018, I gave Dyana, Anna, and Line an opportunity to weigh in once more through e-mail. I asked, "When you look into the future, what do you see as the continuing challenges for further work in supporting mother-artists, and where do you think we, in the broader community, could best put our activist energies?"*

Line: Raising Films has just come out of another huge crowd funder that, while successful, required much more social media presence than any of us have space for in our lives. Combined with the mental-health toll, it's not sustainable. So I'm now thinking about policy, but while some of the structural barriers are systemic, a lot are financial. Child-care and caring costs have to become cheaper if we want to keep the creative industries diverse. And that means the government must believe that a healthy society supports its creatives, its mothers, its parents, its carers. So we must keep trying to change the structures from where we stand, but we must also fight together for change in the bigger political picture, perhaps through an umbrella group. There is much more to do.

Dyana: I'm creating a crowdfunding campaign for the Mother House research and development, to ensure salaries for me and another director and pay for expert support to create a business plan and tool kit for the model's national—and potentially international—replication. We only need about £15,000. I'm also thinking about equal parenting leave, a great option but not helpful to single parents or to those who want to raise their children for the first five years or more. I'm thinking about how to acknowledge the work of mothers and give them the choice to do it with less financial strain and social judgment. I want to create new structures, models, and places to facilitate these choices and provide opportunities for sustainability and artistic development across art forms.

Anna: My challenge is to continue developing my art. PiPA is growing well, but a foreseeable challenge will be ongoing funding and developing a sustainable model for the company. But it boils down to the arts sector being generally underfunded. I worry that arts organizations have to work like businesses to sustain themselves, which traditionally means that money comes before people. I also worry that our Western society's view of parenthood is deeply flawed. We still expect women to do the caring, for kids or adults. The U.K. is shamefully behind other European countries on childcare systems. All kinds of research shows the importance of early attachment and care, which even makes an economic case for supporting the home care for young children, yet early care for our future generations remains undervalued and underfunded.

Author's Note

I appreciate the opportunity and guidance provided by Rachel Epp Buller and Charles Reeve to explore current challenges and achievements of other-mother-artist-activists in the U.K. I also applaud the tremendous investment of time and energy by Andrea O'Reilly and Demeter Press that makes this work possible. I am profoundly grateful for the time, efforts, and wisdom of Dyana Gravina, Anna Ehnold-Danailov, and Line Langebek, and the tremendous activist work they have done through the organizations Procreate Project, The Mother House, Prams in the Hall, PiPA, Raising Films, and Library of Change. My intention is to bring their insights and successes to other mother-artist-activists around the world as

well as to my own creative, maternal, and activist practices in Canada and the U.S. I am deeply indebted to Mary Ann Oughtred, Anne Fitzgerald, Beth Bryant, Mary Lou Belli, Charlie Dougherty, Clare Davenport, Melissa Hylton, Francoise Jacobsohn, Esther Atkin, Michelle Flax, and Jan Winhall—for their grace and generosity of spirit in providing me physical, emotional, and mental space to do this work. And of course, to the two people who allow me to continue to grow as a mother and person: Alexa Hawkes-Sackman and Jake Hawkes-Sackman. As I write this, you are both celebrating very full lives as eighteen-year-old citizens of the world, with rich friendships, university-level rigour, and the complexities of growing into adulthood. You continue to practice curiosity, compassion, and courage, and I could not be prouder of you or love you more. May your life journeys be as meaningful for you as mothering, creative work, and activism have been for me. And to my Dad, Jim Hawkes, whose spirit overcomes all—thank you for your road map of parenting. My heart is also filled by the promise of continued engagement with my sisterhood of talented and inspiring mother-artist-activists—from both sides of the pond.

Endnotes

1. The term "other" here results from discovering that everyone in this conversation was raised outside England and thus, in a sense, is "othered" by virtue of having arrived with a lens outside the hegemonic British experience. Yet their artistic professions, roles as mothers, passion for activism, and choice to reside in London (with the exception of Canada-based Terri Hawkes) joined them together, as did the multicultural lenses through which they viewed U.K. culture and institutions as informed by their experiences as self-acknowledged "other-mother-artist-activists."

2. The 2015 three conference tour was to present a Demeter Press anthology I co-edited with Amber Kinser and Kryn Freehling-Burton, *Performing Motherhood*. I toured from Ottawa, Canada (Congress of the Humanities and Social Sciences) to London, England (Motherhood and Creative Practice), and Rotterdam (The Mothernists). There was much commentary that spring of the zeitgeist of mother-artist-activist gatherings. For more information, see www.culturalreproducers.org/2015/10/the-mothernists-rotter dam.html.

3. The Rotterdam portion of the sisterhood tour culminated in collective sleepovers in the very welcoming home of Deirdre Donoghue, founder of M/other Voices: The Maternal as an Attitude, Maternal Thinking and the Production of Time and Knowledge. For more information, see www.mothervoices.org/.

4. For Prams in the Hall, see www.pramsinthehall.com/.

5. For Raising Films, see www.raisingfilms.com/.

6. https://www.raisingfilms.com/portfolio-items/we-need-to-talk-about-caring/.

7. For Mothers Who Make, see homemcr.org/event/talk-mothers-who-make/.

8. For PiPA/Parents in Performing Arts, see www.PiPAcampaign.com/: "PiPA enables and empowers parents, carers and employers to achieve sustainable change in attitudes and practices in order to attract, support and retain a more diverse and flexible workforce."

9. For Julie's Bicycle, see www.juliesbicycle.com/.

10. PiPA Best Practice Charter was launched in November 2017: www.PiPAcampaign.com/charter/. At time of publication, PiPA is currently "trialling it with 22 theatre companies with the aim to develop a supporting program and toolkit for it," http://www.PiPAcampaign.com/charter/best-practice-charter-program/.

11. For CLOSR, see: www.raisingfilms.com.

12. 'Sign up for the Raising Films' newsletter to be kept up to date with CLOSR, MIP (making it possible) and other schemes.

13. Raising Films has since started creating writers' residencies: www.raisingfilms.com/raising-films-writer-residencies-spring-2019/.

14. For COVE, see covepark.org/about-us.

15. The Cove Park residencies with childcare are now in the active pipeline: covepark.org/about-us.

16. For more on Raising Films funding initiatives, see www.raisingfilms.com/support/.

17. Procreate Project is the first arts organization supporting the development of contemporary artists who are also mothers working across art-forms. For more information, see www.procreateproject.com/.

18. For The Mother House, see www.motherhousestudios.com/. Mother House has finally secured grants and the support from the mayor of London to open the first permanent studio space in London and is talking with investors about creating a social and global brand. For more information, see www.motherhousestudios.com/.

19. Oxytocin was mounted in June 2017 and remounted in March 2019; both events were considered extremely successful. For more information, see www.oxytocinbirthingtheworld.co.uk/.

20. For the Museum of Motherhood, see mommuseum.org/.

21. For the Office for Standards in Education, Children's Services and Skills, see www.gov.uk/government/organizations/ofsted/about.

22. Pregnant Then Screwed is "a safe space for mothers to tell their stories of pregnancy or maternity discrimination and to receive the support and protection they need." For more information, see pregnantthenscrewed.com/.

23. Though past now, this demonstration was mentioned in our conversation regarding moms and dads. More for more information, see www.marchofthemummies.com/.

Part III

By Design

Chapter Thirteen

The Inappropriate Birthing Body and How the Birth Environment Is Implicated

Doreen Balabanoff

"At a primary level, our body knows, this is a body inhabited by motility—the motion of life itself... It is also the body housed by architecture." (Pérez-Gómez 573)

Appropriate (adjective)

- especially suitable or compatible: fitting (Merriam Webster Dictionary)

- correct or right for a particular situation or occasion (U.S. English) (Cambridge Dictionary)

- suitable or proper in the circumstances (Oxford Dictionary)

Inappropriate (adjective)

- not appropriate, unsuitable (Merriam Webster Dictionary)

- unsuitable, esp. for the particular time, place, or situation (U.S. English) (Cambridge Dictionary)

- not suitable or proper in the circumstances (Oxford Dictionary)

The inappropriate birthing body: what can this mean? Increasingly, in a world that prioritizes and promises safety for mother and child, women know this body, and many fear this body. The feeling of this

body's uncertainty and lack of confidence haunts women before, during, and after birth. Many stories online and in diverse studies describe a cascade of medical events and urgencies that can create a traumatic birth experience (Foureur; Stenglin and Foureur; Nilsson; Rouhe et al.; Morris and McInerney; Cohen Shabot). Tokophobia, a fear or dread of childbirth, is now recognized as a psychological disorder requiring healthcare attention (Roland-Price and Chamberlain; Hofberg and Brockington; Laursen et al.). Caught up in a culture of fear, maternity healthcare providers also worry about how their anxieties could affect outcomes (Dahlen; Oteley; Powell Kennedy and Shannon).

The birth environment: how is it implicated? Imagine, for a moment, a woman in labour passing under the large red word EMERGENCY as she enters a hospital at night. Might this sign trigger an adrenergic response (production of stress hormones) as this word and its meanings register in her mind? Then, she traverses the emergency waiting room, triage area, corridors, and elevators en route to the maternity unit, encountering on the way sensorial spatial experiences that trigger many visceral, if not consciously noticed, responses. Even the invisible contributes—the air carries olfactory and auditory signals and messages—as do the people, many under stress, many unwell. Importantly, though, the birthing woman is not sick, and not (usually) in crisis. Yet she now feels anxious and begins to feel like a patient herself while her companion's excitement starts to shift towards concern. Indeed, a woman entering the birth environment becomes a patient (Kitzinger 8) and will be treated as one, although giving birth is not an illness. Why is she entering here, reading the sign that tells her that giving birth is an "emergency"? Clearly, at this entry point, her body and mind respond to the surrounding situation. Thus, the inappropriate birthing body begins with this inappropriate point of entry—this unsuitable spatial and architectural circumstance that does not fit well, which triggers an embodied response that becomes part of the birth process.

This psychophysiological experience exemplifies the powerful interconnected relationships surrounding us as we move through and dwell in our environment or "ecological niche" (von Uexküll; Gibson; Merleau-Ponty; Abram). Considering this environment and body interactivity as causal is inappropriate. The many variables make reductivist explanations unreliable. But all creatures, fundamentally, need a protective domain. All species need to create or find shelter

while birthing. Laugier's "simple hut" is known as the prototypical foundation of architecture (10-14). But the earliest human birth shelters likely were encompassing, protective, and intimate settings, whether forest glades, caves, sacred spring hollows, or alcoves among grasses or rocks or alongside streams. Across the eons, we can imagine that countless women have given birth in such places. The humble hut or abode developed differently in different regions, and it is next in this timeline of birthspace places (see Kitzinger for a broad diversity across cultures). Through most of the long, adventurous history of architecture (as a theoretical and practice-based profession), the discipline's discourse has not included the birth environment—whether natural, humble, grandiose, or clinical—as part of its valued domains (Lepori "Mindbodyspirit Architecture" 95). Yet a more profound program for a sensitive, spiritually meaningful architecture would be hard to find.

In the late nineteenth century, during the inception of hospitalized birth (originally for the poorest women), Florence Nightingale proposed a new birth unit, commissioning architectural drawings to her specifications. Indeed, she spearheaded a new hospital architecture, full of light and fresh air, and new models of care (including the trained midwives). Gina Greene describes that era's filthy, deadly hospital environment, where women shared beds with contagiously ill patients and died in great numbers from (yet mysterious) bacterial infection ("The 'Cradle of Glass'"71-72). Soon after, twentieth-century app-roaches to medicine (and birth) led to the development of a modernist, technological, and clinical birth environment (Greene, "Towards a Modernist Maternity"; Davis-Floyd; Szurek).

Today, twentieth-century birth culture's medical gains have priorit-ized safer births for all involved in birthing spaces and practices. However, the rise of operative birth has complicated safety, with a corresponding rise in danger for mother and child (Gupta and Saini; Kallianidis et al.; Villar et al). Marcia Inhorn defines medicalization as the "biomedical tendency to pathologize otherwise normal bodily processes and states. Such pathologization leads to incumbent medical management" (354). The clinical nature of birthing rooms and units is part of the lack of support for normal physiological birth in the medical model of birth care (Dreger; Hammond et al., "The Hardware"; New-burn and Singh, "Creating a Better Birth Environment," "Feathering the Nest").

Birth is the primary act of human life. Through it, new beings enter the life world on this planet. As noted above, for millennia, women gave birth in secret or private, perhaps sacred, places—in the natural environment, in a birth hut, or in the home. Today, approximately 98 percent of births in the developed world happen in designed birth units in or attached to hospitals (Boucher et al.; Grigg et al.) While not yet ubiqitous, the medicalized, institutional model of maternity care continues to spread across the globe (Betran et al; Johanson; Inhorn). Yet hospitals in less-developed countries struggle to provide adequate, respectful care (Fernandez; Wagner, "Fish Can't See Water," *Born in the USA;* Bohren et al.). Lynn Freedman and Margaret Kruk propose the following definition of disrespect and abuse during childbirth: "interactions or facility conditions that local consensus deems to be humiliating or undignified, and those interactions or conditions that are experienced as or intended to be humiliating or undignified" (42). Many have stressed that the future development of birth approaches must include models of care and strategies that can provide more positive birth experiences (Bryanton et al.; Hodnett et al.; Sandall et al.; Davis-Floyd, "Birth Models That Work"; Byrom and Downe; Barnett et al.; Symon et al.; Chamberlain and Barclay).

An international, transdisciplinary array of researchers and practitioners—midwives, doctors, nurses, scientists, feminist theorists, architects, psychologists, mothers, and more—are currently considering the perinatal time (just before, during, and after birth), scrutinizing many aspects of medicalized childbirth. Studying and changing models of care and birth settings, while important, is difficult, as entire healthcare systems are implicated. The Optimality Index for Birth, originating in the Netherlands as a research tool (King et al. 6), has been adapted in the U.S., the U.K., and other contexts to consider birth from the perspective of optimality rather than adverse outcomes or pathology. Marieke Hermus et al. note that "one of the hallmarks of midwifery philosophy is the 'advocacy of nonintervention in the absence of complications'" (580). They also state that "although the [Optimality Index] is a research instrument, it can be used in care to increase awareness of the effect of interventions...: it can demonstrate ... that every (unnecessary) intervention interrupts the process of physiologic childbirth and often starts a cascade of other interventions" (585). Ulla Waldenström et al. cite four factors leading to a negative

birth experience in Sweden: unexpected medical problems, woman's social life/support, woman's feelings during labour, and caregiver factors (25). Christophe Clesse et al. have provided a literature review analyzing the "medicalization of birth" and claim to provide "a complete overview of Birth medicalization and the subjective experience of women in childbirth" (165). Yet these, among many other studies, omit the birth environment from the discussion (unless women's feelings are queried concerning the environment, which is unusual).

In sum, architects remain in the earliest stages of considering the birth environment as architecture—that is, in all its humanistic, formal, cultural, and poetic potential as a site for sensitive human experience. So reimagining the birth environment adds importantly to the architectural agenda—hence, my interest in asking how to optimize birth as a meaningful life experience and crucial wellspring of mother and child's health (and therefore for entire communities and societies). The many factors at play (cultural, political, economic, and more) preclude straightforward answers. Research (by midwives, nurses and doctors, anthropologists, sociologists, and others) suggests that the hospital space can pose a dilemma for birthing women, ostensibly offering safety while potentially challenging and limiting their birthing confidence (Coxon et al.; Hodnett). Studies in various countries show fewer interventions—fewer caesareans as well as less use of analgesia and augmentation of labour—in (low-risk) women who planned a birth centre birth than in women who planned hospital births (Sandall et al.; Hermus et al.; Maternity Care Working Party).

Hospital birth units support medical monitoring and management of birth. (Clearly, designers who seek to embellish or improve the situation must work in the overarching model set up by hospital authorities, so they cannot challenge the paradigm.) Hence, a ticking clock and hospital protocols take over, sidelining natural rhythms and privacy. Most women choose hospital births, since they believe no other safe alternative exists, even though women are widely dissatisfied with the hospital birth experience (Waldenström; Johnson and Daviss; Boucher et al.), and those who have given birth in hospital once are often interested in other birth settings (Declerq et al. 7). What happens to women in the hospital birth environment puzzles them. Despite their best efforts to prepare for the birth they meant to have—that

they imagined and hoped for—they are not ready for the hospital experience (Hodnett and Simmons-Tropea; Fenwick et al.; Declerq et al.). Many speak of feeling out of control, shut out of the decision-making process, and decimated by their lack of confidence. Many do not get to hold their babies soon after birth—despite evidence supporting the value of immediate skin-to-skin contact for both mother and child. Notwithstanding well-known, significant health benefits, few babies are breastfed (UNICEF/WHO; Kroeger and Smith). And in addition to the short and long-term emotional connection and wellbeing at stake in the birth experience, further health consequences are also under study (Buckley). Recent studies have shown that women of colour in the U.S. have higher rates of operative birth (Edmonds et al.) and of maternal morbidity and mortality (Flanders-Stepans; Roeder). Birth neurohormones oxytocin and vasopressin, significant within the brain and body system, seem to be important in feelings of love and connection. Measuring birth experience quality is hard, but Janet Bryanton et al. show that type of birth (vaginal or Caesarean), degree of awareness, relaxation, control, helpfulness of partner, and being together with the infant following birth are the strongest predictors of a quality birth experience from the woman's perspective. Sarawathi Vedam et al. have developed the Mothers on Respect (MOR) Index, which addresses questions about respect and self-determination during birth. Their discussion notes that "women from vulnerable populations were more likely to score in the bottom tenth percentile of the MOR scale" (207). Many studies focus on birthplace as related to home, hospital, or birth centre outcomes. Few address the nature of the space or sense of place that may be implicated in participants' attitudes and behaviours. Ellen Hodnett et al.'s often cited systematic review found that care providers were the strongest influencers of women's experience. But this finding should not limit efforts to create better birthspace through architectural design, which also influences attitudes and behaviours of caregivers.

Could it be that the hospital birth environment renders the birthing body an inappropriate body, a body that feels unknowing, uncertain, and unsuitable for giving birth? Could increased awareness and knowledge of birth and its processes, and of issues of caregiving within this setting, inspire and activate architects and designers to become agents of change? My interest in designers as knowledgeable actors in

this area stems from my professional awareness of their crucial role in providing design innovation. Although midwives, now at the forefront of birth environment design research, understand that the clinical environment undermines women's capacities and confidence, they are not positioned to affect decision making in the design process. Doctors and nurses are more likely to be invited into predesign briefing sessions and, thus could have influence, but they are trained and practiced in the medical model of birth. Indeed, most will have never seen a natural birth. Women themselves, if asked what they want, may also take the medical model for granted. Yet women feel that the environment can influence how easy or hard it is for women to have the birth experience they want. For example, Mary Newburn and Debbie Singh's 2005 survey found an elevated risk of emergency Caesarean in women who stated they were unable to walk around during labour. In short, although many factors influence birth processes and experiences, the birth environment is a key element in that complex. Sensitive designers taking up greater awareness of these factors will help shift the birth environment towards a more, humane, emotionally resonant, and empowering birth experience.

Architectural theorist Alberto Pérez-Gómez, in the chapter's opening quotation, chooses the word "motility" to describe the "body that knows." In biology, motility refers to organisms with capacities for spontaneous movement. Even at cellular and microscopic levels, motility is an important aspect of the processes of life, with the context always at play. An organism's give and take with its surroundings is in the moment, always in flux—possibilities, necessities, and availabilities appear and disappear in a continuous flow of conscious, unconscious, and subliminal attention, awareness and responsiveness.

Perhaps motility has meaning for architecture's future—but what about motility and an architecture for birth as related to the inappropriate birthing body? Pérez-Gómez states that "the body that knows" is housed by architecture (573). But what does the body know? And how? As the definitions of "appropriate" and "inappropriate" above clarify, particularities of situation, circumstance, and occasion underpin understandings of appropriateness. Some rules or laws are explicit (e.g., "no smoking" signs). But generally, our perceptions (from all the senses) guide our notions of what fits—led by our feelings about what is right in a given place, time and activity. "Fitness" (the capacity to act

appropriately) is situated, and physiologically and psychologically felt. Thus, everything about the spatial setting for birth contributes to the birthing woman's feelings her mind-body perceptions—which, in turn, influence whether she feels at one with her body or at odds and whether she feels inappropriate or appropriate in the setting.

Pérez-Gómez's notion of the body's relation to architecture remains a fertile provocation. The contemporary birth environment houses the birthing body. Our current concept of the labour and delivery room as an architecture for birth anticipates, frame, situates, and actualizes the inappropriate birthing body. We could say that the architectural, spatial setting, even as it exists in our imagination, influences the birthing body's inappropriateness as a felt and embodied perception (Bowden et al.) as well as influencing caregiving (Hammond et al., "Messages from Space"; Harte). Meanwhile, midwifery's return from near extinction in many countries has driven a deep consideration of birth space—in the context of challenging the prevalence of medicalized birth and its built environment.

Birth Territory

> "A review of the literature shows a paucity of theory or research on the effect of environment on birthing." (Fahy et al. x)

In 2008, Kathleen Fahy et al. published *Birth Territory and Midwifery Guardianship* as an educational text for midwives. In the Preface, they note "their extensive review of research and scholarly literature", and position the book as the first theoretical undertaking focused on "the impact that the birth environment has on the childbearing woman and her baby, and by extension, all families and all communities" (ix). Arguing that the environment's influence on birth processes needs attention, Fahy et al. replace the medicalized concept of birth with a midwifery-based, woman-centred paradigm. "The theory of birth territory," they write, "challenges the medical theory of birth which views women's bodies as if they were unreliable machines (ix-x)." The obstetric paradigm is limited to "the three P's": the "powers" or uterine contractions; the "pelvis" and soft tissues; and the "passenger" (fetus), thought of as an inert package. This "reductionist, disembodied and mechanistic theory" ignores a woman's individuality

and the "impact of the woman's thoughts and emotions on her physiology and her baby" (ix-x). Fahy further observes that "because the environment operates holistically and on multiple levels all at once it cannot be accounted for in [a] linear, reductionist medical model" (3)—so obstetrics discounts the environment's possible effects on birth processes. She notes the Foucauldian concept of "disciplinary power" to describe how the medical model of birth influences women and their bodies, as surveillance facilitates the subjects' cooperation (4-5).

In order to counter these disciplining spaces, Fahy et al. propose that midwives should develop and protect "birth territories"— sanctuaries where women can feel safe, confident, and free to find their own consciousness and agency during childbirth (ix-x). Noting that existing power structures often reinforce the submissiveness of women as "a physical, intellectual and emotional weakening" (3), Fahy states that women must feel confident, not submissive, to make the best decisions for themselves and their babies.

The birth territory paradigm uses three key concepts: "terrain" proposes that a sanctum should displace the surveillance room; "jurisdiction" considers how women might be empowered rather than subdued or subverted by authoritative medical management; and "midwifery guardianship" proposes that midwives can and must create and protect birth territory as a private domain honouring the birthing woman's emotional and spiritual consciousness and journey (Fahy 18-19). The goal is a sanctuary space or place that supports an internal focus removed from the ordinary state of mind, and that promotes sensory experience. Fahy describes her own similar experience, at a yoga ashram:

> Time feels slowed down ... my focus has turned to myself. In this environment I notice things I would otherwise not, like the setting sun brightening one side of a cloud while the other side is the colour of midnight blue. I notice things inside myself that I might otherwise either not feel or, if felt, would ignore. I have written with some detail of the sanctuary of this place because I believe this is the type of environment that promotes inner focus which allows us to tune into the subtle messages that our body and psyche send us. In this state ... our bodies and minds function at optimal levels of health, not just in birth, but at all times. (11)

A valuable beginning to reimagining an architecture for birth, the Birth Territory framework prompted ongoing development and testing of a tool to evaluate birth units in order to catalogue desirable attributes and establish key standards for maternity facilities ("Developing the Birth Unit Design Spatial Evaluation Tool" and "Testing the Birth Unit Design Spatial Evaluation Tool"). Considering birthing women's spatial needs further, Maree Stenglin and Maralyn Foureur have discussed the balance/choice between "bound space" and "unbound space" that creates "safe" birth territory.

Two key early voices in the birth environment conversation are obstetrician Dr. Michel Odent and architect Bianca Lepori. Odent studied with Dr. Fernand Leboyer, who is renowned for exploring the baby's birth experience, eschewing forceps, introducing gentle massage and immersion of the baby in a warm water bath, and advocating a reverent environment featuring respectful quiet and low lights. Odent, at his famous Pithiviers clinic, eliminated many of the intrusive medical routines of other medical maternity facilities, advocated close contact and breastfeeding in the first hour after birth, and elevated the use of midwives while focusing his philosophies and practices on making spaces more homelike. Emphasizing that our birth processes are mammalian, Odent (*The Nature of Birth*,17-18) stresses birthing women's need for darkness and privacy/security. He further notes that female mammals usually seek out "a dim corner" in which to give birth and proposes a rediscovery of what mammals know instinctively: "one does not feel so observed in the dark."

> The birth process is a brain process ... the primitive part of the brain that we share with all other mammals is active ... [and] must secrete the hormones necessary for efficient uterine contractions, but its functions can be inhibited.... These inhibitions come from the new brain, the neocortex, which enables us to be rational, scientific, and to communicate through language. Reduced activity of the new brain accompanies the release of the hormones needed for the birth process, which is why, at a certain stage of a normal physiological birth, women divorce themselves from their surrounding and attendants and drift off to another planet. Their level of consciousness changes, as it must if they are to reach the right hormonal balance. On the other hand, you can stop the progress of labor by stimulating the neocortex and

asking the mother-to-be something like "What is your social security number?" (17-18)

Architect Lepori had observed women giving birth undisturbed at home, and her notations of birth choreography typologies show that women move in a spiral before settling on a place that feels right for the birth moment. By contrast, Lepori notes that serially arranged hospital birth space features simplified straight paths, pointing out the "promptness" with which operators are bound to comply (97). She posits that a "theoretic pathway" implicitly delegates the responsibility of birth to particular people, authorizing them to perform routine and specialized interventions and imposing a hierarchy of authority. This pathological birth model designates the bed as the only furniture the woman can use, with the layout accommodating in advance the medical personnel standing around her.

Lepori notes that this architectural assumption positions all birthing women as passive and devoid of agency or authority. Lepori suggests that although women "do not need a homey atmosphere," they do need "a space in which they can express themselves and in which they can move around and change position whenever they wish to.... Even pain dissolves with movement; pain-killers are a consequence of stillness" (100). Thus, Lepori proposes designing for the "moving, feeling and dreaming body" (95). She uses a psychobiological model that sees birth as dynamic and "belonging to the sexual and sensitive sphere"; this leads to spaces and places that will "offer freedom as well as logic, be capable of accepting disorder, of being a place of gestalt synthesis, of holding the continuity of the event according to its stages and natural rhythms" (95-96). Scientific understanding of neuro-hormones as interconnecting all the body's systems, further influences the concept of a sanctuary—a territory—that holds women (and care givers) in a supportive, sensitive mind-body space.

Oxytocin, Adrenaline, and the Environment

Odent highlights the hormone oxytocin's role in birth processes (first explained by Newton et al.'s studies of mammalian birth). Known as the love and connection hormone because sensual and sexual experience activates it (Magon and Kalra), oxytocin promotes bonding and loving aspects of animal behaviour. Environmental factors stimulate oxytocin's release in the brain: warmth, low lighting, candlelight or firelight, soft textures, pleasant sounds, and other sensual and material aspects of the spatial setting all play a role, as do intimacy, privacy, gentle touch, and pleasant, familiar, and supportive companionship (Uvnäs-Moberg). Maralyn Foureur states that the natural oxytocin system is "a key to approaching the creation of safe birth spaces, since it is the agent behind states of relaxation and well-being" (70).

As a neurohormone, oxytocin links sensory stimuli and chemical responses and is secreted into the blood by the pituitary gland in the brain's hypothalmic region. Clearly, the external environment connects directly to the information-gathering perceptual system, and thus, to the mind-body's internal response—perfectly exemplifying Pérez-Gómez' idea of *motility*.

By contrast, stress or danger activates oxytocin's well-known antagonist, epinephrine (adrenaline), one of three catecholamines (hormones released by the adrenal glands). Foureur's fear cascade hypothesis describes how entering the hospital triggers the birthing body to produce catecholamines as a fear response that slows down or stops oxytocin production, which, in turn, slows or stops labour and reduces oxygen flow to the fetus—both of which initiate medical intervention (59-60). This slow-down of labour, Foureur argues, increases anxiety, which further impedes the birth process (70-71). The constant monitoring and examination invade the birthing woman's privacy and frequently return her to her rational brain, which keeps her, her partner, and her caregivers from settling into birth's natural rhythms and shift of consciousness. Instead, they focus on the clock and whether the expectant mother will hit the appropriate targets for labour progression. If not, the cycle continues: induction of labour becomes likely, even mandatory, in some jurisdictions. As this next step uses an intravenous drip, it requires even closer monitoring of the baby and mother and decreases movement further. Contractions

strengthen and increase the likelihood of analgesics—which, if given by epidural, rules out movement completely and further heightens the probability of emergency Caesarean section. Each escalation of medical solutions presents the mother and her support team with decisions driven by the idea that her body is letting her down—without medical aid, her body is not up to the task.

In 2010, Zhang et al. showed (in the U.S.) that the accepted (fifty-year-old) "partogram"—a diagrammatic time-based guide for spontaneous labour's first and second stages—does not match normal birth's contemporary patterns, particularly in first-time mothers ("nulliparas"). They proposed a new partogram allowing uninterrupted labour to continue for longer before triggering intervention, and suggested it could reduce Caesarean births in the U.S. Yet so strong is the belief in the systems and methods of the technocratic birthing culture that it will not shift easily.

The Technocratic Birthing Body and Environment

By the mid-twentieth century, the modernist medical approach promising better birth through painkillers, intervention, and a clinical environment had transformed European and North American birth culture. For example, in 1932, one in twenty women in Italy gave birth in hospital; by 1951, that number was one in seven; by 1958, one in three (Szurek 287-88). In the U.S., many mothers—mine included—do not remember giving birth, having been given drugs that eliminated all knowledge of labour and birth (Arms). Meanwhile, feminist scholars began studying women's roles and experiences in society. In 1978, Brigitte Jordan's influential *Birth in Four Cultures* offered a turning point by alerting feminist anthropologists and sociologists to birth culture. Combining biology and sociology in an approach she called "biosocial," Jordan proposed that birth interweaves physiology with social context: "The physiology of birth and its *interactional context* (or the sociology of birth and its *physiological context*) constantly challenge all efforts to separate them" (3, my emphasis). Robbie Davis-Floyd and Carolyn Fishel Sargent (2–3) noted that Jordan's methodology allowed fruitful dialogue across childbirth models, from the traditional and communal to the highly technocratic. This conversation mattered because, as Jordan underscored, exporting the American approach to

birth damages Indigenous health systems, which affects each woman individually and which women feel *"in their bodies"* (3, my emphasis). By the 1990s, anthropologist Davis-Floyd had voiced concern about how twentieth-century American medicine construed women's bodies as malfunctioning mechanical objects and babies as assembly-line products. Davis-Floyd posited that the medicalized, scientifically understood female body was seen as deviating from the perfect machine prototype of the male body. This view, she suggested, accords with the modernist "assembly line" approach to birthing. As one fourth-year medical resident told her: "We shave 'em, we prep 'em, we hook 'em up to the IV and administer sedation. We deliver the baby, it goes to the nursery and the mother goes to her room. There's no room for niceties around here. We just move 'em right on through. It's hard not to see it like an assembly line (4)." Davis-Floyd noted that "the production of the 'perfect baby' [is] a fairly recent development, a direct result of the combination of the technocratic emphasis on the baby-as-product with the new technologies to assess fetal quality (4)." A male obstetrician she interviewed noted the lack of attention to the mother's experience: "It was what we all were trained to always go after—the perfect baby. That's what we were trained to produce. The quality of the mother's experience–we rarely thought about that. Everything we did was to get that perfect baby" (4).

Architectural historian Greene expands on the emergence of the baby as product, describing the development in France of the transparent hospital bassinette's first prototype as the state sought to insert itself into birth culture. A warming device for premature babies and a replacement for the mother's womb, the new device was also called "an artificial mother," a "mechanical nurse," and a "child hatchery" ("The 'Cradle of Glass'"66-67). Greene posits that this incubator embodies a shift of authority from mother to physician. The transparent, isolating incubator created a new model "for relations between women, their children, and physicians who represented the interests of the state." Separating mother from child was key to making the physician the "mediator necessary for ensuring the child's well-being" and the incubator was a perfect "visual expression of hygiene, sterility, and containment along with objective, scientific observation" that "thus became a conceptual model for the desirable, dispassionate hospital environment" ("The 'Cradle of Glass'"67). It inverted "all the

tropes of an actual womb" in making a "hard-surfaced, dry, and transparent milieu" for the infant on display (Greene, The 'Cradle of Glass'" 66-69). The clear plastic bassinet found today in every delivery room and neonatal intensive care unit (NICU) descends from this device, which may yet prove to be the antecedent of the "artificial womb" now under development (Warmflash).

Jane Szurek offers a remarkable glimpse of a Florentine labour ward in the 1990s, quoted here at length because it richly evokes a birth environment in the throes of medicalization and industrialization:

> In the room there may be at any one time four to ten or more women near delivery. Lying on their backs on the delivery beds, rendered docile and prepared for birth, they are wheeled into the room. Under grayish sheets they lie on separate metal birthing tables arranged in parallel rows. Suspended above each woman is a high-intensity lamp that bathes the lower half of her body with a circle of light. Some of the sheets and pieces of cloth on the floor are blotched with bloodstains, as are the cover-all smocks of the birth attendants—the doctors, anesthesiologists, nurses, hospital midwives, assistants, and cleanup personnel. The room contains a variety of randomly placed machines, tools, wires and tubes. A sense of crisis, risk, and emergency hangs in the air. Women are connected to various computers and machines monitoring their biological functions. Other machines are stationed in the room prepared to be called into operation if wanted. Noise and rapid movements make the atmosphere tense and electric with the business of labor, delivery, and birth. There is talking, commanding, yelling, moaning, crying, screaming. Machines are rolled in, out, and around the sinks. Women continue to be wheeled in and out of the room.... The delivery room ebbs and flows with waves of loudly articulated crisis. In this hyperactive environment, not only is a woman distracted from her own body's promptings, messages, and knowledge as she progresses towards delivery; what she thinks, knows, and feels is drowned out by the background noise and movement. (287-88)

Davis-Floyd characterizes twentieth-century American obstetrical routines as "transformative rituals.... sending messages through

symbols ... experienced holistically through the body and the emotions (2)." She argues that since the recipient does not intellectually process such messages (consciously accepting or rejecting them), hospital birth rituals "map a technocratic view of reality" onto the birthing woman's experience (2). Women unwittingly agree to participate in, benefit from, and trust this notion of technology as progress, although they may feel personally at odds with it. She quotes an interviewee describing feelings of alienation in the technological hospital environment: "As soon as I got hooked up to the monitor, all everyone did was stare at it. The nurses didn't even look at me any more when they came into the room—they went straight to the monitor. I got the wierdest [sic] feeling that it was having the baby, not me" (4). Davis-Floyd also points to the potential future of technocratic birth, quoting the February 1989 issue of *Life* magazine's cover story, "The Future and You": "By the late 21st century, childbirth may not involve carrying at all—just an occasional visit to an incubator. There the fetus will be gestating in an artificial uterus under conditions simulated to recreate the mother's breathing patterns, her laughter and even her moments of emotional stress (55)."

Feminist anthropologists elsewhere also focused on birth cultures. In the U.K., Sheila Kitzinger importantly has established knowledge transfer to contemporary women that could help them rediscover natural birth and women's embodied agency in birth: "Each woman having a baby in a hospital is transformed into a patient. She is a temporary member of a tightly organized, hierarchic and bureaucratic medical system. The admission procedure marks the point at which the institution takes control over her" (8). She contrasted this environment with a home setting's rich, embodied experience—the domestic temporality, full of sensual and sensory complexity as well as familiarity:

When a woman is in a domestic space, the pattern of birth unfolds in a way that can never happen in a hospital setting, however "homely" the environment or attractive the decor. Mealtimes...children getting up and going to school, the rising and setting of the sun, changes in the weather, light streaming into the birth room, clouds gathering, frost and moonlight, the familiar sounds of neighbourly talk, children playing, and in the countryside of cows, sheep or goats, and birdsong—all of these have a profound effect on the parameters of birth time. They can

make a painful labour less distressing and a long labor much more bearable.... This different perception of time affects what the midwife does... An English woman who gave birth in rural Malaysia said that she and the baby 'dictated the pace of proceedings together.' There is a kind of timelessness about birth under these conditions. (141)

In Canada, Margaret MacDonald added notable insight about midwifery, including how care's spatial aspects relate to birth processes, and documents how Ontario midwives subvert institutional hospital space. For example, by keeping women labouring at home as long as possible and avoiding ambulance travel, the midwives felt they were "stealing time" from the public institutional space (221). Midwives also used subtle, moment-to-moment means to "reterritorialize" the hospital space as midwifery space (e.g., encouraging women get into the shower to avoid doctors "getting out the forceps" [262]).

In nursing, Ellen Hodnett's research has long influenced the international discussion on birth environment. Hodnett et al wrote that although "lip service is paid to the benefits of upright positions, freedom of movement, and ambulation in labor," staff members still view the bed as the "safest" place to give birth, with the best access to the woman (166). Not having the woman in the standard hospital bed complicated "continuous electronic fetal monitoring, intravenous infusions, and ... epidural analgesia," and "few physicians have experience in vaginal birth when the woman is not in lithotomy position [flat on back] (166)." Of sixty-one participants, only one woman in the trial gave birth outside the hospital bed. The authors concluded that a "switch in focus from efforts to change practitioners' and women's behavior to altering the clinical environment for labour and birth is promising, timely and worthy of rigorous evaluation" (166).

Nurses and midwives often improve the hospital birth room by making the space more homelike and hiding medical equipment. Yet casually perusing contemporary images shows the clinical nature of such rooms. Using a social semiotic framework to analyze online images of birth rooms, Calida Bowden et al. found three types: the predominant "technological" (focused on the labour bed and medical equipment); the "homelike"; and the "hybrid domesticated." The authors observe that these images "reinforce the notion that the bed is the most appropriate place to give birth and the use of medical equipment is intrinsically

involved in the birth process. Childbirth is thus construed as risky/ dangerous" (1). Furthermore, Bowden et al. suggest that online images "inform and persuade society about stereotypical behaviours, the trends of our time and sociocultural norms," hence establishing women's "attitudes, choices and behaviour" long before arrival in the birthing room (4). They note that their findings support Lepori's (1994) observations that hospital rooms construct childbirth as a medical event (4).

Worldwide, the modernist clinical birth environment belongs to the medical and scientific conceptualization of better birth as technological achievement. Despite striving to maximize the survival of mothers and babies and minimize women's pain—important, desirable goals, certainly—this obstetrical paradigm still disappoints women, even in state-of-the-art facilities. In less-developed locations, a medical facility's promise of better birth may tantalize women while local harsh realities (lack of water, food, sanitation, transportation, and adequate medical staff and supplies) undermine their care and experience. Respectful treatment of women, and of birthing women specifically, remains far off in much of the world (Fernandez; Bohren et al.).

In the architectural world, Christopher Alexander has (rather controversially) challenged modernism as a positive force. Troubled by the mechanical model of the universe that he sees dominating science, culture and architecture, Alexander proposes shifting from a mechanical to an organic model. He supports his theory with underpinnings from many eminent scientists and intellectuals and his work is consilient with the writings of Odent, Davis-Floyd, and eco-philosopher David Abram (one of many advocates for a new paradigm that shifts humanity towards a deeper understanding of the organic and ecological nature of our connection to the world). As we question the mechanical, technocratic model, and its appropriateness for the human (mammalian) body and for our world's other living entities, embodiment theory adds further appropriate insight to this discussion of the birthing body and its relationship to the environment.

Embodiment Theory, Birth Environment and the Knowing (Appropriate) Body

Discussions of the body's interaction with environment, as well as my thesis that birth environment matters in the contemporary dilemma of the inappropriate birthing body, rely on the work of two ground-breaking embodiment theorists: philosopher Maurice Merleau-Ponty and psychologist James J. Gibson. Although they did not know one other, they shared a precursor in biologist Jacob van Uexküll, who argued that animals, embedded in their ecological "niches" (their life worlds), are intrinsically *part of* these environments (Costall).

Maurice Merleau-Ponty's *Phenomenology of Perception* directly challenges Descarte's separation of world and mind with his discussion of subject-object "reciprocity." Merleau-Ponty considers the body-subject as deeply connected to its world, and the following passage shows his closeness to von Uexküll's conceptualization of the inter-woven relationship between animals and the environment: "Already the mere presence of a living being transforms the physical world, makes 'food' appear over here, and a 'hiding place' over there, and gives to 'stimuli' a sense that they did not have" (195). Furthermore, Merleau-Ponty identifies our "situatedness" and "spatiality" as aspects of *being*: "We must not wonder why being is orientated, why existence is spatial ... and why [our body's] coexistence with the world magnetizes experience and induces a direction in it ... being is synonymous with being situated" (252). As his work progressed, Merleau-Ponty's "flesh of the world" ontology, in *The Visible and the Invisible,* deeply and poetically linked the body and the world as co-creators of our lived experience and our consciousness, our sense of self. "My body is the common texture of all objects," he writes, "and is, at least with regard to the perceived world, the general instrument of my 'understanding'" (*Phenomenology of Perception* 244).

Twenty-five years later, Gibson put forward a new field of psychology, which he named "ecological psychology." He eschewed his behaviourist background and focused on our "perception in motion" as information-seeking creatures in our local environs. Gibson highlighted that we experience and comprehend the world through an *active* perceptual (sensory) system in constant touch with the environment (4). As we move through it, we comprehend it according to our environmentally mediated intentions and needs:

it is often neglected that the words animal and environment make an inseparable pair. Each term implies the other. No animal could exist without an environment surrounding it. Equally...an environment implies an animal (or at least an organism)" (4).

Gibson coined the term "affordance" to describe how the environment affords latent possibilities for action:

An affordance is neither an objective property nor a subjective property; or it is both if you like.... It is equally a fact of the environment and a fact of behavior. It is both physical and psychical, yet neither. An affordance points both ways, to the environment and to the observer" (121).

Importantly, affordances "have to be measured relative to the animal. They are unique for that animal. They are not just abstract physical properties" (4). A knee-high platform (for example) affords sitting, but it is different for a child than for an adult. Water affords swimming but also drowning, if one cannot swim. Doors afford passage but also closure (119).

Both Merleau-Ponty and Gibson suggest that the living and the lived body comprehend the environment in two ways, which work in synchronicity. The first is through "universality": our deep evolutionary development in the natural world renders the meaning in environment accessible to us. Human beings have been evolving in natural contexts for millennia. The point is not that we are all the same, but that our perceptual system is built into us in relation to and through our interaction with the surrounding world as developed over thousands of years. We are an organic part of an organic world, not separate from it. Therefore, we understand many things intrinsically—some universal, like day and night; some located in places and cultures that have evolved in unique geographic settings.

The second way we understand the world is the personal, as individual beings in the world. We taste or smell something pleasant or unpleasant, and direct personal experience—our experience in specific surroundings—grounds and informs these sensations and emotions. Yet our similarity with others, in the same or similar settings, connects this personal experience back to the universal (Lakoff and Johnson 4-6).

Recently, the human genome project has corroborated these ideas by discovering that the environment is formative in gene expression. A remarkable process at the cellular and molecular levels seems to provide humanity's diversity from a relatively small gene pool. Our continual and necessary adaptation to and interaction with environment initiates the activation or deactivation of genes (Foureur 74). Matt Ridley has noted that "the more we lift the lid on the genome, the more vulnerable to experience genes appear to be." In this way, environment activates and transforms our becoming who we are (4). That is, the human genome project now corroborates what Gibson, Merleau-Ponty, and many others have stated—the mind, body, and environment are deeply intermingled.

As understood through these most basic concepts of embodiment theory, the environmental envelope of birthspace both frames the birthing woman's experience and actualizes her thoughts and feelings as bodily responses (catalyzing further interactions with her surroundings). As she and the baby move through their birth duet of processes and experiences (Chamberlain), all actors in the space are integral to the place (Harte et al.; Crowther and Hall). Latent possibilities (affordances) emerge through intentionality, desires, actions, and perceptions. Meanings resonate, are felt in and through the body, interweaving states of mind and body. Warmth, smoothness, softness, personally resonant sounds, darkness, flowing air, sparkling water, and a gentle touch—all support the birthing body. But red emergency signage and equipment, hospital smells, centralized white hospital beds, thin curtains, bright cold lighting, and hard, smooth, cold surfaces impede birth processes. They all work against a birth consciousness that enhances and supports the profound task at hand—of being and becoming.

New knowledge about how birth environment supports natural birth processes enables architects and designers to contribute to important change—by solidifying a new paradigm for birth spaces that facilitates a situated, sensual, embodied, and spiritual birth experience (Crowther and Hall; Davis and Pascali-Bonaro; Fahy et al.).

What if designers could use and fuse evidence-based knowledge, theoretically derived knowledge and practice-based (often tacit) knowledge to propose alternatives to conventional room design focused on functional necessities? What if designers could creatively envision atmospheric and sensual aspects of architectural space that foster

oxytocin production? Along with providing a richly afforded space-place for a less medicalized, more healthful birth, architectural designers could help women, infants, families, and caregivers co-create birth as a memorable and positive primary *life experience.*

The ideas and evidence above speak to the question of "what is so inappropriate?" about existing birth environments and suggest ideas towards a birth environment that mind and body feel at one with and can respond to. My doctoral dissertation (2017) explored ways to further harmonize this symbiosis from the point of view of an artist, architectural designer, and mother—one who knows, from lived experience, the inappropriate nature of the hospital birth setting.

Light in the Reimagined Birthing Territory

I began considering the birth environment during my first experience as a mother, a woman giving birth (in Canada). I was in the midst of architecture school, and I can still recall the hospital labour room and delivery room clearly. Two years later in 1985, my thesis project, a "Health Centre," included a freestanding birth centre, set on a bluff overlooking a river. In 1987, I had my second child in a different urban hospital.

Many years later, as I considered a topic for doctoral studies, birth and death spaces loomed large in my mind as nonplaces, architectural environments left bereft, without architectural attention—spaces utterly inadequate for these most profound life moments. Noting that architects were giving some attention to palliative care spaces but birth environments had not changed enough since my experiences, I focused my practice-based PhD on reimagining the birth environment.

A few years before my mother passed away in 2013, I asked her about my birth—her experience of giving birth (Oak Park, Illinois, 1952). She said, to my astonishment, "I was asleep; I don't remember anything." Late one night during my PhD studies, I read an article in which Suzanne Arms describes the "grey, floppy babies" pulled from mothers under the influence of so-called twilight drugs." I burst into emotional, intense sobbing. This eruption amazed me. Where did it come from? What could it mean? Later, I realized that I had been one of those grey, floppy babies and that my mother and I had been robbed of this most primal life moment. I felt then that I understood the

subconscious and unaddressed need within my psyche that had led me to this study of birth experience. But my artistic background focusing on colour and light in the environment has also significantly informed my work on how to change the birth environment.

I have always been attuned to light—its movement, moods, colours, and atmospheres. As an artist and architectural designer, my work evolves by exploring light as a spatial phenomenon—experiential, articulated by form, and connected to the cosmos. I continue to study how light passes through and falls on surfaces, rendering their materiality and form anew moment by moment. Light intrigues me, awakens me, and fills me with wonder.

How can the birthing body be in a symbiotic relationship with its environment? What does this have to do with light? The environment I speak of consists of walls and material finishes, furniture and equipment, people occupying and interacting with the space and each other, and protocols, rules and socio-political frameworks that the space represents. However, it also includes lightness and darkness, which influence us profoundly, even if they go almost unnoticed. Often taken for granted, the cycles of daylight and darkness we have lived with for millennia are embedded in us. They affect our perceptions, emotions, relationships, and orientations, as well as our consciousness and our body and its processes. As part of annual and daily cycles, light and darkness are embedded in our environment's ever-shifting colours and textures, changing with viewpoint, angle of incidence, and time of day. Imbued with biological and cultural meanings, light, colour, and darkness create sensations, feelings, and energies that intimately connect to hormones and physiological processes. All of this belongs to the gamut I refer to when speaking of environmental light and the body—in particular, as I consider the birthing body and the birth environment.

Quantum physicist Arthur Zajonc notes that one can see light only if it *falls upon something*—meeting matter (whether moisture particles or material surfaces). Without that, light is invisible. As an architectural artist and designer, I have discovered this principle through my practice, and I deeply appreciate Zajonc's clear distillation of this profound and rather shocking truth. Although we think of light as visible and visual, it seems to be a form of energy needing surfaces and substances to become visible. This idea is important for architects and

spatial designers. Sensitive, memorable architectural experience puts *making light manifest* at its core.

Early in my studies about birth environment, before I focused on light's relationship to the birth space, a physician told me of an obstetrician's response to hearing about my study: "Tell them not to change the light." I did not think about this reaction much at the time, yet I remember it vividly. But later, as I recognized light's spatial impact on the mind-body, I realized that a change in the light (light-colour-darkness) is precisely what we need.

Midwives often describe the common lighting situation in delivery rooms—the ubiquitous overhead fluorescent light—in tales of trying to make the hospital setting more conducive to natural birth processes. Most likely the fixed lighting includes a spotlight focused on the woman's pelvis as she lies in a hospital bed (in a specific, fixed location). The visual messages (from the designed lighting) about behaviour, location, and expectation (of those in the room), though clear to the body, may be almost invisible to those involved in the space due to cultural familiarities that make all of this normal.

My Research Creation Contribution to the Environment

Phenomenology of practice is formative of sensitive practice, issuing from the pathic power of phenomenological reflections. Pathic knowing inheres in the sense and sensuality of our practical actions, in encounters with others and in the ways that our bodies are responsive to the things of our world and to the situations and relations in which we find ourselves. Phenomenology of practice is an ethical corrective of the technological and calculative modalities of contemporary life. (Van Manen 11)

As discussed above, reimagining and reinventing contemporary and future birth environments is a challenge of our time deserving attention. Reconstituting and reengaging the appropriate birthing body may occur if architects and designers can take up the cause to create environments that facilitate less medicalized as well as more positive, poetic, and soulful birth experiences.

My doctoral dissertation, *Light and Embodied Experience in the Reimagined Birth Environment*—based on birth literature, embodiment

theories, and my practice as an architectural glass artist and environmental designer—synthesized six points for creating better birthing environments that advance the new paradigm set out by birth territory theory and make a room that is fit, suitable, and convivial for the mother's birthing body and the act of birth.

My process of "unconcealing" knowledge and understanding about birthspace used a research-through-design methodology. I sought answers through an artistic design process: making physical architectural elements I could see and study in natural light, with all its diverse modulation (Fig. 1). I wanted to experience materiality as an aspect of spatiality and light, colour, and darkness—as a physical and ethereal presence. I engaged in reflective and reflexive intuitive making; each studio session triggered many thoughts and ideas as well as further experimentation.

Figure 1. Doreen Balabanoff, *Noticing Time and Light – the Implicate Order*, 2016.

Eventually, I designed an urban birthing centre and imagined placing variations of it on existing hospitals' rooftops, with entries and elevators removed from the emergency entry processional (Fig. 2). This key concept allows access to the sky, privileging a birth experience at the hospital but not in it. A central courtyard provides a place for walking, resting, and contemplating, with light, air and water, open to rain and snow, sun, and moonlight. Surrounding the court and its walkways, the birthing rooms started out egg shaped before becoming curvaceous forms with billowing windows and ceilings opening to light from above and views to beyond (Fig. 3). Each room has dark and light areas, ephemeral and material colour—a central private space, a sensual bathing area, and a small private garden (Fig. 4).

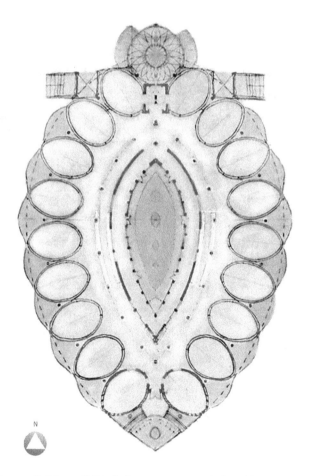

Figure 2. Doreen Balabanoff, Birth Centre conceptual plan, 2016.

Figure 3. Doreen Balabanoff, Rooftop Birth Centre modules, 2016. Cinema 4D modelling by Finlay Peterson and Steve Reaume.

Figure 4. Doreen Balabanoff, Birthing Room, bird's eye view, 2016.

Rather than creating a specific architectural style or programmatic guideline, I wanted to develop concepts that others could use in diverse contexts, geographies, and socioeconomic situations, with light driving the architectural intent. The concepts investigate possible ways to create spatial affordances for birth using natural light (light, colour, and darkness). My PhD process book compiles the exploratory and contemplative process work. Of course, nonhospital settings can use the concepts to enhance design of freestanding or alongside birth centres.

Six Key Points for Birth Environment Design

My work produced six key points. This composite emerged from my experience, tacit knowledge, and experimental artistic and design processes grounded in the theoretical and scientific understandings. These six key concepts outline ways to use natural light (the inseparable trio of light, colour, and darkness) to drive the creation of a sensitive architecture for birth. That is, while derived from my study of light and while describing light's use and play, these concepts accomplish a rich architectural vocabulary that expands our understanding of how to optimize birthspace.

1. Facilitate Awareness of the Cosmos

Heighten a sense of place, of belonging and connectivity to the greater world, by including views of locally significant geographic features, and creatively developing openings to the sky. Enhance views and the interior presence of daylight at dawn and dusk to capture memorable, awe-inspiring, and emotively colored light. Make visible the arcs of solar and lunar movement across the day or night to connect to the cosmos and the cardinal directions—in order to create a fund-amental sense of orientation.

2. Enhance the Phenomenological Interplay between Light and Surface

Design apertures for light (windows, skylights) in relation to surfaces that can catch and magnify light's movement and highlight materiality's sensuality. Heighten phenomenological awareness to shift conscious-ness to a deeper sense of being and dwelling in the moment.

3. Make the Threshold between Inside and Outside Experientially Rich

Afford light play and modulation by using window, door or screening devices between interior and exterior, or between rooms, (e.g. curtains, blinds, screens, stained glass, etc.). These devices can increase intimacy and sensual atmosphere, creating rich experiences while enhancing security and privacy.

4. Develop Modulation and Gradation of Light for Sensual Flow

Facilitate gradation of light on walls in order to create a sensual state of flow, build emotive atmosphere, and encourage relaxed, fluid movement that ameliorates pain while soothing and supporting the birthing body.

5. Use Color to Create Vividness and Depth

Consider color as a resonance of light, colour, and darkness—a range from high to low vibrations and energies that create atmosphere and permeate the body with sensual and poetic feeling. Surfaces reflecting color fill the air, creating harmonic relationships. The birthing body needs both depth (grounding) and vividness (exhilaration).

6. Develop Spatial Aliveness

Design for aliveness of daylight, movement of the body, visibility, and drawing attention to places where air and water move in a play of elements that enhances spatial atmosphere (e.g., vegetation, moonlight, moving water, sensual bathing space, operable windows, diaphanous materials that respond to light and air, reflection, and refraction).

Despite these descriptions' brevity, it should be clear that diverse architectural approaches using humble or high-tech materials could build on these recommendations. Each architect would apply them differently—in hot or cold climates, in urban or rural contexts, and in resource-rich or poor locales. The principles add to or reinforce what designers and midwives already intuitively know about the range of spatial affordances and atmospheric sensibilities that could empower freedom of movement, privacy, agency, emotional resonance, and spiritual consciousness in the birth environment—helping to create the birth that women want.

These concepts build on the foundational and ongoing research of many other disciplines and perspectives. They mitigate and counteract the mechanical birthing environment in order to help women escape the inappropriate birthing body syndrome, and the cascade of medical interventions that awaits them there. They contribute to a new, woman-centred paradigm for appropriate birthspace—which fosters and supports confidence in the appropriate birthing body—in order to put the mind, body, and spirit in a synchronous, positive relationship with a surrounding sanctuary—for the profound life event of giving birth and being born.

Works Cited

Abram, David. *The Spell of the Sensuous: Perception and Language in a More-than-Human World.* Penguin/Random House, 1997.

Alexander, C. *The Nature of Order: An Essay on the Art of Building and the Nature of the Universe: Vol. 2 The Process of Creating Life.* Center for Environmental Structure, 2002.

Alexander, C. *The Nature of Order: An Essay on the Art of Building and the Nature of the Universe: Vol. 4 The Luminous Ground.* Center for Environmental Structure, 2004.

"Appropriate." *Oxford Dictionary,* www.en.oxforddictionaries.com/definition/appropriate. Accessed 21 Mar. 2018.

"Appropriate." *Merriam Webster Dictionary,* www.merriam-webster.com/dictionary/appropriate. Accessed 21 Mar. 2018.

"Appropriate." *Cambridge Dictionary,* dictionary.cambridge.org/dictionary/english/appropriate. Accessed 21 Mar. 2018.

Arms, Suzanne. "Suzanne Arms Interview." ttfuture.org/academy/suzanne-arms/suzanne-arms. Accessed 20 Mar. 2019.

Arms, Suzanne. *A Season to be Born.* New York, Harper Collins, 1973.

Balabanoff, Doreen. *Light and Embodied Experience in the Reimagined Birth Environment.* Dissertation. University College Dublin, 2017.

Barnett, Robin, et al. "Voices from the Front Lines Models of Women-centred Care in Manitoba and Saskatchewan." *Prairie Women's Health Centre of Excellence,* 2002, www.pwhce.ca/voicesFrontLines.htm. Accessed 21 March 2019.

Betran, A.P., et al. "WHO Statement on Caesarean Section Rates". *BJOG: An International Journal of Obstetrics & Gynaecology,* vol. 123, no. 5, 2015, pp. 667-670. *Wiley,* doi:10.1111/1471-0528.13526.

Bohren, Meghan, et al. "Facilitators and Barriers to Facility-based Delivery in Low- and Middle-income Countries: a Qualitative Evidence Synthesis. *Reproductive Health.* vol. 11, no. 1, Sept 2014, pp. 1-17.

Boucher, Debora, et al. "Staying Home To Give Birth: Why Women In The United States Choose Home Birth." *Journal Of Midwifery & Women's Health,* vol. 54, no. 2, 2009, pp. 119-126. *Wiley,* doi:10.1016/j.jmwh.2008.09.006.

Bowden, Calida, et al. "Birth Room Images: What They Tell Us About Childbirth. A Discourse Analysis Of Birth Rooms In Developed Countries." *Midwifery*, vol. 35, 2016, pp. 71-77. *Elsevier BV*, doi:10.1016/j.midw.2016.02.003.

Bryanton, Janet et al. "Predictors Of Women's Perceptions of the Childbirth Experience." *Journal of Obstetric, Gynecologic & Neonatal Nursing*, vol. 37, no. 1, 2008, pp. 24-34. *Elsevier BV*, doi:10.1111/j.1552-6909.2007.00203.x.

Buckley, Sarah. "Does Synthetic Oxytocin (Pitocin) Cause Autism?." *Dr. Sarah Buckley Blog*, Dec 12 2018, www. sarahbuckley.com/does-pitocin-cause-autism/. Accessed 18 Dec. 2018.

Byrom, Sheena, and Soo Downe. *The Roar Behind the Silence: Why Kindness, Compassion and Respect Matter in Maternity Care*. Pinter and Martin, 2015.

Chamberlain, David B. *The Mind Of Your Newborn Baby*. North Atlantic Books, 1998.

Chamberlain, Marie, and Kate Barclay. "Psychosocial Costs of Transferring Indigenous Women from their Community for Birth." *Midwifery*, vol. 16, no. 2, June 2000, pp. 116-22.

Clesse, Christophe, and Joëlle Lighezzolo-Alnot, Sylvie de Lavergne, Sandrine Hamlin, Michèle Scheffler. "The Evolution of Birth Medicalisation: A Systematic Review". *Midwifery*. Vol. 66: November, 2018 Nov, pp. 161-167. doi: 10.1016/j.midw.2018.08.003.

Cohen Shabot, Sara. "Making Loud Bodies "Feminine": A Feminist-Phenomenological Analysis Of Obstetric Violence". *Human Studies*, vol. 39, no. 2, 2015, pp. 231-247. *Springer Nature*, doi:10.1007/s10746-015-9369-x.

Costall, Alan. "Darwin, Ecological Psychology, and the Principle of Animal-Environment Mutuality". *Psyke & Logos*, vol. 22, 2001, pp. 473-484.

Coxon, Kirstie, et al. "How Do Pregnancy and Birth Experiences Influence Planned Place of Birth in Future Pregnancies? Findings from a Longitudinal, Narrative study," *Birth*, vol. 42, no. 2, 2015, pp. 141-48.

Crowther, Susan, and Jenny Hall. *Spirituality and Childbirth: Meaning and Care at the Start of Life*. Routledge, 2017.

Dahlen, Hannah. "Undone By Fear? Deluded By Trust?." *Midwifery*, vol. 26, no. 2, 2010, pp. 156-162. Elsevier BV, doi:10.1016/j.midw. 2009.11.008.

Davis, Elizabeth, and Debra Pascali-Bonaro. *Orgasmic Birth: Your Guide to a Safe, Satisfying, and Pleasurable Birth Experience.* Rodale Books, 2010.

Davis-Floyd, Robbie. *Birth Models that Work.* University of California Press, 2009.

Davis-Floyd, Robbie. *Birth as an American Rite of Passage.* University of California Press, 1992.

Davis-Floyd, Robbie, and Carolyn Fishel Sargent. *Childbirth and Authoritative Knowledge: Cross-Cultural Perspectives.* University of California Press, 1997.

Declercq, Eugene R., et al. "Major Survey Findings of Listening to Mothers III: Pregnancy and Birth." *The Journal of Perinatal Education*, vol. 23, no. 1, 2014, pp. 9-16. Springer Publishing Company, doi: 10.1891 /1058-1243.23.1.9.

Dreger, A. "The Most Scientific Birth is Often the Least Technological Birth." *The Atlantic.* Mar 20, 2012. www.theatlantic.com/health/ archive/2012/03/the-most-scientific-birth-is-often-the-least-tech-nological-birth/254420/. Accessed 19 Mar. 2019.

Edmonds, Joyce K et al. "The influence of detailed maternal ethnicity on cesarean delivery: findings from the U.S. birth certificate in the State of Massachusetts." *Birth (Berkeley, Calif.)* vol. 41, no. 3, 2014, pp. 290-8. doi:10.1111/birt.12108.

Fahy, Kathleen, et al., editors. *Birth Territory and Midwifery Guardianship: Theory for Practice, Education and Research.* Books for Midwives/ Elsevier, 2008.

Fahy, Kathleen, et al. "Preface." *Birth Territory and Midwifery Guardian-ship: Theory for Practice, Education and Research*, edited by Kathleen Fahy, Books for Midwives/Elsevier, 2008, pp. ix-x.

Fahy, Kathleen. "Power and the Social Construction of Birth Terr-itory." *Birth Territory and Midwifery Guardianship: Theory for Practice, Education and Research*, edited by Kathleen Fahy, Maralyn Foureur and Carolyn Hastie. Books for Midwives/Elsevier, 2008, pp. 3-10.

Fahy, Kathleen. "Theorising Birth Territory." *Birth Territory and Midwifery Guardianship: Theory for Practice, Education and Research*, edited by Kathleen Fahy, Maralyn Foureur and Carolyn Hastie. Books for Midwives/Elsevier, 2008, pp. 11-19.

Fenwick, Jennifer, et al. "Pre- and Postpartum Levels of Childbirth Fear and the Relationship to Birth Outcomes in a Cohort of Australian Women". *Journal of Clinical Nursing*, vol. 18, no. 5, 2009, pp. 667-677. *Wiley*, doi:10.1111/j.1365-2702.2008.02568.x.

Fernandez, Evita. "Normalizing and Humanizing Birth in India." 12th International Normal Labour and Birth Research Conference, 2 Oct 2017, University of Central Lancashire. Keynote Address.

Flanders-Stepans, Mary Beth. (2000). Alarming racial differences in maternal mortality. *The Journal of Perinatal Education*, 9(2), 50–51. doi:10.1624/105812400X87653.

Foureur, Maralyn. "Creating Birth Space to Enable Undisturbed Birth." *Birth Territory and Midwifery Guardianship: Theory for Practice, Education and Research*, edited by Kathleen Fahy, Maralyn Foureur and Carolyn Hastie. Books for Midwives/Elsevier, 2008, pp. 57-78.

Freedman, Lynn P., and Margaret E. Kruk. "Disrespect and Abuse of Women in Childbirth: Challenging the Global Quality and Accountability Agendas." *The Lancet*, vol. 384, no. 9948, 2014, pp. e42-e44. *Elsevier BV*, doi:10.1016/s0140-6736(14)60859-x.

Gibson, James J. *The Ecological Approach to Visual Perception*. Classic Edition, Kindle Edition. Psychology Press/Taylor and Francis, 2015. Original work published in Houghton Mifflin, 1979.

Greene, Gina. "Towards a Modernist Maternity: Architecture and the Material Environment at the Prentice Women's Hospital (1975-1985)." Conference Paper Abstract, Barbara Bates Center for the History of Nursing, U Penn, Feb 2014, Robert Wood Johnson Foundation Health and Society Scholars Program. Accessed 30 January 2014.

Greene, Gina. "The 'Cradle of Glass': Incubators for Infants in Late Nineteenth-Century France." *Journal of Women's History*, vol. 22, no. 4, 2010, pp. 64-89.

Grigg, Celia P., et al. "Women's Experiences of Transfer from Primary Maternity Unit to Tertiary Hospital in New Zealand: Part of the

Prospective Cohort Evaluating Maternity Units Study." *BMC Pregnancy and Childbirth*, vol. 15, no. 1, 2015, pp. 597-605. Springer Nature, doi:10.1186/s12884-015-0770-2.

Gupta, Mamta, and Vandana Saini. "Cesarean Section: Mortality and Morbidity." *Journal of Clinical and Diagnostic Research*, vol. 12. no. 9, Sep 2018. *JCDR Research and Publications*, doi:10.7860/jcdr/ 2018/ 37034.11994.

Hammond, Athena D., et al. "Messages from Space: An Exploration of the Relationship between Hospital Birth Environments and Midwifery Practice." *HERD: Health Environments Research & Design Journal*, vol. 7, no. 4, 2014, pp. 81-95. *SAGE Publications*, doi:10.1177/ 193758671400700407.

Hammond, Athena D., et al. "The Hardware and Software Implications of Hospital Birth Room Design: A Midwifery Perspective." *Midwifery*, vol. 30, no. 7, July 2014, pp. 825-831.

Hatem, Marie, et al. "Midwife-led versus Other Models of Care for Childbearing Women." Cochrane Database of Systematic Reviews, 2016.

Harte, J. Davis, et al "Childbirth Supporters' Experiences in a Built Hospital Birth Environment." *HERD: Health Environments Research and Design Journal*, vol. 9, no. 3, 2016, pp. 135-61.

Hermus, Marieke, et al. "Development of the Optimality Index-NL2015, An Instrument to Measure Outcomes of Maternity Care." *Journal of Midwifery & Women's Health*, vol. 62, no. 5, 2017, pp. 580-88. *Wiley*, doi:10.1111/jmwh.12650.

Hodnett, Ellen D. "Pain and Women's Satisfaction with the Experience of Childbirth: A Systematic Review." *American Journal of Obstetrics and Gynecology*, vol. 186, no. 5, 2002, pp. S160-S172. *Elsevier BV*, doi:10.1067/mob.2002.121141.

Hodnett, Ellen D., and Daryl A. Simmons-Tropea. "The Labour Agentry Scale: Psychometric Properties of an Instrument Measuring Control during Childbirth." *Research in Nursing & Health*, vol. 10, no. 5, 1987, pp. 301-10. *Wiley*, doi:10.1002/nur.4770100503.

Hodnett, Ellen D., et al. "Re-Conceptualizing the Hospital Labor Room: The PLACE (Pregnant and Laboring in an Ambient Clinical Environment) Pilot Trial." *Birth*, vol. 36, no. 2, 2009, pp. 159-66. *Wiley*, doi:10.1111/j.1523-536x.2009.00311.x.

Hofberg, Kristina, and Ian Brockington. "Tokophobia: An Unreasoning Dread of Childbirth." *British Journal of Psychiatry*, vol. 176, no. 1, 2000, pp. 83-85. *Royal College of Psychiatrists*, doi:10.1192/bjp.176.1.83.

Hormann, Elizabeth. "Impact of Birthing Practices on Breastfeeding: Protecting the Mother and Baby Continuum." *Birth*, vol. 33, no. 2, 2006, pp. 163-64. *Wiley*, doi:10.1111/j.0730-7659.2006.00097.x.

"Inappropriate." *Oxford Dictionary*, www.en.oxforddictionaries.com/definition/inappropriate. 21 Mar. 2018.

"Inappropriate." *Merriam Webster Dictionary*, www.merriam-webster.com/dictionary/inappropriate. Accessed 21 Mar. 2018.

"Inappropriate." *Cambridge Dictionary*, www.dictionary.cambridge.org/dictionary/english/inappropriate. Accessed 21 Mar. 2018.

Inhorn, Marcia C. "Defining Women's Health: A Dozen Messages from More than 150 Ethnographies." *Medical Anthropology Quarterly*, vol. 20, no. 3, 2006, pp. 345-78. *Wiley*, doi:10.1525/maq.2006.20.3.345.

Jordan, Brigitte. *Birth in Four Cultures.* Eden Press, 1978.

Johnson, Kenneth C., and Betty-Anne Daviss. "Outcomes of Planned Home Births with Certified Professional Midwives: Large Prospective Study in North America." *BMJ*, vol. 330, no. 7505, 2005, pp. 1416. *BMJ*, doi:10.1136/bmj.330.7505.1416.

Johanson, R. "Has the Medicalisation of Childbirth Gone Too Far?." *BMJ*, vol. 324, no. 7342, 2002, pp. 892-895. *BMJ*, doi:10.1136/bmj.324.7342.892.

Kallianidis, Athanasios F., et al. "Maternal Mortality After Cesarean Section In The Netherlands." *European Journal of Obstetrics & Gynecology and Reproductive Biology*, vol. 229, 2018, pp. 148-152. *Elsevier BV*, doi:10.1016/j.ejogrb.2018.08.586.

King, Tekoa, et al. *Varney's Midwifery.* Jones and Bartlett, 2013.

Kitzinger, Sheila. *Rediscovering Birth.* 2nd ed. Pinter and Martin, 2011.

Kroeger, Mary, and Linda J. Smith. *Impact of Birthing Practices on Breastfeeding: Protecting the Mother and Baby Continuum.* Jones & Bartlett, 2004.

Lakoff, George, and Mark Johnson. *Philosophy in the Flesh: The Cognitive Unconscious and the Embodied Mind: How the Embodied Mind Creates Philosophy.* Basic Books, 1999.

Laugier, Marc-Antoine. *Essai sur l'Architecture*, 2nd ed.,1755, frontispiece by Charles-Dominique-Joseph Eisen, www.archive.org/details/essayonarchitect00laugrich/page/n8. Accessed 8 Aug. 2019.

Laursen, M., et al. "Fear of Childbirth and Risk for Birth Complications in Nulliparous Women in the Danish National Birth Cohort." *BJOG: An International Journal Of Obstetrics & Gynaecology*, vol. 116, no. 10, 2009, pp. 1350-355. *Wiley*, doi:10.1111/j.1471-0528. 2009. 02250.x.

Legros, J. J. "Inhibitory Effect of Oxytocin on Corticotrope Function in Humans: Are Vasopressin and Oxytocin Ying-Yang Neurohormones?." *Psychoneuroendocrinology*, vol 26, 2001, pp. 649-55.

Leboyer, Fernand. *Birth Without Violence*. Pinter and Martin, 1975.

Lepori, Bianca. "Mindbodyspirit Architecture: Creating Birth Space. Introduction & Part 1: The Moving, Feeling and Dreaming Body Guides Architectural Design." *Birth Territory and Midwifery Guardianship: Theory for Practice, Education and Research*, edited by Kathleen Fahy, Maralyn Foureur and Carolyn Hastie. Books for Midwives/Elsevier, 2008, pp. 95-101.

MacDonald, Margaret. *Expectations: The Cultural Construction of Nature in Midwifery Discourse in Ontario*. Dissertation, York University, 1999.

Magon, Navneet, and Sanjay Kalra. "The Orgasmic History of Oxytocin: Love, Lust, and Labor." *Indian Journal of Endocrinology and Metabolism* vol. 15 no. 3, 2011, pp. S156-61. doi:10.4103/2230-8210.84851

Maternity Care Working Party. "Making Normal Birth a Reality." NCT, RCM, and RCOG, 2007. www.rcog.org.uk/womens-health/clinical-guidance/making-normal-birth-reality. Accessed 8 Aug. 2019.

Merleau-Ponty, Maurice. *Phenomenology of Perception*. Translated by Donald Landes, Routledge, 2012.

Merleau-Ponty, Maurice. *The Visible and the Invisible*, Translated by A. Lingis, Northwestern University Press, 1968.

Morris, Theresa, and Katherine McInerney. "Media Representations of Pregnancy and Childbirth: An Analysis of Reality Television Programs in the United States." *Birth*, vol. 37, no. 2, 2010, pp. 134-40. *Wiley*, doi:10.1111/j.1523-536x.2010.00393.x.

Newburn, Mary, and Debbie Singh. "Are Women Getting the Birth Environment They Need? Report of a National Survey of Women's Experiences." NCT, 2005, nct.org.uk/files/are-women-getting-the-birth-environment-they-need.pdf, 2005. Accessed 20 Mar. 2019.

Newburn, Mary, and Debbie Singh. "Feathering the Nest: What Women Want from the Birth Environment." *RCM Midwives*, vol. 9, no. 7, Jul 2006, pp. 266-69. PMID: 16886787.

Newton, Niles, et al. "Experimental Inhibition of Labor through Environmental Disturbance." *Obstetrics and Gynecology*, vol. 27, no. 3, Mar 1966, pp. 371-77.

Nightingale, Florence. *Introductory Notes On Lying-in Institutions.* Longmans, 1871. www.archive.org/details/introductorynot00 nighgoog/page/n5. Accessed 20 March 2019.

Nilsson, Christina. "The Delivery Room: Is It a Safe Place? A Hermeneutic Analysis of Women's Negative Birth Experiences." *Sexual & Reproductive Healthcare*, vol. 5, no. 4, 2014, pp. 199-204. Elsevier BV, doi:10.1016/j.srhc.2014.09.010.

Odent, M. *The Nature of Birth and Breastfeeding.* Bergin and Garvey, 1992.

Otley, Henrietta. "Fear of Childbirth: Understanding the Causes, Impact and Treatment." *British Journal of Midwifery*, vol. 19, no. 4, 2011, pp. 215-20. Mark Allen Group, doi:10.12968/bjom.2011.19. 4.215.

Perez-Gomez, Alberto, "The Body and Architecture." *Art and the Senses*, edited by Francesca Bacci and David Melcher, Oxford University Press, 2011, pp. 571-78.

Ridley, Matt. *The Agile Gene: How Nature Turns on Nurture.* Perennial, 2004.

Powell Kennedy, Holly, and Maureen T. Shannon. "Keeping Birth Normal: Research Findings on Midwifery Care During Childbirth." *Journal of Obstetric, Gynecologic & Neonatal Nursing*, vol. 33, no. 5, 2004, pp. 554-560. Elsevier BV, doi:10.1177/0884217504268971.
Roeder, Amy. "America is Failing its Black Mothers." *Harvard Public Health.* 2019 Winter. www.hsph.harvard.edu/magazine/magazine_ article/america-is-failing-its-black-mothers/ Accessed 20 Jul. 2019.

Roland-Price, Anna, and Zara Chamberlain. "Management of Toco-phobic Women." *A Textbook of Preconceptional Medicine and Management: Section 4,* edited by Mahantesh Karoshi. Sapiens, 2012, pp. 281-88.

Rouhe, H., et al. "Fear of Childbirth According to Parity, Gestational Age and Obstetric History." *BJOG: An International Journal of Obstetrics & Gynaecology,* vol. 116, no. 7, 2009, pp. 1005-1006. Wiley, doi:10.1111/j.1471-0528.2009.02154.x.

Sandall, Jane, et al. "Discussions of Findings from a Cochrane Review of Midwife-Led Versus Other Models of Care for Childbearing Women: Continuity, Normality and Safety." *Midwifery,* vol. 25, no. 1, 2009, pp. 8-13. Elsevier BV, doi:10.1016/j.midw.2008.12.002.

Stenglin, Maree, and Maralyn Foureur. "Designing Out the Fear Cascade to Increase the Likelihood of Normal Birth." *Midwifery,* vol. 29, no. 8, 2013, pp. 819-25.

Symon, Andrew G., et al. "Care and Environment in Midwife-Led and Obstetric-Led Units: A Comparison of Mothers' and Birth Partners' Perceptions." Midwifery, vol. 27, no. 6, 2011, pp. 880-86. Elsevier BV, doi:10.1016/j.midw.2010.10.002.

Szurek, Jane. "Resistance to Technology-Enhanced Childbirth in Tuscany: The Political Economy of Italian Birth." *Childbirth and Authoritative Knowledge: Cross-Cultural Perspectives,* edited by Carolyn F. Sargent and Robbie Davis-Floyd, U. of Calif. Press, 1997, pp. 287-88.

UNICEF. Global Breastfeeding Scorecard: Tracking Breastfeeding Policies and Programs. UNICEF/WHO, 2017. www.who.int/nutrition/publications/infantfeeding/global-bf-scorecard-2017/en/. Accessed 20 Mar. 2019.

Uvnäs Moberg, Kerstin. *The Oxytocin Factor: Tapping the Hormone of Calm, Love and Healing.* Da Capo Press, 2011.

Van Manen, Max. "Phenomenology of Practice." *Phenomenology & Practice,* vol. 1, no. 1, 2007, pp. 11-30.

Vedam, Sarawathi, et al. "The Mothers On Respect (MOR) Index: Measuring Quality, Safety, and Human Rights in Childbirth." *SSM–Population Health,* vol. 3, 2017, pp. 201-10.

Villar J., et al. "Caesarean Delivery Rates and Pregnancy Outcomes: The 2005 WHO Global Survey on Maternal and Perinatal Health in Latin America." *Lancet,* vol. 367, no. 9525, 2006, pp. 1819-29.

Von Uexküll, Jakob. *A Foray into the Worlds of Animals and Humans: With a Theory of Meaning.* University of Minnesota Press, 2011.

Wagner, Marsden. *Born in the USA: How a Broken Maternity System Must be Fixed to Put Women and Children First.* University of California Press, 2008.

Wagner, Marsden. "Fish Can't See Water: The Need to Humanize Birth." *International Journal of Gynecology & Obstetrics,* vol. 75, 2001, pp. S25-S37. *Wiley,* doi:10.1016/s0020-7292(01)00519-7.

Waldenström, Ulla. "Experience of Labor and Birth in 1,111 Women." *Journal of Psychosomatic Research,* vol. 47, no. 5, Nov 1999, pp. 471-82.

Waldenström, Ulla, et al. "A Negative Birth Experience: Prevalence and Risk Factors in a National Sample." *Birth,* vol. 31, no. 1, 2004, pp. 17-27. *Wiley,* doi:10.1111/j.0730-7659.2004.0270.x.

Warmflash, David. *Genetic Literary Project,* www.geneticliteracyproject. org/2015/06/12/artificial-wombs-the-coming-era-of-motherless-births/, June 12, 2015. Accessed 15 Dec. 2018.

Zajonc, Arthur. *Catching the Light: The Entwined History of Light and Mind.* Bantam Books, 1993.

Zhang, Jun et al. "Contemporary Patterns of Spontaneous Labor with Normal Neonatal Outcomes." *Obstetrics and Gynecology,* vol. 116, no. 6, 2010, pp. 1281-1287. doi:10.1097/AOG.0b013e3181fdef6e

Chapter Fourteen

Baby Lust: Biology and Four Types of Products

Heidi Overhill

"The aspects of things that are most important for us are hidden because of their simplicity and familiarity. (One is unable to notice something because it is always before one's eyes.)"—Ludwig Wittgenstein (*Philosophical Investigations* 129)

Our human relationship with material possessions is not logical. Even tools engage an emotional response that goes far beyond an appreciation of utility, affecting our sense of self through empowerment in the world. Other possessions, such as Hello Kitty ornaments or the Volkswagen Beetle, appear to achieve much of their appeal through babylike cuteness. Such "baby-fication" may not be merely a marketing gimmick, or even a conscious strategy of designers, but instead might result from a deep-seated psychological factor: our evolutionarily-compelled love of babies. Notoriously weak and delicate, human offspring require constant care and attention, without which our species could not survive. Helpless at birth, a newborn baby has only its appearance to trigger this passion. The baby looks, feels, and smells nice. It is cute; and its cuteness seems neither idle nor accidental. In a very real sense, babies make their living from cuteness. Baby passion seems to affect our innate responsiveness to not only our offspring but also products that resemble babies, which then inspire instinctual protective behaviours. And if we are all potential parents, helpless in the face of cuteness, we are also all former babies, with an

instinctual response to parental nurture. So another type of product seems to do the reverse: evoking such nurture for our adult selves. On the sofa, we lay curled as in a primal lap, gaining support beyond simple physicality. Finally, at every age, we are social creatures and engage in social interaction, so products presenting a social presence with bodies, faces, and legs encourage a sense of their own personality. In short, a better acceptance of the biological processes of life may better help us to understand aspects of the complex human relationship with material culture.

McLuhan Body Extensions

Human beings are unique in our deep engagement with material things, as has been discussed in anthropology (Attfield; Gell), archaeology (Hodder), art history (Kubler), biology (Dawkins; Wilson), critical studies (Brown), philosophy (Margolis and Laurence), sociology (Czikszentmihalyi and Rochberg-Halton), and more.

In design, the most intuitively attractive description of object meaning can be found in Marshall McLuhan's well-known truism that "media are the extensions of man[kind]" (McLuhan and McLuhan). In his definition, all things that carry messages are media, and this description captures how cups, bicycles, and telephones extend the functions of hands, feet, and ears while suggesting that the meanings people attribute to artifacts may be linked to the meanings we find in our own selves. The smooth curves of a new car emulate the musculature of the well-exercised body; and both attract admiring glances.

Although describing artifacts as body extensions is intuitively satisfying, it conceptualizes their impact only in terms of a singular person, and an adult one at that. However, no person was always adult. Nobody stepped full-grown from the forehead of Zeus. We were all once helpless infants, and we share complicated physical and social relationships with those who nurtured us and those whom we ourselves will nurture. This simple fact precedes any other achievement of humanity. Before we did anything else, we had to achieve babies.

Darwin and Freud

Humanity gained our unique dominance over other species because of our large and versatile brains, but brains came at a high price. As biologist Stephen Jay Gould has pointed out, the chimpanzee probably attained the practical upper size limit for primate head size. Any larger head simply cannot fit through the narrow passage of the pelvis. For humans to gain our big heads, the evolutionary solution was to give birth to premature fetuses, which are smaller than full-term babies and thus easier to birth, but are also much less developed (Gould 12). Whereas a newborn chimpanzee can cling to its mother shortly after its birth, a newborn human will smother if laid down the wrong way. To survive, it must be carried, fed, cleaned, and guarded for years, without pause, night and day.

Caring for a baby may be the most demanding activity that a human being can undertake. To meet the baby's needs, a parent must go without sleep, food, washing, social life, and mental stimulation. Any baby that fails to win this level of commitment from an adult will not survive. In words of a child immigrant to Canada in 1832, "my mother died, and they threw her into the sea. And then my little sister, only nine months old, died, because there was nobody to take care of her" (qtd. in Jameson 92).

As Charles Darwin observed, it makes sense for the survival of our species that parents sacrifice their personal wellbeing for offspring. But how is the individual parent persuaded to make that sacrifice? Sigmund Freud proposed an explanation for unspoken imperatives in his description of instinct, or drive—"*Trieb.*" Freudian instinct acts as "a stimulus applied to the mind" urging individuals to action (Foss 564). In his terms, a fundamental life instinct, "Eros," guides human behaviour to ensure survival of the individual and the species.

In the Freudian tradition, when instinctual erotic needs are met, the result is the experience of pleasure (Eaton 28). Thus, food and sex are pleasurable because they support and reproduce the species. But sex alone will not ensure reproduction; far greater effort must go into nurturing the resulting baby, which means that the instinctual drive for nurture must be still larger. And although sex is pleasurable, few people will die to achieve it. In Freudian terms, the "reality principle" intrudes so that would-be lovers will accept the reality of an earthquake and leap up to run for their lives. In contrast, when it comes to babies,

no cost is too high. Parents routinely sacrifice themselves to protect their children, as when a Texan mother recently died after jumping front of a car to cushion her children from the impact (Konstaninideas).

Freud comments that "the instincts are all qualitatively alike and owe the effect they make only to the amount of excitation they carry" (568). In those terms, baby instinct must be so large that it may not be surprising that we fail to notice it. Loving babies is both essential and routine. Robert Graves, writing about the original Greek myth of Eros, notes that the god was initially an abstraction, only later personified as a wild boy shooting golden arrows. He describes the birth of Eros as symbolic, "the meaning being that there is no love so strong as mother-love" (58-59).

Baby passion confirms Freud's observations about instinct. New parents are tousled, dirty, hungry, exhausted—and dizzy with pleasure. We have no proper word to describe baby love, but it is the third great erotic passion of humanity, distinct in its own right. Visitors to a new baby behave much alike. They fiddle with its features, saying things like: "Look at those cheeks! She's adorable." A baby seems to trigger not just emotional affection but also grooming gestures, which may be important to its survival. Babies that are not regularly handled will die of "marasmus," or wasting disease, even if kept clean and fed (Eaton 31).

This is not to say that a baby does not experience anything in its first days; only that its actions are confined to involuntary sucking, limb waving, and crying. This is a limited repertoire to use for influencing adults. Babies with colic cannot even reward parents by stopping crying and will scream nonstop through attempts to relieve their distress. Yet parents choose to cradle the screaming baby close, saying, "shh, shh, mommy loves you," rather than adopting a sensible course of action and leaving the house.

Parents do not leave because even if they did they would not escape thoughts of the baby. Freud asserted that the main difference between an external stimulus and one of instinct is that "no actions of flight avail" for escaping the irritation of instinct (556). Note that the word itself derives from the Latin "instiguere," meaning "to prick from within" (Malkemus 7). It seems that all that is needed to trigger overwhelming, protective, and self-destructive passion in a parent is the simple physical presence of the baby. The baby looks, feels, and smells nice.

Freud states that "the object of an instinct is the thing in regard to which or through which the instinct is able to achieve its aim" (567). A newborn baby is clearly such an object, conveying pleasure by its presence alone. Such impact necessarily predates the emergence of every other desirable object in the history of humanity. Babies are the primal product.

Baby Features in Nonbabies

The visual appeal of cuteness has long been a topic of discussion (Ngai; May). By comparing a "loveable" short-faced Pekinese to a long-faced hound, Konrad Lorenz in 1943 hypothesized that infantile features evolved to inspire parental care (Komori and Nittono 285). In 1947, animator Preston Blair of Warner Brothers drew up details of cute features to use in drawings of animals. Progressive "cutification" can be seen in the evolution of Walt Disney's Mickey Mouse, who grew substantially more round following his first scrawny appearance in 1928 (Gould). A similar pattern can be detected in the evolution of stuffed teddy bears (Hinde and Barton; Morris et al.).

Proportional changes between round baby faces and long adult ones can be described mathematically in terms of "cardoidal strain" (Pittenger et al.; Todd et al.). Other visual qualifies associated with cuteness may include small size, round shape, wide proportions, light colours, and simplicity in detail (Cho 17). Such baby schema features are, unsurprisingly, associated with increased nurturing emotions in adults who view the pictures (Glocker et al.; Volk and Quinsey). Nether gender nor parenting experience appears to make any difference to the speed of the visceral responses (Kringelbach et al.; Thompson-Booth et al.).

Cuteness in nonanthropomorphic products can be introduced when automobile front ends are deliberately given "baby-faced" geometric distortions—which afterwards inspire more positive emotions than did the originals (Miesler et al.). In design folklore, the original Volkswagen Beetle stands as an paragon of such effects. A legendarily bad car, it managed to attract devoted owners, perhaps because its round roof and big headlights inspired nurturing rather than anger whenever it broke down (Patton).

Miniaturization is another key aesthetic of babies. "Look at those

tiny fingers," say spectators admiringly. It is not surprising, therefore, to observe that anything becomes cute when made smaller. Entire industries exist to reproduce large things in smaller versions, under the pretext of doll furniture, pencil sharpeners, snow globes, and tiny erasers resembling fun foods (Mostrin). Architecture engages closely with miniaturization, when scale models are used to communicate design intent so that even bad proposals feature appealing tiny trees and cars.

Another design characteristic of babies is that they are small enough to pick up and have features that require constant attention—stroking, wiping, buttoning, and the dangling of car keys. Many consumer products share similar characteristics, including telephones, televisions, food processors, microwaves, toasters, and laptop computers. In fact, it seems to be an unspoken rule that anything with adjustable controls tends to be small enough to pick up. Such products are also not well characterized as body extensions. Chairs, cups, pencils, and cars are easy to understand as body extensions. But a toaster makes no clear reference to any body part.

Consider music playback. Since the time of Edison, music products have been packaged as wooden cabinets, portable boom boxes, or the original Sony Walkman (1979), which in theory no one wanted until they laid eyes on the adorable first one. The playing of recorded music can be understood as a modification to our "environmental niche" (Odling-Smee and Turner), as when ambient music plays in restaurants and shopping malls. It can also be seen as a body modification—extending the ears to hear sounds from far away or from the past. But if ear-mounted headphones are clearly body extensions, they almost inevitably connect back to some kind of small hand-held box garnished with adjustable controls. Noise appears most appropriate when issued by babies.

Similarly, computers first appeared as room-sized technological installations but rapidly gained their current form as small carry-able boxes. Early computers tested other forms: Univac 1 was built as a bulging desk in 1952 as was the 1963 HP2116A (Campbell-Kelly et al.). But ever since the boxy 1975 Altair 8800 (Computer History Organization), most computers have taken the babylike form of portable lumps covered with finger-friendly features. And at least under the influence of Apple, many of those successful models have also been

arguably cute: small, round, wide, light in colour, and simple in detail. Steve Jobs was apparently insistent that the first Mac Classic also display the cute word "hello" (Boyle).

If babies are the *ur*-product, this might explain the curious phenomenon of perceived product "heaviness," which seems not to relate directly to weight. Babies gain weight as they grow, of course, but it takes formal weighing in the doctor's office to reveal the change. The baby itself seems just the same. And certainly, it remains the same in terms of at least one quantitative measure: specific gravity or weight per volume. We might predict, therefore, that perceived heaviness in objects relates to specific gravity rather than weight. I recall that the original boxy Macintosh Classic (1990) seemed light in comparison the flat Powerbook (1989), even though both weighed virtually the same at 16 and 15.8 lbs, respectively. A more recent Macbook Pro (2015) also feels heavy, though weighing only 4.49 lbs. A quick comparison finds the Classic lowest in specific gravity, at 3.08, the Powerbook at 4.84, and the MacBook Pro at a whopping 12.75. In keeping with its name, the MacBook Air (2015) has a relatively low specific gravity of 7.69, but it still does not approach the specific gravity of human flesh, which is approximately 1.00, the same as water (Boyd). The question arises as to whether the MacBook Air would seem still lighter if its size had been slightly increased at the same time as its weight decreased, further lowering the specific gravity.

Finally, there is the curious relationship of babies to change. As the baby grows, it modifies both its shape and behaviour while maintaining its own identify. It is the things associated with the baby that appear to change rather than the baby. Photographs look old quickly because the baby's identity has moved on to inhabit a different form. The parent scarcely notices. It seems that the clothes are shrinking rather than the baby growing. In other words, parents somehow experience change as constancy—meaning that real constancy must be experienced in some other way, perhaps as dullness, because it does not change.

Certainly, change is an important factor in contemporary design, particularly in clothes design, where "time is a central tenet in the understanding of fashion" (Heidegger qtd. in Aspers and Godart 176). Constant turnover in trendy fast fashion yields large profits for clothing chains such as Zara and H&M (Kim et al.). Advertising alone does not explain it, although general "stimulus novelty" is well understood to

attract human attention (Koster et al.), which is perhaps not surprising for a creature always ready to notice surprises such as ripe fruit or predators. Habituation to repeated stimuli is also a well-known phenomenon, again perhaps explainable as a mechanism to prioritize focus on change (Rankin et al.). In contemporary society, numbness to the old may rob everyday habits of their pleasure (Shlovsky) as well as blinding designers to the existence of mundane problems (Bell et al.).

Taking pleasure in change for its own sake may be associated with the pointless overconsumption of novelty, with resulting ecological damage. The typical remedy proposed for overconsumption is personal restraint (Sandin and Röcklinsberg). But the example of the baby may suggest alternative strategies. No one gets bored with the baby, which learns new tricks before you tire of the old ones. A small number of material goods appear to offer similar virtues. The Japanese art of "*kintsugi*" ("golden repair") restores broken pottery with inlays of golden lacquer, celebrating damage as history (Keulemans). Similarly, anthropologist Grant MacCracken describes the "patina" system of social status in England, where materials that accumulate damage over time, such as silver and oil paintings, develop a pattern of wear that connotes longstanding wealth and prestige rather than shabbiness (McCracken 31-43). Stiff new blue jeans were also a product that increased in prestige (and comfort) with age and softening, although that effect is now offered in prewashed and Spandex versions. In other words, the growing baby could be seen as a paradigm for products that improve over time. Perhaps design in general could aim to better celebrate aging; Sweden now offers tax incentives for appliance repair (Orange).

If baby aesthetics may be common in some aspects of material culture, there seems to be little mention of it in mainstream design commentary. In *Emotional Design* (2004), guru Donald Norman describes "three levels of design: visceral, behavioral, and reflective," with the biological visceral dimension serving as "the start of affective processing" (22). However, the book makes only scant mention of cuteness, dismissing it as a factor that "can outwear its welcome" (104). Similarly, no attention appears to be paid to cuteness in the literature of "product pleasure" (Jordan). A search of conference papers organized by the international Design and Emotion Society reveals nothing on cuteness and only one baby-related article: about the development

of software platforms to facilitate sharing of baby videos (Kim and Zimmerman).

Like many areas of contemporary life, industrial design suffers from legendary gender-bias (Overhill). This might explain the omission of babies from the discussion, as something too feminine to merit worthy attention in a masculine world. But many men make excellent parents, and the oversight seems so pervasive that some broader cultural factor might be at work. Baby passion may be so large that, like air, it is hard to see.

Products for the Id, Ego, and Superego

Like most of Sigmund Freud's ideas, his theory of id, ego, and superego (1923) has long fallen out of fashion (Westen). However, traces of it remain in transactional analysis, where definitions of parent, adult and child ego states suggest that people can cycle through all three even as adults; they can feel variously needy, nurturing, and competent in response to the challenges of life (Berne 23). In the control room of the USS Enterprise in *Star Trek* (1966-67), Mr. Spock is the logical parent, Dr. McCoy the complaining child, and Captain Kirk the adult ego that mediates between them. Here, the concept could be used describe varying human relationships to things. McLuhan's body extensions could describe how material culture is viewed from an adult ego state, whereas baby-schema aesthetics appeal to a nurturing parent ego state. In that case, is there a third type of product that appeals to the third ego state: our recollections of being ourselves once babies?

Sofas, armchairs, and bathtubs appear to satisfy that condition. All are too large to pick up and lack the kinds of interactive controls found in baby objects. They also offer no clear extension to the adult body. A dining chair extends the adult rump to facilitate sitting, but users of sofas and armchairs drape themselves over the soft surfaces in a wide variety of postures. At the same time, sofas are curiously standardized in their fixed relative proportions of width and depth, almost to the point of ritual. Whether French provincial or postmodern in styling, virtually all sofas are just too short for stretching out the full body and just wide enough not to roll off.

In considering products that could appeal to child ego states, it is necessary to note that as babies, our bodies were smaller and rounder

than our adult versions. Mental recollections of childhood do not adjust for this change but rather position ourselves as invariant observers. It is a commonplace that people returning to childhood haunts are surprised how much smaller everything seems. Things look smaller because the standard for measurement is your own body. You endure; the world shrinks. Therefore, if an object is to keep the same relationship to your adult body as it once had to your baby body, it must enlarge to keep up.

This observation appears to explain the sofa. It is a giant lap. Its arms are the arms of the former parent, its back the parent's stomach, and its cushions the thighs. Some sofas even decorate the stomach with bellybuttons. The sofa is proportionally wider and shallower than a lap because your adult body is longer and narrower. To maintain the same topological fit to the lean adult body as the original lap provided to a rounded baby body, the sofa must elongate. The shortness of the sofa is explicable once it is understood as a lap because in a lap, the baby lies cradled, body bent. Sofa usage as well as proportion corresponds with childish need. After a hard day at the office, you flop on the sofa. Sick at home, you curl up on the sofa. In theory, the cramped sofa is less comfortable than your proper bed, but it is more comforting. It is a parent object.

The armchair, of course, is also a lap, but a lap for an older child, perhaps a toddler. It corresponds to the age when you can perch in a parental embrace while maintaining a healthy sense of independence. Note that parent objects such as sofas are scarce in offices, where workers are expected to act like grownups. Sofas are found only in upper management, where VIPs enjoy a full expression of personality

Parent objects seem typically passive. They generally feature no moving parts or adjustable features. This could be explained if babies do not recognize parental handling as originating from the parent. A young baby seems just as astonished by its own sneeze as by a truck horn outside. The limits of its own body do not seem to be apparent. Babies do not like being wet, but they also do not like having their diapers changed. The essential feature of a parent could be simply presence. And where baby objects tend to proliferate in number, one parent object generally suffices.

La-Z-Boy furniture seems to refute this analysis because it does move to adjust to various postures. However, this can be seen as a step

even furthers back in time than the sofa and to an effortless floating in the womb—leading us, of course, to the bathtub.

Social Products

If we can usefully consider radios to be babies, sofas to be parents, and chairs extensions of adult buttocks, there still remains a number of things that fit none of these categories. Some large and complex items cannot be carried, or sat upon, and correspond to no part of the user's body. These include kitchen appliances, washing machines, vending machines, and pianos, which seem to share a quasi-social presence. They are all roughly the size of a fellow human being; they respond politely to actions taken on their controls, and in appearance, they often have faces, legs and heads—features that give them personality and a social presence.

The anthropomorphic organization of social objects could be detected in the persistence of impractical yet expressive features. Refrigerator freezers are most efficient when placed underneath the main compartment because heat rises. But many models of refrigerator continue to place the freezer above, keeping the hard head on top.

With the rise of interactivity and ubiquitous computing, social products are proliferating. They begin to offer not just the generic response of a sales clerk or parking lot attendant; they are approaching the personal response of a concierge, who is familiar with your desires and history and can initiate responses in light of that awareness.

Reversal

Alas, our beloved products lie to us. They deceive us about mortality. Unlike us, they are immortal and endure in lands, air, and seas long after our mortal remains are gone. The teacups on my shelf have already outlived my great-grandmother, my grandmother, and my mother, and they will outlive me as well, even if I break or discard them. On the dusty plains of Iraq, former Mesopotamian communities can be detected thousands of years later by the shards of broken ceramic laying on the dusty ground, enduring long after everything else has gone (Roaf).

McLuhan's "fourth law of media" proposes that things when

pushed to extremes "reverse meaning" (McLuhan and McLuhan). Thus, eating food is good because it sustains life, but eating too much food will kill you. A car is faster than a horse, but millions of them create a traffic jam. We now possess so many lovable things that they are starting to reverse meaning on us, clogging our air, water, and land with unlovable debris that is on the verge of stifling human life.

Freud described Eros, the life drive, in concert with Thanatos, the drive to death. Perhaps we pollute because we want to die—but then Freud has been long debunked, and we do not have to look to him for anything except poetic insight. Perhaps we are only accidentally trying to exterminate our species.

Conclusion

The human relationship with things is ancient. Material culture is inextricably part of how humans cope with the world—enhancing the abilities of our bodies and minds and modifying our ecological niche to provide new opportunities. Some artifacts, such as cups and telephones, can be characterized as extensions of cupped hands and spoken voices. Others, such as dolls and laptop computers, offer cute babylike characteristics that seem to appeal to a fundamental human drive to care for helpless human babies. A third type of product appears to offer a sort of primal comfort to adults in a babylike mood, proffering a sort of parental presence in the form of an accommodating sofa or bathtub. Finally, a fourth group of artifacts, such as pianos and vending machines, appear to stand independently like a separate person, offering a quasi-social experience. These four categories of things can be seen to correspond with four aspects of human nature: ourselves as independent adults, as supportive nurturers, as former babies, and as sociable beings.

Of these types of artifacts, the babylike cute ones appear to have been underexamined as design, which could be attributed to pervasive gender bias: a dismissal of parenting as something feminine and, therefore, a distraction from the serious business of life. However, blindness towards babies seems to go still further and to neglect not just the experience of raising children but also the reality of one's own personal birth, growth, and death. Accepting the importance of babies could demand accepting the inevitability of mortality. Anyone reading

this chapter inhabits the "long now" of self-aware adulthood—a period in which we can read scholarly books and debate the meaning of design—but this moment is not eternal. We did not know it in childhood, and as we age, we will eventually die or slip into dementia. We are subject to forces beyond our control. To admit birth is to open the gate to death.

To admit death is to admit the damage our species inflicts on our earth. It becomes clear that if self-interested Eros is to succeed in its mission to nurture survival, its next blooming must lead us to love our planet, not just our species. As objects of the past reveal, we need to embrace Eros to do that right. We need to save ourselves not through moral self-denial; we must do good because it ... it has been designed to feel good—just as good as hugging a baby.

[An earlier version of this essay was published in *The Good, the Bad, and the Ugly Object*. Seminar Proceedings. Ottawa, ON: Carleton School of Industrial Design, 1994, pp. 57-65.]

Works Cited

Aspers, Patrik and Fréderic Godart. "Sociology of Fashion: Order and Change." *Annual Review of Sociology*, vol. 39, 2013, pp. 171-92.

Attfield, Judith. *Wild Things: The Material Culture of Everyday Life*. Berg, 2000.

Bell, Genevieve, et al. "Making by Making Strange: Defamiliarization and the Design of Domestic Technologies," *ACM Transactions on Computer-Human Interaction*, vol. 12, no. 2, June 2005, pp. 149-73.

Berne, Eric. *Games People Play*. Ballantine Books, 1973.

Blair, Preston. *Advanced Animation: How to Draw Animated Cartoons*. Walter F. Foster, 1947.

Boyd, Edith. "The Specific Gravity of the Human Body." *Human Biology*, vol. 5, no.4, December 1933, pp. 646-72.

Boyle, Danny, dir. *Steve Jobs*, 2015, www.imdb.com/title/tt2080374/. Accessed 14 Mar. 2019.

Brown, Bill. "Thing Theory," *Critical Theory*, vol. 28, no. 1, 2001, pp. 1-22.

Campbell-Kelly, Martin, et al. *Computer: A History of the Information Machine*. Third Edition. Westview Press, 2014.

Cho, Sookyung. "Aesthetic and Value Judgement of Neotenous Objects: Cuteness as a Design Factor and Its Effects on Product Evaluation." Unpublished PHD Thesis. University of Michigan, 2012.

Computer History Organization, "Timeline of Computer History," www.computerhistory.org/timeline/computers/. Accessed 21 Jan. 2017.

Czikszentmihalyi, Mihaly, and Eugene Rochberg-Halton, *The Meaning of Things: Domestic Symbols and the Self.* Cambridge University Press, 1981.

Darwin, Charles. *The Expression of the Emotions in Man and Animals.* University of Chicago Press, 1872.

Dawkins, Richard. *The Extended Phenotype.* Oxford University Press, 1982.

Eaton, Merrill T., Jr., et al. *Psychiatry.* New Flushing Medication Examination Publishing, 1969.

Foss, Torberg. "Editorial Column: Freud 100 Years." *The Scandinavian Psychoanalytic Review,* vol. 38, no. 2, 2015, pp. 81-85.

Freud, Sigmund. *Beyond the Pleasure Principle;* Translated by C. J. M. Hubback, International Psycho-Analytical Library, 1922, *Bartleby,* 2010. www.bartleby.com/276/. Accessed 9 Aug. 2019.

Freud, Sigmund. "Instincts and Their Vicissitudes," *The Freud Reader,* edited by Peter Gay, W.W. Norton, 1980, pp. 562-67.

Gell, Alfred. *Art and Agency: An Anthropological Theory.* Clarendon Press 1998.

Glocker, Melanie, et al. "Baby Schema in Infant Faces Induces Cuteness Perception and Motivation for Caretaking in Adults." *Ethology,* vol. 115, 2009, pp. 257-63.

Gould, Stephen Jay. "Human Babies as Embryos." *Ever Since Darwin: Reflections in Natural History.* New York, NY: W.W. Norton, 1977.

Gould, Stephen Jay "Mickey Mouse Meets Konrad Lorenz." *Natural History,* vol. 88 no. 4, May 1979, pp. 30-36.

Graves, Robert. *Greek Myths.* Cassel, 1955.

Hinde, Robert A., and L. A. Barton. "The Evolution of the Teddy Bear." *Animal Behaviour,* vol. 33, no.4, 1985, pp. 1371-73.

Hodder, Ian. *Entangled: An Archaeology of the Relationships between Humans and Things.* Wiley-Blackwell, 2012.

Jameson, Anna. *Sketches in Canada.*, Brown, Green, and Longman, 1852.

Jordan, Patrick W. "Human Factors for Pleasure in Product Use." *Applied Ergonomics,* vol. 20, no. 1, 1998, pp. 25-33.

Keulemans, Guy. "The Geo-cultural Conditions of *Kintsugi,*" *Journal of Modern Craft*, vol. 9, no.1, 2016, pp. 15-34.

Kim, Hyunsook, Ho Jung Choo, and Namhee Yoon. "The Motivational Drivers of Fast Fashion Avoidance." *Journal of Fashion Marketing and Management,* vol. 17, no. 2, 2013, pp. 243-260.

Kim, Sook Yeon, and John Zimmerman. "Supporting New Parents in Their Desire to Share Baby's Life," 6th Annual Conference on Design & Emotion, Modeling Experience, 2008, www.designand emotion.org/library/page/viewDoc/213. Accessed 9 Aug. 2019.

Komori, Masashi and Hiroshi Nittono. "Influence of Age-Independent Facial Traits on Adult Judgments of Cuteness and Infantility of a Child's Face." *Procedia—Social and Behavioral Sciences,* no. 97, 2013, pp. 285-291.

Konstantinides, Anneta. "Army Veteran Mother Dies." *Daily Mail,* 14 Aug. 2018, www.dailymail.co.uk/news/article-6059705/Mother-dies-jumping-three-children-save-car.html. Accessed 9 Aug. 2019.

Koster, Raphael, et al. "Stimulus Novelty Energies Actions in the Absence of Explicit Reward," *PLoS ONE,* vol. 11, no. 7, 2016, p. e0159120.

Kringelbach, Morton L., et al. "A Specific and Rapid Neural Signature for Parental Instinct." *PloS one,* vol. 3, no. 2, 2008, doi.org/10.1371/journal.pone.0001664.

Kubler, George. *The Shape of Time: Remarks on the History of Things.* Yale University Press, 1962.

Lorenz, K. "Die angeborenen Formen möglicher Erfahrung. Zeitschrift für Tierpsychologie," vol. 5, 1943, pp. 235-409. doi:10.1111/ j.1439-0310.1943.tb00655.x.

Malkemus, Samuel Arthur. "Reclaiming Instinct: Exploring the Phylogenetic Unfolding of Animate Being," *Journal of Humanistic Psychology,* vol. 55 no.1, 2015, pp. 3-29.

Margolis, Eric and Stephen Laurence, editors. *Creations of the Mind: Theories of Artifacts and Their Representation.* Oxford University Press, 2007.

May, Simon. *The Power of Cute.* Princeton University Press, 2019.

McCracken, Grant. *Culture and Consumption: New Approaches to the Symbolic Character of Consumer Goods and Activities.* Indiana University Press, 1990.

McLuhan, Marshall. *Understanding Media: The Extensions of Man.* McGraw Hill, 1964.

McLuhan, Marshall, and Eric McLuhan. *Laws of Media: The New Science.* University of Toronto Press, 1992.

Miesler, Linda, et al. "Isn't It Cute: An Evolutionary Perspective of Baby-Schema Effects in Visual Product Designs." *International Journal of Design,* vol. 5, no. 3, Dec. 2011, pp. 17-30.

Morris, P.H., et al. "The Survival of the Cutest: Who's responsible for the evolution of the Teddy Bear?" *Animal Behavior,* vol. 50, no. 6, 1995, pp. 1697-1700.

Mostrin, J. "Small Wonders." *The New York Times,* October 25, 2011, pp. 9-12.

Ngai, Sianne. "Our Aesthetic Categories." *PMLA,* Special Topic: Literary Criticism for the Twenty-First Century, vol. 125, no. 4, Oct. 2010, pp. 948-58.

Odling-Smee, John, and J. Scott Turner. "Niche Construction Theory and Human Architecture." *Biological Theory,* vol. 6, no. 3, Sept. 2011, pp. 283-89.

Orange, Richard. "Waste Not Want Not: Sweden to Give Tax Breaks for Repairs." *The Guardian,* 19 Sept. 2016, www.theguardian.com/world/2016/sep/19/waste-not-want-not-sweden-tax-breaks-repairs. Accessed 9 Aug. 2019.

Overhill, Heidi. "Hard & Soft: Women and Industrial Design," in *Shaping the 90s: Towards a New Design Curriculum,* Carleton University School of Industrial Design, 1992, pp. 35-42.

Patton, P. "2012 Volkswagen Beetle: A Bug with a Rampaging Y Chromosome." *The New York Times,* 18 Apr. 2011.

Pittenger, John B., et al. "Perceptual Information for the Age Level of Faces as a High Order Invariant of Growth." *Journal of Experimental Psychology: Human Perception and Performance,* vol. 5 no. 3, 1979, pp. 478-93.

Rankin, Catharine, et al. "Habituation Revisited: An Updated and Revised Description of the Behavioural Characteristics of Habituation," *Neurobiology of Learning and Memory*, vol. 92, no. 2, 2009, pp. 135-38.

Roaf, Michael, *Cultural Atlas of Mesopotamia and the Ancient Near East.* Facts on File, 1990.

Sandin, Per, and Helena Röcklinsberg. "The Ethics of Consumption." *Journal of Agricultural Environmental Ethics*, vol. 29, no. 1, 2016, pp. 1-4.

Shlovsky, Viktor. "Art as Technique." *Modern Criticism and Theory: A Reader*, edited by D. Lodge and translated by L.T. Lemon and M. J. Reiss, Longmans, 1988, pp. 16-30.

Sony, "Just Try It." *Sony History*, 1996, www.sony.net/SonyInfo/ CorporateInfo/History/SonyHistory/2-06.html. Accessed 9 Aug. 2019.

Thompson-Booth, Chloe, et al. "Here's Looking at You, Kid: Attention to Infant Emotional Faces in Mothers and Non-Mothers." *Developmental Science*, vol. 17, no. 1, Jan. 2014, pp. 35-46.

Todd, James T. et al. "The Perception of Human Growth." *Scientific American*, vol. 242, no. 2, February 1980, pp. 132-44.

Volk, Anthony, and Vernon L. Quinsey. "The Influence of Infant Facial Cues on Adoption Preferences." *Nature,* vol. 13, no. 4, 2002, pp. 437-55.

Westen, Drew. "The Scientific Legacy of Sigmund Freud Toward a Psychodynamically Informed Psychological Science." *Psychological Bulletin*, vol. 124, no. 3, Nov. 1998, pp. 333-71.

Wilson, Frank R. *The Hand: How Its Use Shapes the Brain, Language and Human Culture.* Vintage Books, 1998.

Wittgenstein, Ludwig. *Philosophical Transactions.* 4th ed. Wiley-Blackwell, 1998.

Chapter Fifteen

Making Space for Artist-Mothers in Asia: A Conversation

Ruchika Wason Singh and Rachel Epp Buller

Many of the conversations and relationships that led to *Inappropriate Bodies* and that grew through this volume developed in a combination of face-to-face and online interactions, but this conversation follows threads that we discussed entirely virtually in messages exchanged over a series of months. The digital world is at its best when it fulfills its potential to connect us across great distances, helping us to find commonalities. We would not say that artists create or that mothers mother in the same ways across the world; cultural, political, ethnic, and socioeconomic contexts vary widely and yield differing maternal expectations and standards of (in)appropriateness. Yet when it comes to exploring intersections of artistic and maternal practice, recurrent themes weave through global conversations: collaboration, solidarity, resistance and persistence, visibility, and a desire to dedicate time and space to the pursuit of creativity in contexts of maternity. Ruchika Wason Singh's Archive for Mapping Mother Artists in Asia (AMMAA) launched in 2016 and provides a platform to virtually connect artist-mothers within Asia— based in a sense of like-mindedness and solidarity—and attempts to meet their needs through such tangible offerings as short-term residencies in a creative space and potential collaborations. In our conversation, Wason Singh reflects on the successes and ongoing challenges of her long-range project.

Rachel Epp Buller: In the last few years, several artists have established dedicated work spaces for artist-mothers and sought to create connections between them across the globe. I'm thinking, for example, about Sarah Irvin's U.S.-based Artist-Parent Index, Sarah Cullen's Mothra artist-parent residency in Canada, or Dyana Gravina's Mother House initiative in the U.K., discussed with Terri Hawkes in this volume. Where does The Archive for Mapping Mothers Artists in Asia (AMMAA) fit into this? What affinities or departures do you recognize compared to other projects?

Ruchika Wason Singh: When I initiated AMMAA, I decided to focus specifically upon Asia, as the region encompasses different cultural lineages than in the West, and this affects the nature, continuity, and consistency of artmaking in the life of a female artist, if she chooses to become a mother. While I am based in India, what I perceive as similarly gendered and maternal expectations within neighbouring countries made me expand the project to Asia more broadly rather than focusing on India alone. I consider AMMAA an empowerment project that addresses the imbalance in artist-mothers' personal and creative lives through methods of mapping, mobility, and visibility.

In the beginning, I launched the project as a blog, followed by a website, to map the mother-artists in Asia (or those of Asian origin), who recognize their dual identities in their life. The concept of mapping I addressed first through a profiles section on the website. As the project evolved, I sought to not just gather and map the information but also explore aspects of visibility and mobility. Although mapping is online, visibility extends further into creative spaces in the form of artist workshops, exhibitions, and forums. Visibility is about creating platforms where the mother-artist and her work can participate in larger conversations. These events should help them negotiate time for networking and allocate opportunities to exhibit and to participate in the flexible-time modules planned through AMMAA. The aspect of mobility stemmed in part from my own struggle to find a short-term artist residency for myself. Duration plays a crucial role here. Whereas most artist residencies worldwide are anywhere from a month to a year or longer, the AMMAA international artist residency is two weeks. I see this as a way to make mobility a practical and possible scenario for artist-mothers.

Figure 1. Ruchika Wason Singh, publicity image for A.M.M.A.A. project launch, 2016.

Buller: Your three-pronged approach of mapping, visibility, and mobility begins first from the perspective of empowering individuals. Are these approaches applicable also to larger artistic, art historical, or social systems? What I mean is could mapping, visibility, and mobility be part of a design approach for systemic change?

Singh: Socially and culturally, in India as well as other countries of this region, it is often difficult to choose both motherhood and artistic practice as significant at the same time. The AMMAA provides platforms to make both paths possible in a practical way. For example, the artist residency has offered mobility to Miharu Hatori (Japan) and Leyla Varlik Senturk (Turkey) in 2017 and to Gi-Ok Jeon (South Korea/

Thailand) in 2018. Creating Days-Out, a 2018 art workshop, offered more localized mobility and interconnection to artists living and working in India: Kavita Nayar, Ritu Kamath, Merlin Moli, and Shruti Gupta Chandra.

AMMAA also offers mapping and visibility in the form of an art collection, a slowly growing collection of works by artists who participate in onsite events at Critical Dialogues Art Space in Delhi. I would like to see the collection eventually become more visible through a book publication and a curated, travelling exhibition.

A broader concern related to visibility is that maternal feminism is almost nonexistent in feminist art historical discourses in Asia. To the best of my knowledge, it is so far only in the research and writings of Wulan Dirgantoro (2017), Cecily Cheo (2012), and Shuqin Cui (2015) that we find hope for claiming space and voices for maternal bodies and identities in Asian contexts. I would like to see art historians explore how, in both form and content, questions of maternal body or identity bring forth new narratives, which until now have not been mapped, recorded, or heard in Asian art history.

Buller: What has the reception been like for the AMMAA? Have artists and others been receptive or resistant to the kind of mapping you're attempting and to your projects related to visibility and mobility?

Singh: The AMMAA seeks to answer questions that probably have always existed but maybe have never been asked. Although my intention has been to bring forth routes for addressing maternal contexts as well as maternal challenges within artistic practice, the project has been viewed by some artists and art historians as questionable. In my opinion, this could be because the project does not fit well within the already established paradigms of feminist research. As a result, some Indian and other artists whom I approached have not joined the project. Their resistance has come in the form of objections to becoming categorized or bracketed within the terminology rather than seeing the project as liberating. Polite denial has also come from artists who have strong maternal content in their work but prefer not to have that highlighted. They fear a limiting of artistic identity through the project rather than seeing its possibilities for visibility and acknowledgment.

Yet the project has found support for its networking and dissemination of information from a variety of male and female artists, art critics, and cultural workers. At first, I presumed that language and

communication could restrict the work. But to my initial surprise, the project appealed to artists outside of India. Currently, the highest number of participating artists outside of India is from Japan. I have received expressions of interest from artists in western and eastern African countries, who have either spent considerable time in Asia or have an Asian heritage, and I have welcomed them into the project. Patty Hudak, for example, is not Japanese but has lived in Tokyo for many years, and her installation work incorporates the Japanese tradition of *sumi-e* ink on *washi*, a fibrous Japanese handmade paper.

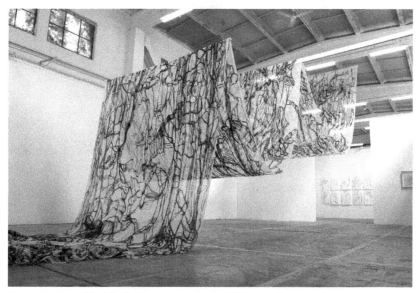

Figure 2. Patty Hudak, *Sailing to Byzantium,* 2015, acrylic on voile. Image courtesy of the artist.

I have also welcomed volunteers to this multicultural work. For example, artist Ma Yanling from Beijing has been very forthcoming and her daughter, based in New York, has worked as an intermediary and translator, providing information on Ma Yanling's work for the site. Similarly, Nozomi Kaneko, a Japanese researcher and translator, will interview Miharu Hatori, a senior calligraphy artist from *Tamamura-machi* in Gunma, Japan, to further clarify the information provided by the artist herself. This kind of volunteer labour is valuable to the work of mapping and visibility.

Figure 3. Ma Yanling, *Black Swan,* 2014 performance. Image courtesy of the artist.

And just recently, in December 2018, I had the wonderful opportunity to share my project with the Guerrilla Girls at the Kochi Muziris Biennale. The Guerrilla Girls responded so positively to the project in person, and later they followed up by sending me reading materials and information about related projects outside of Asia. Their support and validation felt significant and very encouraging.

Buller: In this same vein, much of this volume stems from ongoing conversations about art and maternity between artists, mothers, writers, and thinkers across disciplines and across countries. What other conversations of this sort have led to fruitful connections for you in your life or practice?

Singh: The project of mapping has brought forward many artists whose works I never knew, who may not operate in the commercial mainstream through gallery representation. Here I feel that the project has contributed because the open call provides a ground for many artists to apply and to participate in meaningful exchanges. The workshops and residencies have offered places for greater understanding

of how different cultural and social situations permit or prohibit certain aspects of artistic life and maternity—that what is appropriate in one context is seen as inappropriate in another. Age has also played an important factor. Since the project has involved a wide range of ages, young mothers to grandmothers, we can recognize the polarities of our experiences. Empathy, cooperation, understanding, and mutual respect have come out of these interactions.

Certainly my association with Procreate Project, Demeter Press, and the Museum of Motherhood has encouraged me by acknowledging my own art as well as contextualizing it. This greatly inspired me to take up the initiative and provide a platform to those within Asian countries who may still be in a dilemma about the artistic validity of their maternal expressions.

Buller: In recent decades, feminist and other artists have turned to collaboration in part as a way to circumvent much of the art world's focus on the individual. Some artist-mothers see collaboration with their children as a related levelling of hierarchy, whereas others turn to collaboration as necessary tool for social change. How has collaboration been formative in your own ways of working?

Singh: My daughter Meher and I have not shared in what I consider a true collaboration, although she is one of the very immediate critics about my art, which I welcome. Even though she lent a voice piece for the beginning of my artist film on the making of my work called *Transit Spaces* and co-participated with me and my husband in a photo project by U.S.-based artist Annu Mathew, for a future true collaboration, I want her to be an aware and active participant in the work, where she can voice her own opinion and possibilities in the work.

Even before I started AMMAA, I envisioned the still-developing project of Creative Collaborative Mothers as a platform where two or more mothers could come together to share, discuss, and develop work together and alongside each other. It differs from AMMAA because its geographical and cultural expanse is not just limited to Asia. I think collaboration between artists from Asia and the West could be very important. The collaboration, ideally, develops with equal participation and exchange, leading to a greater understanding of the artistic and maternal lives of others.

I am open to collaborations with other groups working with similar interests, which could facilitate mutual aims of mapping, visibility and

mobility. By connecting AMMAA with other programs around the world, I seek exchanges and dialogues of solidarity and faith in the choices that the maternal allows us to make. Through such connections, I could see future directions of AMMAA opening up towards different dimensions of maternal experiences, addressing such topics as single mothers, single fathers mothering, or queer mothers.

Buller: What challenges do you expect to continue addressing as you move the AMMAA project forward?

Singh: The feminist discourse in Asian art has major lacunae of maternal subjectivities and spaces in artistic, social, and political terrains. In this sense, the challenge has been to create a new niche within feminist spaces, where voices of the mother as artist can be heard. I think even before the visual can be approached, we must continue advocating for the acknowledgment of maternal subjectivity as an appropriate or legitimate dialogue within feminism in Asia.

Currently, AMMAA is a self-motivated and self-funded feminist research initiative. The limitation of funding has shaped the expanse of the project to a slow but steady progression. Even so, I choose to see the positives. AMMAA was born out of empathy towards this experience of struggle and to find a space and scope where the maternal and artistic spaces and desires could come much closer. To put it simply, the support system in the art scenario, which I found missing for myself, is what has given the vision to, structured, and empowered my project.

It is in the documentation of the struggles and what might be perceived as the failures of artist-mothers as artists—therein lies the success of the AMMAA.

Works Cited

Cheo, Cecily. "Participatory Practices between Mother and Daughter: The Art of Amanda Heng and Shia Yih Yiing." *Reconciling Art and Mothering*, edited by Rachel Epp Buller, Ashgate, 2012, pp. 95-107.

Cui, Shuqin. *Gendered Bodies: Toward a Women's Visual Art in Contemporary China.* University of Hawaii Press, 2015.

Dirgantoro, Wulan. *Feminisms and Contemporary Art in Indonesia: Defining Experiences.* Amsterdam University Press, 2017.

Chapter Sixteen

The Let Down Reflex: Addressing the Spaces of Art, Labour, and Parenthood

Amber Berson and Juliana Driever

Questioning who is welcome in the art world is the core of *The Let Down Reflex,* an ongoing curatorial project that explores institutional issues of accessibility. We assert that the art world favours players without families or those with the ability (via paid assistance or a partner's consistent, unpaid labour) to assign familial duties to others. From the high-commitment and low-pay opportunities that promise exposure to the demanding social events calendar, being present in both professional and personal realms is prohibitive, particularly for those in the emerging and mid-career stages of their work life and those working multiple jobs to make ends meet.

As an exhibition, *The Let Down Reflex* is about more than children in gallery and museum spaces or the position of the parent-artist. It is about access in a larger sense and the disregard of alternative bodies of knowledge. Creating a space for families in cultural institutions is an accessibility issue that should concern everyone, regardless of parental status. When we began organizing our thoughts and experiences into an exhibition about parenting within the art world, we were weary from concealing our roles as parents to protect our careers. Assumptions that our appetite for professional involvement would—and maybe should—change because of our parental status exhausted us, as did feelings of loneliness and alienation from the larger (art) world caused by fear of raising these issues. Using intersectional feminist theory and

praxis as a grounding, this chapter will explore our experiences, situating *The Let Down Reflex* in a network of likeminded projects. We hoped that *The Let Down Reflex* would create a forum for safe exchanges, especially since our research revealed a similarly desiring community. Whether in conversation with those who were loudly voicing the validity of the maternal or interacting with parents less able or willing to broadcast their experiences, we quickly saw that this issue needed, and still needs, urgent redress. Our project imagines an art world where the moniker "mom" is not demeaning, where childcare is always considered, and where a lack of parental leave does not force artists to choose between home and work.

"Let Down Reflex" is a medical term that references the involuntary reflex that causes nursing mothers to produce breastmilk. The term takes on a double meaning in this exhibition, as it refers simultaneously to this bodily function and to the reflexive tendency of the system to let down parents, particularly mothers. *The Let Down Reflex* creates a radical presence for families where they are typically absent: residency programs, low-pay and high-demand exhibition opportunities, panel discussions, and so on. Of course, parents are not the only people excluded from the art world; statistically as well as anecdotally, the young, single, white, typically male, able-bodied, and high-rolling artist is typically awarded the most opportunities (Maranda; Reilly).

This project began as a one-off exhibition at the Elizabeth Foundation for the Arts project space in New York (2016) and has since mushroomed into a series of articles, public talks, and programs at The Agnes Etherington Art Centre (2017) and The Blackwood Gallery at University of Toronto, Mississauga (2017). *The Let Down Reflex* highlights the need for a more flexible system in which artist-parents can find advocacy in the art world, encouraging a model that promotes sustainable practices for those actively caring for young children. We have invited artists to create work that critiques the perception of parenthood—and, more specifically, motherhood—as a liability and to move towards building a feminist space for the flourishing of labour-based practices that dovetail with the realities faced by families. Acknowledging our vulnerability while doing so, we want to effect lasting change in the art world and to begin conversations around reasonable accommodations for families in spaces that have not previously offered them. We want art spaces to know who to contact if

they would like to offer childcare and to understand how their liability insurance affects where and when they offer care services. We want spaces to have a plan in place for storing strollers and to understand the importance of creating a chill-out room for over-stimulated kids as well as a having a breastfeeding-positive space (regardless of legal requirements). We want public programs, openings, and installation or deinstallation efforts to be scheduled at family-friendly times. In short, we want art administrators to shift their consideration of these issues as matters of accessibility and hospitality. Below, we will discuss *The Let Down Reflex*, as exhibition, policy, and action.

The Let Down Reflex as Exhibition

It is not enough for us to ask for parental leave (in the U.S.) or qualitatively and quantitatively greater leave (in Canada). We can simply look at Sweden as an example of how things could be done and work towards that ("10 Things"). This type of work is basic in its activist approach. Our dreams can and should be greater. They should dismantle the system that they were created in and aim to rebuild something new and great and more diverse and inclusive and safe. Our exhibition, *The Let Down Reflex*, was not utopian, but our desires were. We cannot claim that art can fix societal problems, but it should be a place where we can at least imagine a better future. For us, that future is one in which everyone is welcome, not least of all families.

The Let Down Reflex highlights the need for a more flexible system in which artist-parents can find art world advocacy in order to encourage a model that promotes sustainable practices for those actively caring for young children. It asks what feminist tactics were in place in the past that we have come to take for granted and whether they are they being considered in the current art world infrastructure. The exhibition also explores what strategies can be developed to improve current conditions and to alter current systems to build a better future aligned with our personal values as desiring bodies operating in the (art) world.

The above questions drive this exhibition, as it asks artists to contemplate work that critiques the perception of parenthood, particularly motherhood, as a liability and move towards building an intersectional feminist space for the flourishing of labour-based practices that dovetail with the realities faced by families.

The artists worked from a variety of approaches. Some claimed space as parents. Lise Haller Baggesen and Deirdre Donoghue's *The Mothernists* (2017) refers back to Baggesen's installation *Mothernism* and the artists' co-organized conference of the same name. According to Baggesen and Donoghue's description of the project, "*The Mothernists* attempts to open up philosophical, political, aesthetic and social questions made visible through the co-existing practices of mothering and cultural reproduction, bringing these into the diverse discourses that the participants professionally as artists, writers, philosophers, curators, historians and educators are part of." Baggesen's installation *Mothernism* (2013-2016), included in the 2016 iteration of *The Let Down Reflex* at the EFA Project Space, created "a mother sized space in the gallery," allowing the use of the space to be dictated by the audience. Some of Baggesen's imagined original uses included a child area, a safe haven for breastfeeding, and a disco.[1]

Kerri-Lynn Reeves's *The Mother* (2017), a three-person, macramé hammock, created a gently cradled space for social interaction and relaxation. For Reeves, the triangle's symbolism draws out an understanding of the social, spatial, and historical aspects of her own experience of the process of passing into motherhood. Unfortunately, the request to install *The Mother* in an outdoor space at the University of Toronto Mississauga (UTM) campus was denied just days before the show opened, and we (as curators, in discussion with the artist) were forced to consider an alternative. Subsequently, it was decided to situate the work—nearly 16 feet in length when installed as it was intended in the gallery—folded in a tidy bundle before a photograph of the Blackwood staff holding it in the outdoor space where it was to be hung.

Reeves's *The Mother* was meant to give us respite from our quest to be the perfect parent, partner, or artist by itself taking on the role as the perfect thing. Nevertheless, no single object (or person) can bear the level of responsibility that we as a public are demanding from *The Mother*. Its failure to be actualized presented us with the opportunity to highlight the ways in which we must ask for help. Instead of holding us up, we had to find a way to hold it. Although it was not possible to present *The Mother* the way that Reeves designed it, we believe we still found a way to honour the spirit of the work and the care that Reeves put into its making.

Responding to their own question "Does your gallery, museum, conference center, or festival provide Childcare?" posed by their 2015 work *And Everything Else,* Home Affairs' designed *Artsit* (2017), an assistive device for use by families and caregivers in museum and gallery settings. Based on conversations with parents and gallery and museum personnel, Home Affairs' (Arzu Ozkal, Claudia Pederson, and Nanette Yannuzzi in collaboration with Ozlem Ozkal) prototype offers a possible solution to expand access to those who may be otherwise disinclined to bring their children to a museum. Home Affairs' design considers the needs of families holistically, allowing parents and children the opportunity to experience an exhibition in a way that considers their comfort. For the EFA exhibition, the group produced a series of thank you letters in their work, *Award Letter #1 and #2,* which were sent to institutions (galleries, residency projects, and programs) that support families financially or otherwise—lauding those who are providing access rather than pointing a critical finger at those who do not.

Similarly, Cevan Castle, of The Center for Parenting Artists, proposed a design-oriented solution for families who use the UTM campus. Beginning her project *Map of Family Spaces on Campus* (2017) by conducting informational interviews in collaboration with the UTM Family Care Office and canvassing members of the UTM campus, Castle's developed temporary signage, based on the American Institute of Graphic Arts' universal symbols, to install at select public locations on campus. It affirmed the presence of families on campus and identified spaces that families can access for practicalities like breast-feeding and pumping.

The *Wages for Housework* movement is a major reference point for Jacqueline Hoàng Nguyễn's contribution.[2] Nguyễn's *The Wages Due Song* (2015) and Leisure's (Meredith Carruthers and Susannah Wesley) installation *Conversation with Magic Forms* (2015-2016) work through historic precedents of feminist calls to action and attempts to see where new shifts in the politics of gendered labour and social reproduction can occur. Nguyễn's work draws on archival research on the Wages Due Lesbian Collective, a women-run collective of socialist feminists who worked as an extension of the international wages for housework movement. While digging through the archives, Nguyễn discovered a songbook of feminist protest songs written by Wages Due founder Boo Watson and began a process of intergenerational dialogue.

Likewise, Leisure's work investigates the studio practices of Barbara Hepworth, a U.K. sculptor and mother of four, including triplets, who integrated family life into her studio in the St. Ives artist colony. Interestingly, Hepworth's model for playfulness in children and in the studio had a secondary effect, living on in the work of her son, Simon Nicholson. In the 1970s, he penned *The Theory of Loose Parts*, a child-led learning theory, which argues that environments with a large number of variables and moveable parts foster greater creativity, inventiveness, and discovery.

Shane Aslan Selzer's work, *Horizonline: Gowanus* (2013-2016), and Dillon de Give's performance, first *By My Own Admission* and now, *By Our Own Admission* (2016-2017), make visible the tensions between being a parent and an artist. Selzer's work speaks to the isolation she felt as a parent and gives the viewer a sense of her claustrophobia via the soundtrack created with her infant son. De Give's work was originally performed as a staging of his nightly bedtime routine with his two-and-a-half-year-old son, Peregrin, within a gallery space. Conceived as a way to combine childcare with artistic duties, de Give made apparent the juggling of performing the everyday labour of caring for a child (which, as primary caregiver, is a way he tangibly contributes to the economy of his household) with acting as an artist. For *The Let Down Reflex* at the Blackwood Gallery, de Give invited parents and caretakers to discuss the details of their bedtime routines in front of a live audience, allowing for catharsis, information sharing, and a sense of community.

In *Kids at a Noise Show* (2016), LoVid (Tali Hinkus and Kyle Lapidus) combed through their archives to assess the ingredients of art spaces and institutions that welcomed them as artist-parents. The resulting video work includes interviews with artists, curators, and administrators they worked with since the birth of their three children, highlighting the ways in which they were able to integrate their family and their professional commitments. At both the Agnes Etherington Art Centre and the Blackwood Gallery, LoVid also presented *House-Hold*, a live performance done in collaboration with their three children, in which the family improvises a set of arresting visuals and sonic displays.

Finally, Shani K Parsons's carefully curated video program brought together the work of all types of parents in the art world, with special attention to those less visible. In her own words, the chosen works

reside at the "intersections between motherhood and artistic practice as they relate to issues and themes of care" (Parsons).

The Let Down Reflex as Policy

There are a plethora of ways that the art world can become a better reflection of the world we want to see, and it is up to us as artists and cultural workers to continue to push towards a collective and always-shifting utopia. On a practical level, it is possible to urge the spaces we work with to offer childcare both to artists that they are working with and to visitors. When childcare does not factor into the budget, there are still steps we can take in the immediate present and for the future, including proposing a set of guidelines or best practices and writing childcare into future budgets (Mother's Rights). If our funders do not know that childcare is a priority, then it is up to us to let them know in our applications and in our feedback.

Although we recognize that parenting in the art world affects mothers and fathers, mothers are disproportionately affected ("The Gender Pay Gap"). Addressing this matter of accessibility is, of course, beneficial for everyone; when more people can attend something because of a lack of barriers, institutions have more robust and diverse visitor demographics. If we start to see families integrated more fully into the events and programs at cultural organizations, it is possible to imagine how it might precipitate a trickle-up effect. The increased visibility and acceptance of women with children in these spaces will create a pathway for more great art by women, more women with gallery representation, more women in museum shows and collections, and more women in the annals of art history. Although *The Let Down Reflex* targets changes at an institutional level and urges individuals to push hard for these shifts, it also advocates for change at a policy and governmental level. For example we need to look at exclusion from residency programs based on parental status as an issue of workplace discrimination or human rights discrimination. Simply put, we need to value artwork as labour. Beyond this, we need to make governments accountable to all parents, not just parents with lucrative nine-to-five jobs where parental leave is built in and where access to said leave is simplified. Artists and cultural workers are often self-employed, or contract workers, or underemployed, or students, and even in countries

with strong legislation around parental leave, these types of workers seem to fall through the cracks. That artists, who are professionals with advanced degrees, should produce their work as largely uncompensated or undercompensated labour is what throws the issue of parenting and care work in this particular industry into such high relief, making the art world a uniquely challenging place for those with families. Even though workers in other industries also face discrimination and struggle towards a livable wage, artists and culture workers face the particular challenge of maintaining financial solvency and striving towards security within an economic system that expects prestige and opportunity to pass as a form of currency. But families cannot eat accolades.

We model our protocols on the writings, ideologies, and efforts of several key writers. The essays in Victoria Law and China Martens's 2012 book *Don't Leave Your Friends Behind: Concrete Ways to Support Families in Social Justice Movements and Communities*, for example, give voice to activists' experiences and struggles of remaining a part of their community after parenting and caretaking responsibilities take hold. The writings of Silvia Federici as well as from the Wages for Housework movement are also influential to the way we consider care work as labour and as essential to cultural production. We are moved, too, by the work of Christa Donner and the Cultural ReProducers, a community organization with a mandate to help make "the art world a more inclusive and interesting place by supporting arts professionals raising kids." (Donner) In addition to offering a digital platform for parent-artists to connect and update each other on relevant opportunities, Cultural ReProducers has written a manifesto and a set of demands for institutions to expand access for families and parents. Their guidelines state that events should be interesting and relevant to arts professionals as well as child friendly and accessible in terms of scheduling and cost. In our continuing work on *The Let Down Reflex*, we have discovered the work of others who were thinking along similar lines. Following the end of her maternity leave, the managing editor of canadianart.ca Leah Sandals began an informal panel series that spoke to many of the same themes we were exploring with *The Let Down Reflex*. Through her writing, we learned of new initiatives at the Ottawa Art Gallery to promote more inclusive space for families, thanks to the efforts of Stephanie Nadeau, the Ottawa Art Gallery's curator of public engagement.

We encourage better inclusion for everyone, regardless of parental status. Furthermore, as Victoria Law and China Martens write, "we have heard, time and again, about the many ways that race, gender, class, geography, custody agreements, and health, among other factors, impact families and children. Not all groups of parents struggle equally" (2). Accommodations must be flexible and adaptive in order to meet the needs of changing communities. Carry this concept to artist-run culture and the idea that we must update our tactics to create more inclusive spaces still resonates. It is hard to make space, but it is crucial. When asked, "Why should I care? I don't have children," we should remember who founded art spaces and who maintains leadership positions in these institutions and what needs to change to shift these organizations into the future—meaning, we need to start asking if everyone is at the table (Law and Martens 9, 62).

The Let Down Reflex as Action

Although progress has been slow and inconsistent, there has been some institutional headway in thinking through these questions, with a handful of diversity and inclusion programs in North America addressing the engagement of parents and families in cultural programs ("Next Practices in Diversity and Inclusion"). While providing access is critical, we still need to make a radical pivot in developing the methods by which audiences are engaged once they arrive. Are families showing up to a sponsored museum event so that parents can watch their children make crafts in a sequestered space? Or is the engagement of children and families considered holistically and carefully, allowing for the fullest encounter with the venue's offerings?

The outreach model programs that museums and cultural spaces use to distill and cloister child-led experiences tends to limit the influence and status of children and families. Children and those who care for them are rarely able to take possession of cultural spaces as primary audiences—places where their desires, needs, and intellectual and physical exploration of the space are prioritized and where they are given the opportunity to be true participants. One notable exception to this standard was Palle Nielsen's *The Model – The Model for a Qualitative Society,* which unfolded over a three-week period at the Moderna Museet in Stockholm in the fall of 1968.

In the book *Palle Nielsen: The Model—A Model for a Qualitative Society* (1968), Lars Bang Larsen describes an exhibition that was "nothing short of a mass utopia of art activism, aimed at applying an anti-elitist concept of art for the creation of a collectivist human being" (31-32). *The Model* was an adventure playground designed specifically for the Moderna Museet space; an anarchic environment where anyone (mostly children) could play, paint on, arrange, and rearrange, build upon, or destroy various movable elements in the space. Similar to Simon Nicholson's theory of loose parts, Nielsen's *The Model* gave its mostly young participants the freedom to design their own experience and to adjust the hallowed space of the museum to suit their peripatetic activity and agenda. The exhibition demonstrated the process and aesthetics of change through play and turned what many may consider to be meaningless dabbling into an intentional and powerful trans-formation of a major cultural institution. The project was part socially engaged art experiment and part institutional critique; it was wildly popular during its short run.

Today, it seems that cultural institutions are very wary of litigation. It seems unlikely that one could encounter a museum that would expose itself to the liability risk posed by hosting crowds of families—with access to building supplies and tools, and the ability to climb and build potentially unsteady structures as they did in *The Model*. As we push for creating inclusive programs for families and devising fair institutional policies that will govern how audiences and staff members move with and through our cultural spaces, can we work with and within these institutions to implement realistic and sustainable guide-lines? How can we train arts administrators to be effective shepherds of these spaces and groom curators to think more broadly about modes of presentation for varied audiences? These questions of designing spaces for a more feminist future—critical spaces, adaptable spaces, and spaces that allow for the greatest accessibility—drive our imag-ination for a cultural utopia.

As curators of *The Let Down Reflex*, we felt strongly that engaging with the concept of accessibility in the art world must be done with a commitment to openness. Inviting artists to create closed-loop blueprints or templates for (feminist) futures seemed antithetical to our project and undermined the potential for our own personal growth along the way. In our opinion, many of the projects that made up *The*

Let Down Reflex exhibition embodied the spirit of utopian methodology. This is particularly evident when considering the panel organized by Jacqueline Hoàng Nguyễn for the exhibition. Set-up as an open-forum, *Wah-wah, shh, chomp, munch, nom, burp, poot, slurp, yum, toot, mwah. But who's holding the baby?* also featured Christa Donner, Marisa Morán Jahn, and Maiko Tanaka. Of the invited speakers, only Christa Donner's professional practice centres on families and children in the art world. Morán Jahn is an artist who focuses on improving conditions for domestic workers in the U.S., and Maiko Tanaka is a curator who worked on the Grand Domestic Revolution Handbook—"a compendium of living research developed by artists, designers, theorists, neighbors, and activists who investigate and expand the status of the home outside the narrow lens of private concerns," from 2010 to 2103 (Binna Tanaka). Although anyone could propose a working group, four themes were set out to guide the discussion: *who cares?* led by Nguyễn; *reimagining arts institutions in an age of cultural reproduction*, led by Donner; *designing for fair care*, led by Morán Jahn; and *collective cooking across cultural difference*, led by Tanaka.

LoVid's proposal for the exhibition perhaps most effectively challenged our project through their sheer refusal to engage with our terms. We had asked them to put together a proposal that spoke to the challenges of being a parent in the art world, and what we received in return was a love letter to everyone in their community who had made being an artist-parent possible for them and their family. LoVid's unwillingness to limit their narrative to the framework we proposed widened our way of seeing and allowed us to push the exhibition discussion further.

Our project is based on an intersectional understanding of feminism—the ways in which gender intersects with race, class, ability, parental status, and a myriad of other factors affecting personal experiences. We recognize that there is no simple solution, and no single action will make the art world more accessible to everyone. Rather, access needs to be constantly reevaluated, opened up, and occasionally radically reassessed in order to truly effectuate changes. As curators, we take this to mean that *The Let Down Reflex* is a project in flux that is open to criticism and to new ways of thinking. Mounting the exhibition is not the end of the discussion for us.

Feminism embodies hopefulness within its framework; this is evidenced in the ways in which feminist proponents have struggled for and achieved successes in changing the current systems. Although feminist theory has not always been able to articulate its desire beyond its present struggle, there has always been permission inherent to feminist systems that allows for critiquing certain blind of its spots for maximum success. In her book *Mothernism,* Lise Haller Baggesen quotes Anohni (known, at the time, as Antony Hegarty) speaking about the Future Feminism Foundation, and the general sense that feminism is no longer necessary because some women have reached economic parity with men. The Future Feminist Foundation collectively advocates that "Future Feminism requires the participation of all people" and for "feminine systems in all areas of governance"[3] (Grassley; Sturges; Adams). Anohni states economic parity should not be "the climax of feminism." They continued: "It's like gay rights, as if gay marriage is the end point, as if we just want to be included in these business-as-usual institutions. That's not the point of being queer, just as mitigated reproductive rights aren't the point of being a woman" (qtd. in Baggesen 35). Feminism, therefore, needs to always being pushing just past the imagined future. Feminism is emancipatory—for everyone.

The next time that you go to an artist talk, attend a gallery opening, or visit a museum, take five minutes to ask, "Who's here?" "What is the quality of their engagement?" Even though providing access is critical, we must also develop methods by which audiences are engaged once they arrive. At this moment of reclaiming and owning feminist identities in all of their possible variations, it is a matter of urgency for anyone invested in feminist futures to stand up and build supports for mothers, parents, and families of all stripes.

Endnotes

1. The disco refers back to a chapter in Baggesen's book *Mothernism* (2014), in which she develops an argument for disco maternalism(s) and queer historicity (77-86).

2. The Italy-based *International Feminist Collective* spawned the *International Wages for Housework* campaign in 1972—a historical movement that addressed the effects of unpaid, unrecognized

reproductive labour and which advocated for redress in attempt to end capitalism. The organization was founded by Selma James, Brigitte Galtier, Mariarosa Dalla Costa, and Silvia Federici.

3. The Future Feminist is a loose body formed by Anohni as well as Laurie Anderson, Marina Abramovic, Terence Koh, Lydia Lunch, Lorraine O'Grady, Narcissister, Viva Ruiz, Carolee Schneemann, Kiki Smith, and Kembra Pfahler, among others.

Works Cited

"10 Things That Make Sweden Family-Friendly." *Sweden.se*, Government of Sweden, 21 June 2016, sweden.se/society/10-things-that-make-sweden-family-friendly/. Accessed 10 Aug. 2019.

Adams, Tim. "Antony Hegarty: 'We Need More Oestrogen-Based Thinking.'" *The Guardian*. 20 May 2012, www.theguardian.com/music/2012/may/20/antony-hegarty-interview-meltdown-gender. Accessed 10 Aug. 2019.

Baggesen, Lise Haller. *Mothernism*. Green Lantern Press, 2014.

Berson, Amber, and Juliana Driever. "May 2016/The Let Down Reflex: Part 1." *M / Other Voices*. 29 Aug. 2016, www.mothervoices.org/column/2016/5/7/may-2016-the-let-down-reflex-part-1. Accessed 10 Aug. 2019.

Binna, Choi, and Maiko Tanaka. *The Grand Domestic Revolution Handbook*. Anagram Books, 2014.

Donner, Christa. "Cultural Reproducers Event Guidelines." *Cultural Re/Producers*, 21 Mar. 2016, www.culturalreproducers.org/p/about.html. Accessed 10 Aug. 2019.

Donoghue, Deirdre. "The Let Down Reflex." *M / Other Voices*. M / Other Voices, 7 May 2016, www.mothervoices.org/news/2016/5/7/the-let-down-reflex. Accessed 10 Aug. 2019.

Grassley, Tanya Kim. "Turning The Tides." *The Forumist*. 10 Nov. 2014, theforumist.com/turning-the-tides/. Accessed 10 Aug. 2019.

Larsen, Lars Bang. *Palle Nielsen: The Model—A Model for a Qualitative Society (1968)*. Museu D'Art Contemporani de Barcelona, 2010.

Law, Victoria and China Martens Eds. *Don't Leave Your Friends Behind: Concrete Ways to Support Families in Social Justice Movements and Communities*. PM Press, 2012.

Maranda, Michael. "Waging Culture | Hill Strategies." *Home | Hill Strategies*, www.hillstrategies.com/content/waging-culture. Accessed 10 Aug. 2019.

"Next Practices in Diversity and Inclusion." *Association of Art Museum Directors*. Association of Art Museum Directors, Aug. 2016, aamd. org/sites/default/files/document/050916-AAMDNextPractices Div-Incl.pdf. Accessed 10 Aug. 2019.

Nicholson, Simon. "The Theory of Loose Parts. An Important Principle for Design Methodology." *Studies in Design Education Craft & Technology*, vol. 4, no. 2, 1972.

Parsons, Shani. "Love's Labours A moving image program curated by Shani K Parsons." 28 Oct. 2017, blackwoodgallery.ca/exhibitions /2017/TakeCareC2_LetDownReflex.html. Accessed 10 Aug. 2019.

Reilly, M. "What Is Curatorial Activism?" *Art News*, 8 Nov. 2017, www.artnews.com/2017/11/07/what-is-curatorial-activism/. Accessed 10 Aug. 2019.

Sandals, Leah. "6 Questions About Art & Parenthood." *Canadian Art*. 7 Jan. 2016, canadianart.ca/features/6-questions-about-art-parenthood/. Accessed 10 Aug. 2019.

Sturges, Fiona. "Antony Hegarty: 'It Takes Nerve to Get through Your Sense of Shame on Stage.'" *The Independent*, 14 July 2012, www. independent.co.uk/news/people/profiles/antony-hegarty-it-takes-nerve-to-get-through-your-sense-of-shame-on-stage-7939045. html. Accessed 10 Aug. 2019.

"The Gender Pay Gap." *The Economist*. 7 Oct. 2017, www.economist. com/news/international/21729993-women-still-earn-lot-less-men-despite-decades-equal-pay-laws-why-gender. Accessed 10 Aug. 2019.

Chapter Seventeen

The Body in Letters: Once Again, Through Time and Space

Rachel Epp Buller, Lena Šimić, and
Emily Underwood-Lee

The following text traces the beginnings of a transcontinental epistolary exchange between three women who identify as artists, writers, and mothers. Although we each find ourselves drawn to letters for personal reasons, we acknowledge that our exchange operates within a lengthy history of feminist thinking through correspondences and epistolary experiments. Early suffragists in the U.S. and across Europe developed and strengthened their platforms by sharing ideas back and forth with feminist sisters near and far (Fillard and Orazi). Letters proved a pivotal means of communication during the second wave for English-speaking feminists on both sides of the Atlantic: archives give witness to feminist epistles as a place for processing both the personal and the political (Jolly). For two years beginning in 1975, a group of English female artists, seeking solidarity, mailed each other small artworks as a way of reaching out and finding connections. What came to be known alternately as Feministo, Postal Art Event, or Portrait of the Artist as a Young Woman/Housewife functioned as a kind of epistolary consciousness-raising group. In a time before digital connectivity, these letters offered a system of support and encouragement as well as a way of processing difficult ideas and shared experiences (Tobin). In 1981, London/LA Lab paired artists from the two cities in a cross-continental exchange of words, stories,

and performance. As digital communication has overtaken handwritten missives in recent decades, mail art collaborations and exchanges of all sorts have proliferated, perhaps a nostalgic longing for earlier times.

Part of our shared interest in letters involves intentionally choosing the epistolary format as a site for intellectual exchange. Andrew Berardini posits that "All writing to be read by someone else is a kind of letter. One person writing to another. From me to you." Yet the particulars of the letter form and its mode of relational address allow for a blurring of authorial voices and a possible flattening of hierarchy within the academy. Nearly two decades ago, Anne Bower argued for letters as a better form of scholarly exchange than academic articles because letter writing has the potential to shift our relationship to our material—and to each other—and to offer greater opportunities for intimacy and engagement. As we consider together various inappropriate bodies, implicit in our discussions are long-standing accepted conventions of academic writing and the ways in which feminist writers have intervened in recent decades, using inappropriately informal or personal voices and methodologies. We approach the letter form as one in which deep listening and genuine care offer radical possibilities for transforming academic writing and relationships inside and outside of the academy. We assert commonality between the rhythms of epistolary time and maternal time—the extended time needed for giving and receiving care through our words and through our bodies. The materiality of the epistolary exchange offers tangible evidence of these caring labours.

Dear Lena and Emily,

I remember as a child reading about the idea of round-robin letters among groups of friends who lived far apart. One person wrote a letter to the group and mailed it to one friend, and then that friend wrote a letter of her own to send along with the first one to the next friend, and so on so that the final recipient received several letters all at once, before beginning the process again. The round-robin form facilitates an ongoing conversation across time and space, a way of sharing both everyday news and deeply felt emotions.

As I've engaged in letter writing in my own practice, I've been thinking about how this format might allow us to wrestle with some ideas—the lag times allowing us to sit with each other's thoughts and then to build on ideas through a series of rotating exchanges.

As you know, the handwritten element is also important to me. I think of letters I have received over the years and how I immediately recognize some writers by their script when their letters arrive in the mailbox. And so there is that physical trace of the person and, thus, an emotional connection to the object. But there is also the element of care inherent in the handwritten letter—the time that it takes to sit down, to slow down, to take time, and to take care.

In her book *In Love and Struggle,* on feminist correspondences of the second-wave movement, Margaretta Jolly sees in their letters an attempt to make and extend community and to facilitate mutual care. She argues that their letters reveal that "feminism encouraged women to feel that they had a 'right' to be cared for" (18).

Yet as I consider this project exploring inappropriate bodies in art and design, I wonder about the ways in which such caring bodies, such feminist actions, and such gestures of maternal care, have been side-lined. Maybe you've read Helena Reckitt's essay "Forgotten Relations"? She articulates so well how Bourriaud conveniently managed to omit, or even negate, the feminist precedents for relational aesthetics. What were the maintenance art actions by Mierle Laderman Ukeles, after all, if not attentions to relations and relations of care in particular?

And I think of the letter-writing body performing this seemingly antiquated action. Is it perceived to be inappropriate as well? Old-fashioned and out of touch? Given our contemporary obsession with instantaneous response, might letter writing be an act of resistance? The care of letter writing as a radical political act?

With fond wishes—

Rachel

Thank you for the letter, Rachel—Emily, these are now addressed to you. I managed to fight my desire to email you both and announce that I have received the letter. This feels better, more secretive, more engaged. I found this piece of paper in my bag—it's finally found its purpose.

The only person I write letters to is Zöe Svendsen. Zöe and I met in Helsinki in 2006; we were both PhD students and delivered our first papers. Somehow it happened that we became letter writers. She wrote me a letter for the revolution back in 2009, for me to use in my autobiographical solo performance "Masha Serghyeevna." This feels different, more slow, less active, more careful, less bombastic. This is about picking up the garbage after the revolution, as Ukeles would have it.

Rachel, you ask us to sit with each other's thoughts; you wonder about inappropriate bodies and old-fashioned and out-of-touch practices, which makes me remember Lisa Baraitser's Skype keynote for the Mothernists II symposium in Copenhagen where we first decided to do this. Lisa talked about outdated practices, things we keep on doing even when they are no longer "in." Maternal art is so "in" at the moment, but there's a kind of saturation with it as well. It needs to "move" towards something else. We are stuck in the idea of progress.

Lena

Dear Rachel (+ Lena when you read this),

It was thrilling to receive your letters. I opened them at my kitchen table and read in a great hurry while the children ate and played around me. For me, the form of the letter is akin to time travel. I imagine the journeys your letters took to reach me—the time you wrote them made present here in my kitchen. I project myself forward to the time you will open and read this—somewhere far away, perhaps different to this dark, wet, Welsh night surrounded by comforting domestic chaos or perhaps very similar.

I think about the proposition you made, Rachel, that letter writing slows down time, allows lag and contemplation. Yes, time is slow now. (I had to wait until I had time on my own to write this, and I take my time, take care with my words.) Your words stay with me through time. But time is also crushed as I read these letters and I imagine myself with you Rachel on 9 November and with Lena on 16 November. I call to mind the generations of letter writing women evoked by you, Rachel, in your work on the history of letters by women and girls. I think of the bodies of all these women—the way their hands held pens

and wrote letters as a gesture towards home or to reach out of their domestic confinement.

Is an inappropriate body sometimes simply a body out of place or out of time, away from the familiarity of the here and now?

Yours, Emily

Dear Lena and Emily,

What a joy to receive your packet of letters! I think in traditional round-robin format, the original sender takes out her letter and inserts a new one, but I think I will just add mine to the pile and we can continue on this way, sitting with each other's words and revisiting things as we wish.

Lena, the paper you used was fantastic. What if I divided all of my lists into these categories—must, should, could, would like to? Where would I find the overlap? Would I make time for things differently? How telling that the categories of "could do" and "would like to do" included so little about family: not that they don't make the list, but their needs tend to be so much more urgent. (Or at least we perceive them that way.)

Do you really think that maternal art is "in" at the moment? Sometimes I think so, but then I wonder if I'm just in a little bubble that is disconnected from the real art world where it's still inappropriate. It also seems that when maternity comes into vogue, in art or elsewhere, it often circulates around the mother's body, and sometimes includes a baby. I'd be interested to know from your experience, Lena, how it has been working with your children as they grow, or, rather, what you've noticed of perceptions. Are children and youth also inappropriate bodies? Are they too old to be cute and too young to be taken seriously, or does their youth lend cachet instead? How do they enter in to art discussions and how do they change the ways in which you choose to engage?

I appreciate seeing you both through your script—the way that you form letters, the pens you choose for writing, etc. I suppose those choices tell us something about each other as well. Like you, Emily, I too imagine the generations of letter writers and what their scripts and their bodies might tell us of their stories.

I'm drawn to your suggestion, Emily, that an inappropriate body might simply be a body out of place or time. It makes me think of the Silvia Federici pamphlet of essays we received in Copenhagen. She writes of the dula (or doula) as a vital part of the reproductive justice movement, a nod to the role of communities of women in the past but one that could help transform contemporary society. And there is so much in her writings about collective, communal, or cooperative structures—common in days gone by and now inappropriate by capitalist standards. But, as she writes, they are "essential to a reorganization of our everyday life and the creation of non-exploitative social relations" (19). Maybe it's an imperative to look to those bodies that are out of time and place to help us figure out the ways forward.

Rachel

A Croatian photographer Mara Bratoš made some beautiful images of teenagers in their rooms, possibly on their bed, sitting awkwardly. The series was called "Porteti I," and it dates to mid-90s, I believe. Mara was also young back then; she's my age, 43 at the moment. I remember encountering her work in a catalogue in our Dubrovnik Museum of Modern Art last January—reencountering the images that I saw years ago. I knew the people she photographed, one boy in particular: youth, fragility, confidence, and such beauty—something lost right now in 2018. He's also in his early forties now, time past. When I saw these photographs of these young people, these frail and awkward and gorgeous bodies, I thought I need to do this—photograph my teenagers sitting at the edge of their beds, unmade, now in 2018, in their environment, context, world. Just ask them to sit and capture a moment. Of course the result won't be an artistic photograph to be featured in an artist catalogue, but it would be a moment taken from this time. "Sit on the bed." "Pose." A kind of performance of vulnerability, staged and enacted with a dose of youthful confidence. "Look straight into the camera." Snap. Seductive as well, inviting, yet so contained, within a frame of an encounter and a photograph. With my Institute[1] children, as time passes, activities and performances differ. My Sid who is 10 is still the perfect age for the Institute. He's willing to participate in art events and discussions—he requested it specifically for 2018, at our annual AGM (Annual General Meeting).

The older boys are more politicized—they embody and carry some of the Institute ideology but not too keen to participate. Not always. To them, it doesn't really matter to be in an art context—why bother? They are building their own worlds, exiting ours, at least the Institute version of our family world. I do find children more readily acceptable (seen as risk takers, challenging, queer even) within the art context. Mothers are probably more boring—"There she goes again with her mother art." Yes, maybe we are framed in our own little bubble, as you say Rachel, but there's something trendy about maternal art, in the U.K., at least. There's a kind of explosion and not necessarily alternative art production only but conforming with the art market. In Croatia, Mara Bratoš, the photographer I mentioned, a celebrity artist now actually, just had an exhibition of her pregnancy photographs—a huge success in terms of popular appeal, a celebrity event. We keep on building communities and networks. As part of Family Activist Network (FAN), I received an email today in which one member writes about another: "I always remember how much Ana cares for pregnant FAN mamas and those breastfeeding. She will always hang back and offer her maternal wisdom—another form of paying attention from the knowing position of how hard it is to 'act' when you are creating life, when you are nourishing new life." I need to let go of creating a new life at forty-three, of my teenagers as children. My inappropriate body out of time and place is an old photograph of a teenage boy, confident, awkward, beautiful.

Lena x

Dear Rachel and Lena,

Your letters arrived, and I picked them up when I got home from work, all flustered, at bedtime, and surrounded by children who did not want to sleep. One child asked me to read the letter to her. I did. She cut me off. "Mommy—is this you talking about feminism AGAIN?" Another member of my family, when hearing of my latest publication said "Is she banging on about motherhood AGAIN?" This "again" that keeps coming up makes me wonder—why is doing something for a prolonged period, doing something in depth, thinking, processing and rethinking such a problem? This letter writing project forces us to slow down, to stay with it, to endure, and to wait.

I have recently been thinking about Kristeva's Women's Time (1981) in order to develop another piece of writing that I am working on with Lena. Much of Kristeva's argument can be applied to the way the maternal shifts time, and I experience these letters in the same way. I send writing away, and writing comes back to me. Things are slowed, and I can enjoy repetition.

I enjoy the routine of my mothering—the same walk to school, five days a week, thirty-nine weeks a year. Through the repetition, I notice changes. My eldest used to run tree to tree, stopping by each one, each step marking the distance it was safe for her to stray; now she walks behind me chatting to friends we pick up along the way or holds my hands and talks about the day ahead.

Doing this walk again and again is so valuable. Reading your writing again is such a pleasure. I do not want to reject "AGAIN." Let us remain with "repetition" and "eternity." Let us resist the drive to the "new" as Kristeva suggests.

Yours, Emily

Dear Lena and Emily,

Our packet of letters is getting thicker, and I find that I read them all again when they arrive. Rilke writes about that tendency, and it comes up often in my reading—both fiction and nonfiction—about letters. What is it about letters that so invites us to revisit them? Some of it, I think, must be the materiality, the particular paper and handwriting that draw us in and help us feel close to the person. But while the materiality gives pleasure, I think the reason for rereading is more nebulous. Maybe it's an attempt to reexperience certain emotions— the initial surprise and anticipation upon receiving the letter or the pleasure taken at reading words so specifically addressed to us. Sometimes, I find, my first excited read of a letter is so quick as to be almost cursory, so rereading is when I slow down and take time with the words—an act of care in the revisiting.

And this revisiting, this intentional repetition, reminds of your "again," Emily. I wonder what, exactly, is perceived as tiresome, even inappropriate, about sitting with an idea or focusing on one thing for an extended period. Is it simply that we are supposed to be ever in

search of the new? The cyclical time that Kristeva discusses, the nonlinear quality, feels so resonant of the rhythms and routines of family life and, in some ways, of academic work life as well. I find comfort in these rhythms, and I well recall the cyclical patterns of routines when my children were small. The anticipation of regularly recurring events, as well as the slowed-down time, not rushing about but adapting to a child's pace, taking time to time care, as in letter writing—this is what I think of as maternal time. And then I think of how children seek out repetition—reading favorite books hundreds of times out loud—why, indeed, would we reject this "again"? Yes, let us remain with repetition.

This maternal time becomes more difficult to sustain, though, as our children age. As you say Lena, they are building their own worlds. And so many of their experiences focus on linear progression—moving from one grade to the next or reaching milestone birthdays. I see clearly how their growing has appeared to speed up exponentially since they entered the linear time of school. I sometimes long for the days before, not only for when they were small but for when we experienced time together differently. The teenager photographs that you describe, Lena, I imagine them as powerful in part because they capture a momentary slowing down in what is otherwise a rapid linear movement of growing and getting ready to leave. Maybe melancholic, prematurely nostalgic, for both child and parent?

I recently reread Sara Ruddick's *Maternal Thinking*, where she writes of it as "a discipline in attentive love" (123)—the gifts of attention and listening, which are both sustained and repetitive, durational practices. She also writes that "women's and mothers' voices have been silenced, their thinking distorted and sentimentalized. Hence it will take sustained political and intellectual effort before maternal thinking is truly heard" (127). This is also part of the "again," that we must be persistent to combat easy dismissal. Our insistence upon maternal time and maternal thinking and upon care and attention and repetition and listening becomes a political act, an act of resistance.

Yours, in solidarity—

Rachel

Dear Emily and Rachel,

I'm such a sucker for the new. I run on energy that's raw and exciting. I love it when I am learning, figuring things out, failing even, but finding out—WHAT'S THIS NEW LAND OF KNOWLEDGE, of context? I have that terrible colonial conquest instinct—MAP IT OUT, ORGANIZE. I dread AGAIN and REPETITION. I loved your letters; they were poetic and declamatory, making sense, calling for a different sensibility, and theoretically I agree with you, but I can't. I'm out. I can't stand rereading the same old picture books I read to Neal who is now seventeen, to James, who is now four. I've had it with farm animals, and Alfie and Annie-Rose and Petra and other baa-baa, moo-moo, diggers, tractors, firemen, and fish! I can't slow down for James. I run with him and encourage his nuclear flow, his momentum, his mania in our household. I worry about it as well, but I've had enough of being this patient slow caring mother-creature. Of course there are four other bodies/energies in our household who also impact on our youngest. I read your letters, and they encouraged me to slow down, with James. We had a lovely morning in town—went to the independent bookstore News from Nowhere where I got this card, especially for you two, and James got a postcard as well with a woman skater jumping across some rugged landscape in Afghanistan. I will keep it for him on our Institute wall. James chose his postcard. We read a story. We went to two shops. We were a little perfect mother-son unit in our independent Bold Street in Liverpool—almost a picture book. Lovely Saturday morning, but it was an effort as well. I feel my proper maternal time is with my eldest and his needs as a teenager. It's almost as if my mothering is in tune with my two older teenagers, their needs and demands. Little ones are neglected, somehow carried along the way, as if by accident. And yet, they will be fine, with less mothering pressure upon them.

Lena x

Dear Rachel and Lena,

I recently heard about a project. A group of women, who went to school together, bought a notebook. They wrote an entry in it and then sent it to another member of the group who did the same. When the last page of the book was filled, it was the responsibility of the person who had it at that time to keep the book safe, buy another, and start the process again. They kept this going for over fifty years. The formation of the group changed over time as the women's lives took different paths. New women were invited to join—either school alumni or former teachers.

I was told about this by a friend who had attended a talk by one of the women's offspring (daughter or granddaughter, I think). This new woman was in the process of trying to find and reunite all the original books. I'm not sure of the dates, but I got the impression the original writers are now long dead. I have tried searching the literature to find anything about this but don't have enough details and have been unsuccessful. I don't know if anything has even been published. I don't really mind—the idea is appealing to me, even if I have got the details wrong.

As I look over our previous letters I come back to my thoughts about letters moving away from their original writer's bodies.

Again I think of you both, geographically separate but present with me as I write this. I wonder if letter writing invokes the body even after death? In my thinking of those notebook-writing women, am I somehow invoking their ghosts even though I don't know their names, the specifics of their lives, or if they ever existed?

I think of my kids' letters to Father Christmas. He has no body (he is not real!), so we are unable to post letters to him. Instead, we send the letters up the chimney by throwing them in the fire and watching them burn. This act takes us through so many referents without originals—a letter burnt to a man who does not exist. It is something like notebooks evoked in my third hand accounts.

Are these letters without bodies (inappropriate or otherwise)?

With love,

Emily

Endnote

1. This refers to the artist's Institute for the Art and Practice of Dissent at Home, founded in 2007. https://dissentathome.org/

Works Cited

Berardini, Andrew. "The Letter Writer, Frances Stark." *Mousse,* vol. 26, 2010, moussemagazine.it/frances-stark-andrew-berardini- 2010/. Accessed 10 Aug. 2019.

Bower, Anne L. "Dear—: In Search of New (Old) Forms of Critical Address." *Epistolary Histories: Letters, Fiction, Culture*, edited by Amanda Gilroy and W.M. Verhoeven, University Press of Virginia, 2000, pp. 155-75.

Bratoš, Mara. "Portreti I." Exhibition. *Mara Bratos*, www.mara-bratos. hr/hr/izlozbe/portreti-1/. Accessed 10 Aug. 2019.

Federici, Sylvia. "Introduction to *On Reproduction, Intergenerational Solidarity and the Dancing Body.*" *Visuel Arkivering*, vol. 11, Oct. 2017, pp. 3-5.

Fillard, Claudette, and Francoise Orazi, editors. *Exchanges and Correspondence: The Construction of Feminism.* Cambridge Scholars Publishing, 2010.

Jolly, Margaretta. *In Love and Struggle: Letters in Contemporary Feminism.* Columbia University Press, 2008.

Kristeva, Julia. "Women's Time." Translated by Alice Jardine and Harry Blake. *Signs,* vol. 7, no. 1, autumn 1981, pp. 13-35.

Reckitt, Helena. "Forgotten Relations: Feminist Artists and Relational Aesthetics." *Politics in a Glass Case: Feminism, Exhibition Cultures, and Curatorial Transgressions,* edited by Angela Dimitrakaki and Lara Perry, Liverpool University Press, 2015, pp. 131-56.

Rilke, Rainer Maria. *Letters to a Young Poet.* 1934. Translated and with a Foreword by Stephen Mitchell, Vintage Books, 1984.

Ruddick, Sara. *Maternal Thinking: Toward a Politics of Peace.* Ballantine Books, 1989.

Tobin, Amy. "I'll Show You Mine, If You Show Me Yours: Collaboration, Consciousness-Raising and Feminist-Influenced Art in the 1970s." *Tate Papers,* no. 25, spring 2016, www.tate.org.uk/research/publications/tate-papers/25/i-show-you-mine- if-you-show-me-yours. Accessed 10 Aug. 2019.

Ukeles, Mierle Laderman (1969) *Manifesto for Maintenance Art 1969!* Exhibition, *Arnolfini,* www.arnolfini.org.uk/blog/manifesto-for-maintenance-art-1969. Accessed 10 Aug. 2019.

Chapter Eighteen

Maternal Bodies and Collective Action

Natalie Loveless (Canada/USA) in conversation with
Christa Donner (USA), Andrea Francke (England/Peru),
Kim Dhillon (U.K./Canada), and Martina Mullaney
(England/Ireland)

The following was produced in the fall of 2016.

Introduction

Given the recent election in the U.S., it is more important than ever to fight for and protect the greater visibility of minority and nonconforming bodies in our public, pedagogical, and artistic spaces. Since 2010, I've been researching the role of the maternal body in contemporary art. Rather than focusing on art works *about* the maternal body—those offering alternate images, such as Renee Cox's infamous *Yo Mama!* or Catherine Opie's *Self Portrait/ Nursing*—my focus has been on the performing body itself. I am interested in the capacity of the live body to generate collaborative, interventionist, and social practice communities. The art-activist (or, as I have written about elsewhere, the "mamactivist") artists that are gathered together here, though engaging in collaborative, interventionist, and socially oriented practices, have a further distinction that unites them. They all work in a manner congruent with what Irit Rogoff has termed the "pedagogical turn" in the arts (Rogoff et al).

Of course, making fine distinctions between activist art, participatory art, interventionist art, art-as-social-practice, dialogic art, and the

pedagogical turn is the stuff of disciplinary geekiness. Playing with these fine lines, and highlighting distinctive nuances that may help us argue for placement in one category more strongly than another are, part of the joy of the field. But when it comes to the issues at stake on the ground and in people's lives—increasing threats against bodies of colour, nonconforming bodies, and the rights of women over their bodies, sexuality, and capacity to work, vote, and not be constrained to the kitchen and nursery, even when they choose to procreate—the joy of categorical distinction fades. In such a context, I have little at stake in policing the distinctions between genres. The value of understanding these works as pedagogical art interventions is less genre work than an assertion that the pedagogical is of dire necessity right now. When bigotry rises, radical pedagogy, whether institutionalized or extrainstitutional, is often the first to go (Bauhaus) and must be protected. We must rise up, teach in, teach out, and intervene. Other ways of thinking and doing must be modelled and shared. Our capacities to think critically and engage in respectful participatory dissent must be nurtured. Dissent, challenge, and debate must make us all take each other a little more seriously and call each other up to learn and relearn, question and requestion. This must become the renewed norm. Dogma must be challenged. And this is precisely where the artists I have the privilege of speaking with here have focused their practices.

What follows is a critical conversation between me and the founders of *Cultural ReProducers* (Christa Donner), the *Invisible Spaces of Parenthood* (Andrea Francke and Kim Dhillon), and the *Enemies of Good Art* (Martina Mullaney). These collectives each function as organizing nodes and as art interventions in themselves. They intervene in museum institutions and other artistic, pedagogical, and public spaces; they investigate the possibilities of combining art practice and family commitments; they create platforms for exchange; and they organize public discussions and arts-based events that raise awareness and encourage political artistic action regarding the still regularly segregated practices of parenting in contemporary Western cultural and intellectual spaces. And they do this not simply for the mother. The political fabric of the social is what is at stake here.

I tracked each of these artists down and invited them into a group conversation. What follows is an edited version of our exchanges.

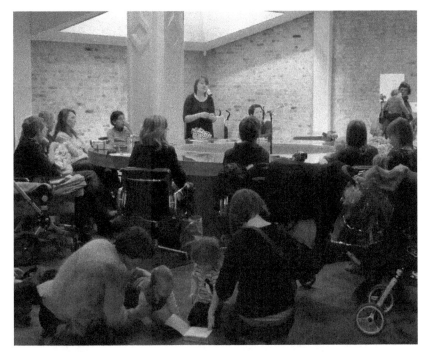

Figure 1. Enemies of Good Art, Whitechapel Gallery Meeting, © Enemies of Good Art 2010.

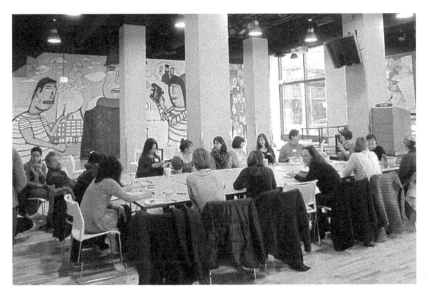

Figure 2. Artists and administrators brainstorm together in the workshop *Making it What We Need*, part of the Cultural ReProducers Childcare-Supported Event Series, 2015 (photo: Andrew Yang).

Figure 3. Andrea Francke, Oscar Francke Coco (her son), and Kaye Egerton (nursery assistant at the University of the Arts London), at the London College of Communication protesting to keep the UAL nursery open during the University and College Union strike action on 27 May 2010.

Loveless: Maternal bodies have been historically configured as inappropriate to the museum and other art establishments. Nursing bodies continue to be shamed in public; female art students are still told that they will never succeed if they become parents; artist residencies—the bread and butter of the independent artist—rarely support families; and openings rarely happen at child-friendly hours. Although the art world is not the only vocational profession that remains, despite the gains of the past forty-odd years of feminist activism, unwelcoming to visible mothers, these issues take a particular form in the art world. Each of you is committed, in one way or another, to maternal interventions into museum institutions and other public spaces. It is a given of each of your practices, as I read them, that the maternal body is a traditionally inappropriate body for the art world, as the mewling and puking infant is seen as a bother to the decorum of high cultural spaces and the labour associated with parenting is seen as antithetical to the production of the artistic and intellectual objects valued by such spaces. That said, even though I am sure that none of you disagree with this assessment of the given norms of the art world, your collective work focuses less on the maternal body as a coherent entity (whether welcomed or abjected) than on the collective practices of what we may call, with a nod to Rosalind Krauss, parenting in the expanded field.

Before discussing the latter, I would like to ask each of you to say a little something about the absence of a specifically maternal body in either the title or framing of your projects.

For a while now, I've argued that claiming the term "maternal," deessentializing and politicizing it, is important both conceptually and practically. As I understand it, the experience, as a feminist artist, of becoming-mother led each of you, in your own ways, to develop projects that ground the maternal as a politics rather than an identity. In this thinking, I take my cue from the feminist philosopher Sara Ruddick, who in *Maternal Thinking* (1989), argues for mothering as a labour practice that any body can inhabit. I know some folks who have taken issue with this tactic—of holding onto and deessentializing the terms of the maternal—because, while it is a position that renders fathers and other caregivers able to step into and claim the maternal as a practice rather than a biological facticity, it nonetheless requires an immense amount of discursive work (work that shifting to the term "parenting" sidesteps). I am curious to have each of you weigh in on this.

Donner *(Cultural ReProducers):* It is a powerful idea to redefine "the maternal' to include a wide range of caregiving roles, and in theory I'm all for it. But we are operating within a deeply entrenched patriarchal system here, and if we want to promote and normalize a diversity of approaches to raising children, I think it makes more sense to use language that's not so loaded by gender and biology. As women, mothers are inherently up against some very specific hurdles when it comes to career and family life whether or not they have ever given birth or nursed a baby. So for me, the distinctions between "motherhood" and "parenthood" are as important as the places where the terms overlap.

Mullaney *(Enemies of Good Art):* When I think about the term "mother," I come to the conclusion that it will continue to be problematic while the role of the mother continues to be denigrated. We can try to redefine "mother" to include other caregiving roles, and, yes, it is vital that we do so, but we cannot escape the fact that (I am speaking here from the U.K.) more women than men continue to perform that role (if looking at traditional caregiving duties carried out in terms of the family and who occupies the role of breadwinner). Women are disadvantaged under patriarchy and capitalism, mothers more so. I believe that it is mothers who suffer most in terms of art careers,

although this is not particular to the art world. In my home, although the mothering work is shared, it remains mostly me who carries the brunt of the labour. The term "mother" is a difficult term to define; I have no answers right now.

Francke *(Invisible Spaces of Parenthood):* Writers such as Andrea O'Reilly talk about mothering and fathering as practices that can be ungendered. Still, as time goes by, motherhood and mothering are becoming really problematic categories for me. I feel that while the mother has become more and more present as a theme and a subject position in the art world (quite drastically in last few years in London at least), it has also transformed itself into a fetishized position that seems to contract solidarity instead of expanding it. I've always aimed for the mother part of me to be allowed into the conversation and the knowledge, feelings, labour, and structural conditions to be acknowledged, but I find it disturbing when it gets taken over as an essentializing identity. I want motherhood to be accepted as a valid position but not the only or main position, especially when it gets used to construct ideas about what a woman is. I like the terms mobilized by this volume (*Inappropriate Bodies*) because it reclaims connections with sick bodies, deviant bodies, racialized bodies, and bodies that are permanently linked to others by conditions of care. As a mother I was made to feel I did not belong in the art college, but this situation can only become a collective struggle when it opens up and when we acknowledge that there are many other bodies that are made to feel that way, not only through infrastructural and access issues but also by choices of curriculum, staff, marking, etc. As reproductive technologies make visible the instability of scientific understandings of what or who a mother is, as a political practice, I am interested in dislocating the conversation out of binaries between mother-nonmother and mothering-nonmothering and into frameworks of social reproduction, care labour, distribution of access, and so on.

Dhillon (Invisible Spaces of Parenthood): Agreed! To me, the collective body, or the body politic in relation to motherhood, is far more interesting than subjective bodily experience. Why is that? I don't think it's about positioning away from an essentialist reading; rather, I don't feel I have anything to offer an essentialist representation of the maternal body. The clashes I felt having my first child were infrastructural and ideological: the confounding of experiences with

realities, hopes, and expectations. For example, my work with Andrea developed out of an unavoidable necessity. We both were involved independently in activist campaigns for parents' rights at art colleges around 2010. This evolved into a collaborative practice by 2014.

Loveless: This is a perfect segue to another question that I wanted to ask about how this work started for each of you. I wonder if each of you could speak explicitly to the way that becoming-mother, and the specificities and complications with becoming so inside the art world, instigated this focus in your work. Also, as each of your projects is ongoing, how have your collectives shifted over the years?

Dhillon: As I'm the one who jumped the gun a bit and anticipated this in my previous answer, I will go first. For me, it was unintended and unavoidable. I was heavily pregnant when I began a PhD at a U.K. art school. Like many, I felt isolated from art world events and exhibitions with a young baby. So I started a public program for parents at the Whitechapel Gallery to try to address that. The attitude to parents at the college I was at was retrograde and pretty discriminatory, so I had to take up an activist cause to address it. But the questions (and the answers) became so complex that a creative practice offered more possibilities for exploration. This is where Andrea and I started collaborating. I've always been a feminist art historian or writer, but to make work about the maternal, or stemming from the maternal, was never an intention; it just happened. So, the subjective experience fed the resulting exploration of the collective and political body.

Donner: Unlike Kim—and most of you, I believe—I'd actually started making work across a broad spectrum of fertility and identity before I became a mother because I have a disease that can make pregnancy difficult or impossible. So I was looking at the reproductive and the social systems of other organisms, which are perfectly natural but often wildly different from our own. And at the same time I'd started interviewing women who had radically different experiences and perspectives on the topic of motherhood. There was a lot of desire in this project but also a vague anxiety about it all. And then I got pregnant.

Cultural ReProducers came out of the overwhelming isolation I found—and that many of us face—in new motherhood. There are so many barriers for mothers making a career in the arts, but they're mostly invisible or hard to fathom unless you've experienced them

firsthand. My response was to make what I needed most at the time, which was essentially a support system and an online resource hub. As other parents have gotten involved, we've been able to develop events and publications to address specific issues like childcare, artist pay, event timing, access to residency programs, and critical dialogue. We discovered pretty quickly, as mothers curating art events with onsite childcare, that it was easy to be pigeonholed as some sort of art babysitting service. That prompted us to articulate our goals more clearly and to present our events as models for what's possible, placing the onus on institutions. Now we're working on a toolkit for institutions that would also situate artist-parents to be paid as creative consultants. All of this has become a sort of second child for me, both in the kind of energy that goes into it and in terms of helping me think more expansively in my studio practice, which has since expanded into an exploration of nonpatriarchal societies.

Francke: Like Christa and Kim, my interest began from my personal experience of becoming a mother and having to deal with a set of expectations that began with my own and expanded into society's. I think this is what makes me uncomfortable about constantly reinscribing the category. When I finally felt ready to claim ownership of my own identity, I was shocked by the different ways in which becoming a mother had stuck certain concepts to me that excluded me from the public space or the political arena. Being a mother meant I couldn't be an artist, and fighting against the closure of the nursery in my art college was reduced simply to an effect of my motherhood state. The whole experience seemed to be framed under the idea that this state (motherhood) should determine what I should want or not want, how should I behave, and what I could and couldn't do. I think it is important again to reinforce that for me the main battle is not about allowing mothers to enter the same space as the ideal heteronormative middle-class white man to become an artist. To echo Christa, I think of this work as a world making practice and a politics that is constructed through acknowledging the different subjectivities that constitute the world in its current segregations. My practice is more and more about moving out of motherhood, parenthood, and social reproduction and becoming more general about politics and theory. Motherhood was my route to consciousness raising. It was through the experience of mothering in a patriarchal society that my politics were formed.

Mullaney: My experience is both similar to and different from those shared thus far. From the beginning, I conceived of *Enemies of Good Art* as an art work. Initially, I modelled the project on second-wave feminist activism, in particular consciousness-raising exercises. It seemed appropriate at the time. In 2009, no one in the art world was talking about the mother, the presence of the family among artists, the inaccessibility of the art world and indeed its hostility towards the family (at least not yet in the U.K.—Andrea Liss's 2009 *Feminist Art and the Maternal* had just been published in the U.S. and Myrel Chernick and Jennie Klein's 2004 *Maternal Metaphors* was not yet known across the pond). I was engaged with various activist groups in London, and as a soon-to-be a single mother, I felt that I had a lot reasons to be active. I imagined *Enemies of Good Art* might form itself into a group; I had fantasies of it being the next big feminist movement and modelled events based on those ideas. I was a ball of angst, raging against the injustices and prejudices hurled towards mothers every-where, and it seemed I was not the only artist and mother to feel this way.

Enemies of Good Art came out of two things: a discussion I had with an older friend while I was pregnant, and a walk around the Goshka Macuga installation at the Whitechapel Gallery shortly after my first child was born (2008). My friend wondered how I could continue to practice art while experiencing motherhood for the first time; Macuga's invitation to the public to use the sixteen-seater table, the centrepiece of the installation, for public meetings resulted in an invitation to artists who were mothers to meet and discuss. Before becoming a mother, I thought I understood my practice or at least had an understanding of how I made work. Since becoming a mother, I realize that I was in just as much turmoil prior to motherhood as I am now. Having a child in my life has not in any way prohibited me from making work, but it has given me the confidence to explore my practice and let it grow. How I make work has not changed significantly, but how I function in the art world has. *Enemies of Good Art* emerged as a "fuck you" to the institutions that made me and other mothers feel that we were no longer welcome, that our genius was no longer a possibility, and that our dedication was somehow diminished. What was surprising to me was how easy it was to meet (with the agreement of each institution) in most of London's major publicly funded galleries

and critique the space, all of this happening during gallery open hours. We took the fictional Cyril Connolly's assertion that "there is no more somber enemy of good art than the pram in the hall" (from the 1938 novel *Enemies of Promise*) and debated the issues arising from this infamous quote in major art spaces as a way to make people step up and take notice of the appalling sexism attached to being a mother in the art world.

Loveless: There is something at the core of what you've raised that I'd like to highlight. Although we have acknowledged that these negative conditions are not unique to the art world, it is deeply disappointing that the art world isn't any more enlightened on this issue than any other community. What you each argue in the face of this is that it is not an issue of (and here we might recall Linda Nochlin's germinal 1971 essay "Why Have There Been No Great Women Artists") allowing mothers more readily into the patriarchal structures of power that still, more often than not, configure art world training and professional spaces ("add mothers and stir"). Rather, what is needed is an examination of the structures of power and ideological presuppositions that produce the exclusions in the first place.

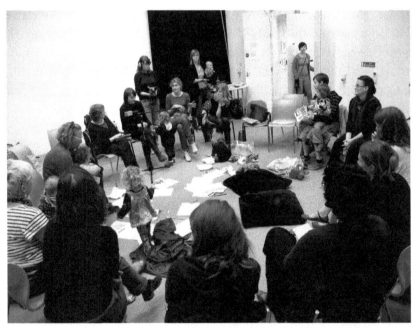

Figure 4. *Enemies of Good Art*, Royal College of Art Meeting, © Kristian Buus 2010.

Mullaney: I feel a certain amount of pessimism to the degree that when we come together at various discursive events we see the same faces; we see very few men in the audience, and we talk about the same issues. I've recently left London and the Southeast of England. I realized that, as a single mother, I could no longer use London as I had done, attending talks, private views—all of which were mostly held in the evenings. I relocated so that I might attain headspace, physical space, and time. London and other major cultural centres are amazing places to live but only if one can afford it. It is impossible to avoid the question of class and who can afford to be an artist now, let alone a mother-artist, in light of the recent global economic crisis and the government's response to it. In the U.K., funding to individual artists has seen a massive cut while the introduction of university fees by this government is already having a significant effect on who gets to go to art school. Women, mothers in particular, are economically dis-advantaged to levels not experienced for the past twenty-five years on this side of the pond. Given these conditions, the question now is: how do we, as mothers, maintain our practice?

Donner: It seems like we're all working through similar questions here. What now? Where do we go from here? How do we keep going? Now that my daughter's started preschool, time and headspace have opened up immeasurably, but the challenge of these projects that create and support our communities, at least in my own practice, is that it can be easy for the demands of organizing to rush in and fill any open space—just like parenting—so it's still hard to make the time I need for the other kinds of work I want to be doing in the studio. It's really easy to feel burnt out by organizing. Your point that we need to address this issue of being our own audience may be part of keeping that momentum going. I love the international community that's formed around these issues over the past few years, which, on the one hand, provides a much-needed network of support, validation, and conn-ection, but it doesn't do us much good to keep having these conversations only among ourselves. The harder and more important work, as in any area of activism, is to engage with the people who don't agree with us or just aren't really aware of the problems in the first place. Lately, I have been working with administrators at a prestigious college of art to better support faculty raising children, and I am getting involved in artistic conversations about climate change and human

impact, where issues of parental support in the arts have just not been on people's radar. As the people directly engaged with making choices with and for the next generations, parents may be among the fiercest activists in these areas, so it's critical to make sure these perspectives are supported and visible.

Dhillon: My art practice arose from motherhood. I am an art historian and writer whose art practice emerged as a response to motherhood rather than having a practice into which a baby was introduced, and then struggling to reconcile a baby into that practice and life. As I felt the problems I was facing institutionally at the Royal College of Art couldn't be ignored, I began initially several projects which were more activist in scope than art practice. (I had also in 2010 begun *Crib Notes* at the Whitechapel Gallery, London, and this was a "talks and tours" program for parents and caregivers with young children that I saw more as a public program than an art or activist project, but it was foundational to what would become my art practice.) It was at this point that I began collaborating with Andrea Francke (January 2014) on *Invisible Spaces of Parenthood* (ISP). We organized a conference, Creche Course at the Showroom Gallery, London. It wasn't until this point that I even recognized what I was doing as an art practice. But as Andrea and I were doing virtually the same thing, she as an artist, and me as a writer, she then encouraged me to recognize the practice as that and galvanized it as such. So you can see that my practice was instigated by motherhood; that my experience of practice and motherhood are somewhat symbiotic.

Francke: The question of how we maintain our art practice as mothers is very tricky because I'm someone that is in a privileged position. I don't think I would have an art practice now if at the moment my marriage collapsed my mother hadn't told me: I gave up on my dreams and my practice to raise two kids without your father's help; I'm not going to let you do this. I would not have an art practice if old friends and new friends hadn't organized around me and helped me with stuff like babysitting or just reminding me to breathe. I would not have an art practice if the art galleries that I work with like The Showroom and CCA Derry hadn't found ways to commission me for projects that allowed me to make a living while also having time to reorganize my life. I wouldn't have an art practice if at that moment the educational institution I was attending, Open School East, hadn't

allowed me to take Oscar with me to lectures and tutorials, never making me feel it was a problem. In fact quite the opposite, everybody was always happy to have Oscar around, to take school hours in consideration when scheduling things that I really wanted to attend and to appreciate that I couldn't be there all the time. I understand these are all personal solutions but I want to make them visible for two reasons. The first one is that I'm one of those people who get invited to round-tables as the token participant. I'm the nonwhite female immigrant single mother that proves that the system is inclusive, and I just want to make sure, as I try to in every one of those occasions, to say that I'm an exception and it's not because I deserve it more. It's because of a series of fortunate events and conditions that are not open to everybody. The second reason is that some of those structures of support came from institutions: a gallery that makes you feel welcomed instead of uncomfortable when you tell them they can't change the dates of your opening for a third time because all of the arrangements it involves in your life; a tutor that doesn't book meetings thirty minutes before school pickup time; being paid properly for work instead of being expected to be grateful for the opportunity to do something. I think all of those are simple structural changes in the way people conceive their relation to you that make a massive difference in who gets to be an artist and who doesn't. And this shouldn't end with mothers, some of us are caregivers, some of us are disabled, some of us have a really hard time going into a gallery space that is filled with racist or sexist or homophobic art. I don't have a full and proper solution to the inclusion problem. I think we need a welfare state that supports parents and children and doesn't demonize single mothers. I think education and childcare should be free but also well remunerated and respected. I think art schools should have a curriculum that shows students that there have always been a variety of people making art and thinking about the world. How teachers can go a whole term without teaching one artist or thinker who is not white, not male, not able bodied is a mystery to me (and shocking though this is, I experienced this in my training). I think we should give up on the fantasy of nuclear families and embrace queer kinship. I think that children should not be fetishized but respected. Similarly I think motherhood should not be fetishized but respected.

Figure 5. *Invisible Spaces of Parenthood* (Kim Dhillon and Andrea Francke), Poster for *Creche Course*, The Showroom, London, 11 January 2014.

Francke and Dhillon: This is what we want to ask the group: what would, for each of you, be the mark of "success"? (And we say that in quotes because we don't intend to reify a binary relation to "failure"). Over the past five to six years, there has been a really exciting momentum of projects and practices that engage or address the maternal in new ways. A lot has stemmed from activism, much from subjective experience. Multiple approaches and perspectives are becoming evident. Where do we see these going? And within this spectrum of practice, how do we understand the mode that we, gathered here, favour: the production of collectives? We all practice under different

names: *Enemies of Good Art, Cultural ReProducers, Invisible Spaces of Parenthood.* I wonder about that. Is it a strategy, at the outset, to distinguish from our individual practice or to differentiate from our subjective experience? Or to not have the maternal subsume our other practices? Is it a strategy to use a pseudonym so that it can be universal beyond our own experience? Something else entirely?

Mullaney: In terms of where I think things are going, there have been great things happening—artists like Lenka Clayton turning their homes into residencies, Mierle Laderman Ukeles's recent retrospective in NYC, more residency opportunities for artists with children (not always with childcare attached sadly)—and we've all been to the endless conferences and symposia on these topics in the last few years. But as I highlighted in my prompt, we keep meeting the same faces over and over again. We are our own audiences. There's a new project in London right now, *Mother House* (a play on Judy Chicago & Miriam Schapiro's *WomanHouse*—CalArts 1972) run by The Procreate Project. They recently held a discussion on this topic. I couldn't go to the discussion, but my thoughts on this are that we have only ever been our own audience. We open women or mother houses, create women-only residencies, places to live, galleries, departments in universities, and that's where we stay. *Enemies of Good Art* is not my practice; it is a project I worked on in response to first-time motherhood. It's not something I want to hide from in any way. I fully acknowledge the importance of that project to my practice: it was a turning point for me. For sure, I don't want motherhood to dominate my work, in the same way I never wanted to become known as the photographer who made aesthetically pleasing works around abjection. The title *Enemies of Good Art* was meant as a provocation, and I avoided the word "mother" as a way of transcending that maternal audience, "our own audience" so to speak. But I don't see *Enemies of Good Art* as a pseudonym. It's a project I carried out at a particular time in response to a particular experience—one that I never imagined would go on to fuel further research and become the basis for my PhD.

Donner: I am still and always mulling over the "where do we go from here" question. I think it would be easy for someone on the outside of this experience to look and say "oh, the problem is solved now. Clearly motherhood is no barrier to a career in the arts, as everybody wants to talk about it." I was just in a meeting at the college where

I teach, and during introductions, four of the women there mentioned the fact that they're mothers—something I can't imagine happening just five years ago. But we all know that the double standards and institutionalized sexism and more general exclusion haven't gone away. Now that the taboos have broken open a bit, I'm troubled to find that artists have some of the same "Lean in" supermom expectations that working mothers in other fields have had to wrestle with: the idea that you'll need to prove to the gallery system that you can dedicate the same kind of energy to your career as someone without children, although you have a completely different balance of emotional and physical labour to work with. That's not really a goal I want to perpetuate. In terms of where I do hope it will go, I think this discussion around parenthood and caregiving opens up some really important questions about broader cultural values, gender biases, access, and caring labour. Martina is absolutely right here that we need to think about this problem of being our own audience for these things. These are issues that go far beyond the art world and beyond parental caregiving. I'm thinking about care for our elders, mental health support, care for our ecosystems, and our bodies. Being part of the art world and part of the current focus on mother-artist activity gives us a certain platform from which to experiment. It seems important to consider how to include other populations in this conversation if we want it to function as more than a support group.

To answer the pseudonym question, it's true that having a group name can be practical, as I do have a studio practice that operates separately from my work with *Cultural ReProducers*, and I find it helps distinguish the two. *Cultural ReProducers* was originally intended to be a collective project—a bit more collective than it has turned out to be so far. Although I run most of it, there have always been key collaborators—in particular Christina LaMaster and Selina Trepp—who work on specific projects. We also have a very active and international community through social media, although when it comes down to organizing projects even the most active participants are understandably limited in what they have the time and energy to contribute. I hope the name suggests something that many people can feel they can participate in or be a part of: a community, an organized group, a sense of solidarity.

Figure 6. Christa Donner and Selina Trepp introduce an event in the *Cultural RePToducers* Childcare-Supported Event Series at the DePaul Art Museum, Chicago, 2014 (photo: Andrew Yang).

Donner: While we are here discussing issues that are urgent and present to us, artists making it work as mothers aren't exactly a new phenomenon, nor are groups dealing with these issues. (I am thinking of 1970s collectives such as the Hackney Flashers and Mother Art, which were pretty much erased from art history after they wound down.) When I first started doing research for *Cultural RePToducers*, it took some real digging to find projects along these lines, and I was thrilled to discover both of your collectives happening across the ocean. Since then—over the past five years or so—there has been an explosion of essays, exhibitions, conferences, digital, and physical communities. Artist motherhood—and the challenges of working motherhood in general—is suddenly a hot topic, no longer taboo. Why now? And what next: optimism, pessimism, exhaustion?

Francke: This is a really interesting question because definitely here in London, artist motherhood has become an art trend. There is a bigger context in which this trend is inscribed. There is a visibly renewed interest in feminism and with it an emergence of a multiplicity of interpretations and practices of its politics. I find many of the practices that

are framed as feminist or around motherhood quite problematic and align with political models I'm not interested in—same thing with a lot of the artist motherhood projects and commissions. I think it functions a bit similarly to what happened with multiculturalism and racial equality in the art world—where documents, images, and actions were used to perform the veneer of equality while freeing the institution from actually practicing it. Museums commission artists to do a project on motherhood, a university hosts a lecture, or a gallery offers a tour for toddlers, but none of those institutions address curriculum issues, access, childcare infrastructure, or how their own staff need to choose between becoming mothers and progressing in their careers. In other words, I think the taboo still exists, and the hypervisibility of a certain version of motherhood as an elevated subject and what that motherhood subject needs helps to sustain it.

Mullaney: I've been looking at the *Hackney Flashers* and *Who's Holding the Baby* for years. It's fantastic work on so many levels. Yes, it is generally assigned to the archives of museums (although it has received renewed attention over here in the past few years), but I don't agree with you that motherhood is no longer a taboo. The problem is that while all these great efforts are being made, women still generally do the lion's share of all childcare, even in the maternal-activist art world. We gathered large groups of artists together when *Enemies of Good Art* was in full swing, and we only ever managed to get a few men to join us. If we think we are making headway with this, we are mistaken. With current global politics in turmoil, neoliberalism and capitalism dominating how we live, feminism is still a topic for discussion, and we know how this goes. In the not too distant future, we won't talk of feminism because it will once again become a dirty word. Second-wave feminism has been heavily criticised both in the U.S. and in the U.K. for forgetting the mother. Current global feminisms are looking at violence against women, predominantly, and this is a good thing. But although the mother is making some waves in our small section of the art world, it is making no impact on the wider art world of work.

I am not hopeful for the future in terms of the mother in the art world. It is not a paradigm shift we're experiencing; it's just back on the agenda for now, and it will get forgotten about again very soon. History has been unkind to the mother-artist. There are a few maternal

artworks that dominate the canon of art history, but where are all the rest? I am not in mourning; I am angry, however, that the state and the art world make it so fucking difficult.

Dhillon: Along these lines I must say that it is impossible to write an answer to this question, sitting here on 14 November 2016, less than a week after America elected a fascist, misogynistic president, without readdressing the question to this context. The question points to the lack of visibility or awareness of the projects that preceded us—projects that engaged feminism, questions of care, labour—by thirty years, such as that of the *Hackney Flashers*. It is important to note that the *Hackney Flashers* never considered themselves artists but rather a collective of social activists attending to the lack of visibility that permeates much of the work around the subjects of motherhood and care. We can see this in the Bauhaus. (ISP recently completed a commission with the Serpentine exploring the Bauhaus and the kindergarten; the reason the Bauhaus made puppets was a practical one—there were children present). For example, when I took up the campaign at the Royal College of Art in 2013 to open or organize a space for childcare, for parents, and to remove boundaries that prohibit children from entering the building, it got a real push when I discovered, through a conversation with Richard Wentworth, that there had in fact been a nursery at the College in the 1970s, which was started in 1969 by a student, Jane Furst. A fully staffed day nursery ran on site for a decade and children were part of the college culture. By 1983 it was closed, and for a no doubt complex array of reasons to do with cost, staff, space, enrollment, all furthered by a change in college rector administration and the rise in Thatcherist neoliberalism. What happened between then and now? How rapidly can an ideology erode progress to the point that it is whitewashed from the collective memory or to the point that seems laughable that children may be in the art school space, let alone that the administration might subsidize a nursery for their care to afford their parents time to study and work? But it had eroded to that point when I enrolled in 2009, seven months pregnant with my first child.

But you ask why now. I expect something to do with the fourth wave. Kira Cochrane has written something to the effect of the fourth wave being the generation told we could have it all but shocked when we realize sexism persists, but utterly confident in our ability to tackle it.

Now, Cochrane is herself embracing neoliberal ideology with the "have it all" mentality—that we are in it for ourselves and that liberties and rights are things to possess. But she is correct in the analysis of the revelation that one confronts when presented with ideological sexism and discrimination—that there is so much still to do. So, I imagine the "why now?" can be attributed at least in part to this generational realization and confrontation. The saddest thing in Hillary Clinton's concession speech last week wasn't when she reminded little girls out there that they are worth every chance they get, that they can fulfill their dreams, and that they are every bit as valuable as the boys. The saddest thing is that this still has to be stated because we know it is not the reality.

Loveless: This is, perhaps, an ideal moment, then, to step in and ask each of you to speak to how you imagine your work will change, if you do, in light of the recent presidential election in the US—one that only highlights the waves of nationalistic xenophobia that have been shaking our social fabric in the West of late.

Donner: Like many in the US and elsewhere, I'm still regrouping and reorienting after the election, and I suspect that will take some time. I've been doing plenty of calling representatives and organizing artistic protest around issues that will impact our families for years to come, but for the long game, it's important to remember that as parents we have already been undertaking some of the most critical work for the future: raising the next generation of caring, thoughtful, resourceful adults. More than ever before, it feels urgent that the creative voices of mothers and other caregivers be heard.

Dhillon: I am currently developing a project for an exhibition in Glasgow in January 2017 called *We Tell Ourselves Stories in Order to Live*. It involves a library of 1970s nonsexist, multiracial children's literature made by feminist publishing collectives. In the project research, I have been in touch with a wonderful group of feminists who worked collectively in North Carolina in the 1970s as Lollipop Power, a publishing collective. The answer to "what next" in Christa's previous prompt might have been something along the lines of "perseverance without fatigue" if I had been asked a month ago. But we have just had the most brutal reminder of how much there is still to do, how much progress has been eroded by neoliberalism, and how much will be eroded now. I did not think I would realistically, in my lifetime, face a situation

where Roe versus Wade would be overturned and that is now a very tangible reality. Let us not forget how quickly progress can erode, but also the power of collective organizing.

Figure 7. *Enemies of Good Art*, Tate Modern Meeting, © Kristian Buus, 2010.

Mullaney: I'm struggling with your question. I'm struggling to keep my answer coherent and short. When the Brexit vote passed here in the U.K., we were swimming in disbelief, quickly followed by a profound sense of sadness. The anger coming out of the U.S. is telling. People are standing up and speaking out, and I hope it continues. Brexit feels inevitable (and still to some of us unbelievable), the result of too many years of austerity under the Tories and a rise in far right politics taking hold in the U.K. and Europe. Perhaps for similar reasons Trump was inevitable too. I'm sure I'd weather all of this better if I hadn't brought a child into this mess. How my practice will react to the recent U.S. presidential election and the increasing reality of the U.K. withdrawing from the European Union, I do not know. As two signifiers of a growing negative global politics that can only mean greater difficulties ahead for many, I only know that it will.

Figure 8. *Cultural ReProducers* event at Gallery 400, Chicago, 2014 (images: Christa Donner).

Figure 9: *Invisible Spaces of Parenthood* (Kim Dhillon and Andrea Francke), *Shapes* (workshop), *Changing Play* commission at Portman Early Years Centre, London. Commissioned by Serpentine Galleries, London. Photograph © Manuela Barczewski, www.serpentinegalleries.org/exhibitions-events/artist-talk-invisible-spaces-parenthood

Afterword

Charles Reeve

The author (foreground) with his older sister, Dorothy, in August 1963 with
grandmothers Dorothy Reeve and Gladys Parham in background.

I'd like to begin (or end?) by returning to Mary Kelly's short film
Antepartum (1973), one of the works that Rachel rightly includes
among the precursors to this book that far preceded our first
discussions of it. The early 1970s—second-wave feminism's mid-
point—brought forth what we might call "cultural feminism": an
influx of feminist sensibilities into cultural production that made
culture's various forms (visual art, music, scholarly analysis, etc.) vital
as much for developing feminist ideas as for broadcasting feminist ideas
developed elsewhere. For me, this historical significance, through sheer

happenstance, maps onto personal significance: the moment when matrilineal influence took hold, sketching first thoughts for the afterword that I (I say "I" but the point is that it feels more like "we," me together with, among others, Phyllis Reeve, Dorothy Reeve, and Gladys Parham) now write. So I'd like to start there, in 1973, when I was ten years old and Mary Kelly's son was not quite born, his prenatal presence prompting *Antepartum*'s ambivalent relation to much of that moment's most "advanced" (as we used to say) art.

On the one hand, *Antepartum*'s DIY aesthetic and emphasis on the artist's body align with that moment's high avant-garde. But the films of Gordon Matta-Clark, Robert Smithson, and Chris Burden, for example, leveraged the industrial strength machismo (minimalism, earthworks, and the like) that dominated that era's art world. In contrast to Matta-Clark et al., Kelly and other feminists of the time— like Judy Chicago, Cindy Sherman, Laura Mulvey and Linda Nochlin—highlighted the masculinism of a value system that, coding itself as "neutral," branded as inappropriate for the artistic context any themes, materials, or techniques that convention read as feminine: nothing about cooking or housework; no textiles or ceramics; no knitting, quilting, or crocheting; certainly, no babies. (Though something could be made of Matta-Clark's penchant for cutting houses in half.) In that context, these feminist oppositions were bold. Whether they succeeded remains less clear, not least due to debates surrounding what constitutes success. Thus, assessing what feminists want in the cultural sphere and whether we can get it is an important subtheme of this book. So it seems apposite to conclude by bringing this subtheme into view—especially given the aspirational quality of many of this book's chapters—in order to ponder gains, concessions, and next steps around the specific strand of feminism considered here. What was, is, and will be at stake in undoing the mothering body's (in)visibility?

The cultural sphere's expanding inclusiveness and the widespread appreciation now enjoyed by the above-named women and their art and writing suggest that these feminist challenges worked: for instance, the Brooklyn Museum's worthy home for Chicago's path-breaking *Dinner Party* (1974-1979), that redoubtable acme of what Jane Gallop just a few years later would call "vulvarity." And this recognition correlates with a shift in expectations. Try to imagine a national gallery today organizing a sweeping survey of contemporary art in which fewer than

a fifth of the artists are women—as the National Gallery of Canada did five decades ago with "Sculpture '67," notwithstanding that it was part of that year's centenary extravaganza Expo 1967 and that the gallery's director and the exhibition's curator—Jean Sutherland Boggs and Dorothy Cameron, respectively—were women.

Any endeavour today that claimed to assess contemporary art's state of play without giving equal representation to women would not be credible. Nor would gender inclusivity alone suffice. Already in the early 1970s, the importance of common cause between marginalized groups was coming clear (as in Huey P. Newton's famous speech of August 1970 aligning black liberation with that of women and gays). By 1989, when Kimberlé Crenshaw put the term "intersectionality" into circulation, alert folks understood that people belonging to more than one equity-seeking group (female and racialized, for example) often experienced a discriminatory multiplier effect, each form of inequity deepening the opportunity costs associated with the other. This awareness helped usher BIPOC (Black, Indigenous, people of colour) women onto the artistic stage, with other voices—differently abled, queer—soon to follow. And that proliferation of subject positions addressing feminism applies equally to discussions of mothering. (The voices from equity-seeking communities in this book could be joined by many others: artists such as Renee Cox, Catherine Opie and Alison Lapper; writers such as Alexandra Kahsenni:io Nahwegahbow and Cecily Cheo; people who toggle between making and writing, such as Faith Ringgold.)

However, these successes, while real, are also precarious. Consider the 2015 exhibition *The Art of Our Time* at the Museum of Contemporary Art in Los Angeles, wherein then-chief curator Helen Molesworth deconstructed the usual installation of a permanent collection: you know, the one in which, without entering a room, you can identify the work of five out of six artists ("Frank Stella, Donald Judd, Andy Warhol, Carl Andre, Dan Flavin ... oh, Agnes Martin!"). Against this background, Molesworth took as one organizing principle that no room could have only white male artists. Despite there being a few exceptions (a room devoted to Mark Rothko, another room featuring three marquee white males from the late 1960s), commentators hailed Molesworth's approach as path breaking (Miranda). And that seemed true, but also disconcerting: how lamentable that, a decade and a half

into the twenty-first century, this modest degree of inclusiveness still seems remarkable.

Consider, in addition, most artists' day-to-day reality. We know this tough situation is even tougher for women. How much tougher? In Canada, Michael Maranda at the Art Gallery of York University spent several years investigating the financial and professional trajectories of Canadian artists. Along the way, he unearthed appalling links between income and gender: whereas in 2007, women artists earned on average 27 percent less than men artists; by 2012, this gap had widened considerably to 60 percent. At a time when, across the board, the wage-gender gap was gradually shrinking, in Canada's art world, it more than doubled in just five years. And while Maranda's data lack the detail to break out the further opportunity cost experienced by women artists who have children, it likely is substantial. Forty-five years after Chicago, Nochlin, Kelly, et al., literature still, as Maggie Nelson said in relation to her memoir *The Argonauts*, cannot grasp pregnancy and birthing as "part of human experience that might be able to be attended to in language." So too in the visual realm, and it seems probable that artists who are mothers pay a price for this refusal, given the significant "motherhood earnings gap" in the general population (Zhang).

A further fact underscores this point about the general population: a recent study of Canada's postsecondary institutions found that racialized women university instructors earn, on average, 68 percent of what their non-racialized male colleagues earn, whereas racialized women college instructors earn only 63 percent of what non-racialized male instructors earn (Canadian Association of University Teachers). Even the academic community, notwithstanding its view of itself as particularly enlightened, has a way to go. Evidently, affirmative action and employment equity often miss the point: saying that all things being equal, you'll hire the female and/or racialized candidate, the member of an equity-seeking community, assumes an unbiased assessment of whether all things are equal. It assumes male and nonracialized candidates being held to the same standards as female and racialized candidates, which frequently turns out not to be the case. In fact, as Roderick Ferguson shows, such itemization of minority differences mostly makes those categories available for modes of power (he's discussing gender and race in universities but includes other public and private institutions in this process) to incorporate into their

"range of mastery" (Ferguson 54).

So perhaps we need to change how we think about change. As Natasha Warikoo and others argue, soft approaches relying on good intentions will not do the job alone: we need to measure the gaps caused by difference; we need to set calibrated targets to overcome those gaps; and we need to integrate into that process some thinking about how we change systems, where the real-world effects of inappropriateness operate. As long as pregnancy and mothering appear as inconvenient aspects of life that are inappropriate to mention in polite company, our world will go on confining awareness of this bias to pockets of feminism here and there and viewing feminism itself as a special interest rather than a value that any sentient person would hold.

Changing that situation has everything to do with the importance Rachel and I attach to bringing discussions of design into this conversation—far-reaching assessments that stood conventional thinking on its head. For example, Doreen Balabanoff argues that women giving birth lapse into medical crisis not despite being in hospital but because of it: the hospital causes the crisis. Heidi Overhill reads the return of the repressed written across the designed landscape: we hide infants and mothers while furiously distributing reminders of the mother-child relationship throughout our daily lives, such as the babylike laptop (note the name!) on which I type, the motherlike embrace of the couch on which I recline while doing so. And from objects to systems: the explorations by Terri Hawkes, Dyana Gravina, Anna Ehnold-Danailov, Line Langebek, and others of social and organizational systems that augment (not dampen) creativity by integrating childcare into the studio. These steps—inventive cultural analysis, innovative architecture, and new organizational thinking—are small. Baby steps, as we say. But they nonetheless point to an emerging social ethos organized around feminism.

As much as this book participates in a promise to the future, though, it also shares an indebtedness to the past. "All feminist academics I know seem to go into academia because of experiences with their mothers"—thus the idea that Vanessa Reimer and Sarah Sahagian position as driving the book they edited together, *Mother of Invention: How Our Mothers Influenced Us as Feminist Academics and Activists* (1). Although Reimer and Sahagian qualify this thought—too general, too hyperbolic—they stick with it because, they say, it "felt

true to our experiences" (2). Mine too. How did I end up in art history? It's not the most predictable career. In fact, for years, I wondered if it was a career: it felt like a journey I was fortunate (and "fortunate" is the word) to follow, with no apparent destination despite its clear starting point—or four clear starting points.

So, returning to 1973: I am by far the youngest person in a group comprising an artist named Don Potts and ten or fifteen women, including my mom—docents at the Vancouver Art Gallery. The women listen to Potts discuss his exhibition *My First Car* so they can lead tours of it. I'm there because Mom thought I'd be interested and I am, intrigued by the life-sized maquettes of the impossible dream car named in the show's title: a beautiful system of foils to help it hug the ground while travelling superfast; and delicate wings enabling it to fly; a spidery wood skeleton that would disintegrate if the thing exceeded twenty kilometres per hour or collapse on landing if it took off. At a time when most dream cars epitomized "Detroit iron"—souped-up Javelins and Chargers, with their drag-racing slicks, growling Cyclone headers, and ear-splitting Aerosmith soundtracks (see the opening of Richard Linklater's 1993 film *Dazed and Confused* for reference)—Potts's vehicle was less a car than a few gestures towards the idea of a car.

Often, in fact, I found my young self at such events, and in the years since, when these moments floated into my mind, they struck me as incoherent. My presence made sense, but the presence of any of my sisters would have made more sense, since they participated in the arts more actively than I (actually practicing between music lessons, for example). Four decades later, I asked Mom how she knew. Toying with me (meaning, deflecting the question), she narrowed her eyes, looked into the distance, and said mysteriously, "A mother knows these things."

Perhaps they do (am I necessarily mystifying and essentializing— two mental habits this book seeks to dismantle—by saying that?), if only because they provide much of what matters most about the context in which we grow up. And therein lies the tale of my second starting point, less of origin than emergence. Why did my mother volunteer at the Vancouver Art Gallery instead of pursuing the academic career foreshadowed by her graduate work at the University of British Columbia (UBC) through the mid-1960s? UBC was relatively ad-vanced: it opened Canada's first Women's Studies program in 1971 ("A

Brief History"). By contrast, on Canada's east coast, Dalhousie University forbade married women to have tenure until 1966, just five years earlier (Horn). But barriers existed, affecting my mom deeply enough that she still recalls Germaine Greer's famous line near the start of *The Female Eunuch*: "If you think you are emancipated, you might consider the idea of tasting your own menstrual blood—if it makes you sick, you've got a long way to go, baby" (57). The point, as Mom noted, was the double standard: few of us would think twice about sucking the blood from a cut finger.

I was eight years old when Greer's book came out, so not at a juncture where I would have discussed it with Mom. But my parents deliberately stocked their library with controversial and topical books, *The Female Eunuch* alongside J.K. Huysmans (*Down There*), Cyril Belshaw (*Under the Ivi Tree*), Henry Miller and D.H. Lawrence —as well as a human skull, its top neatly sawed off and then kept in place with three hooks. Throughout my teens, I stared at those books, too fascinated by their titles to dare open them. (The skull also held a certain fascination.)

The stage was set and, soon enough, the play would wind its way towards the third starting point—what now seems like an inevitable meeting with Jess Dobkin in 2005, when I was running the professional gallery at OCAD University (at the time, the Ontario College of Art & Design). A series of conversations had led me to Paul Couillard, a performance artist and curator seeking a venue for Dobkin's *Lactation Station Breast Milk Bar* as part of a performance festival on the theme of taste (the conclusion of an extensive project curating performances on each of the five senses). When he explained Dobkin's idea to turn a gallery into a chichi bar that served flights not of wine but of breast milk, I could not resist. The turn, à la Greer, on the awkward position of the mother's body as at once exalted and despised—breastfeed! but not in public—struck me as a compellingly timely take on the stubbornness of our ambivalence towards the place of mothers in society (Reeve).

One last starting point: as often happens, while in graduate school, I found myself writing my first course description, which—common pitfall—was a bit too complicated for its freshman audience. So my department chair encouraged me to make the description less recondite. Helpful, except she concluded by saying, "Imagine your

grandmother reading this." Which one? My paternal grandmother, Dorothy Reeve, graduated in mathematics in 1925, then got a teaching certificate. And although she gave up her career when she married my grandfather, she cherished the vocation and found ways to keep it alive well into her 60s. Gladys Parham, my mother's mother, raised two children mostly alone (her husband died very young) while juggling a nursing career and, briefly, a rooming house. Whereas a nursing credential was less surprising for a woman in the first quarter of the twentieth century than a math degree, Gladys, like Dorothy, showed what in her milieu would have been a surprising assurance that she could use her head to take care of herself. Furthermore, both women built on family cultures of intelligence and learning. Dorothy's brother Clifton Hall was a well-regarded educational philosopher; another brother, Henry, has a building named after him at Montreal's Concordia University to honour his role in stewarding that institution (Cooper; Malloy). Gladys came from a highly literate, politically savvy family, with a fluently bilingual (French and English) matriarch. Thus, for myself, as I imagine for many others, I would add "and grandmothers" to Reimer and Sahagian's idea that experiences with their mothers often tip feminists towards academia. And no doubt Reimer and Sahagian would entertain the possibility of such a revision (see, for example, Janice Okoomian's elaboration of the idea of "ancestral feminism" in *Mother of Invention*).

How disconcerting—to reprise Molesworth—that we still need to lay out these ideas this far into the twenty-first century. Yet, clearly, we do. Increasingly, the various small organizations I work with receive queries from folks trying to juggle parenting with careers in academia and/or the arts. Too often, I find myself saying we do not have childcare or a hang-out room for slightly older kids or a breastfeeding room: cost; liability; we tried that once, and it was really hard; the usual bullshit. And I empathize: ten days ago, Charlie, my five-year-old son that Rachel mentions in her introduction, got a sister, Minnie who, annoyingly, also will not be joining me everywhere I go. But the essays and conversations here point to the long arc: for instance, how radically, in much of the world, franchise has expanded over the last two hundred years, especially since the early twentieth century. And I wonder: by the time Minnie's in college, will the U.S. have had its first woman president? Perhaps. If yes, I wonder if that historic woman will

turn our social structures towards unconditional compassion. I wonder if she will start to undo the damaging effects of the pernicious ideology—promulgated by Baroness Thatcher who, by contrast, left her femininity behind—that the idea of society is at best a fiction, at worst a con.

Endnote

1. I need to mention another memory that I don't include in the narrative because it doesn't have the same *ur*-moment impact but nonetheless sticks in my mind and has an interesting overlap with both *Antepartum* and *My First Car*: I remember the enormous awning that Evelyn Roth crocheted from videotape for the Vancouver Art Gallery on the occasion of its *Pacific Vibrations exhibition* (1973) and the car cozies that she also crocheted from videotape around the same time.

Works Cited

"A Brief History of UBC." *University of British Columbia*, archives. library.ubc.ca/general-history/a-brief-history-of-ubc/UBC Women's Studies. Accessed 10 Aug. 2019.

Canadian Association of University Teachers. *Underrepresented & Underpaid: Diversity & Equity Among Canada's Post-Secondary Education Teachers*. Canadian Association of University Teachers, 2018.

Cooper, Jed Arthur. *Clifton L Hall; Eloquent Essentialist*. Alpha Editions, 1988.

Crenshaw, Kimberlé Williams. "Demarginalizing the Intersection of Race and Sex: A Black Feminist Critique of Antidiscrimination Doctrine, *Feminist Theory and Antiracist Politics*." *Feminism in the Law: Theory, Practice and Criticism*, University of Chicago Law School, 1989, pp. 139-68.

Ferguson, Roderick. *The Reorder of Things: The University and Its Pedagogies of Minority Difference*. University of Minnesota. 2012.

Gallop, Jane. *The Daughter's Seduction: Feminism and Psychoanalysis*. University Press. 1982.

Greer, Germaine. *The Female Eunuch*. Farrar, Straus and Giroux. 1970.

Horn, Michiel. *Academic Freedom in Canada*. University of Toronto Press. 1998.

Malloy, Brenda Margaret. *Henry Foss Hall, A Canadian Educator, 1897-1971: The Interaction between a Man and a Developing Institution*. Dissertation. The Florida State University, 1975.

Maranda, Michael. "Waging Culture: The Sex Gap (!)" The Art Gallery of York University, 2014, theagyuisoutthere.org/everywhere/?p=4472. Accessed 11 Aug. 2019.

Miranda, Carolina. "9 Ways in which Helen Molesworth's Permanent Collection show at MOCA Is Upending the Story of Art." *Los Angeles Times*, 8 Jan., 2016, www.latimes.com/entertainment/arts/miranda/la-et-cam-tour-of-moca-permanent-collection-helen-molesworth-20160107-story.html. Accessed 11 Aug. 2019.

"Maggie Nelson and Olivia Laing: *The Argonauts*." *YouTube*, 31 May 2016, www.youtube.com/watch?v=s-Yxhc2nNxo. Accessed 11 Aug. 2019.

Newton, Huey P. "The Women's Liberation and Gay Liberation Movements" *Blackpast*, 1970, www.blackpast.org/african-american-history/speeches-african-american-history/huey-p-newton-women-s-liberation-and-gay-liberation-movements/. Accessed 11 Aug. 2019.

Okoomian, Janice. "Lentils in the Ashes: Excavating the Fragments of Ancestral Feminism." *Mothers of Invention: How Our Mothers Influenced Us as Feminist Academics and Activists*, edited by Vanessa Reimer and Sarah Sahagian, Demeter Press, 2013, pp. 168-80.

Reeve, Charles. "The Kindness of Human Milk: Jess Dobkin's *Lactation Station Breast Milk Bar*." *Gastronomica: The Journal of Food and Culture*, vol. 9 no. 1 (Winter 2009): 66-73.

Reimer, Vanessa, and Sarah Sahagian "Introduction: The Invention of Our Book," *Mothers of Invention: How Our Mothers Influenced Us as Feminist Academics and Activists*, edited by Vanessa Reimer and Sarah Sahagian, Demeter Press, 2013, pp. 1-20.

Warikoo, Natasha. *The Diversity Bargain and Other Dilemmas of Race, Admissions, and Meritocracy at Elite Universities.* University of Chicago Press. 2016.

Zhang, Xuelin. "Earnings of women with and without children." *Perspectives on Labour and Income*, vol. 10, no. 3, 2009, pp. 5-13.

Contributor Notes

Rachel Epp Buller is a feminist, art historian, printmaker, book artist, professor, and mother of three. Her artistic, written, and curatorial work addresses these intersections, focusing on the maternal body and feminist care in contemporary art contexts. Her books include *Reconciling Art and Mothering* (Ashgate) and *Mothering Mennonite* (Demeter). She speaks and exhibits her work internationally and is the recipient of major grants in the United States and Germany. She is a board member of the National Women's Caucus for Art (US), a regional coordinator of the international Feminist Art Project, and associate professor of visual arts and design at Bethel College (US).

Charles Reeve is an art historian at Toronto's OCAD University who has placed modern and contemporary culture at the heart of his writing and curating for more than thirty years, with a particular focus on the various intersections between writing and visual art. Concerned as much with changing institutions as with analyzing them, he was president of his faculty union from 2012 to 2019, and president of the Universities Art Association of Canada from 2016 to 2019.

Doreen Balabanoff is an internationally known artist and designer with a deep interest and expertise in colour and light within architectural space. She is a professor of Environmental Design at OCAD University in Toronto, Canada, and holds two architectural degrees: an MArch (UCLA, 1985) and a PhD (University College Dublin, 2017). Her artwork and research are focused on phenomenological and sensory aspects of spatial experience. Her practice-based doctoral dissertation, *Light and Embodied Experience in the Reimagined Birth Environment,* proposes that an architecture grounded in careful consideration of natural light (light, colour, and darkness) can play a transformative

role in supporting natural birth processes and creating sensitive and satisfying birth experiences for all involved. Doreen is the founding president of the Colour Research Society of Canada (the Canadian member of the International Colour Association).

Amber Berson is a writer, curator, and PhD student conducting doctoral research at Queen's University on artist-run culture and feminist, utopian thinking. She most recently curated *Utopia as Method* (2018); *World Cup!* (2018); *The Let Down Reflex* (2016-2017, with Juliana Driever); *TrailMix* (2014, with Eliane Ellbogen); **~._.:*JENNIFER X JENNIFER*:.~* (2013, with Eliane Ellbogen); *The Annual Art Administrator's Relay Race* (2013, with Nicole Burisch); *The Wild Bush Residency* (2012–14); and was the 2016 curator-in-residence as part of the France-Quebec Cross-Residencies at Astérides in Marseille, France. She is the Canadian ambassador for the Art+Feminism Wikipedia project. Her writing has been published in *Breach Magazine*, *Canadian Art*, *C Magazine*, *Revue.dpi*, *Esse*, *Fuse Magazine*, and the *St. Andrews Journal of Art History and Museum Studies*.

Kim Dhillon is a Canadian artist, writer, and art historian, living in Vancouver. She completed her PhD by thesis at the Royal College of Art. Her project explored the importance of feminist second generation conceptual artists to the development of text in contemporary art. She has collaborated with Andrea Francke on the project *Invisible Spaces of Parenthood* since 2014, which is an ongoing research project exploring parents, children, the labour of care, and their visibility in societal infrastructures. Recent publications include the article "The C-Word: Art, Activism, Motherhood, and Childcare: in *Studies in the Maternal* (Winter, 2016), co-authored with Andrea Francke, and the chapter "Invisible Care: Nursery Provision for Infants in U.K. Art School," in *We Need to Talk About Family: Essays on Neoliberalism, the Family and Popular Culture* (2016).

Jess Dobkin has been a working artist, curator, community activist, and teacher for more than twenty years, creating and producing intimate solo theatre performances, large-scale public happenings, socially engaged interventions, and performance art workshops and lectures. Her practice extends across black boxes and white cubes, art fairs and subway stations, international festivals, and single bathroom stalls. She's operated an artist-run newsstand in a vacant subway

station kiosk, a soup kitchen for artists, a breastmilk tasting bar, and a performance festival hub for kids. Her recent performance, *The Magic Hour,* was developed and produced in a multi-year residency at The Theatre Centre with support of the Canada Council. She received a Chalmers Arts Fellowship to fund her international archival research in 2018-2019. She's taught as a Sessional Lecturer at OCAD University and the University of Toronto, and was a fellow at the Mark S. Bonham Centre for Sexual Diversity Studies at the University of Toronto. Her film and video works are distributed by Vtape, and her performance work is held in performance art archives internationally.

Christa Donner is an artist, mother, curator, and organizer who investigates the human/animal organism and its metaphors. Donner's work is exhibited widely, including projects for Gallery 400 (Chicago, USA); the Max Planck Institute for the History of Science (Berlin, Germany); the Worldly House at dOCUMENTA 13 (Kassel, Germany); BankArt NYK (Yokohama, Japan); Chiaki Kamikawa Contemporary Art (Paphos, Cyprus); the Museum Bellerive (Zurich, Switzerland); ANTI Festival of Contemporary Art (Kuopio, Finland); the Centro Columbo Americano (Medellin, Colombia); and throughout the United States. In 2012, Donner initiated *Cultural ReProducers,* an evolving creative platform that supports cultural workers working it out as parents through events, publications, skill sharing, and an extensive online resource for artists and institutions. In 2014 she curated the exhibition *Division of Labor* with Thea Liberty Nichols, addressing the impact of parenthood on an artist's practice and career. She teaches at the School of the Art Institute of Chicago.

Deirdre M. Donoghue is a theatre maker, visual and performance artist, doula, birth educator, founding director of the international *M/other Voices Foundation for Art, Research, Theory, Dialogue and Community Involvement,* and a mother of two. She is currently a PhD candidate at The Institute for Cultural Inquiry, Utrecht University. Her research is on the social and political relations and imaginaries produced and proposed by the artworks and artistic processes of mother-artists. Deirdre is one of the founding members of *ADA: Area for Debate and Art,* Rotterdam and is co-organizer of The Mothernists conferences (2015, The Netherlands and 2017, Denmark). Her artworks have been exhibited internationally, most recently at Haus der Kulturen der Welt,

Berlin; Gaîte Lyrique, Paris; Malmö Kunsthall, Malmö; and Museum of Motherhood, New York. Upcoming works include "The Matrixial Regeneration Project" for Centrum van Beeldende Kunst; "Almende Manifesto" for the The Second Triennale of Beetsterzwaag, and *Mattering Bodies* for Theatre aan de Laan, The Netherlands. Recent publications include "Entre Nous: Moments, Holes and Stuff" in Natalie S. Loveless, ed., *New Maternalisms Redux* (2018).

Juliana Driever is a curator and writer focused on collaborative practices, public space, and site specificity. Recent curatorial work includes *The Let Down Reflex* (2016-17, with Amber Berson at EFA Project Space, New York, NY and the Blackwood Gallery, University of Toronto Mississauga); *Socially Acceptable* (2015, Residency Unlimited/ InCube Arts); *Art in Odd Places 2014: FREE* (with Dylan Gauthier, New York, NY), and *About, With & For* (2013, Boston Center for the Arts). Her writing has been featured online with A Blade of Grass Foundation and Bad at Sports, in the print volume "Service Media: Is it 'Public Art' or Art in Public Space?," and in a number of exhibition catalogues.

Anna Ehnold-Danailov is a theatre director, born in Germany but a resident in the U.K.. She has directed classical, physical, and devised theatre and has written for festivals and theatres across the U.K.. She is the artistic director of theatre company Prams in the Hall (www. pramsinthehall.com), which produces bold adaptations and inspirational new writing whilst developing different working methods to enable parents to continue working in their creative fields. In 2015 Anna co-founded Parents in Performing Arts (PiPA). PiPA's vision is of a world in which carers and parents are able to flourish in the performing arts at every stage in their career. The aim of the campaign is to enable and empower parents, carers, and employers to achieve sustainable change in attitudes and practices in order to attract, support, and retain a more diverse and flexible workforce. Anna has two children, eight and three years old at the time of writing. She considers them the catalysts of her work with both Prams in the Hall and PiPA.

Andrea Francke is an artist born in Peru and currently based in London. Most of her work revolves around long term projects. Recent projects include *Invisible Spaces of Parenthood* (a collaboration with Kim Dhillon exploring the legacies of second-wave feminism and their

implications within art and its infrastructures, labour, and care), *Wish You'd Been Here* (a project that reflects on hosting as an artistic and feminist method along Eva Rowson), and *FOTL* (a reading and writing group on maintenance, labour, and care with Ross Jardine). Commissions and exhibitions include The Showroom (London), Serpentine Gallery (London), and CCA Derry—Londonderry, among others. She is currently a PhD candidate in Latin American cultural studies at the University of Manchester. Her doctoral research develops a decolonized genealogy for social practice in Peruvian art through an Andean philosophy framework.

Lydia Gordon is the associate curator for exhibitions and research at the Peabody Essex Museum in Salem, MA. At PEM, Gordon helps organize complex temporary exhibition and publication projects, including *PlayTime* and the chapbook and digital catalogue featuring her essays "Notes on Leisure" and "Play Is Part of Our DNA" and *Jacob Lawrence: The American Struggle*, accompanied by the multi-author scholarly publication, featuring her essay "History Forward: Jacob Lawrence and Contemporary Art." Gordon is the organizing curator for *Hans Hofmann: The Nature of Abstraction* and the curator of *Vanessa Platacis: Taking Place*. Gordon also serves as an adjunct professor of Art History at Montserrat College of Art. She earned her BA in art administration from Simmons College in 2010 and her dual MA in art history, theory and criticism, art administration and policy from the School of the Art Institute of Chicago in 2017.

Dyana Gravina is an artist, facilitator, activist, and art producer. She has worked for over ten years in the entertainment industry and contemporary arts. She has led international productions and collaborated with brands and institutions, including the Biennale of Venice, IPM International Music Conference, The Devine Comedy musical theatre, and Goldsmiths University of London. Now based in London, she is the founder and creative director of Procreate Project, a pioneering arts organization supporting the development of contemporary artists who are also mothers, working across art forms.

Terri Hawkes is a joyful member of the "sisterhood-of-the-traveling-mother-artist-activists" and is pleased to share this moniker with many extraordinary people she has met on her journey thus far, including numerous contributors to and subjects of this anthology. As

an activist, Terri is a passionate advocate for mothers and youth in the arts; as an artist, her creative writing, directing, and acting have been produced in theatre, film, television and radio, garnering numerous award nominations; as an academic, Terri holds an honours MFA in playwriting (UCLA), an MA in gender, feminist and women's studies (York University), and has contributed to Demeter Press publications *Performing Motherhood* (co-editor), *On Mothering Multiples* and *Screening Mothers: Motherhood in Contemporary World Cinemas*. As a mother, Terri feels privileged to witness the coming of age of her two remarkable adult children, Alexa and Jake Hawkes-Sackman, with whom she shares artistic passions. The trio has joined forces in co-founding a program mentoring and supporting Canadian youth in accessing the arts: *art4you*.

Alicia Harris (Assiniboine) is a PhD Candidate at the University of Oklahoma. Her research interests include Indigenous relationships to place and expressions of kinship. Her forthcoming dissertation examines Native North American land arts practices, as they link to ancestral practices of place-making, and as interruptions of the settler state. Alicia is an Associate Member of the Fort Peck Assiniboine and Sioux Tribes in northeastern Montana.

Julia V. Hendrickson is the associate curator at The Contemporary Austin in Austin, Texas, where in 2016 she organized the first solo museum exhibition of Lise Haller Baggesen's *Mothernism*. Her current curatorial endeavours include solo exhibitions by Janine Antoni, Huma Bhabha, and Jessica Stockholder. With artist Anthony B. Creeden, she co-directs Permanent.Collection, an experimental, non-commercial exhibition space. She received her MA in 2012 in the history of art from the Courtauld Institute of Art, London.

Niku Kashef is a mother, interdisciplinary artist, educator, and independent curator. Her work explores geography, biography and place, as a physical location, our perceived relationship to it and how this experience is shaped. She addresses social issues of identity, scientific inquiry, collective memory, motherhood, and home through the lens of finding and building community by means of a shared experience. Niku has exhibited work in collections of national and international venues, including the Monterey Museum of Art, The Museum of Arts & Crafts-ITAMI (Japan) and the Yucun Museum of

Art (China). She is a lecturer of art at California State University, Northridge; a participating adjunct at Woodbury University, a coordinator for the CSU Summer Arts program, and an independent curator having done past work with the United States National Committee for United Nations Women in Los Angeles. She has curated and moderated a multi-city, annual ongoing series of panels for parent-artists since 2014.

Tina Kinsella is Head of Department of Design and Visual Arts at the Dún Laoghaire Institute of Art, Design, and Technology (IADT), Research Fellow at the Centre for Gender and Women's Studies, Trinity College Dublin and Fellow at the Graduate School of Creative Arts and Media (GradCAM). Her writing and research are inter-disciplinary, drawing on philosophy and psycho-analysis to consider the relationship between theory, contemporary artistic practice, expanded performance, visual culture, and the politics of represen-tation. Her most recent research focuses on the affective dimensions of art and activism, leading to the development of two concepts that she entitles the "affectosphere" and "affectivism," which address how psycho-corporeal aesthetic affects can be activated to produce political effects and collective affiliative structures capable of recontouring our social imaginaries. Kinsella publishes widely and was a research collaborator for Jesse Jones's installation *Tremble Tremble* at the 57th Venice Biennale 2017.

Jennie Klein is a professor of art history at Ohio University in Athens, Ohio. Her research interests include feminist art and art history, feminist art and the maternal, contemporary performance art, and visual culture. She is presently working on two edited volumes, one on the work of Marilyn Arsem and the other on the work of Elizabeth Stephens and Annie Sprinkle.

Line Langebek is a screenwriter, translator, lecturer, mother, and campaigner. She's passionate about using stories as a way to instigate change and is one of the founders of Raising Films. She is also co-founder of Library of Change and currently co-chair of the WGGB's Film Committee. As a screenwriter, she wrote the feature film *I'll Come Running* with US director Spencer Parsons. Other credits include *Sink or Swim* for Channel 4's Coming Up strand, the documentary *Duam Drïte: We Want Light* for French television, and *Field Story* (dir. Eva

Weber) for BFI's big budget Shorts Scheme. Line is an alumna of the Lighthouse/BFI Guiding Lights programme (mentor Frank Cottrell Boyce), and she is currently working on several commissioned feature film and TV projects, including *Dagmar*, a feature film based on a true crime story as well as a kids' animation/live-action series. She teaches screenwriting at Regent's University.

Caroline Seck Langill is a writer and curator whose academic scholarship and curatorial work looks at the intersections between art and science, as well as the related fields of new media art history, criticism, and preservation. Her interests in noncanonical art histories, gender studies, and Indigenous epistemologies have led her to writing and exhibition making that could be considered postdisciplinary. With Lizzie Muller, she has been looking at questions of liveliness in art and artifacts. This ongoing research resulted in the exhibition *Lively Objects for ISEA: Disruption* (2015), wherein undisciplined artworks were woven through traditional displays and historical tableau at the Museum of Vancouver. Caroline Seck Langill resides in Peterborough and works at OCAD University, in Toronto, where she is a professor and the Vice-President Academic and Provost.

Natalie S. Loveless is a conceptual artist, curator, and associate professor of contemporary art history and theory in the Department of Art and Design at the University of Alberta, where she also directs the Research-Creation and Social Justice CoLABoratory (researchcreation. ca). Loveless specializes in feminist and performance art history, art as social practice and the pedagogical turn, and artistic research methodologies (research creation). Recent projects include "Maternal Ecologies: An Autoethnographic and Artistic Exploration of Contemporary Motherhood," *How to Make Art at the End of the World: A Manifesto for Research-Creation* forthcoming with Duke University Press, and a chapter on feminist art and the maternal for the forthcoming Wiley-Blackwell *Companion to Feminist Art Practice and Theory*, co-edited by Hilary Robinson and Maria Elena Buszek.

Martina Mullaney is an Irish artist living in North Yorkshire, England. She is studying for a PhD by practice at University of Reading with the project *The Missing Mother*. She graduated with an MA in photography from the Royal College of Art, London in 2004. She has exhibited with Yossi Milo Gallery in New York; Fraenkel Gallery, San

Francisco; Gallery of Photography, Dublin; and Fotogallery, Cardiff. In 2009, she initiated *Enemies of Good Art*, a multidisciplinary project interrogating the artist in relation to the family. It was executed through a series of public meetings, performances, lectures, and live radio broadcasts. Events took place at theTate Modern, the ICA, Southbank Centre, and Chisenhale Gallery in 2015. Live discussions were broadcast on Resonance 104.4FM. In the spring of 2016, she was the first artist in residence with Idle Women.

Heidi Overhill is a professor at the Sheridan College Institute of Technology and Advanced Learning in Oakville, Ontario, where she teaches studio practice and the history of design and media in degree programs in the Faculty of Animation, Arts, and Design. As a practicing designer, Heidi was previously senior designer at the National Gallery of Canada and continues to consult in Canada and overseas. Most recently, she wrote the interpretive plan and conceptual design for thirteen galleries in the new six-story National Museum of Natural History in Manila, the Philippines, which opened 2017. In fine art, she has been profiled in *Canadian Art* for her conceptual project *MoMe: The Museum of Me* (2010). She is currently a PhD candidate in the Faculty of Information at the University of Toronto where she is interpreting the design of the Western domestic kitchen as the location of information rather than work. Her scholarly writing has been published in the A+ journals *DesignIssues* and *Curator: The Museum Journal,* and in the proceedings of ASIST (Association for Information Science and Technology). She is co-author with Roger Ball of *DesignDirect: How to Start Your Own Microbrand* (Hong Kong: Hong Kong Polytechnic University, 2012; Mandarin translation 2014) as well as the world's first sarcastic baby name book: *The Only Baby Name Book You'll Ever Need* (Toronto, ON: Key Porter, 1996).

Irene Pérez is a visual artist whose works explore concepts of cultural and social identity, gender, language, and memory. Born in Terrassa, Barcelona, Spain, Pérez began her career in Chicago, USA, where she lived between 1999 and 2009. Her studies include art history at the Autonomous University of Barcelona, photography and fine arts at College of DuPage, IL, and fine arts with a concentration in sculpture and painting at the University of Illinois at Chicago. Pérez works with various media including works on paper, textiles, and sound. Her

works explore personal experiences in a multidisciplinary manner with the goal that they become the vehicle to generate thought. Since 2017, she has been developing a project under the name *Seeds for Resistance*, which takes as its starting point the many conversations Pérez has with her daughter, specifically those about the lack of female references in history in general and in textbooks in particular. This premise, together with the practice of feminist mothering, has allowed the artist to continue working with the idea of her previous project, *New Universe: Exploring Other Possibilities,* that refers to education as the engine for change.

Shira Richter is a practicing, multidisciplinary research-thinker-artist-speaker who has been ARTiculating motherhood, mothering, mother value, and worth (care work) in socioeconomic, political, and artistic contexts for nearly two decades. She is the director of the internationally award-winning documentary film *Two States of Mind* (2002) about women's voices regarding the Israeli-Palestinian conflict and UN resolution 1325. She is the artist-creator of two photography-text-video installations: *The Mother Daughter and Holy Spirit* (2006) and *Invisible Invaluables* (2011). Her writing on care labour economies has been published in the Israeli press and in *Counting on Marilyn Waring: New Advances in Feminist Economics* (2014).

Lena Šimić is a reader in drama at Edge Hill University. Originally from Dubrovnik, Croatia, Lena identifies herself as a mother of four boys, a transnational performance practitioner, a pedagogue, and a scholar. A co-organizer of the Institute for the Art and Practice of Dissent at Home, an art activist initiative in her family home in Liverpool, U.K., Lena is currently researching contemporary performance and the maternal. Lena has presented her arts practice and research in a variety of academic journals (*Performance Research, Contemporary Theatre Review, n.paradoxa, RiDE, Feminist Review,* and *Studies in the Maternal*) and in various arts venues and festivals in the U.K. and internationally. Lena has published five artist books: *Maternal Matters and Other Sisters* (2009), *Blood & Soil: we were always meant to meet...* (2011), *Five 2008-2012* (2014), *The Mums and Babies Ensemble* (2015) and *4 Boys [for Beuys]* (2016). Together with Emily Underwood-Lee, she has co-authored *Manifesto for Maternal Performance (Art) 2016!* as well as co-edited "On the Maternal" (2017) issue of the *Performance Research* journal.

Ruchika Wason Singh is a visual artist, art educator, and independent researcher based in Delhi, India. She holds BFA and MFA degrees in painting from College of Art, New Delhi; and a PhD as a U.G.C. Junior Research Fellow from he University of Delhi. In 2016, she initiated the ongoing research project *AMMAA—The Archive for Mapping Mother Artists in Asia*. Recent international engagements include *The Blood of Women—Traces of Red on White Cloth* curated by Manuela de Leonardis, Italy, and Croatia (2016-2019); Salon de Beaux Arts, Carrousel Du Louvre, Paris, France (2019); *Utopia Land*—Month of Art Practice (MAP) International Artist Residency Program, The Heritage Space, Hanoi, Vietnam (2017); and a solo exhibition *Project Habit/At*, Huong Ngo Art Space, Hanoi, Vietnam (2017). Currently, she is a visiting professor at Ashoka University, Sonipat, India.

Emily Underwood-Lee is research fellow at the George Ewart Evans Centre for Storytelling at the University of South Wales in Cardiff, U.K.. Her research is focused on the stories women hold in their bodies, how they tell them, and how they receive them. In particular, she focuses on performance, autobiographical stories, and the body in a variety of contexts, including feminist performance art, narratives of illness, performance and the maternal, and performance and disability. Together with Lena Šimić, she has co-edited the special edition of *Performance Research* "On the Maternal" and is working on the co-authored monograph *Maternal Performance: Staging Feminist Journeys through Motherhood*, due to be published by Palgrave in 2021.

Index of Illustrations

Deepest appreciation to
Demeter's monthly Donors

DEMETER

Daughters
Linda Hunter
Muna Saleh
Summer Cunningham
Rebecca Bromwich
Tatjana Takseva
Kerri Kearney
Debbie Byrd
Laurie Kruk
Fionna Green
Tanya Cassidy
Vicki Noble
Bridget Boland

Sisters
Kirsten Goa
Amber Kinser
Nicole Willey
Regina Edwards